The world that made Mandela

A Heritage Trail

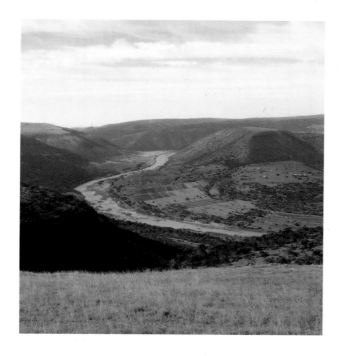

by
Luli Callinicos

publishers

Johannesburg

First published in 2000 by
STE Publishers
143 Hunter Street, Bellevue East
Johannesburg, South Africa

The moral right of the author has been asserted.
©Luli Callinicos 2000

Contemporary photographs by Peter McKenzie
unless otherwise indicated
©Peter McKenzie 2000

Copyright for photographs vest in the photographer

Edited by Ivan Vladislavic

Publishing management and consultancy by Zann Hoad of

Designed by Brian Palmer at Those Three

ISBN 1-919855-01-7

Electronic origination by Colors
Printed by Colorsprint

Bound by Haste Book Binders

Set in Bauer Bodoni 11 on 13.5pt
and Franklin Gothic

Foreword

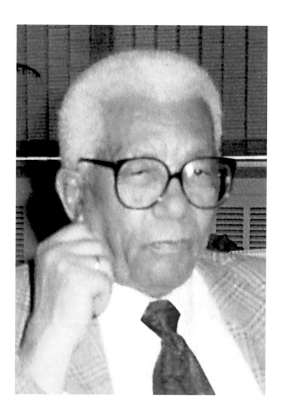

This is a book which examines a landscape that for many decades was hidden from official view. Nowhere in the maps of apartheid South Africa could one find Bochabela in Mangaung (Bloemfontein), or Montsioa Stad in Mafikeng, or Galeshewe in Kimberley. Luli Callinicos has made some of these hidden places visible and relevant again by linking them to the life of one of our nation's most admired mentors, Nelson Mandela.

But this book goes further: it also vividly represents the rich and dynamic world that was the making of Nelson himself. In doing so, it pays tribute to the people of South Africa, to the liberation movement, and to the places which impacted so powerfully on his life.

The concept of the book reminds me strongly of a speech made in 1952 by Dr SM Molema, esteemed author and ANC national treasurer, to the Annual Conference of the South African Indian Congress. It was the year that white South Africa was celebrating the 300th anniversary of the arrival of Jan van Riebeeck.

'Remember the salient, the dominant fact of South African history,' he said, 'that all the monuments, all the celebrations and all the feasts of the white man have a diametrically opposite meaning to the black man; because every monument of the white man perpetuates the memory of the annihilation of some black community, every celebration of victory the remembrance of our defeat, his every feast means our famine and his laughter our tears.

Such are the Great Trek celebrations and the Voortrekker Monument; such are Dingaan's Day and Union Day, and such are the approaching Van Riebeeck celebrations.'

Molema was pointing towards the necessity of reclaiming the landscape to celebrate our history and our heritage — that is, the heritage of *all* our people. It was a message which the Freedom Charter later reaffirmed; that the country belongs to all who live in it. *The World That Made Mandela*, I believe, makes a valuable contribution towards the process of redressing the imbalances in our cultural landscape.

Every South African should read this book. And to our international readers, I suggest that *The World* offers a glimpse of a fundamental South African experience, communicated through our places, our people, our history. And should this book encourage you to come and visit us, bear in mind that your physical presence at each site, besides stirring you with the power of its uniquely historical bearing, will also be a means of empowering the community itself.

W. M. Sisulu

WALTER SISULU

Acknowledgements

This book, like all productions, is a collective effort. It would not have seen the light of day without a dedicated team of skilled crafters.

Firstly and foremostly, I must thank Sharon Levy, whose vision, initiative, enthusiasm and hard work transformed the initial book from a supplement of the *The Educator's Voice* to a much more ambitious heritage trail which aims to link, through words, images, voices, and above all places, our spectacular and dramatic past with the achievements and challenges facing present-day South Africa. In the formative period of the book, the Millenium Project was also very encouraging and their support very valuable. Members included Beryl Baker, Ahmed Kathrada and Minister Jeff Radebe.

Reedwaan Vally, who warmly committed himself to the project from the outset, has shown a dedication, generosity and courage which have gone far beyond the normal duties of a publisher. To the dedicated team at STE, in particular Pippa Dyer, also to Sarah Maseko, Thabo Matlejoane, Nikki Robertson, Regan Ross, Adam Rumball, and to Kallie Forrest and Rita Potenza, who all attended to the seemingly endless details of a fairly complex book, and to indexer Mirie Van Rooyen and proof-reader, Owen Hendry, to Barrett Stewart, Brian Palmer and Tiffany Turkington of Those Three and Beat Schmid, Rodney Emmenes and all at Colors — thank you. In addition, Ivan Vladislavic's uncompromising excellence in editing assisted in clarifying both the structure and the text. Peter McKenzie's gifted eye has produced an elegant collection of sites of significance which helps us to view our landscape anew. I am particularly grateful to publishing manager Zann Hoad, whose experience, expertise, discipline, astuteness and emotional-intelligence kept the whole project on track.

In the Eastern Cape I owe a great debt to a number of extraordinary people. My special thanks go firstly to Nokuzola Ntetani for her intimate knowledge of the community memory and oral history of Thembuland, and for her generosity in sharing this heritage; to Vuyo Jarana and Chief Nokwanele of Qunu, and to the Qunu Initiative Development Project; to Chief Charles Nokayi and David Nokayi of Mvezo; to Lewis Matiela and Ernest Booi, to the SAHRA-commissioned young and keen oral historians who have harvested amazing narratives from the storytellers of the area. (Unhappily, there is not enough space to include all these unfolding memories, but there are guides who will narrate them to those visitors who are interested in hearing them and visiting sites of significance in the old Transkei.)

A special thanks is also due to Lesley Townsend, conservation architect of the South African Heritage Resources Agency (SAHRA) for her dedication, imaginative approach and determined defence of the community's heritage.

My mother-in-law Enid Webster provided unique photographs and memories of Healdtown in 1937. She was Mandela's English teacher (Miss Cook, the daughter of the Rev. Arthur Cook, Warden of Wesley House when Mandela was a student at Fort Hare). She has always been a fund of information about her remarkable family and their dedication to a higher purpose in life. I thank her for being an inspiration to me in many ways.

If I had the space I could tell a tale about every one of the people who generously shared their information and insights with me, but I shall have to content myself with a mere list of names. These include Jane Ayres, Flo Bird, George and Rita Bizos, Sympathy Dube, Eric Etzkin, Thanduxolo Lungile of SAHRA in the Eastern Cape, Denver Webb and Similo Grootboom, Gail Gerhart, Nadine Gordimer, Rica Hodgson, Shaun de Waal, Michael Kahn, Wandile Kuse (a Madiba himself), Archie and Rita Mackellar, Xolela Mangcu, Reggie Mokgokong of the Alexandra Tourist Forum, NG Patel for information about the development of the Oriental Plaza, Herma Gouws and Daniel November of SAHRA in the Free State for historical information about Mangaung, Bochabela and Waaihoek, Carol Hoch and Dolf Haveman of DACST, Marie Human of Baileys Archives, Anne van Bart, Aubrey Paton of TML Syndication, Barry Feinberg, Graham Goddard, Esther van Driel, Esther Zulu of Mayibuye Centre, Naudé van der Merwe, Pam Hamilton of PictureNET Africa, Sally McLarty for her beautiful map illustration, Peggy Luswazi, Columbus M. Malebo for his knowledge on St Mary's Cathedral and the precinct around the DOCC, Margaret Mojapelo for her work and information on the Tokoza Memorial, architects Phillip Mashabane and Jeremy Rose who are working with the Soweto Heritage Trust; Sandy Rowoldt of the Cory Library, Jeff Peires, Hugh Macmillan, Greg Nott, Meg Pahad, Carol Steinberg, Raymond Tucker, and Ciraj Rassool for photographs, conceptual insights and memories of the District Six community and Robben Island; to Lazar Sidelsky for his memories of his famous articled clerk and the photograph of himself; to Walter and Albertina Sisulu for their wedding photos; and to Graeme Reid, Neil Fraser and Herbert Prins for their expertise and commitment to the transformation of Johannesburg city. Other very helpful expert informants are Elsabe Brink, Thabang Khanye and Sue Krige, Paula Girshick, Elinor Sisulu (for her wisdom, warm support and practical assistance), as well as Johan Bruwer and Jennifer Kitto of SAHRA in Gauteng. Special thanks also go to my daughter Thalia Hambides for her (unpaid) practical help and expertise, as well as to my mother, Thalia Callinicos, for her keen interest in my work, and unfailingly warm support. And then there is my husband and intellectual partner Eddie Webster, who over thirty years, both directly and indirectly, has always been a constant source of stimulation and warm encouragement in my creative endeavours.

Above all, the many people who have talked to me during my various research projects, and shared their rich memories of day-to-day life in 20th Century South Africa. Their voices have all contributed towards building up the bigger picture of South Africa's social, political and economic landscape of past and present. To them, and to Walter and Albertina Sisulu, whose own lives were a constant inspiration to Nelson Mandela himself, I dedicate this book.

Luli Callinicos — August 2000

Glossary

SOME CLICK AND OTHER DISTINCTIVE SOUNDS IN XHOSA

This is how the following letters in Xhosa are pronounced:

X – as in Xhosa: smack both sides of your tongue against your inside cheeks as if urging on a horse.

R – as in Mtirara, Mandela's guardian and the Regent of Thembuland: a sound like a thick H.

TH – a T followed by an H as in Thembu or Luthuli should be treated as a silent h. It merely indicates an aspirated accent on the syllable that follows.

Q – as in Qunu and Mqekhezweni: click the tip of your tongue to the roof of your palate

C – as in ingcibi, or the town of Cofimvaba: click the end of your tongue against the front of your palate, like a sound of annoyance.

hl – as in Rolihlahla: pronounce the h before the l.

Map of the sites in this book

Key for the sites on the map

Eastern Cape

Site 1: Mvezo, Umtata

Site 2: Qunu, Umtata

Site: 3: Mqhekezweni, Umtata

Site 4: Bumbane, Umtata

Site 5: Clarkebury, Umtata

Site 6: Tyhalarha, Umtata

Site 7: Healdtown, Alice

Site 8: Fort Hare, Alice

Site 9: The Bhunga, Umtata

Site 33: New Brighton, Port Elizabeth

Site 56: The Steve Biko Garden of Remembrance, King Williams Town

Site 67: City Hall, East London

Site 70: Qunu, Umtata

Johannesburg, Soweto and Alexandra

Site 10: Newtown Compound

Site 11: The Pass Office, Albert Street

Site 12: Alexandra Township

Site 13: Walter Sisulu's Office

Site 14: The Sisulu Home, Orlando West

Site 15: Park Station

Site 16: Dr Xuma's House

Site 17: City Hall steps

Site 18: The Supreme Court

Site 19: Bantu Men's Social Centre

Site 20: The Planet Hotel

Site 21: The Donaldson Orlando Community Centre

Site 22: Wits University

Site 23: Kapitan's

Site 24: Kholvad House

Site 25: Mary Fitzgerald Square, Newtown

Site 27: Luthuli House

Site 28: Chancellor House, Fox Street

Site 29: National Acceptances House, Rissik Street

Site 30: Gandhi Square Rissik Street

Site 31: Red Square, Fordsburg

Site 34: The Magistrates' Courts, Johannesburg

Site 36: Sophiatown

Site 37: Meadowlands, Soweto

Site 38: St Mary's Cathedral, Johannesburg

Site 40: COSATU House, Johannesburg

Site 41: Freedom Square, Kliptown

Site 43: The Old Fort, Johannesburg

Site 45: Orlando Hall, Soweto

Site 46: Sharpeville

Site 50: Rivonia

Site 52: 8115 Ngakane Street, Orlando West

Site 53: Phefeni School, Orlando West

Site 59: Jabulani Stadium, Orlando

Site 63: World Trade Centre, Kempton Park

Site 68: 4 Thirteenth Avenue Houghton, Johannesburg

Pretoria

Site 42: Union Buildings, Pretoria

Site 44: The Old Synagogue, Pretoria

Bloemfontein

Site 26: Makgasa Hall, Bochabela

Durban, Stanger, Pietermaritzburg

Site 32: Curries Fountain, Durban

Site 35: Chief Albert Luthuli's house, Groutville

Site 47: Plessislaer Hall

Site 48: Ngquza Hill, Bizana, Pondoland

Site 49: Howick

Site 64: Ohlange School, Inanda

Cape Town

Site 39: District Six, Cape Town

Site 51: Robben Island

Site 54: Rocklands, Mitchells Plain, Cape Town

Site 58: Pollsmoor Prison, Cape Town

Site 60: Victor Verster Prison, Paarl

Site 61: Grand Parade, Cape Town

Site 62: Groote Schuur, Cape Town

Site 65: Genadendal, Cape Town

Site 66: Houses of Parliament, Cape town

North-West Province

Site 69: Montsioa Stad, Mafikeng

Mpumalanga

Site 55: Machel Monument, Mbuzini, Komatipoort

Northern Cape

Site 45: Galeshewe, Kimberley

Introduction

The concept

Volumes have been written about Nelson Mandela and his inspiring life. It is a story we need to hear. The books celebrate the miracle of his historic achievement — of his personal development, and of his key role in shaping the peaceful transition to a new and democratic South Africa.

Yet, as Mandela himself has so often insisted, he himself was shaped by the political traditions and values of his ancestral roots; by the resourcefulness and resilience of the men, women and children of South Africa; by his organisation, the African National Congress; and by the high calibre of committed colleagues who helped to mould his vision and his finely honed political judgement.

The World That Made Mandela is concerned to explore his fascinating universe. In order to do this, it traces the sites and places of meaning in Mandela's life. These sites range from rural villages, to missionary schools and other institutions of learning; to the workplaces, townships, buses and trains, offices and prisons of the metropolis, and many other localities beyond.

Many of these places still exist. They are visible, tangible reminders of the past. They are sites of significance, given powerful meaning because of their association with historical events or with well-known or well-loved people. Some of the places and sites have been identified and recognised by local communities, by local, provincial or national government, or by the South African Heritage Resources Agency (SAHRA). Some are run down, or bear the bitter marks of struggle. Where their historical significance has been officially recognised, plaques are being placed to mark them. In other instances, interpretive centres have been set up. Representations and museums are also being planned.

Places of meaning have an immense power to evoke the past.

Simply by being there, a visitor can feel a physical identity with historic moments or public figures. When these sites are linked with other sites, a bigger picture begins to emerge. Visitors are given a deeper understanding of the unfolding events over time, and a sense of the wider context in which a particular site and its significance are placed.

The significance of history trails

History trails exist throughout the world. They have been recognised as an important component of the tourist and heritage industries. They contribute significantly to foreign exchange as well as to a nation's sense of its own identity. The appreciation of heritage and an understanding of our shared though often painful past is generally acknowledged to have an important potential for nation-building. A trail that explores Mandela's cultural landscape could make a notable contribution to such a project.

In South Africa, history trails are beginning to emerge and develop almost spontaneously, by popular demand. Visitors from abroad, for example, are seeking to invoke connections between their own cultural ancestors and South Africa's historical experiences. Swiss, German, Scottish and other European tourists are visiting 18th and 19th-Century mission stations throughout the country. Malaysian, Indian, Chinese and African-Americans are seeking to explore and deconstruct the slave routes, the ordeals of indentured labour, and Gandhi's momentous experiences in South Africa which led to the development of his moral philosophy of Satyagraha. These visits have the powerful potential to bestow insights into the roots of apartheid and all its ills. They also interrogate apartheid's shared legacy of racism and discrimination that lingers throughout the world.

The Mandela trail which this book aims to facilitate is a response to a popular international and national demand for a way of identifying with Mandela's world-wide contribution to a new vision of humanity. *The World That Made Mandela* will help to build up a portrait of Mandela as a whole person, a product of his society and his culture, as well as his own personal experiences.

By beginning with Mandela's rural roots, this book reveals his grounding in the humanistic legacy of Africa. Then again, his missionary education equipped Mandela with the skills and learning of the white ruling class, and so empowered him to meet the oppressors of his people on a more equal footing. Mandela's life as a black man in Johannesburg's townships, despite his education and profession, as well as his prison experiences — long before Robben Island — gave him first-hand experience of the oppression of ordinary people persecuted by the pass system, the curfew, the Group Areas Act and other oppressive laws and human rights abuses entrenched in the apartheid system.

Because the book explores a trail of inter-linked sites over time and space, the narrative uncovers the wider context that influences the lives of all individuals. This will enable readers to gain a sense not only of the life of Nelson Rolihlahla Mandela, but also of the sites that helped to shape his destiny, the times in which he lived, and the ways in which he responded to them.

The World That Made Mandela tries to avoid becoming a humdrum hagiography. This book is a tribute to, and celebration of, our society, its traditions, its values, its communities and its landscape which shaped a remarkable life — the life of Nelson Rolihlahla Mandela, who demonstrated to South Africa and the world how to draw on the strengths of his multi-layered culture, and emerge from a seemingly fearsome impasse to point towards the solution.

Luli Callinicos

Contents

PART 1

PART 2

PART 3

PART 4

PART 5

PART 6

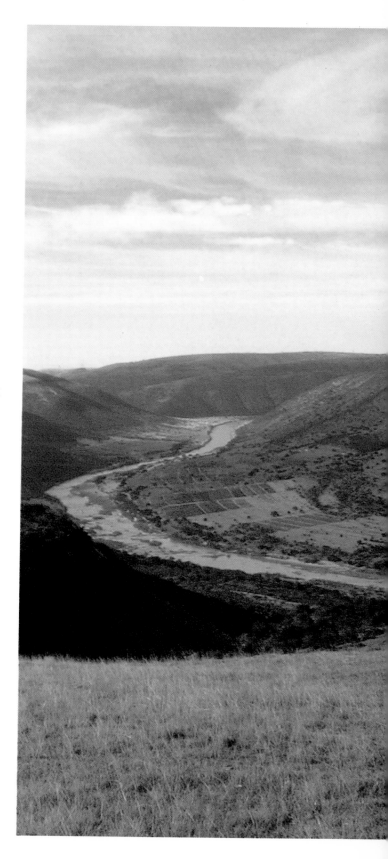

Part One

'The whole life of any thinking African in this country drives him continuously to a conflict between his conscience on the one hand and the law on the other... a law which, in our view, is immoral, unjust and intolerable.'

'Many years ago, when I was a boy brought up in my village in the Transkei, I listened to the elders of the tribe telling stories about the good old days before the arrival of the white man. Then our people lived peacefully, under the democratic rule of their kings and their *amapakati*, and moved freely and confidently up and down the country without let or hindrance. The country was our own, in name and right. We occupied the land, the forests, the rivers; we extracted the mineral wealth beneath the soil and all the riches of this beautiful country. We set up and operated our own government, we controlled our own arms and we organised our trade and commerce. The elders would tell tales of the wars fought by our ancestors in defence of the fatherland, as well as the acts of valour by generals and soldiers during these epic days... This is the history which, even today, inspires me and my colleagues in our political struggle.'

– From Mandela's statement while on trial, 1962

The area of South Africa known as the Transkei has been through many upheavals in the past three hundred years. In the 19th Century it was the scene of intense conflict between the Xhosa-speaking people and white settlers. During the apartheid period, the Transkei became the first nominally independent 'homeland'. In reality, it was deeply dependent on the apartheid government. Homeland officials, who were widely regarded as 'sell-outs', relied on Pretoria for generous funding as well as military backing against grass-roots opposition.

Today, the Transkei once again forms an integral part of the Eastern Cape, one of the nine provinces of South Africa. But the province is still trying to redress the imbalances and divisions amongst its people wrought by the old homelands system.

Growing up in the Eastern Cape

Nelson Rolihlahla Mandela was born in Thembuland, a kingdom which was annexed by Britain in 1855. His ancestors had settled on the south-east coast of South Africa in the early centuries AD. Over the years, military and diplomatic alliances with Khoisan communities whom they encountered in the Transkei led to intermarriage and the incorporation of physical features and characteristics of the language, values and culture of these indigenous people.

By the beginning of the 18th Century, the Xhosa, of whom the Thembu are a major component, were well established in stable communities of homesteads boasting extensive cattle herds. At that time, the survivors of a shipwreck on the east coast gave an account of these 'hospitable people, disposed to peace rather than war', opposed to violent behaviour amongst individuals, and dedicated to their chiefs, who presided over a democratic system of decision-making.

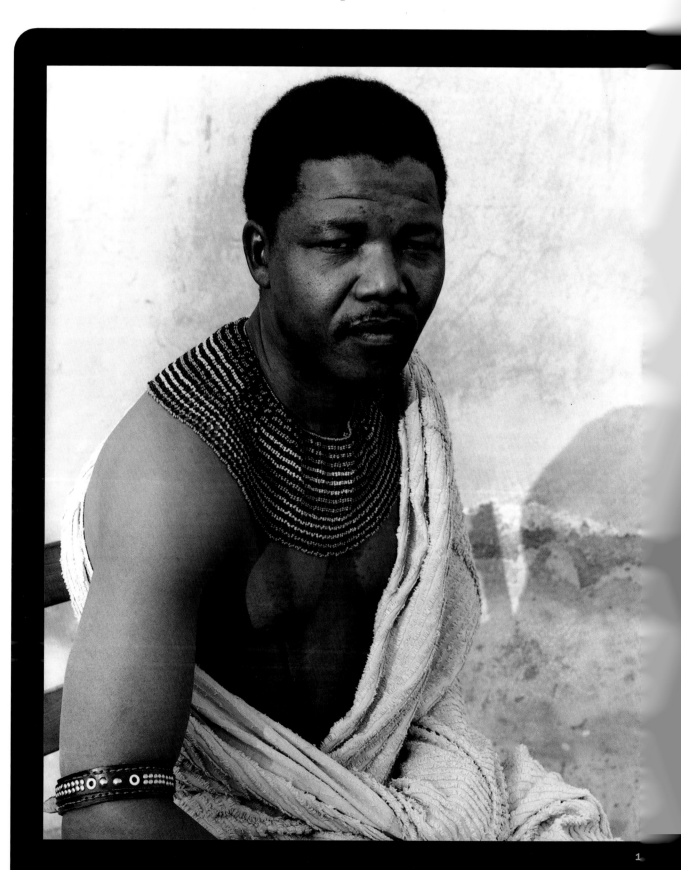

1

A photograph released by Mandela in 1962, while he was underground. This was a graphic message to the people of South Africa, asserting his African heritage. The image continues to resonate with young South Africans today.

In the latter part of the 18th Century, Boer and British started to arrive and settle in the Transkei. A hundred-year struggle began to defend the land and retain control over the culture and traditions of the Xhosa-speaking people. It was only after many battles, capped by the devastating cattle-killing of 1856/7, that the Xhosa finally succumbed to the colonisers.

The cattle-killing was a self-inflicted national tragedy. In 1856, a young woman named Nongqawuse prophesied that if the people killed all their cattle and refrained from sowing crops, their ancestors would arise from the dead on an

Part One

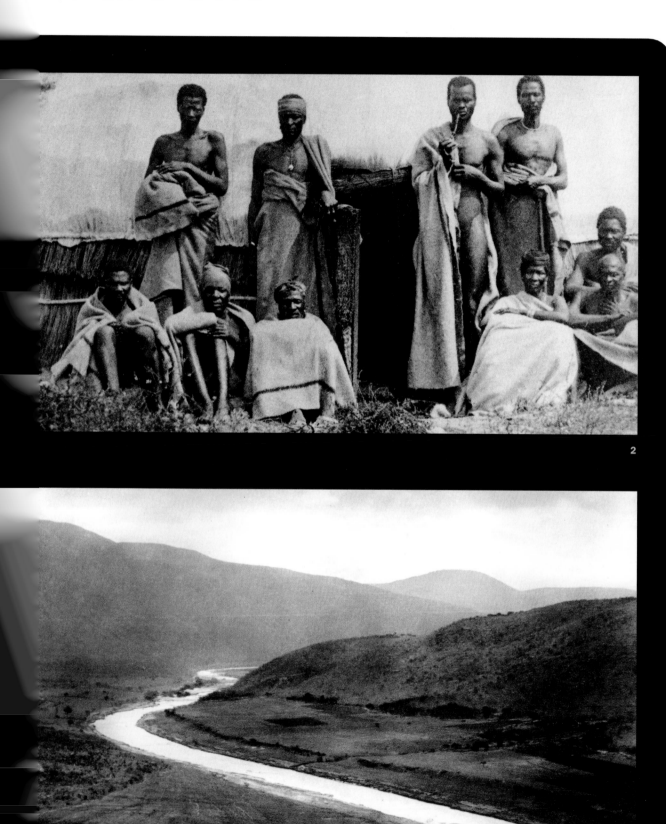

appointed day and drive the white interlopers into the sea. After decades of war, the Xhosa were so desperate and demoralised that they resorted to this magical solution. The Xhosa were decimated. Many died of starvation, and the colonisers were able to consolidate their power over a weakened people. Leaders and chiefs were imprisoned, and thousands were forced to begin working for the white colonisers in order to survive.

Momentous events occurred in 1918, the year of Mandela's birth. The great influenza pandemic caused hundreds of thousands of deaths throughout the world. It was also the year in which the First World War came to an end. This was basically a war between two rival empires, Britain and Germany, whose colonies had been dragged into the conflict. In Europe, some twenty million young men lost their lives.

2
Xhosa chiefs imprisoned on
Robben Island, 1863

In South Africa, the entire Transkei had by then been incorporated into the Union of South Africa, a state in which racism was deeply embedded. In the South African constitution of 1910, Africans were excluded from the franchise unless they lived in the Eastern or Western Cape. Even then, only African men who were fairly substantial property owners or had a certain level of education were entitled to vote. (In 1936, even this concession would be taken away.) All the other provinces specifically excluded African men — as well as women of all races — from the right to vote.

3
A view of the Great Kei River, 1936

In the Transkei, the chiefdoms were still governed by the old British system of indirect rule, which gave white magistrates the final say

over the village headmen appointed by the king. The magistrates, as representatives of the national state, had the power to depose a headman as they saw fit.

At around the same time, the industrial revolution was reaching into the heart of the rural areas. The discovery of minerals — diamonds, gold, coal — created a voracious demand for cheap labour. Growing numbers of young black men were recruited to provide low-paid contract labour for the mines, roadworks and railways in the rapidly growing cities of the Transvaal, Natal and the Western Cape.

It was against this backdrop that a baby boy, Rolihlahla, was born to Gadla Henry Mphakanyiswa, chief of the village of Mvezo in Thembuland, and his third wife, Nosekeni.

4

This old map shows the labour recruiting stations set up by the gold mines in Gauteng. Thembuland, from Umtata down to East London, provided a major supply of migrant workers.

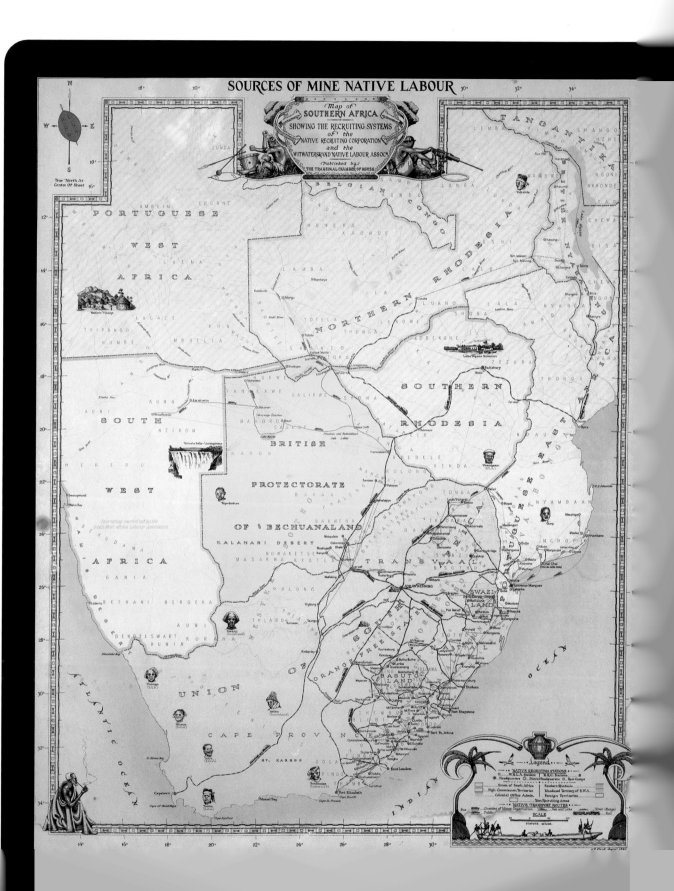

Mvezo

SITE 1

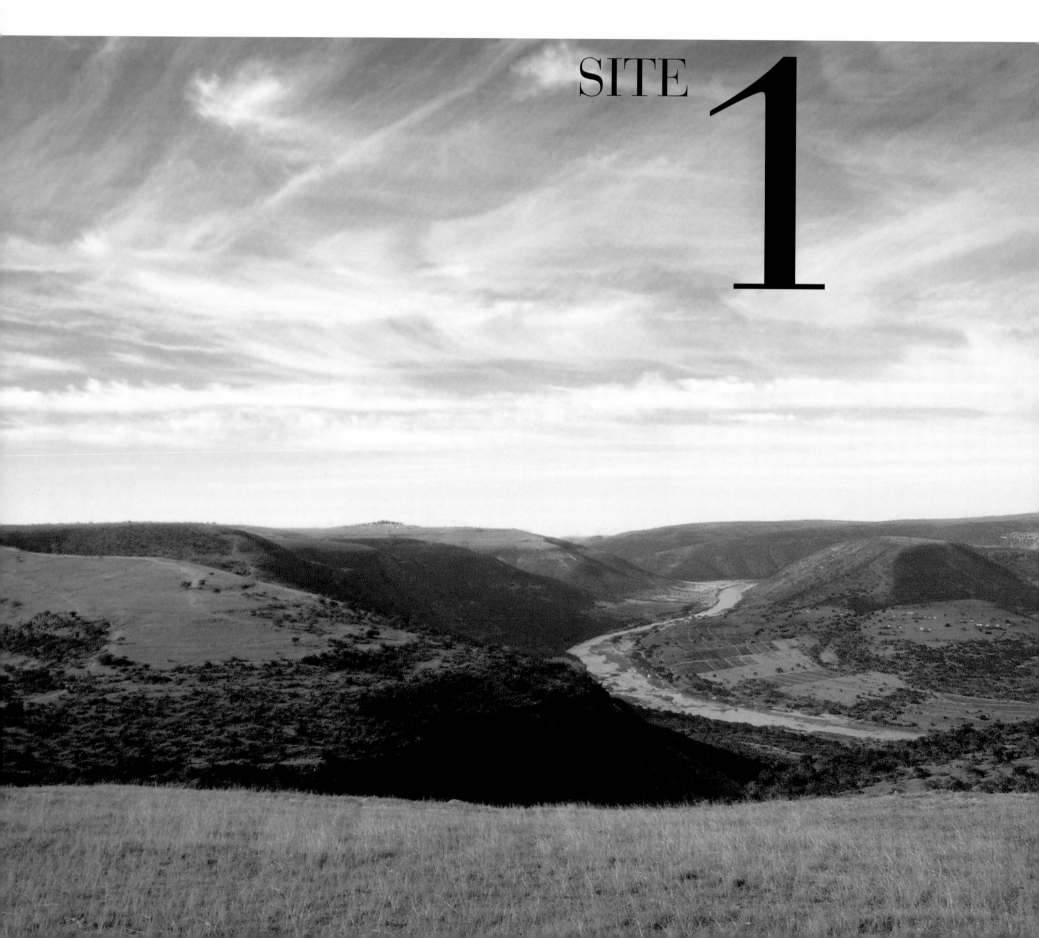

The Birth of a 'Trouble Maker'

Mvezo, Nelson Rolihlahla Mandela's birthplace, is tucked behind a string of villages among Thembuland's gently rolling hills. The traveller comes unexpectedly on the beautiful little village. Its first homesteads are on a plateau, with fine views over the Transkei landscape to the west and south. A walk to the remains of the Mandela homestead, one kilometre away, reveals a stunning vista of the Mbashe River, at the foot of a steep ravine. On the opposite horizon lies the town of Idutywa, the birthplace of Thabo Mbeki, Mandela's successor as President of the African National Congress and as President of South Africa after the second democratic elections, in June 1999.

1
A Thembu man on his wedding day, early 1930s
2
A Thembu mother and child, early 1930s
3
A view of Thembuland, 1936

Mvezo

Rolihlahla's father, Gadla Henry Mphakanyiswa, was the headman of Mvezo. A tall, imposing man, a descendant of chiefs, his duties were to preside over village meetings and to officiate at birth, initiation, marriage, harvest and funeral ceremonies. Although Gadla did not read or write, his opinions were highly respected, and he was chosen by the king to be a member of his royal council. Gadla's status was further enhanced by his prosperity — he had four wives, who bore him thirteen children.

4
Chief Nokayi of Mvezo stands with his daughter next to the remains of the Mandela homestead.

Rolihlahla was born to Gadla's third wife, Nosekeni Nkedama. Her little boy was the youngest of Gadla's four sons. His name, prophetically, means 'pulling the branch of a tree'. This has been taken as a metaphor for disturbing the established order. The baby's name was apt, for soon after his birth Gadla's fortunes changed.

Significantly, this turn of events was directly related to the Thembus' subordinate status under colonial rule. Gadla had made a ruling in a minor dispute regarding cattle. When the local white magistrate called him to account for his decision, Gadla refused to go. According to tradition, a chief was 'a chief by the people' and not by some extraneous authority. It was not seemly to be summoned by an outsider, who

5
Women at the Mbashe River. There is a Xhosa saying that denotes experience and wisdom: 'I have crossed famous rivers.' Mandela's first symbolic crossing took place as an infant, when he forded the Mbashe River on his mother's back on the journey from Mvezo to Qunu. His journey of discovery was to continue throughout his life.

presumed to supplant the traditional duties of a headman. This disobedience to the colonial regime lost Gadla his position, and also the government stipend and the land that went with it.

Some Madiba praise names[1]

Dlomo
a forebear's name dating back to the 1500s
Dlanga
another ancestral name
So-Pitsho
father of Pitsho
Myem-Myem
appealing, delectable
Madiba
reconciler, digger of ditches
Zondwa
begrudged
Ngqolomsila
straight tail
Vela-bembhentsole boyik' abelungu
desist, for fear of the white man
Zondwa Zintshaba
begrudged by the enemies

Praise names are a concatenation of names and places conveying the heritage of the clan. They express feelings of awe and worship, invoke places associated with past exploits, and recall ancient memory. Each name, selected from the genealogical tree, has a history, a memory. All contribute towards the process of defining the identity of every member of the clan. In addition, every individual is given a host of additional names at key rites of passage through life. Note the meaning of 'Madiba', the clan name by which Mandela is affectionately known throughout South Africa.

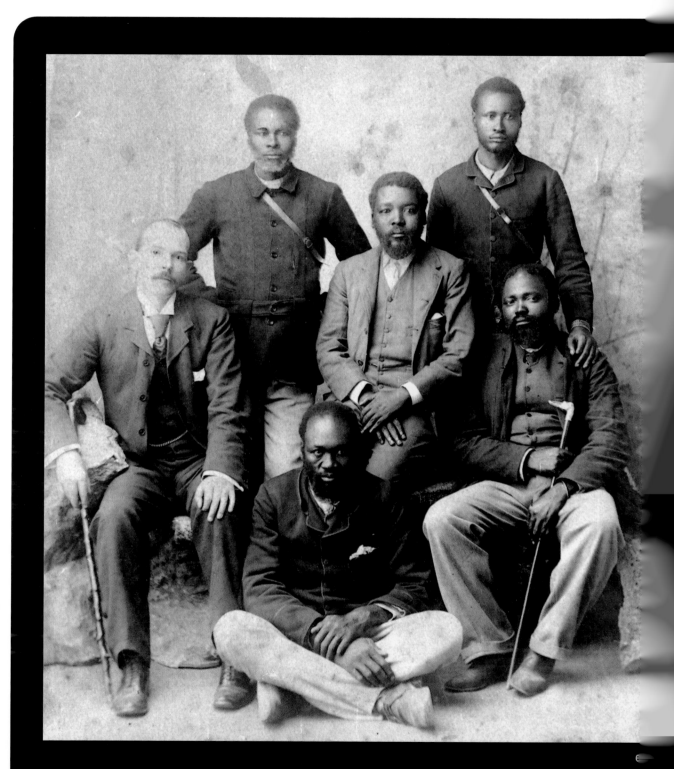

A local magistrate in the Thembuland district poses with his headmen, chief (holding the stick) and interpreter. The magistrate's stick is clearly a statement of his own authority, a symbol of the colonial challenge to traditional leadership.

Qunu

SITE 2

A Chief is a Chief by the People

Unlike Mvezo, Qunu, consisting of 18 villages, is close to the main road that runs from Umtata to East London. It is an accessible twenty-minute drive from Umtata, the home of the Bhunga building, which houses the Mandela Museum. Yet the area remains underdeveloped. In his autobiography, Mandela recalled that 'Qunu was a village of women and children: most of the men spent the greater part of the year working on remote farms or in the mines …' Today, many men are back in the village — retrenched from the mines, unable to provide the cash supplement so necessary for survival in the rural areas. They will have to find ways of restoring practical and social value to their roles in the homesteads.

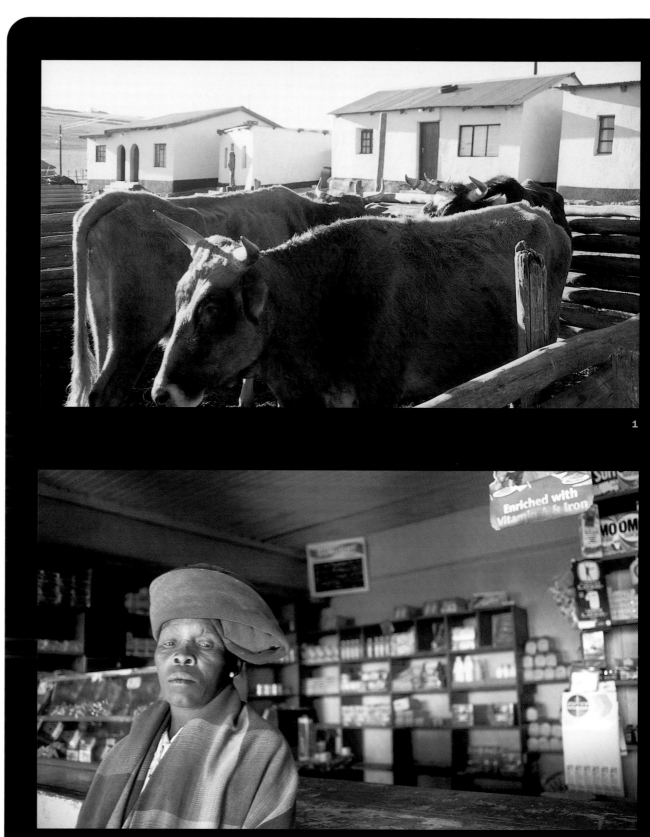

1
A Qunu scene. In the background, the home Mandela built for his mother. Cattle still remain crucial to South Africa's rural economy despite the cash wages that migrant workers manage to bring home.

2
The trading store in Qunu

Qunu

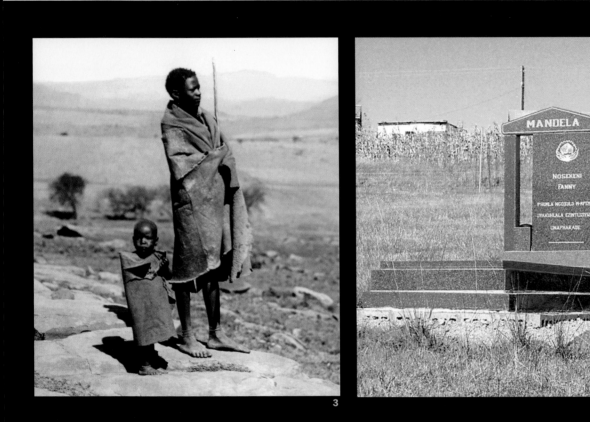

After the dismissal of Gadla as chief of Mvezo, the family moved to Qunu, where Rolihlahla's mother had been born. She made a home of three huts for herself and her four children. Gadla visited regularly for a week every month. The children were surrounded by their extended family — cousins, uncles, aunts and grandparents.

3
A herdboy and his toddler apprentice, in 1930s Thembuland. Herdboys started to contribute to the cattle economy of the homesteads at an early age.

4
The grave of Nosekeni (mother of Nelson and Constance Mandela), who died in 1968.

Rolihlahla began his herding duties at a very young age. Cattle were crucial to the homestead economy. Not only did they provide milk for family consumption, but they measured the wealth and status of the head of the homestead. They were vital for marriages. Following negotiations, an agreed number of cattle were given as a wedding gift to the family of a bride, as compensation for the loss of a loved and valued daughter. The labour of women was pivotal to sustaining the homestead.

In Mandela's childhood, a white trader could be found within walking distance of nearly every village in the Transkei. The trader supplied the manufactured items that were increasingly becoming needs in even remote rural homes. As more and more young men left to find work in the towns and earn money for the family, the traders' hold over the villages grew. As a white and literate businessman, the trader not only had the power to bestow and withhold credit, but he could also advise villagers on their

5
Expertise in stick-fighting confirmed the masculinity of boys and young men.

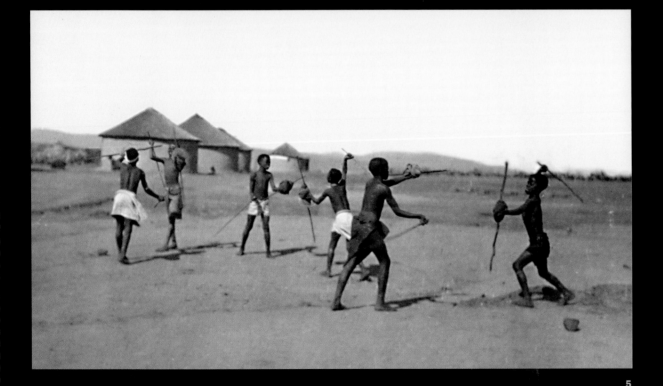

legal limitations and job possibilities in the city. The trading store became a gathering place where young people could socialise.

Children, especially boys, were often away from the homestead all day herding cattle. To while away the long hours in the grazing fields, *'we played with toys we made ourselves. We moulded animals and birds out of clay. We made ox-drawn sledges out of tree branches. Nature was our playground. The hills above Qunu were dotted with large smooth rocks which we transformed into our own roller-coaster.'* These traditional skills remain: to this day, young people still create charming clay figurines, which they try to sell to passers-by on the main road.

6

A photograph taken in the 1930s, showing a smooth rock, similar to the one in Qunu where Mandela and other children played.

Stick-fighting was immensely popular with boys and young men. Games taught the youngsters social skills. In contests of strength, endurance, dexterity and tactical sense — the qualities developed by stick-fighting — Rolihlahla absorbed values that would be vital to the ultimate resolution of the momentous struggles that lay ahead. *'I learned that to humiliate another person is to make him suffer an unnecessarily cruel fate. Even as a boy, I defeated my opponents without dishonouring them.'*

Nosekeni had been converted to Christianity, and she and her husband agreed that his youngest son should acquire an education. It was on Rolihlahla's first day of school that he was given a new, colonial identity. Western education required that the young boy's teacher, Miss Mdingane, bestow upon him a respectable 'English' name — and what better namesake than Lord Nelson, the great British naval hero?

7

The remains of the school and the church Mandela attended at Qunu. In the background the new Presbyterian church is being built.

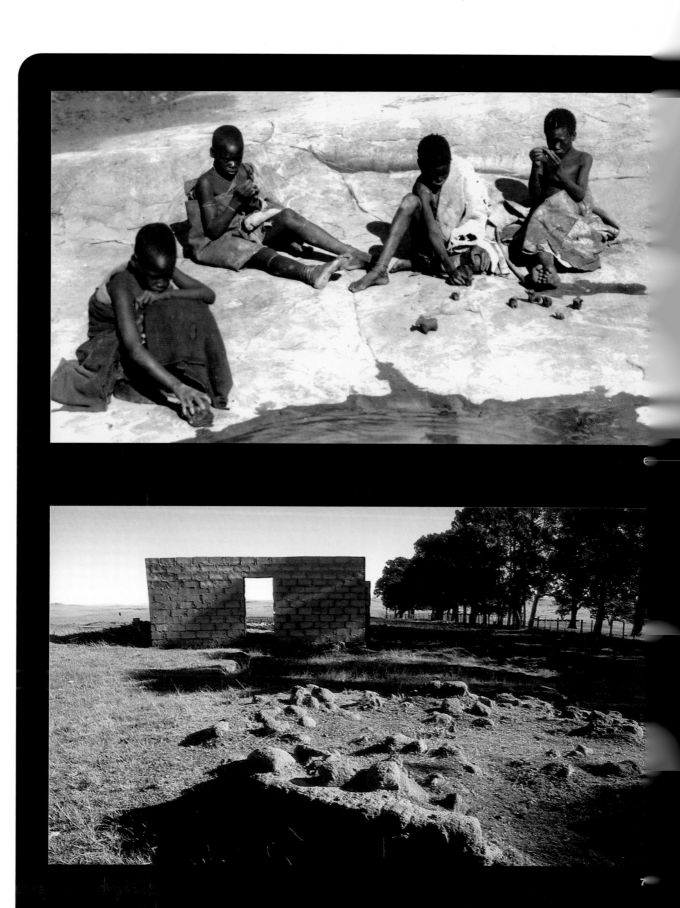

Mqhekezweni

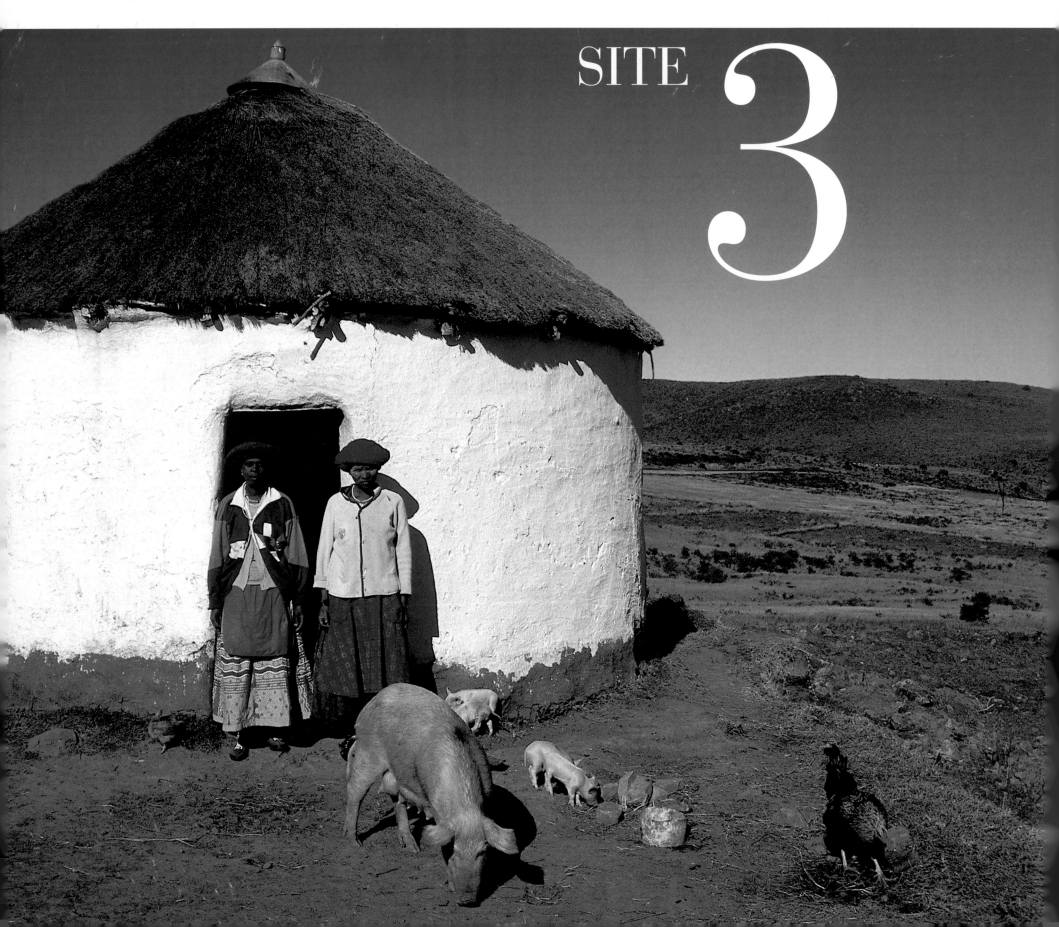

SITE

3

At the feet of the elders

After the death of his father, Rolihlahla was adopted by Jongintaba, the regent of Thembuland. He came to live at Mqhekezweni, home of the regent and a bustling centre of Thembu life. Meetings, which were open to all, were frequently held here to discuss matters such as drought, the culling of cattle, magistrates' directives, or new government laws. Mqhekezweni is now a neat, quiet village, spread out around the large house and verandah built by the regent. The tall trees next to the homestead of the original chief remain important village landmarks.

1
The Great Place at Mqhekezweni
2
A meeting of elders at a Great Place (not Mqhekezweni) in the 1960s

Mqhekezweni

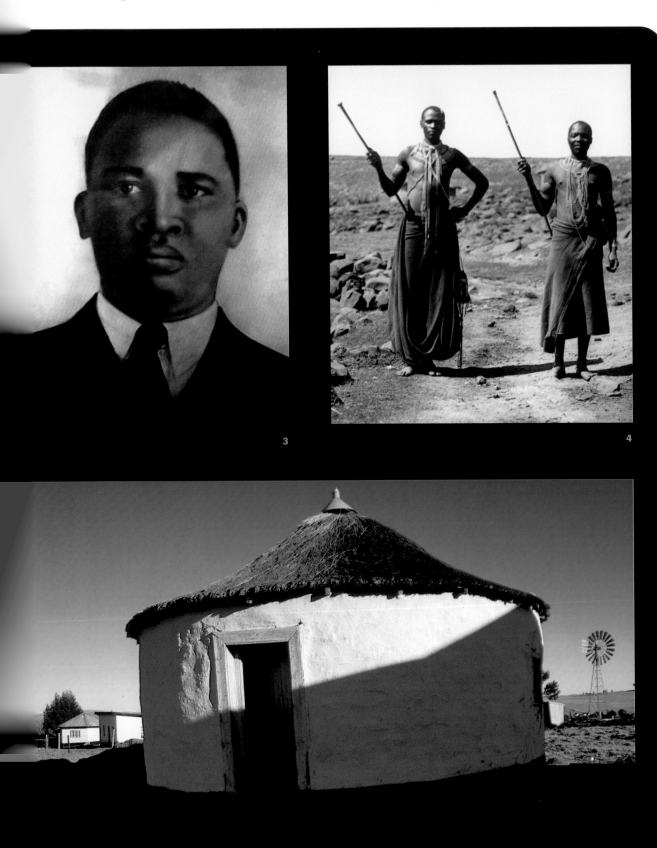

3

4

5

Gadla, the patriarch, was much older than his two younger wives. Rolihlahla was only nine years old when his father died of a lung disease. At the time of Gadla's death, Thembuland was ruled by a regent, David Jongintaba Dalindyebo, because the king, Sabata, was still an infant. Gadla had been one of the counsellors consulted on the selection of a regent after the sudden death of Jongilizwe, and had recommended Jongintaba as the most educated man and also the best mentor for the young king.

3
Portrait of Justice, handsome in his school uniform
4
Two young Thembu friends, around 1929

Jongintaba, like Gadla, was a member of the clan of Madiba, and had an obligation to Gadla. He had in any case always admired him, and had been distressed by Gadla's fall from grace. He determined to adopt his late kinsman's youngest son and raise him as his own. So it was that the young Rolihlahla moved once again. His mother took him on the long and rocky road westwards to Mqhekezweni, the home and Great Place of the regent, and handed him over to a life of opportunity.

5
The hut Justice shared with Nelson

Nelson and Justice, the regent's only son, were brought up together. Four years older than Nelson, and already at boarding school, Justice was 'tall, handsome and muscular', a fine sportsman with many social graces. He was also a great entertainer, able to sing and dance with ease, and popular with girls. He became Mandela's 'first hero after my father'.
In later years, Mandela looked back on the value of the lessons he had learnt at

Mqhekezweni. At a council meeting, or imbiso, *'everyone was heard: chief and subject, warrior and medicine man, shopkeeper and farmer, landowner and labourer'... 'It was democracy in its purest form.'* Mandela was struck by the freedom to criticise the regent, by the opinions of the regents' councillors, 'wise men who retained the knowledge of tribal history and custom', and by the regent's duty to listen carefully, not speaking until the end of the day-long meeting. His role was to sum up what had been said, and to suggest a consensus from all the diverse opinions. During the day the regent would serve a banquet, and at the very end, a poet or imbongi would sing the praises of the ancient kings, and perform 'a mixture of compliments to and satire on the present chiefs', to the great amusement and entertainment of the audience.

6

The regent Jongintaba. 'He was a man with a sturdy presence upon whom all eyes gazed. He had a dark complexion and an intelligent face.'

His adoptive father Jongintaba — 'One who looks at the mountains' — became for Mandela the ideal traditional leader — a man with insight, dignity and warmth, committed to genuine consensus, yet ultimately not afraid to lead.

7

Mrs Nozolile Mtirara, Justice's widow, in Mqhekezweni. Justice died in 1974.

6

7

Bumbane

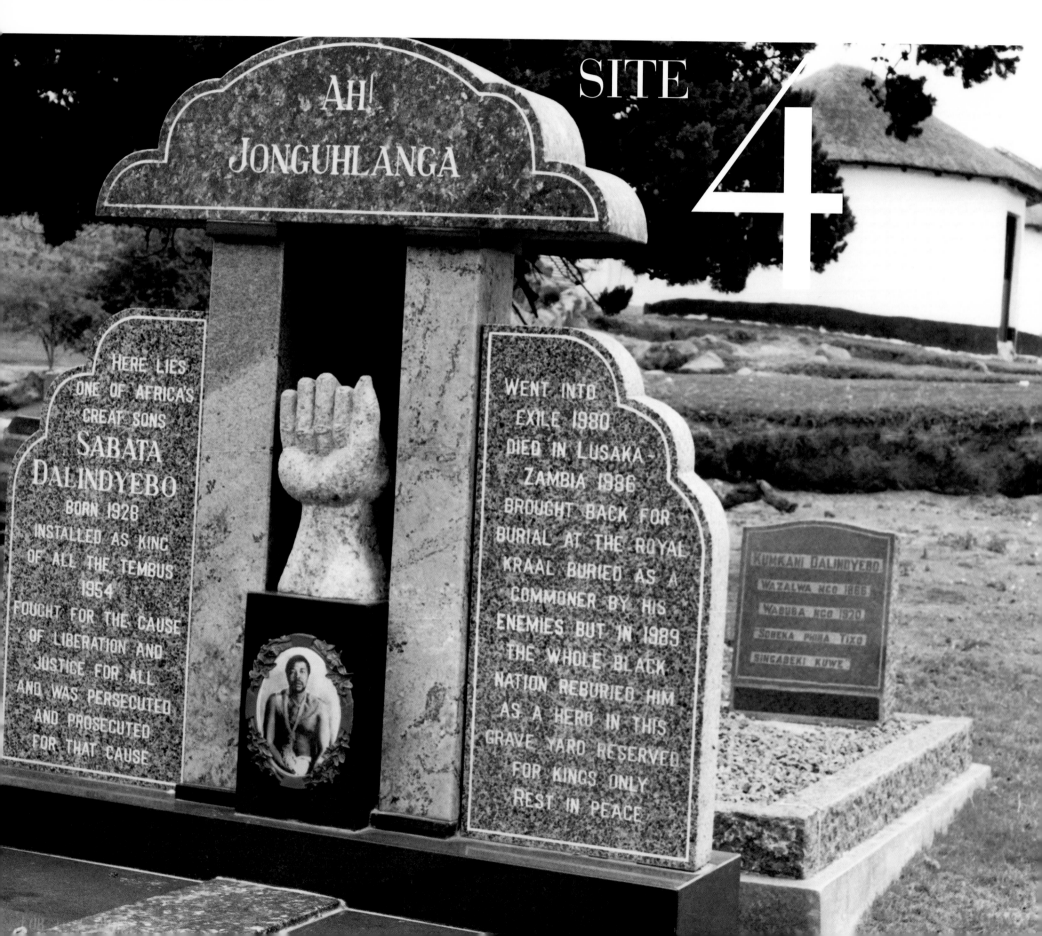

SITE 4

AH! JONGUHLANGA

HERE LIES ONE OF AFRICA'S GREAT SONS SABATA DALINDYEBO BORN 1928 INSTALLED AS KING OF ALL THE TEMBUS 1954 FOUGHT FOR THE CAUSE OF LIBERATION AND JUSTICE FOR ALL AND WAS PERSECUTED AND PROSECUTED FOR THAT CAUSE

WENT INTO EXILE 1980 DIED IN LUSAKA - ZAMBIA 1986 BROUGHT BACK FOR BURIAL AT THE ROYAL KRAAL BURIED AS A COMMONER BY HIS ENEMIES BUT IN 1989 THE WHOLE BLACK NATION REBURIED HIM AS A HERO IN THIS GRAVE YARD RESERVED FOR KINGS ONLY REST IN PEACE

KUMKANI DALINDYEBO WAZALWA NGO 1888 WABUSA NGO 1920 SOBEKA PHINA TIXO SINGABEKI KUWE

Home of the comrade King Sabata

During Mandela's childhood and youth, Bumbane was reduced in significance, as the ruler of the Thembu resided at Mqhekezweni. When Sabata Dalindyebo ascended the throne at his coming of age, it was again restored to its former status. The young Sabata had a strong sense of Thembu tradition and identity. He firmly and publicly opposed the apartheid government's attempt to co-opt the traditional leaders under a 'Bantu Authorities Act' to pursue their policy of divide and rule. He also objected strongly to the arrest of his kinsman, Nelson Rolihlahla in 1962. After Sabata went into exile, Bumbane again declined. Today, it is once again the home of the reigning king, Zwelibanzi Buyelekaya, son of Sabata.

1

1
Sabata as a toddler
2
Sabata with Winnie Mandela, the wife of his kinsman. She was reporting to the King on the circumstances of her husband's arrest in 1962.
3
King Sabata Dalindyebo (extreme right), standing a little apart from the others, is part of a delegation of homeland leaders and chiefs outside the Bhunga in the sixties.

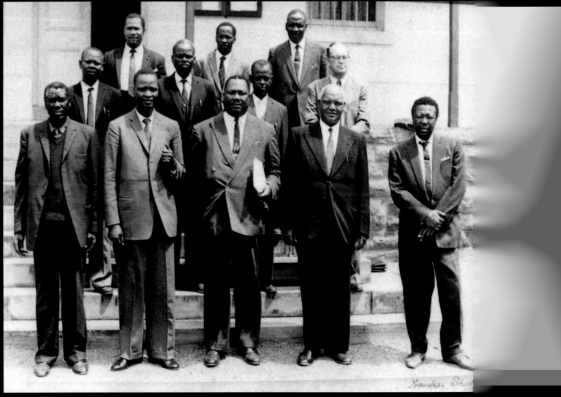

Bumbane

I was born at Umtata, Transkei, on the 18th July 1918.

I was only 12 yrs of age when my father died. After my father's death, my cousin, DAVID DALINDYEBO, then Acting Paramount Chief of Tembuland, became my guardian. He brought me up and educated me.

I am related to both SABATA DALINDYEBO, the present Paramount Chief of Tembuland, and to KAIZER MATANZIMA, the "Chief Minister" of the Transkei. Both of them are, according to Tembu Custom, my nephews.

I hold the degree of Bachelor of Arts of the University of South Africa which I obtained in 1942.

Later I studied law and early in 1952, I was admitted as an attorney. The same year, I set up practice in Johannesburg in partnership with Mr OR TAMBO, a co-conspirator in this case. This partnership was dissolved in 1960 as a result of my being detained during the State of Emergency and as a result of Mr Tambo's departure from the ~~Union~~ Republic. After the State of Emergency I continued practising until March 1961, when I went underground as a result of certain events which I will deal with later in my evidence.

Mandela's lineage, in his own handwriting. This is an extract from his draft statement, 'The State v Nelson Mandela & Nine Others' during the Rivonia Trial, in which he was sentenced to life imprisonment, 1964.

Sabata Dalindyebo was an infant when his father. King Jongilizwe of the Thembu, died. The regent chosen to rule on his behalf was Jongintaba, whom Mandela's father Gadla had recommended.

Sabata's lineage can be traced back many generations. In 1996, at a hearing of the Truth and Reconciliation Commission on human rights abuses committed by white supremacists in the past, Chief Anderson Joyi, a kinsman of the late King Sabata, began his testimony by invoking the ancestors. He recalled the names of nineteen generations of his forebears, punctuating each name with his knobkerrie on the floor:

King Thembu begat Bomoyi;
and Bomoyi begat Ceduma;
and Ceduma begat Mngutu;
and Mngutu begat Ndande;
and Ndande begat Nxego;
and Nxego begat Dlomo;
and Dlomo begat Hala:
and Hala begat Madiba;
and Madiba begat Thato;
and Thato begat Zondwa;
and Zondwa begat Ndaba;
and Ndaba begat Ngubengcuka;
and Ngubengcuka begat Mtikara;
and Mtikara begat Ngangelizwe;
and Ngangelizwe begat Dalindyebo;
and Dalindyebo begat Jongilizwe;
and Jongilizwe begat Sabata;
and Sabata begat Buyelekaya;
and this is where I begin.

When the writer Antjie Krog, who tells this story in her book *Country of My Skull*, asked him why he started his testimony with his lineage. Chief Joyi explained: 'Their names organise the flow of time ... Their names give my story a shadow. Their names put what has happened to me in perspective. Their names say

I am a chief with many colours. Their names say we have the ability to endure the past ... and the present.'[2]

By the time Sabata came to the throne as a young man, he had developed a strong sense of Thembu tradition and identity. He firmly and publicly opposed the apartheid government's attempt to co-opt traditional leaders under the 'Bantu Authorities Act', the latest twist in their policy of divide and rule. He also objected strongly to the arrest of his kinsman Nelson Mandela in 1962.

In 1980, Sabata was deposed by K.D. Matanzima, who had accepted the homelands policy to become prime minister of the Transkei, a pseudo-state beholden to the government in Pretoria for its very survival. In that year, Mandela was visited on Robben Island by a delegation of Thembu chiefs seeking his advice. Mandela counselled them to support Sabata rather than Matanzima. Sabata went into exile and joined the ANC. He died in Mozambique. In 1993 his body was exhumed and reburied at Bumbane. The reburial, in the precinct of Sabata's Great Place, the seat of the democratic institution of the Thembu people, was a highly significant and popular ceremony.

Sabata's confrontation with the magistrate signified the challenge of many traditional leaders to white supremacy. 'You can be changed at any time,' Sabata warned the chief magistrate of Umtata, 'but Sabata can never be changed from being the king of Thembuland'

SABATA'S ROW WITH UMTATA CHIEF MAGISTRATE

NEW AGE

Vol. 8, No. 50. Registered at the G.P.O. as a Newspaper 6d. 5c.

NORTHERN EDITION Thursday, September 27, 1962

"I'll Never Set Foot In Your Office Again"

THE temper of the people throughout the Transkei has been inflamed by a number of recent incidents. Among them are:
● A flaming row between Chief Sabata Dalindyebo and the Chief Magistrate of the Transkei (see below);
● A clash in Pondoland resulting in the death of a woman and a policeman (see story on this page);
● A rejection by tribesmen of Government offers of money for Bantustan (see story on page 3).

Woman Shot, Policeman Stabbed In Pondoland Clash

DURBAN.

BACKED by the Government, certain chiefs in Pondoland are carrying out a reign of terror against their own people.

In many areas beatings and deportations are the order of the day. One incident that aroused the anger of the people of Eastern Pondoland last week was the death from a bullet wound of 67-year-old Mrs. Etha Mdatya, mother of four children. The husband of the dead woman is in jail, charged with murder. It is alleged that he stabbed the policeman who did the shooting.

The events leading up to these incidents began on September 7, at (Continued on page 3)

DURBAN DEMONSTRATION

Last week yet another demonstration was held in Durban—this time by children of unemployed workers outside the Post Office. These two little demonstrators can barely see over their placard.

IN TEMBULAND

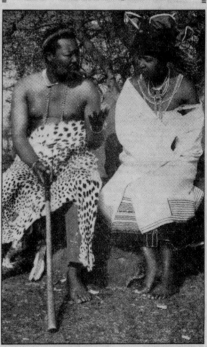

Chief Sabata Dalindyebo in conversation with Mrs. Winnie Mandela.

BIG news of the Transkei is the stone barrier that has shot up between Chief Sabata Dalindyebo and the Chief Magistrate of Umtata, Mr. Leibbrandt.

The week before last Chief Sabata was summoned, together with his uncles and councillors, to Mr. Leibbrandt's office. The meeting was to discuss affairs in Tembuland proper.

Chief Sabata went to the Magistrate, together with his cousin and brother Chief Zwelihe of the Amahala tribe. The other councillors, Chief Sabata told the magistrate, were busy with umgidi, a traditional feast, and could not attend.

The magistrate became angry on hearing this and told Chief Sabata he was a liar. He also ordered the Chief to stand up when he spoke to him. He added that Sabata was a 'fool' for having sacked his good councillors, and that the magistrate knew well what went on in Tembuland 'under cover of darkness.'

SABATA HITS BACK

Fuming with anger, Chief Sabata told the Chief Magistrate he had successfully widened the gap that had divided the Chief and the Magistrate for many years.

From now on, Sabata said, he would never again set foot in the office of the Magistrate. He had quarrelled with the former Chief Magistrate and sworn never to visit his office, and he had not done so. 'I now tell you that you will never see Sabata in this office again.'

Sabata added: 'How dare you tell me to stand when talking to you as though I am a naughty little schoolboy? Have you forgotten that I am the great grandson of Chief Ngubencuka, and so a king of Tembuland? You can be changed at any time from being chief magistrate of Umtata, but Sabata can never be changed from being the king of Tembuland.'

NOT A SERVANT

Chief Sabata reminded the magistrate that he was not a servant of the Government, and that at the last session of the Transkeian Territorial Authority it was said that chiefs were not the servants of the Government but the hereditary political leaders of their people. As for his 'good' councillors being sacked, said Sabata, the magistrate found them 'good' only because they were 'government boys' and because of this they had been sacked by the Tembu.

The magistrate told Chief Sabata he would be reported to Mr. Young, the Secretary for Bantu (Continued on page 3)

HOW TRANSKEI HEARD OF MANDELA'S ARREST

OFFICIAL news of the arrest and forthcoming trial of Nelson Rolihlala Mandela, South Africa's foremost resistance leader and member of the Tembu Royal House, was carried to Tembuland last week by Mrs. Winnie Mandela.

Mrs. Mandela was given an audience at Bumbane, the Great Place of the Tembu, by Chief Sabata Dalindyebo, head of Tembuland Proper, and Chief Zwelihle of the Amahala.

From Bumbane the Tembu tribe sent a telegram to the Chief Magistrate of Johannesburg protesting at the arrest of Mandela.

Official couriers were sent to report the arrest to all the tribes of Tembuland.

Nelson Mandela is an uncle of Chief Sabata. The news of his arrest has been taken in Tembuland as an attack on the tribe, already in a tough fight with the Government over Bantu Authorities and the dud self-rule being pushed through in the new Transkei constitution.

Clarkebury

SITE 5

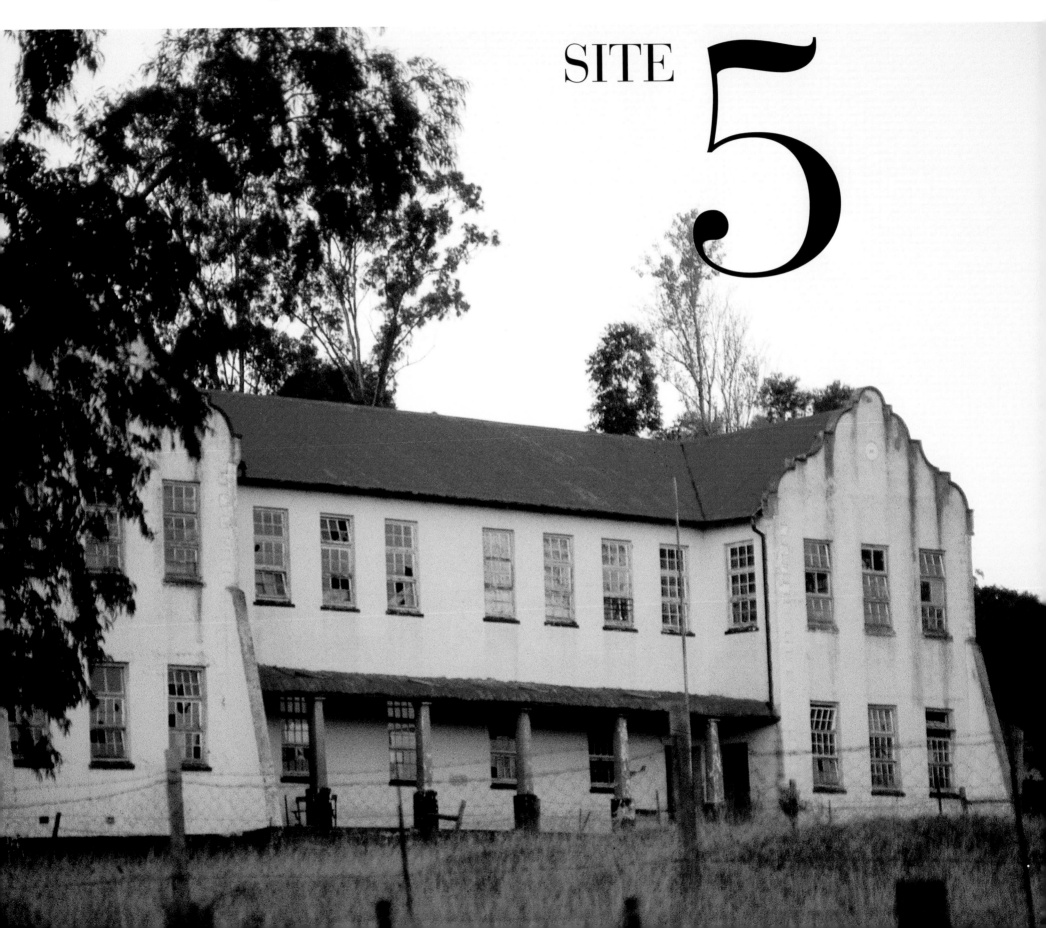

A favour returned

In 1934, Mandela enrolled at the Methodist high school called Clarkebury. In those days it was a prestigious educational centre including a teachers' training college, workshops for practical courses, hostels and fine sports fields. It produced many leaders, including chiefs, church ministers and a future ANC president — Dr A.B. Xuma. In the apartheid era, after the passage of the Bantu Education Act in 1953, the state cut off Clarkebury's funds, and its prestige declined. During the student unrest of the 1970s, parts of the college were burned down in protest against the Transkei homeland government. (See also Site 53.) Today, a programme is being prepared to restore the crumbling buildings and revive the institution's educational legacy. The rector hopes to establish a training school which will create jobs. 'Mandela inspires local people to realise that small communities can produce great leaders.'

1
Training and Practising School Building, Clarkebury, erected in 1900
2
The tailoring department, Clarkebury, around 1928

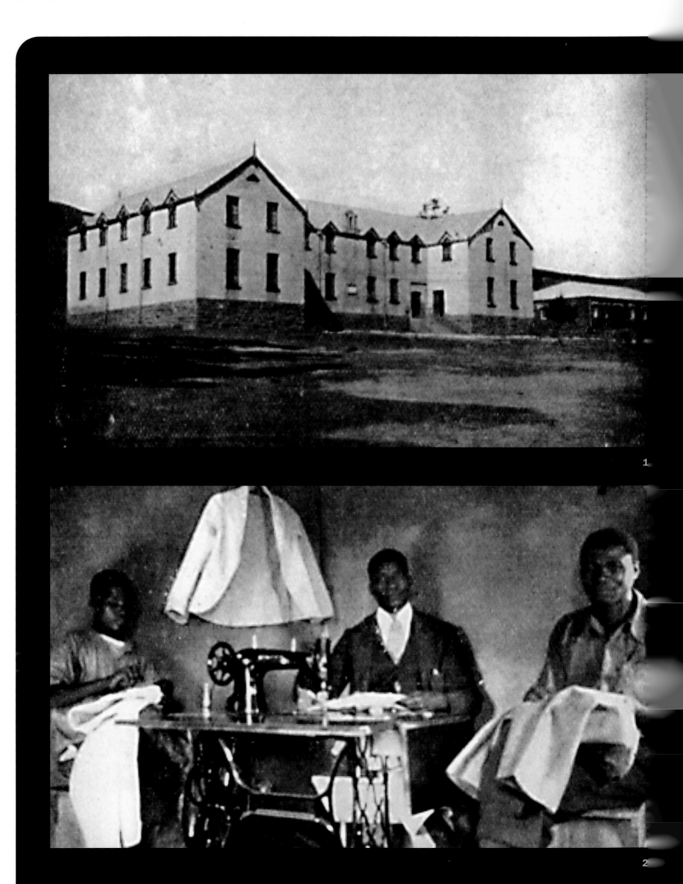

Clarkebury

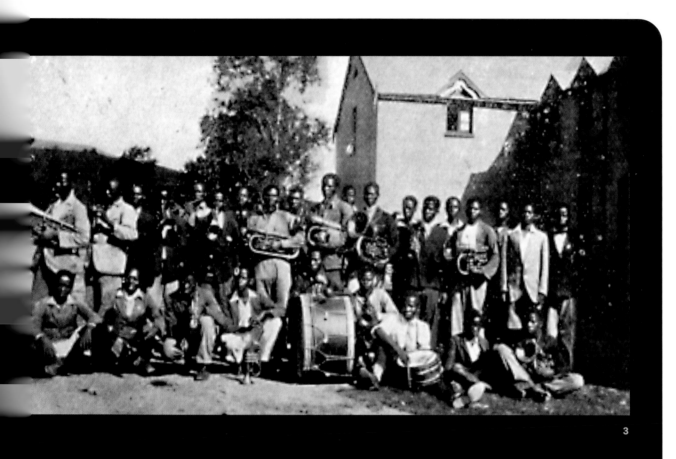

Clarkebury, the Methodist high school, was situated across the Mbashe River on land which King Ngubengcuka had bestowed on the missionaries several generations earlier. It was Ngubengcuka, an ancestor of both Mandela and Jongintaba, who had united the Thembu tribe in the 1820s. Founded by the Reverend Richard Haddey, the institution was named after the distinguished British theologian, Dr Adam Clarke.

3
The school band poses next to the Training and Practising School Building, Clarkebury, in 1900.

The regent had determined that Mandela would follow in his father's footsteps, as a kingmaker, wise counsellor and representative of the community in deliberations with their leaders. But in the modern world, counsellors should be as highly educated as the royals. Mandela's late father Gadla, though unschooled himself, had been very alert to the skills that education imparted. Education could provide leaders with the means to engage their colonial masters on a more equal footing, on behalf of and in the service of their people. The young Mandela was to be rigorously trained at the regent's own Alma Mater. Following his older friend Justice to Clarkebury, Nelson relished this legacy, conscious that he was one of a select band of young men to be accorded this privilege.

Through their educational institutions, missionaries exercised an important influence both on traditional leaders like the regent and on the political leaders of the future. The regent instructed Mandela to treat the college principal, Reverend Harris, with respect, as 'a Thembu at

4
Staff and students of Lovedale College, Eastern Cape, an influential Anglican missionary institution, shown here in the 1880s. Clarkebury was, however, an older establishment

heart'. His was the first white hand that Mandela had ever shaken. From then on, the youngster's education heralded a marked change, as Western manners and values came into his life.

'Classes commenced the following morning, and along with my fellow students I climbed the steps to the first floor where the classrooms were located. The room itself had a beautifully polished wooden floor. On this first day of classes I sported my new boots. I had never worn boots before of any kind, and that first day I walked like a newly shod horse. I made a terrible racket walking up the steps and almost slipped several times. As I clomped into the classroom, my boots crashing on that shiny wood floor, I noticed two female students in the first row were watching my lame performance with great amusement.'

'At Clarkebury, plenty of the boys had distinguished lineages, and I was no longer unique. This was an important lesson, for I suspect I was a bit stuck-up in those days. I quickly realised that I had to make my way on the basis of my ability, not my heritage.'

Mandela earnestly wanted to be a credit to the regent. He worked conscientiously, passing his junior certificate in two years instead of three. After Clarkebury he moved on to the even more distinguished Healdtown, near Alice, and then to the University of Fort Hare. In time to come, Mandela would confront the rulers of South Africa with knowledge and understanding gained in the heart of their own culture, as well as the wisdom and experience drawn from his Thembu heritage.

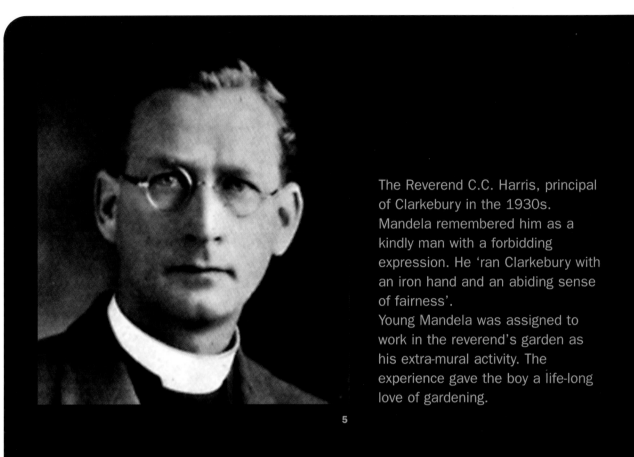

The Reverend C.C. Harris, principal of Clarkebury in the 1930s. Mandela remembered him as a kindly man with a forbidding expression. He 'ran Clarkebury with an iron hand and an abiding sense of fairness'.
Young Mandela was assigned to work in the reverend's garden as his extra-mural activity. The experience gave the boy a life-long love of gardening.

5

6

Missionaries took the education of girls seriously. As potential mothers, they could become the bearers of the Christian culture and values.

Tyhalarha

SITE 6

'I am a man!'

Just off the main road beyond the Tyhalarha school stands an ancient tree (umgqokolo). This was once the site of the Great Place of King Ngangelizwe (1841-84). His homestead has disappeared back into the soil, as organic African architecture often does. Oral history tells us that King Ngangelizwe would go on a prolonged retreat (itola) from time to time, meditating and praying for his people. Then he would suddenly appear at Tyhalarha, sit under the ancestral tree and wait for a young boy to bring him a bowl of fresh milk, before leaving again. King Ngangelizwe is buried at Tyhalarha.

On his tombstone is inscribed the genealogy of the kings of Thembuland. Traditionally, Tyhalarha was the royal initiation site for the Thembu. A spot in a secluded valley near the banks of the Mbashe River was carefully selected for the young royals.

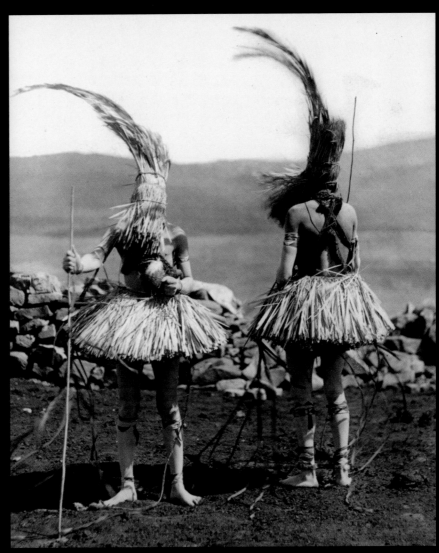

1

As in all societies, clothes denoted identity and status. On Rolihlahla's first day of school, for instance, he proudly wore his father's cut-off trousers, indicating that he was now a scholar. Initiates wore special clothes fashioned from nature, and painted their faces white. For weeks after they graduated, the young men (amakrwala) painted their faces with ochre, covered their heads and kept their eyes lowered. They also used a special style of speaking known as hlonipha. The new names given to initiates, their painted bodies and masks, signified a change of identity — the transformation of boys into men. To this day, a graduate's new status is marked by special garb. In the second week he wears khaki trousers and a striped jacket with a hat or cap, and carries a stick.

Tyhalarha

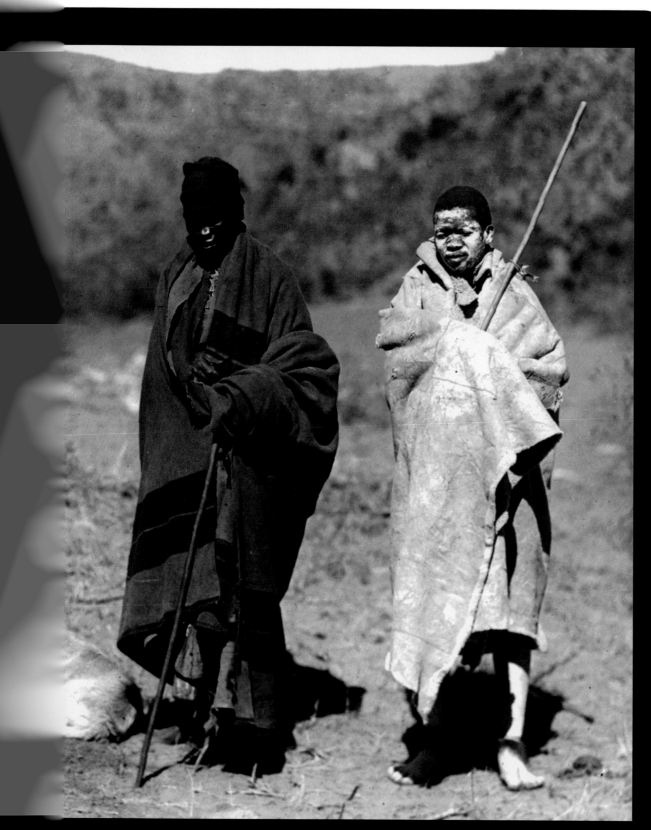

At the age of sixteen — the age varied according to circumstances and convenience — Nelson Mandela was initiated into adulthood. One of his fellow initiates was his adoptive brother Justice.

The initiation ceremony was a test of manhood and courage. The old clothes of the initiates were taken from them and they went naked. Early in the morning they were accompanied down to the river, where they were washed and purified. The circumcision was then performed by a famous ingcibi, who used his assegai 'to change us from boys to men with a single blow'. To cry out was a great disgrace. Mandela still remembers his tension and anxiety before the critical moment:

'I shuddered slightly, knowing that the ritual was about to begin ... Without a word, he took my foreskin, pulled it forward, and then, in a single motion, brought down his assegai. I felt as if fire was shooting through my veins: the pain was so intense that I buried my chin in my chest. Many seconds seemed to pass before I remembered the cry, and then I recovered and called out, "Ndiyindoda!" [I am a man].'

2
Amakweta youths in Thembuland in the 1930s, around the time when Mandela was initiated.

The traditional healer or *ixhwele* played a crucial role in the ceremony, for he knew which leaves and herbs to administer to the wound to guard against infection and fever.

Mandela's new name, Dalibhunga, like his first name Rolihlahla, had a prophetic ring: it means 'founder of the Bhunga' or parliament. As is the custom to this day, the initiates were addressed by older men on how to conduct themselves, and exhorted to put away childish things and reflect on their responsibilities to the community as a whole. A speech by Chief Meligqili, a son of the late king, was branded in Mandela's memory. It was years before he was able to translate the implications of the chief's

message actively into his own life, yet the words stayed with him and he recalled them vividly sixty years later:

'There sit our sons, … young, healthy and handsome, the flower of the Xhosa tribe, the pride of our nation. We have just circumcised them in a ritual that promises them manhood, but I am here to tell you that it is an empty, illusory promise, a promise that can never be fulfilled. For we Xhosas, and all black South Africans, are a conquered people. We are slaves in our own country. We are tenants on our own soil. We have no strength, no power, no control over our own destiny in the land of our birth.'

At the time, Mandela rejected these words, perceiving them as negative, backward and unappreciative of the value of Western education. But Chief Meligqili *'had sown a seed, and though I let that seed lie dormant for a long season, it eventually began to grow. Later I realised that the ignorant man that day was not the chief but myself.'*

3

The tombstone of Ngangelizwe records the history and ancestry of the Thembu, going back to 573 AD. Ngangelizwe, like Mandela himself, was descended from the great monarch Ngubengcuka. Ngangelizwe's son, King Dalindyebo, was a founder-member of the ANC in 1912: as an enrolment fee for his people he donated thirty cattle. The Native National Congress, as it was first called, started as a progressive, nation-building organisation designed to unite the black people of South Africa against an oppressive, racist government. It was this organisation that Mandela and his Youth League colleagues would modernise and broaden in the forties and fifties, and eventually transform into a mass-based, non-racial, national liberation movement.

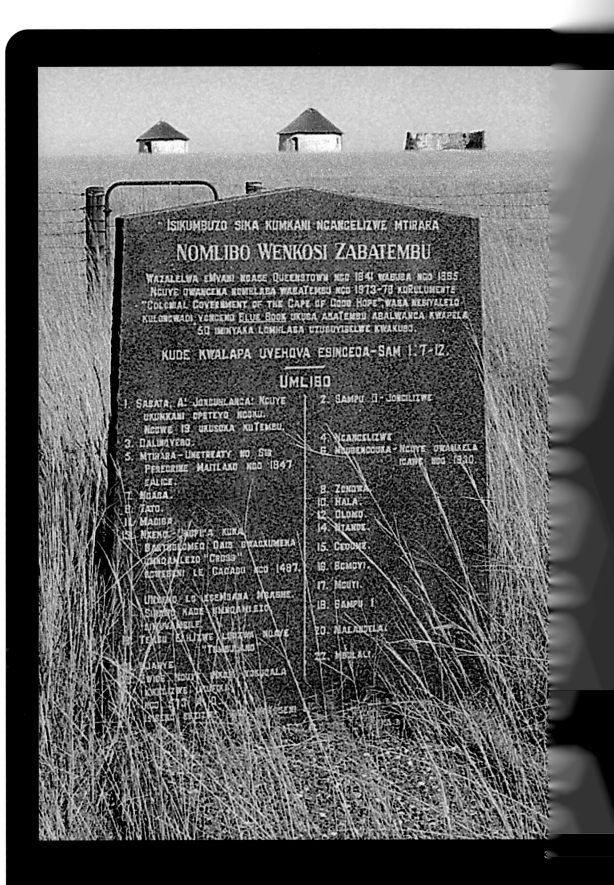

Healdtown

SITE 7

A missionary education

Healdtown, one of the top Methodist mission schools in the Eastern Cape, was founded in 1855, close to Fort Beaufort, Fort Brown and Fort Hare, after governor Sir Harry Smith had subjected a number of Xhosa chiefdoms to British rule. The school, established to train Mfengu Christians in crafts and industry, was named after an eminent British parliamentarian, James Heald. Over the years it widened its sphere to include secondary school and teacher training courses, and by 1934 it boasted 800 boarders.

Like Clarkebury, Healdtown was burned down by protesting students in the 1970s. Its fine central tower and clock have since been restored and some of the premises are now used as a high school. But there are still smashed windows and rusted roofs awaiting repair.

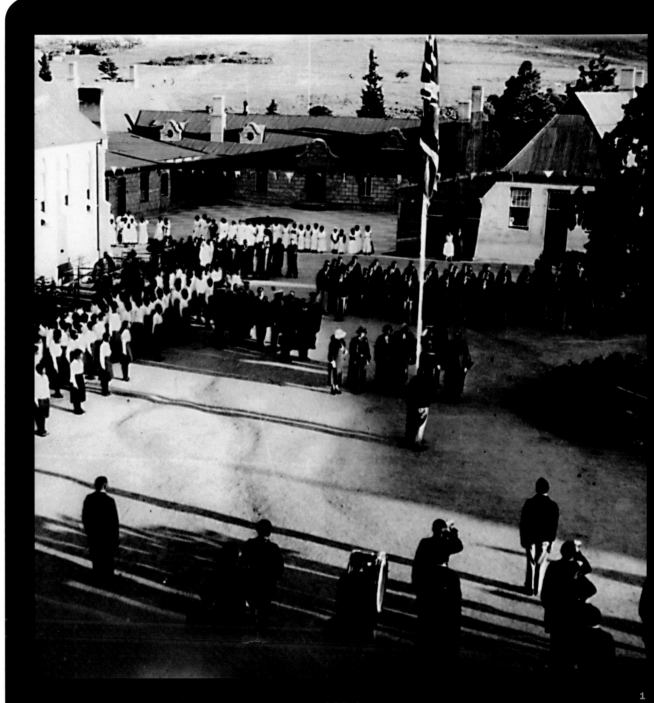

Nelson Mandela must be somewhere in this 1937 Sunday morning parade, accompanied by the school's brass band, in the quadrangle at Healdtown. The weekly ceremony regularly attracted a wide and admiring audience. Mandela graduated from Healdtown in 1938.

Healdtown

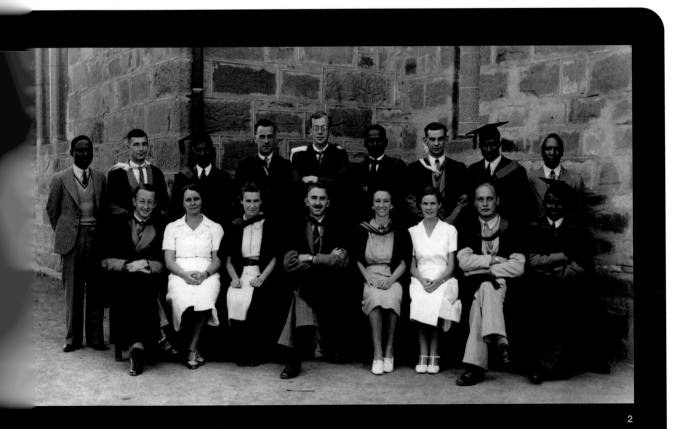

2

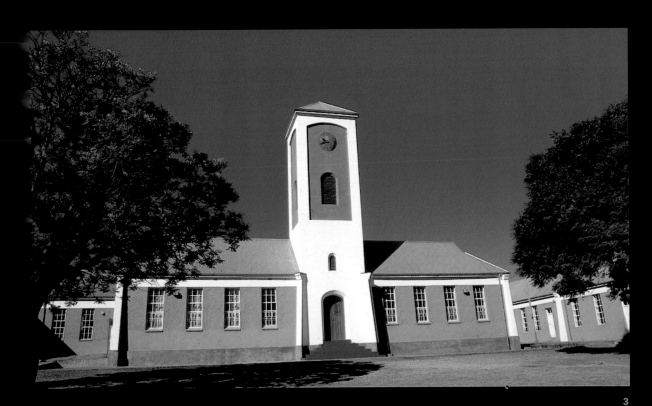

3

Healdtown, the Wesleyan college which Mandela began to attend in 1937, broadened his horizons in various ways. Like Clarkebury, the curriculum immersed the students in British history, geography, literature and music. However, Mandela's black teachers often diffused the colonial agenda by including Xhosa traditions, narratives and customs in their lessons.

The young man was introduced to new physical and sporting disciplines. He started long-distance running and boxing — a novel alternative to traditional stick-fighting. Contemporaries recall early evidence of Mandela's leadership qualities, such as the time when he leapt onto the dining-room table and exhorted his fellow scholars to take more responsibility for their own behaviour. In his matriculation year, he was appointed as a prefect.

2
Mandela's teachers at Healdtown: a small band of dedicated people
3
Healdtown's restored clock tower and classrooms

The staff were multiracial and multi-ethnic. For the first time, Mandela came across a fellow student who was not Xhosa-speaking. He was also struck by a mixed-marriage couple on the staff — the man was Sotho and the woman Xhosa.

Under the influence of his teachers, Mandela began to think in broader terms about his future role in the service of his people. Perhaps, he mused, the most useful profession would be law: he could develop the skills to counter the power of the magistrates and bureaucrats who administered the colonial order — those who had deposed his father.

The missionaries brought mixed blessings.

As Mandela neared the end of his schooling, he gradually became aware of the more destructive role they played in helping to break down traditional culture. Many strongly disapproved of polygamy, traditional dress and lobola, the bedrock of the traditional homestead economy. The Christian message of brotherly love and care for the poor had been warmly embraced by many thousands of black men and women in the early years of the century. But for the first time, Mandela began to notice that these noble values were sometimes contradicted by the way the church tolerated — and even supported — some of the oppressive structures of the colonial and racist system. While there were missionaries who were open-minded and sensitive to the integrity of black culture, many others seemed confined within their own narrow Victorian values. They justified colonialism as a means of imparting a European idea of 'civilisation' and Western notions of morality to 'heathens'. They believed that they were saving the souls of black people for God. In the process they rejected traditional customs and rituals as 'superstitions', when in fact these practices celebrated the values of sharing, compassion and respect for others which Christianity itself aspired to.

'I believe their benefits outweighed their disadvantages. The missionaries built and ran schools when the government was unwilling or unable to do so. The learning environments of the missionary schools, while often morally rigid, were far more open than the racist principles underlying government schools.'

4

A plaque in the chapel honours the Reverend John Ayliff, at the expense of the colonised.

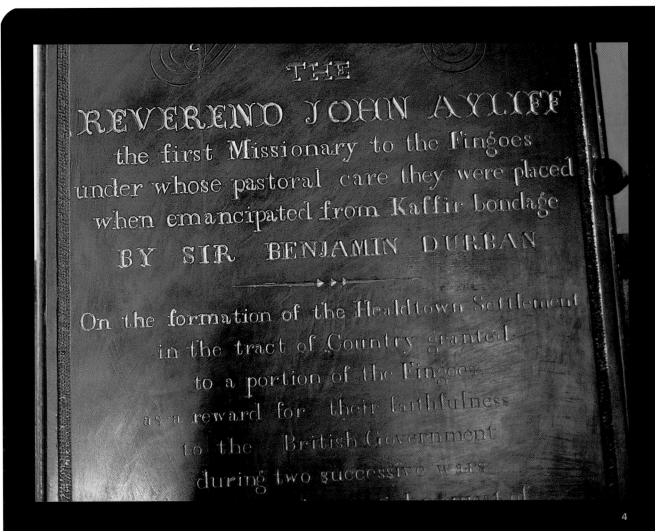

4

Like most black students attending mission schools, Mandela realised that the benefits which a Healdtown education clearly provided 'often required subservience' and a negation of his own traditions. Yet many did not realise how starved they were of an affirmation of their own culture.

Mandela recalls: 'The renowned *imbongi* or praise poet, Krune Mqhayi, was invited to visit the school. Suddenly, the door opened and out walked ... a black man dressed in a leopard-skin kaross and matching hat, who was carrying a spear in either hand ... The sight of a black man in tribal dress coming through that door was electrifying. It is hard to explain the impact it had on us. It seemed to turn the universe upside down.'

'You sent us the truth, denied us the truth;
You sent us the life, deprived us of life;
You sent us the light, we sit in the dark,
Shivering, benighted in the bright noonday sun.'
From a poem by Krune Mqhayi on the occasion of the visit by the Prince of Wales, 1925

Fort Hare

Alma Mater of African leaders

The University of Fort Hare is renowned for its historical role as the Alma Mater to leaders of nationalist movements throughout Africa. During the wars of colonial conquest, Fort Hare was established as one of a string of military outposts. In 1916 missionaries of three Christian denominations pooled their resources to create a university of high standing for young black men and women. During the apartheid era, the resources of Fort Hare were steadily underdeveloped. Today, as with all the universities in South Africa, Fort Hare is facing major structural changes. And like other historically black universities in the country, it is suffering from declining student numbers and a shortage of funds. Fort Hare is repositioning itself; its vision is to assert and celebrate the 'unique brand name of Fort Hare' as an African university, and to play its part towards the intellectual development and realisation of an African Renaissance.

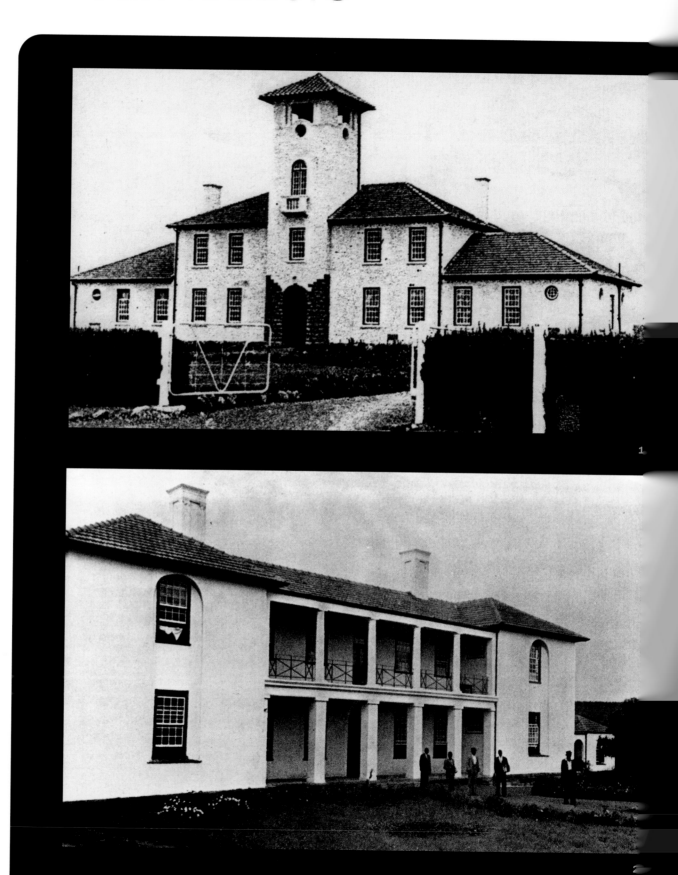

1
Fort Hare in the 1940s

2
Wesley House,
Mandela's student residence, 1938

Fort Hare

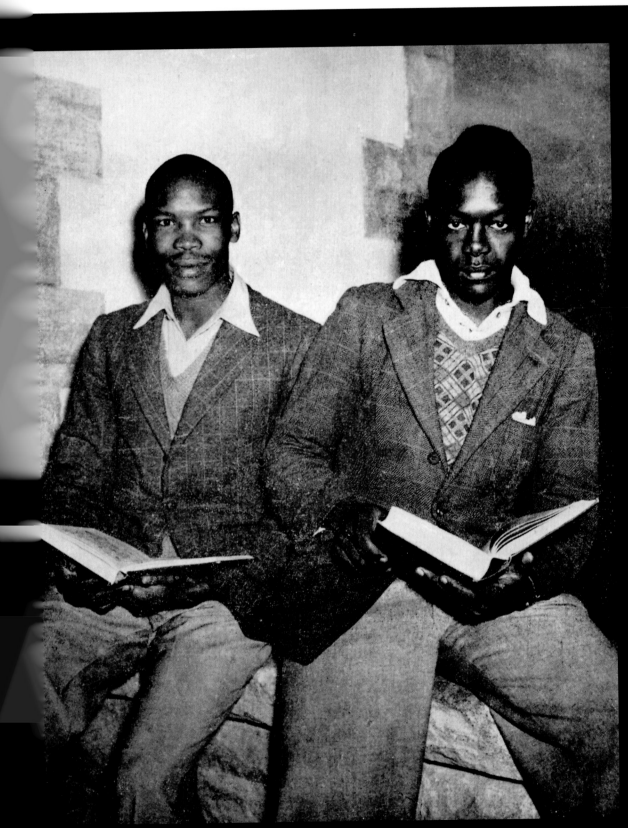

Fort Hare University provided an alternative avenue to the institutionalised racism in even the most liberal universities. Fort Hare educated the tiny percentage of blacks who reached a tertiary level of education. In 1940 there were only 150 students. This young elite included princes, political leaders and future heads of state from many countries in Africa.

At Fort Hare, Mandela's intellectual, social and political horizons expanded rapidly. He was deeply impressed by the black lecturers, among whom D.D.T. Jabavu and Z.K. Matthews were powerful influences. Almost unconsciously, he was developing an awareness of a black society beyond traditional boundaries, then gradually grasping the need for the different ethnic groups to unite.

Mandela began to rethink the assumption that his role in life was to return to the village and act as a counsellor to King Sabata. He had been groomed to be a leader. Despite his warmth of manner and sense of humour, Mandela had a natural air of authority. This trait was quickly recognised, and he was elected onto the Students' Representative Council.

This leadership position unexpectedly led to a turning point in his student career. For the first time, he clashed openly with authority. The students were unhappy with the food in the residences. They demanded that the SRC be given more say in the running of the university. As their representative, Mandela agreed to boycott the university procedures. He was given an ultimatum to abide by the university rules or leave. Although he was in his final year, only months away from finishing a BA degree, he left and returned to Mqhekezweni.

3

Two students of Fort Hare, Prince Seretse Khama, grandson of King Khama of Botswana, and Charlie Sjonje of Kenya, around 1941

'I had taken a stand, and I did not want to appear to be a fraud in the eyes of my fellow students … I knew it was foolhardy for me to leave Fort Hare, but at the moment when I needed to compromise, I simply could not do so. Something inside me would not let me.'

It was at Fort Hare that Mandela first met his future partner, comrade and lifelong friend, Oliver Tambo, 'a serious young science scholar whom I had met on the soccer field'. Tambo, an Anglican, was the students' representative of its Fort Hare residence, Beda Hall. Tambo is shown here (right), outside Beda Hall with two keen debating friends Lancelot Gama (left) and Congress Mbata. Both were to become active with Tambo, Mandela, Walter Sisulu and others in the formation of the ANC Youth League, a few years later.

'He came from Pondoland, in the Transkei, and his name was Oliver Tambo. From the start, I saw that Oliver's intelligence was diamond-edged; he was a keen debater and did not accept the platitudes that so many of us automatically subscribed to. Oliver lived in Beda Hall, the Anglican hostel, and though I did not have much contact with him at Fort Hare, it was easy to see that he was destined for great things'

4
Oliver Tambo (right) and friends Lancelot Gama and Congress Mbata, 1940

5
Pages from the Fort Hare Calendar, 1940, showing Mandela's name on the register of students

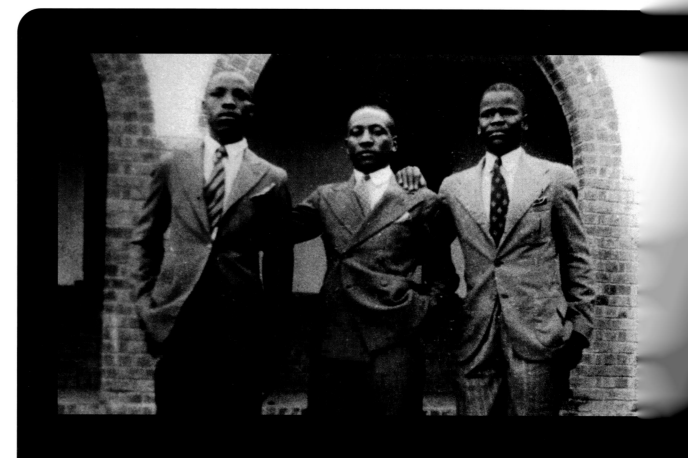

South African Native College.

CALENDAR

FOR 1940

TWENTY-FIFTH YEAR.

Fort Hare, Alice, Cape Province, S.A.

	Name.	Address.	Hostel.
33.	Kgware, Wm.	Brandfort, O. F. S	M
34.	Khomo, (Miss) Edna	Middelburg, Transvaal	W
35.	Khomo, Euclid	Middelburg, Transvaal	P
36.	Kironde, Apollo	Kampala, Uganda	A
37.	Kongisa, E.	Bluegums, Herschel	M
38.	Kraai, V. P.	Kimberley	A
39.	Langa, A.	Pietersburg	A
40.	Langa, O. T.	Alcock's Spruit, Natal	M
41.	Lebenya, L. E.	Kenegha Drift, Matatiele	A
42.	Lebona, A. D.	Johannesburg	A
43.	Lediga, Solomon	Pretoria	P
44.	Lethlaka, M.	Cofimvaba, Transkei	A
45.	Lubisi, J. M.	Senekal O. F. S.	M
46.	Lule, Y. K.	Kampala, Uganda	A
47.	Lusaseni, D.	Matatiele	P
48.	Maduna, S. S.	Mount Frere	A
49.	Mahabane, S. P.	Winburg	M
50.	Mahali, E.	Mfula, Transkei	A
51.	Mahase, Edgar	Maphutseng, Basutoland	P
52.	Majam, S. H.	Johannesburg	A
53.	Majombozi, L.	East London	M
54.	Makanda, Michael	Cedarville, Cape	P
55.	Makasi, A. B.	Nocwana, Willowvale	M
56.	Makhetha, John	Mohlanapeng, Basutoland	P
57.	Malahlele, (Miss) Mary	Roodepoort, Transvaal	W
58.	Malander, Eric A.	Kim...	M
59.	Malunga, S. D.	...montein	M
60.	Mamabolo, P.	...shoane, Transvaal	P
61.	Mandela, Nelson	Mqekezweni, Transkei	M
62.	Maphathe, K. Thulo	Mafeteng, Basutoland	P
63.	Marks, G. St. Clair	Port Elizabeth	M
64.	Maseko, (Miss) Phyllis	Idutywa	W
65.	Mashinini, B.	Harrismith	M
66.	Matanzima, K. D.	Qamata	M
67.	Mayekiso, A.	Flagstaff	A
68.	Mbata, J. C. M.	Johannesburg	A
69.	Mbatha, M. B.	Mangeni, Natal	A

The Bhunga, Umtata

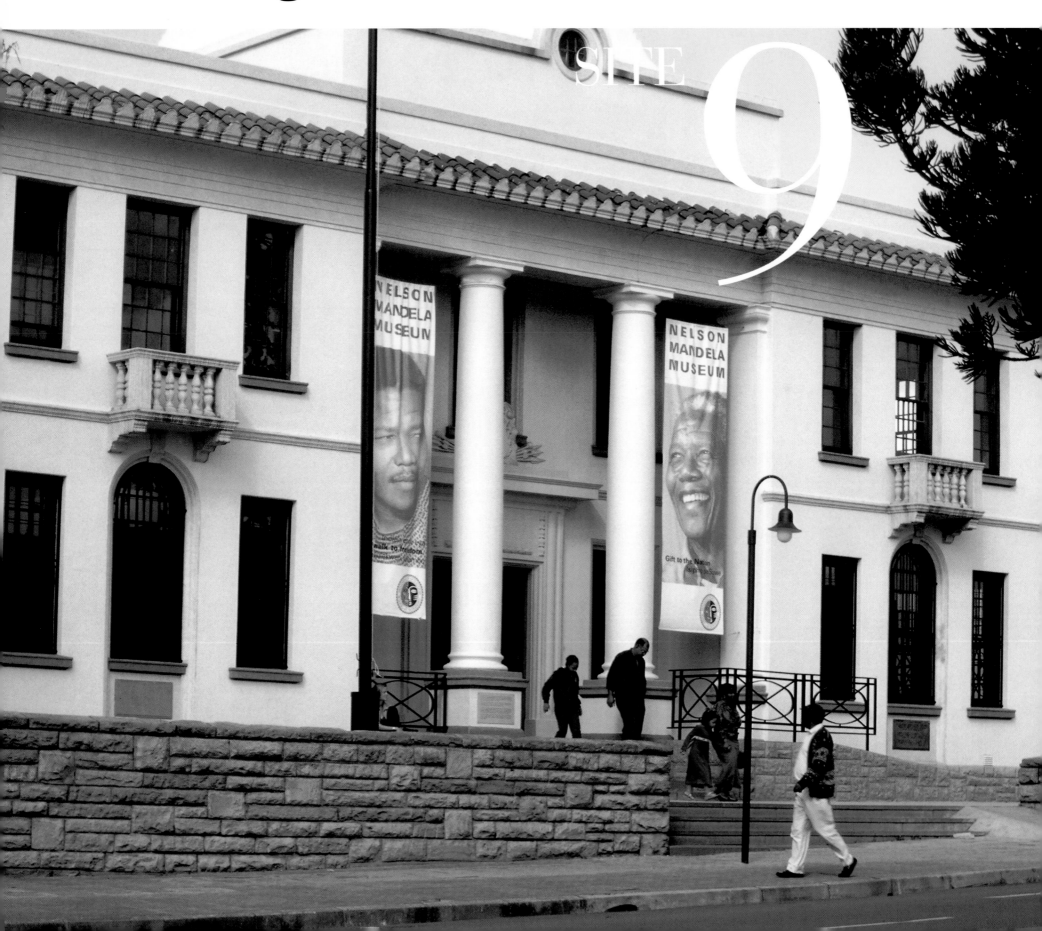

SITE 9

Symbol of colonial rule

During colonial rule, the Bhunga, located in Umtata, one-time capital of the British colony, was the seat of the Transkei parliament. When the British annexed the area, they selected the small Thembu settlement alongside the Umtata river as their colonial administrative capital. While Mandela was growing up, Umtata was very much a white, colonial town. Black people were required, as in other parts of 'white' South Africa, to get off the pavement if whites were walking past. Racial segregation was common long before apartheid. Today, Umtata is a vibrant multiracial city. In 2000, the Bhunga became the site of the Nelson Mandela Museum. It houses the many grand, curious and touching gifts and awards that the President received, both during his long years of imprisonment and in recognition of his foresight and leadership after his release. Mandela donated all these gifts to the state.

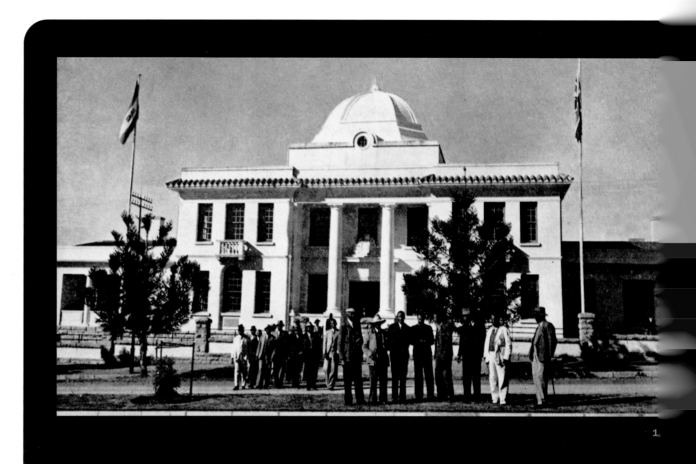

1
Chiefs pose in front of the Bhunga building, around 1944.

2
Some of the gifts on display. Of particular interest is the genre of scores of 'folk-art' portraits of Mandela, lovingly painted, photographed, decorated and embellished, in homage to the President.

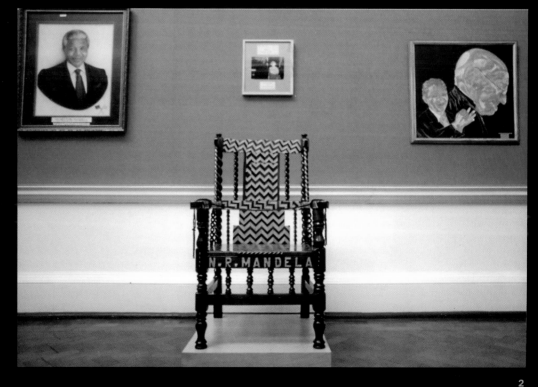

The Bhunga, Umtata

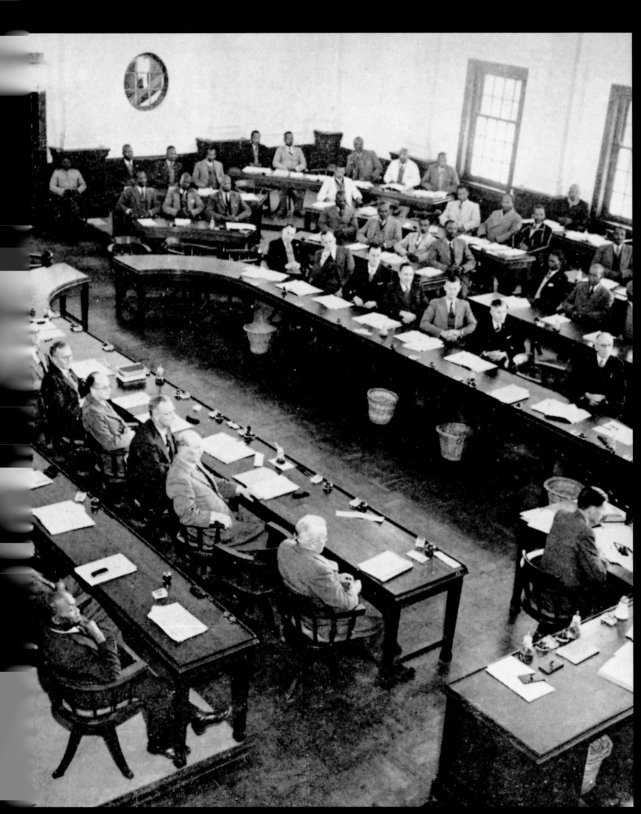

The Bhunga building, the site of the Mandela Museum in the heart of Umtata, was originally constructed in the 1930s to accommodate the United Transkeian Territories General Council, an elected body going back to 1894. It was parliamentary in form, with motions, debates and resolutions. In practice, however, it was conservative, and the colonial magistrates would review the decisions at the end of each session. The Bhunga thus bred democratic aspirations while at the same time frustrating them.

Many traditional leaders, dependent on the government for their income, felt caught between their duty to their people and the impositions of a succession of racially oppressive governments. Nevertheless, with the funds at their disposal the Bhunga was able to arrange some development programmes. In 1938, it granted a Fort Hare bursary to a brilliant young Mpondo student called Oliver Tambo. Tambo was a future professional and political partner of Nelson Mandela, and would become President of the ANC in its long years of exile.

When Dr Hendrik Verwoerd, 'the architect of apartheid', introduced the homeland system in 1963, the Bhunga became the seat of the Transkei Homeland Parliament. This consisted of 64 chiefs and 45 elected members. In the 1963 elections, the majority of elected members supported the opposition leader, Chief Victor Poto. But the majority of the chiefs supported the homeland leader, Chief K.D. Matanzima. The Bhunga continued to function as a false democracy.

3
Government-sanctioned chiefs deliberate at the Bhunga, around 1936.

It was only in 1994 that the Bhunga building became host to a genuinely democratic institution, the Kei District Council, which is the local authority for Umtata and its neighbouring

districts. The Council has relinquished a major portion of the building for the use of the Museum.

The handsome colonial edifice now houses hundreds of wonderful, commonplace, strange and curious gifts and awards presented to Madiba, both during the years when he was the world's best-known political prisoner and since then as an internationally renowned free man and South Africa's first democratically elected president. Of particular interest is the genre of folk portraits, lovingly sent to President Mandela from hundreds of admirers throughout the villages and townships of South Africa. The Museum's unique photographic exhibition of the life and times of Mandela puts both the tributes to his life and the struggle against apartheid in historical context.

When Mandela returned to Mqhekezweni and informed the regent of his decision, his guardian was furious at his irresponsibility. He immediately put Mandela to work as his assistant in village affairs. But sensing that his ward was restless, the regent decided that it was time for Mandela to grow up — and marriage was the swiftest route to maturity. He duly arranged matches for both Justice and Nelson. But both young men had absorbed the Western idea of having control over one's fate. They felt that many exciting opportunities awaited them in the wider world, and decided to run away. As if to confirm their immaturity, they helped themselves to one of the regent's cows, made their way to Umtata, sold the beast, and with the proceeds left for Johannesburg — the city of gold.

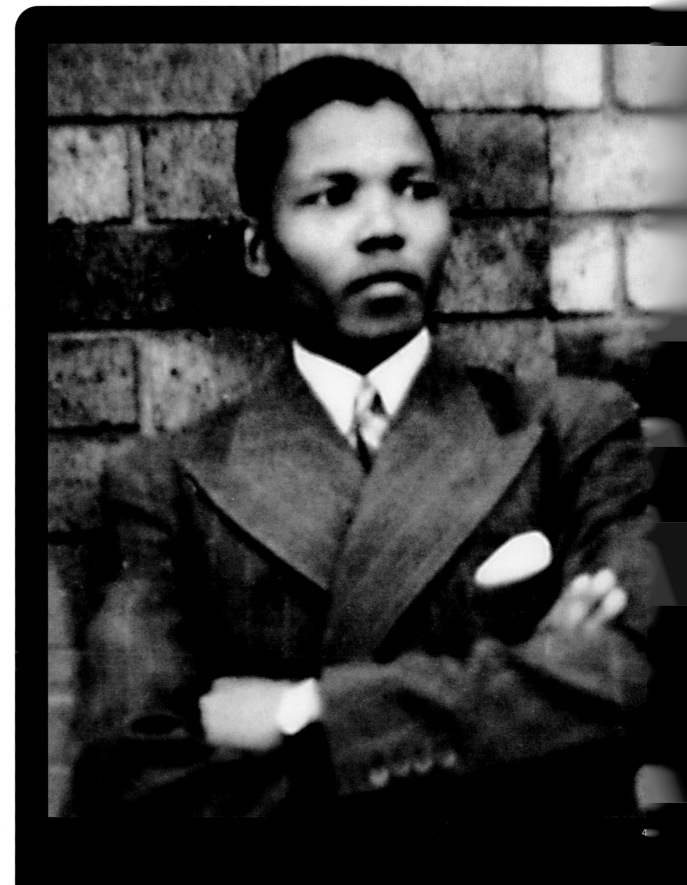

4

Mandela in Umtata, in his first suit, presented to him by the regent.

Part Two

'Johannesburg had always been depicted as a city of dreams, a place where one could transform oneself from a poor peasant into a wealthy sophisticate, a city of danger and of opportunity.'

'Johannesburg. Six thousand feet above the sea... The second biggest city in Africa, and by far the richest. No river, no lake, no sea within four hundred miles. Only gold, a mile below it, and everything that gold can buy. Fast, tough, rich, vulgar, new, and proud of it. A million people, half white, half black, one half fearing the other.'

Johannesburg, eGoli, the city of gold. The discovery of a gold nugget here in 1886 sparked off South Africa's rapid and, for many, traumatic industrial revolution. The fledgling city was named by Boer President Paul Kruger after one of his town planners, Johannes Rissik. Within fifty years a mining camp had been transformed into a metropolis of international standing. It is Johannesburg that best represents the spectacular shift from a land economy to a peculiarly South African form of mining capitalism. The mines, drawing on the legacy of colonialism, developed a migrant labour system and a set of institutions that were blatantly coercive and racist. The labour policy of the mines set the pattern for the country's entire economy, rural and urban, in the 20th Century.

 Scarcely one hundred years later, Johannesburg is the hub of the South African economy and has a population of close on four million. The downtown area, which became so familiar to Mandela after his arrival in 1941, has changed in many ways. With the collapse of apartheid in the early nineties, the

The landscape of black Johannesburg

pent-up black population of the townships flowed into the inner city and there was a 'white flight' of residents and businesses to the northern suburbs. Apartment blocks, empty hotels and offices became crowded residences, often without adequate facilities or social infrastructure to support day-to-day living, especially for families. By the beginning of the year 2000, there were 160 000 people living in the inner city, but they were struggling with the deterioration of many resources.

 After the first democratic elections in 1994, various public and private partners came together to formulate a 'vision' for Johannesburg. They have developed a programme of planning, environmental upgrading, business incentives, coordinated informal trading, housing strategies, security and marketing for a vibrant mixed use of the inner city. The regeneration of downtown Johannesburg as a dynamic African city is becoming increasingly and excitingly visible. Some of these initiatives are touched on in the pages that follow.

1
Johannesburg today

Part Two

As we retrace the footsteps of Johannesburg's black inhabitants of the 1940s, a vanished world reappears. The mine hostel, the pass office, the railway station. Diagonal Street, Sophiatown, Orlando. The world of black men and women in a racially divided city. The places they frequented still speak of the challenges they had to face, and the creative and resourceful solutions they found to survive in a hostile environment.

In 1940, the year of Mandela's arrival, Johannesburg was on the threshold of a population explosion. Only a few months earlier, South Africa had joined the Second World War as an ally of Britain in its fight against Nazism. Economically, the War stimulated the manufacturing industry in South Africa, creating a need for more workers in the towns to service the growing number of factories, shops and municipal authorities. Like most blacks and many whites then living in Johannesburg, Mandela was a 'country boy'. He was struck by the bright lights, the traffic, the crowded pavements, the exciting energy of the metropolis.

Johannesburg was truly a melting pot. Thanks to the pervasive migrant labour system, ethnic groups from all over southern Africa lived side by side here. While the blurring of identities could be confusing, the heady mix of cultures, languages, philosophies and urban lifestyles was stimulating, even inspiring.

But the city was also an inhospitable place for black people. There was a racial curfew, for instance: blacks had to be indoors after 9 p.m. The pass laws forbade black men to stay in the city for longer than 72 hours unless they carried an officially endorsed 'pass'. Negotiating the

2

A common scene in downtown Johannesburg: hundreds of newly arrived migrant workers being escorted from the railway station to the gold mines.

2

contradictory currents of Johannesburg was to change the direction of Mandela's life for ever.

'I had reached the end of what seemed like a long journey, but it was actually the very beginning of a much longer and more trying journey that would test me in ways that I could not then have imagined.'

3
Sophiatown in the 1940s, adjoining one of Johannesburg's ubiquitous mine dumps, since demolished

Newtown Compound

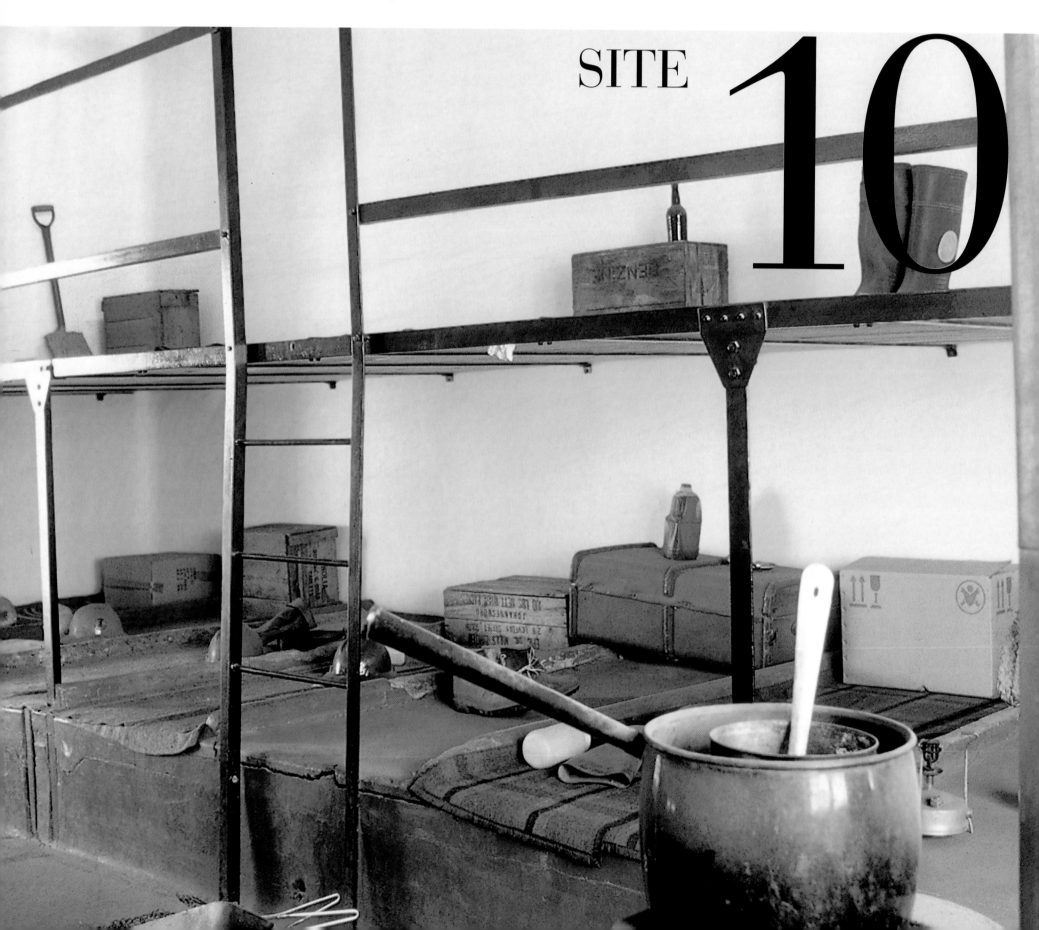

The migrant's destination

The first destination of migrant workers arriving in the city was the hostel or compound. The Newtown hostel shown here was built in 1915 as a 'model compound' to house Johannesburg's municipal workers. It has now become the Workers' Library and Museum, retaining the shower room, common lavatories, the lock-up room for offenders, and other evidence of round-the-clock social control. The museum is a living example of what conditions were like for migrants in the 1940s. Their mattresses were straw mats on concrete bunks; their wardrobe a nail in an exposed rafter; their drawer a box or trunk.

The migrant labour portion of the compound has been adapted to suit the needs of a usable Workers' Library. The concrete bunks in the other dormitories were demolished and the interiors redesigned to provide exhibition space, seminar and reading rooms, a library and resource centre, and a Workers' Bookshop. This sensitive renovation earned the architects a prestigious award.

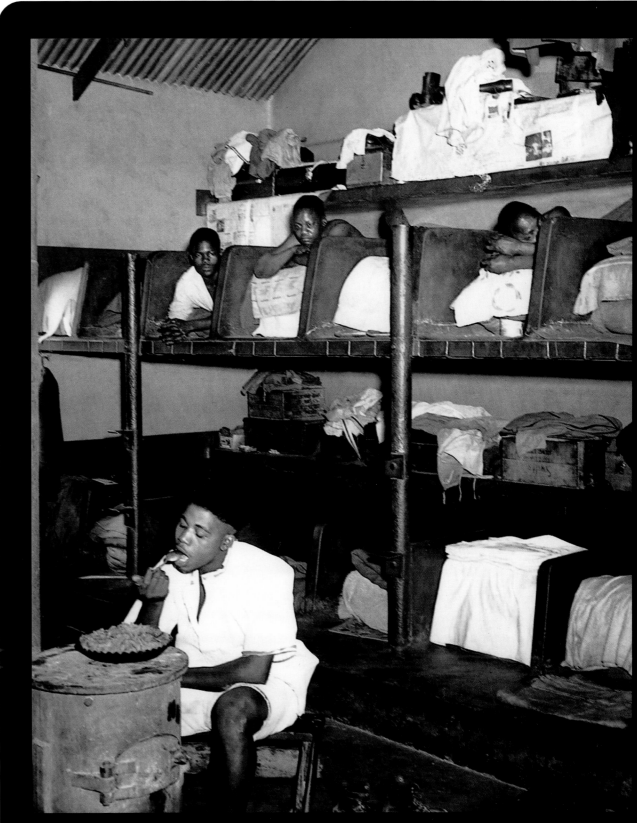

1
A typical mine hostel interior, 1940s

Newtown Compound

2

The system of migrant labour affected the lives of every black man, woman and child, changing for ever the homestead economy, the close-knit extended family, the traditional division of labour, and the relationship of children to their absent fathers.

It was usual for black workers from the Eastern Cape to travel to Gauteng, the 'place of gold', to find work in the mines. Mandela and his cousin Justice had friends from Qunu who were working at Crown Mines. When the two young men arrived in Johannesburg, they therefore made their way to the Crown Mines hostel, which was similar to the one shown of the Workers' Museum. They had no trouble finding employment on the mine. Being high-school graduates, they had an uncommon opportunity for blacks: the option of becoming office clerks rather than labourers. As members of the royal family of Thembuland, the two personable young men were warmly welcomed by the induna of the Xhosa-speaking section of the mine.

2
Migrant workers on the mines: the different styles of clothing suggest how diverse cultures were brought together by the migrant labour system.

While most black mineworkers considered themselves fortunate to find work for cash wages, low as these were, once employed they were confronted not just with appalling and alienating living conditions in the hostels, but with extremely dangerous working conditions in the mines. For many decades, an average of seven hundred men died underground every year. Thousands more were permanently disabled. The migrant labour system of cheap black labour was perfected by the diamond and gold mining industries in the late 19th Century. They took advantage of the dispossessed or depleted

kingdoms during the land struggles, and insisted that only male labourers on contracts — without their families — would be employed in the mines. As a result, mineworkers' wages were far below living standards. It was up to the women in the villages back home to supplement the family income with their labour in the fields and the homesteads. Essentially, rural women subsidised the cheap labour costs of the mining and other industries in the 'white' cities. The migrant labour system set the pattern for South Africa's economy, backed by racially oppressive laws to control resistance to this most gross form of exploitation.

'Everywhere I looked I saw black men in dusty overalls looking tired and bent. They lived on the grounds in bleak, single-sex barracks that contained hundreds of concrete bunks separated from each other by only a few inches.'

While the migrant labour system in South Africa has proved very difficult to surmount, conditions in the hostels and in the mines themselves have improved. This is largely due to the struggles of the National Union of Mineworkers, which has campaigned since its inception in 1982 for more acceptable living conditions and higher wages, for the elimination of job reservation (the apartheid practice of reserving skilled jobs for whites), and for health and safety underground.

As it turned out, the sojourn of Nelson and Justice at Crown Mines was brief. The induna discovered that they had left home without the blessing of the regent, and they were sent packing. But Mandela's encounter with the mining industry was not forgotten: in 1988, when he was still in prison, he was elected Honorary President of the National Union of Mineworkers.

3

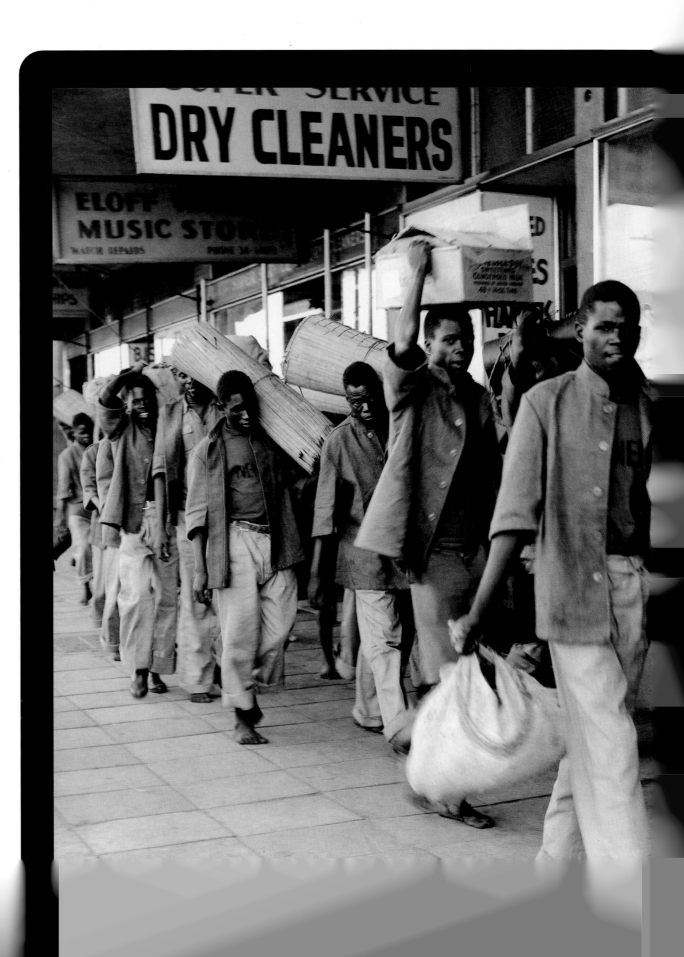

Newly arrived migrant workers walk through the streets of Johannesburg on their way to

The Pass Office, Albert Street

SITE 11

The hated 'dompas'

The old pass office at 80 Albert Street was built after the Anglo Boer South African War, when the outcome of that conflict confirmed that the mining houses were set to dominate the economy. The pass system, established in 1809 to control runaway slaves in the Cape, regulated the flow of black workers into and out of the cities according to the needs of white employers. In the 1960s, the Albert Street building was extensively enlarged to accommodate the dramatic increase in the regulation of black labour under apartheid. After the collapse of the pass system in the mid-eighties, the building stood empty for a number of years. Today, it is serving inner-city people more kindly as a women's hostel and a shelter for homeless children.

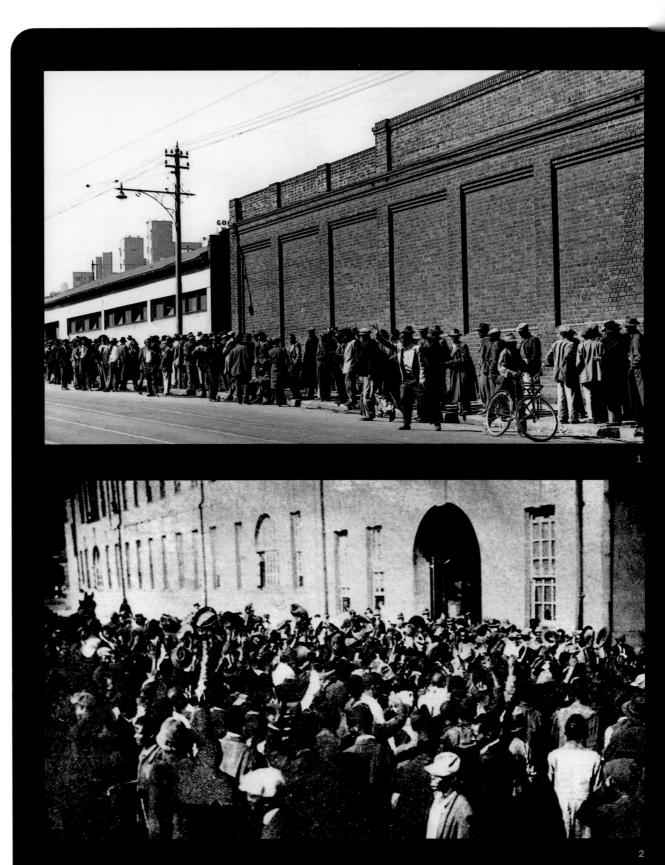

1
Outside the Johannesburg pass office, 1940s
2
Protest against the pass laws,
Johannesburg, 1919

The Pass Office, Albert Street

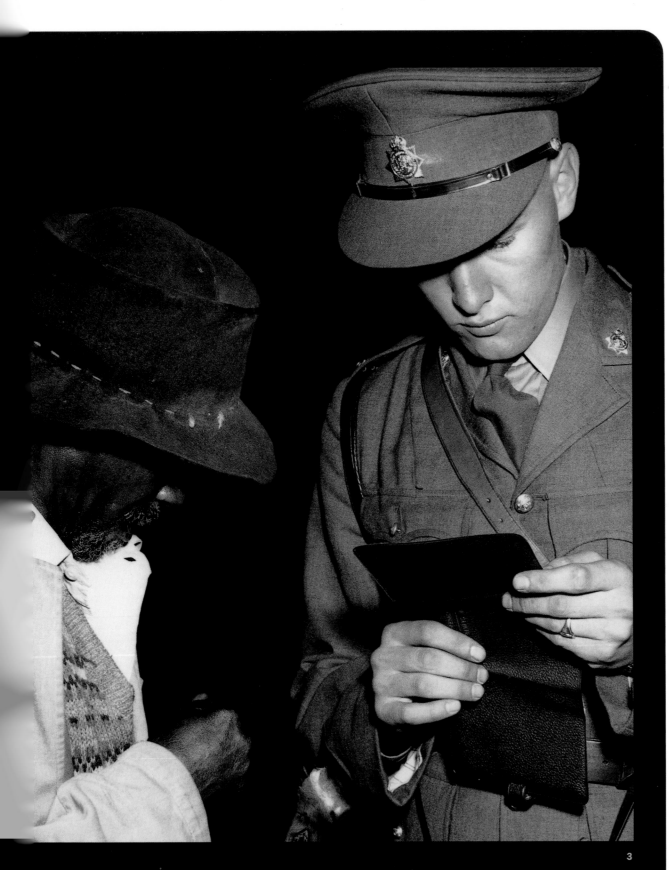

The pass remains the most powerful and detested symbol of apartheid and the colonial legacy it perpetuated. Every day, hundreds of desperate black work-seekers, permitted to stay in the city for no longer than 72 hours, would queue interminably for the privilege of obtaining a work permit or 'pass'. This piece of paper meant that one could stay in the 'white' city for just as long as one was employed — usually by a white boss. Any black man apprehended without a pass would be arrested and imprisoned, or heavily fined for infringing the pass laws.

The pass laws were a tyranny for blacks. Resistance to the pass system occurred many times. As early as 1913, black women in the then Orange Free State successfully resisted the imposition of passes on them. In 1919, the ANC in the Transvaal organised a campaign for a 'free labour system'. Bags of discarded passes were collected in all the mining towns and handed in at pass offices. Although Congress leaders were arrested, the campaign succeeded in attracting attention to the grievances of black workers and work-seekers. The campaign underlined the fact that the racial restrictions kept black wages extremely low. ANC leader D.S. Letanka declared: 'The Pass Law is nothing but slavery and forced labour'.[3]

Without a pass, black men were 'endorsed out' of town, or sent to work as convicts on white-owned farms, where there was a shortage of cheap labour.

3

'Show me your pass!' Graphic evidence of the humiliation the apartheid authorities inflicted in their attempt to control the movement of black people.

There were many more attempts to resist the pass laws. In the 1920s again the Industrial and Commercial Workers' Union held anti-pass

compaigns. In 1930, Communist Party speaker
Johannes Nkosi and three other men were shot
down by police at a pass resistance rally, during
which 4000 passes had been collected for
burning. In 1944, the ANC conducted on anti-
pass campaign. Schoolteacher David Bopape,
who joined the ANC in 1942 and was to work
with Mandela and others in the Youth League,
was elected organiser of this campaign and
travelled the country addressing meetings and
mobilising resistance. Further anti-pass
campaigns were to create more upheavals in the
1950s, during the ANC's era of mass
mobilisation. So deeply did this blight on the
lives of black people affect generation after
generation, that eventually, in 1960, resistance to
the pass system at Sharpeville and Langa was to
bring about an historic turn of events in South
Africa's political landscape.

In the decade that followed, opposition was
ruthlessly crushed. In the 1970s and 1980s,
resistance was linked to the re-emergence of the
democratic labour movement and its migrant
worker membership. Eventually, as a result of
these intense struggles, pass controls were
relinquished in 1985.

As one of a tiny number of university-educated
blacks in Johannesburg (or anywhere else in
South Africa), Mandela was exempt from
carrying the hated 'dompas' — the 'stupid pass'.
But, in a bitter irony, he was nevertheless
apprehended more than once. He still had to
carry a document to show that he was indeed
exempt from having to carry a pass!

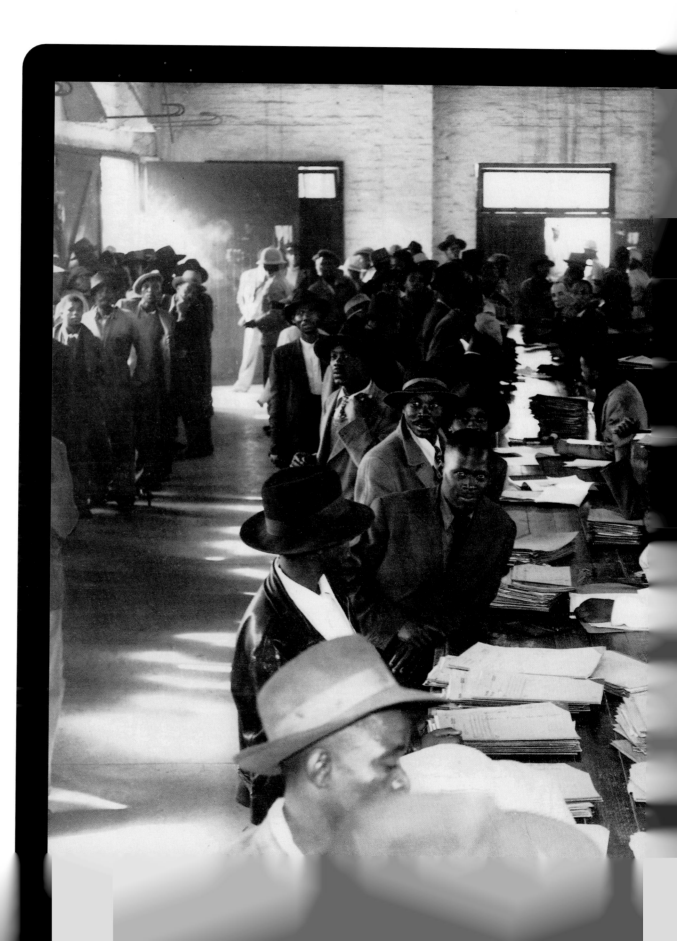

4

The Johannesburg pass office, 1944.

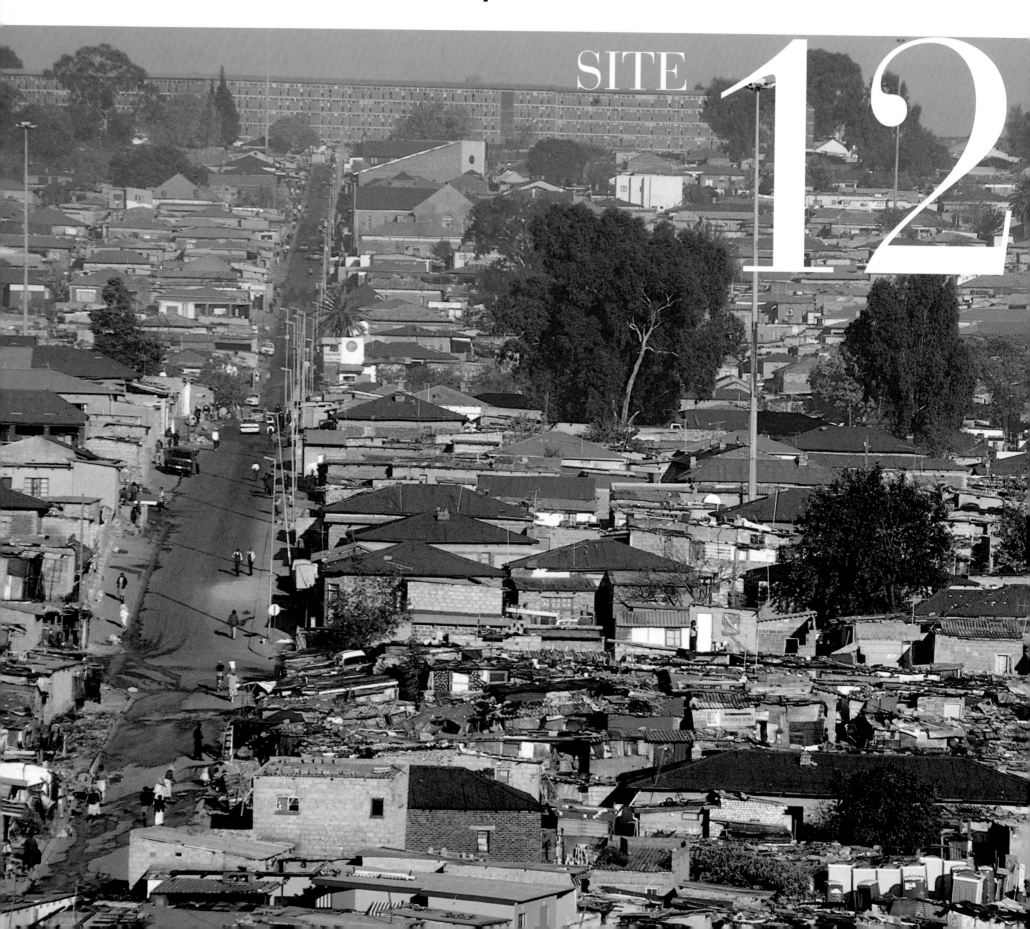

Alexandra Township

SITE 1²

A kind of heaven

Alexandra was established in 1912 as a freehold township for blacks. Through steady and determined resistance, its inhabitants managed to avoid the removals of the apartheid era, although landowners lost their property rights. In the 1960s and 1970s, under the grand apartheid scheme, massive hostels were built for migrant workers. Today the area is bursting at the seams. Shacks crowd the banks of the Jukskei River, perched dangerously on the flood-line. On the east bank of the Jukskei, an exciting start in development has been made with the construction of new houses. Built as residences for visiting athletes during the All Africa Games in 1999, these houses have since been occupied by families from the informal settlements.

1

Alexandra township in 1942

2

Mr Xhoma's house in Seventh Avenue, where Mandela became a lodger in 1941, staying in a tin-roofed room at the back of the property. *'Alexandra occupies a treasured place in my heart. It was the first place I lived away from home.'*

Alexandra Township

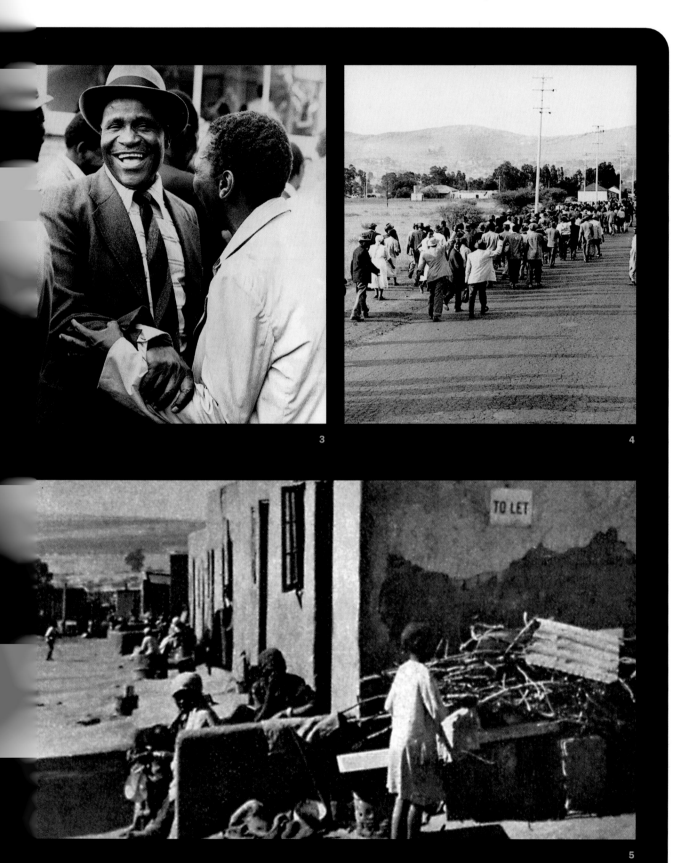

3

4

5

Alexandra Township, located on the edge of the Johannesburg municipal area some twenty kilometres from the city centre, has always provided the metropolis with workers. In 1942, a year after Mandela moved from Crown Mines to Alexandra, the magazine *Libertas* described it as a town of hard-working and desperately poor people, infamously exploited and terrorised, racked by continually encroaching debt, and trying heroically to live decent lives under degrading conditions.

3
Thomas Nkobi (later to become ANC Treasurer in exile) after addressing a meeting in Alexandra in the 1950s. Fellow Alexandrans Alfred Nzo, Madzunya and Joe Modise were also leading political figures.

4
People walk to work during the Alexandra bus boycotts.

For the first time, Mandela was on his own, facing the hard facts of urban poverty. Along with thousands of black professionals, such as teachers and nurses, he was paid a miserably low wage. Though educated, he was shabbily dressed, frequently walked many kilometres to work, and often went hungry. It was only through the generosity of his landlord and landlady that he got at least one square meal a week.

5
Alexandra, 1942. The 'TO LET' notice was rare, as housing space was at a premium.

The African culture of sharing was not entirely lost in the city. As a freehold township, Alexandra was more easily able to provide hospitality in the African tradition than those townships under the sway of superintendents, who monitored the tenants and imposed 'lodgers'

permits' on the residents to control the influx of newcomers. Such generosity had been quickly noted by Johannesburg employers, and became another justification for low wages. 'So far it has been unnecessary to provide relief for the permanent population,' the Native Affairs Report commented complacently during the Depression of 1932, 'but that is due to the practice of natives helping each other.'

'The township was desperately overcrowded; every square foot was occupied by either a ramshackle house or a tin-roofed shack ... On almost every corner there were shebeens, illegal saloons that were shacks where home-brewed beer was served.

In spite of the hellish aspects of life in Alexandra, the township was also a kind of heaven. As one of the few areas of the country where Africans could acquire freehold property and run their own affairs, where people did not have to kowtow to the tyranny of white municipal authorities, Alexandra was an urban Promised Land, evidence that a section of our people had broken their ties with the rural areas and become permanent city-dwellers ... [I]nstead of being Xhosas, or Sothos, or Zulus or Shangaans, we were Alexandrans.'

In the early 1940s, bus fares were raised by a penny, an amount low-paid workers could ill afford, and the residents of Alexandra retaliated with a series of bus boycotts. Remarkably, given the distances people had to walk to their jobs in the city centre, the boycotts succeeded. For Mandela, the boycotts demonstrated the enthralling power of urban collective action. They also served as an example of successful mass action, of the kind he and his colleagues in the Youth League proposed to the ANC a year or two later.

The Oliver Tambo Community Centre in present-day Alexandra offers training facilities to support income-generating projects such as basket weaving and sewing. It includes a resource centre, a library and the ANC Parliamentary Constituency office, which focuses on public participation in the legislative process. The centre is named after Mandela's legal partner and political ally. As President of the ANC, Tambo was Mandela's immediate predecessor. He is widely honoured as the leader who held the ANC together during its three most difficult decades of banning and exile.

6

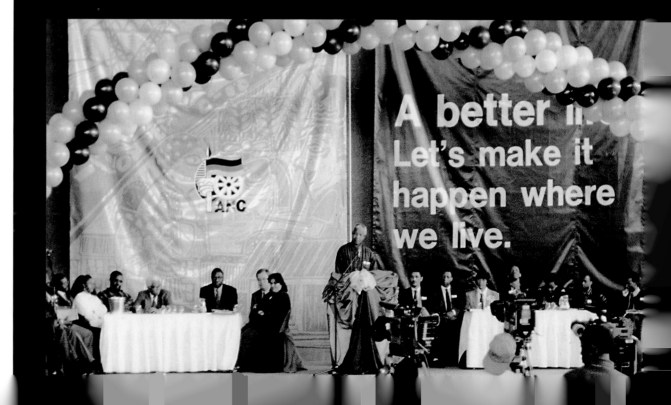

7

Return to Alex: Mandela speaks at the Alexandra local elections in 1995.

Walter Sisulu's Office

SITE 13

Magnet for intellectuals

The west end of downtown Johannesburg provided space for black businesses. There were Indian trading stores selling clothing, shoes, hats, foodstuffs and imported merchandise at bargain prices; African shopkeepers and traditional herbalists; record shops stocking American jazz and the latest black South African music, both rural and urban; and some black offices. Walter Sisulu's estate agency, Sitha Investments, was situated in West Street, in the heart of the Diagonal Street precinct. The style of the area offered an exciting glimpse of a bustling city in Africa, at variance with the orderly European style of the white central shopping area. Diagonal Street was lively, colourful and noisy, and attracted a middle-class clientele seeking to escape convention and predictability. Much of this vibrancy remains today.

1

Walter Sisulu visiting the site of his old office in 1996. The premises are now occupied by a clothing store. Sisulu is being shown a photograph of the building taken in the mid-forties.

Walter Sisulu's Office

Walter Sisulu in the early 1950s. Sisulu was to become a permanent key influence on Mandela and his closest colleagues. It was he who initiated the political shifts of South Africa's major liberation movement, the African National Congress. Born in Engcobo in the Eastern Cape, Walter and his sister Rose were secretly fathered by a white trader and magistrate, but raised by their mother in a traditional homestead. Walter had to leave school early to look for work. Only thirty years old in 1941, he had a range of life experiences. Unlike many of Johannesburg's African elite, including Mandela himself, he had direct knowledge of the black working class.

2

Walter Sisulu's office was within easy reach at the west end of town. Many black professionals, newly arrived in the city, came here seeking direction from this remarkable young man.

Sisulu had a sociable nature, and consciously set out to help 'develop any African [he] thought had the potential'. He also had a maturity and wisdom beyond his years, a quality which must have arisen partly from the diversity of his experience, first as a worker and trade unionist and then as an entrepreneur — a remarkable progression considering the odds against any black man living in a white-controlled city. Sisulu's office became a formative meeting place in the lives of dozens of young intellectuals and activists, including Mandela.

Sisulu exerted an influence by example and commitment, through his network, which included whites as well as blacks. It was Sisulu who introduced Mandela to Lazar Sidelsky, the lawyer who gave him articles. During his time with the firm, Mandela carried on studying and finished his BA degree at the end of 1942.

3

3
A view of Diagonal Street, close to Walter Sisulu's office. The multi-racial precinct provided black men and women with economic opportunities.

4
Mandela pours a glass of water for Sisulu, his old friend and mentor, during the negotiations at the World Trade Centre in 1993.

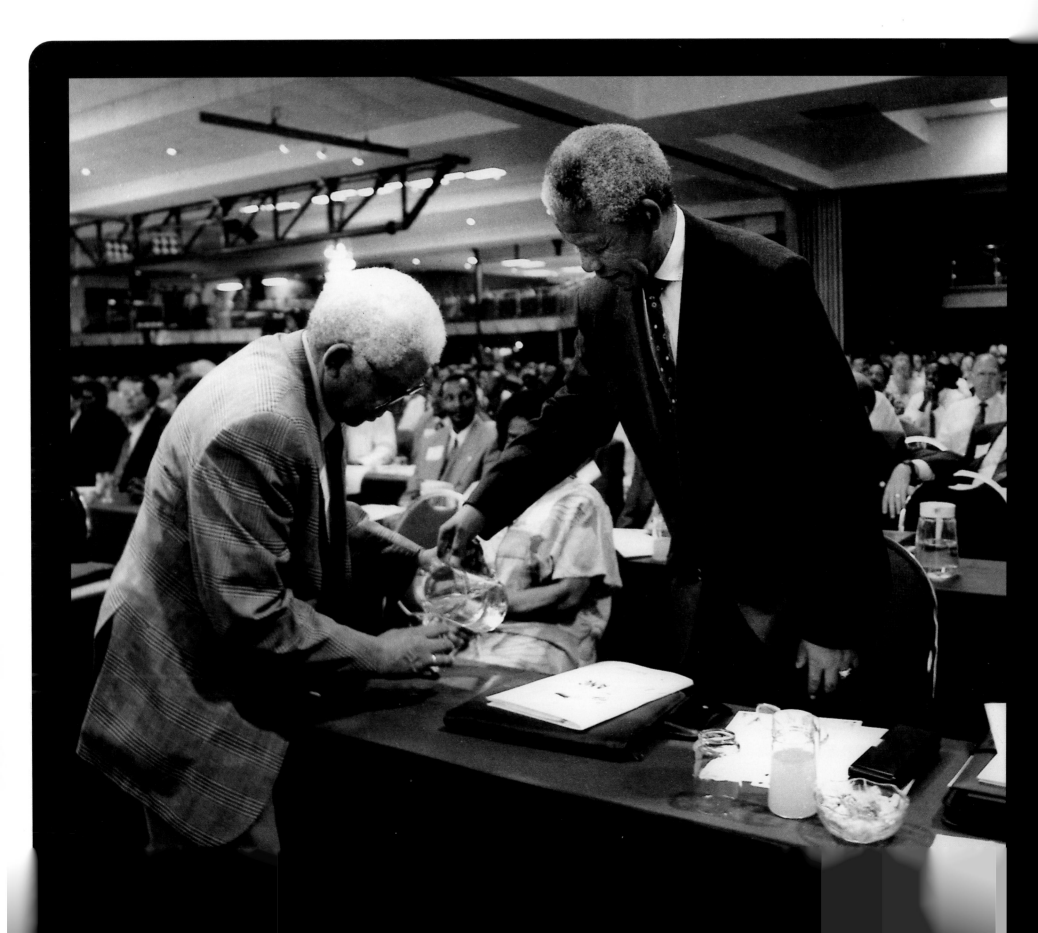

The Sisulu Home, Orlando West

SITE 14

Home from home

Walter Sisulu, his mother and stepfather moved to Orlando East in 1934, barely two years after it was established. The new township was named after councillor and benefactor Orlando Peale. In 1940, Walter's family moved to their present home at 7372 Magang Street in Orlando West. It was this house, the typical Spartan township 'matchbox', that Mandela came to know so well. While the facilities may have been minimal and the rooms cramped and overcrowded, the hospitality of Walter and Albertina Sisulu transformed it into a warm and welcoming home. In time to come the house accommodated an extended family of nine children. In recent years, the 'match-box house' was enlarged to include a verandah and two extra rooms.

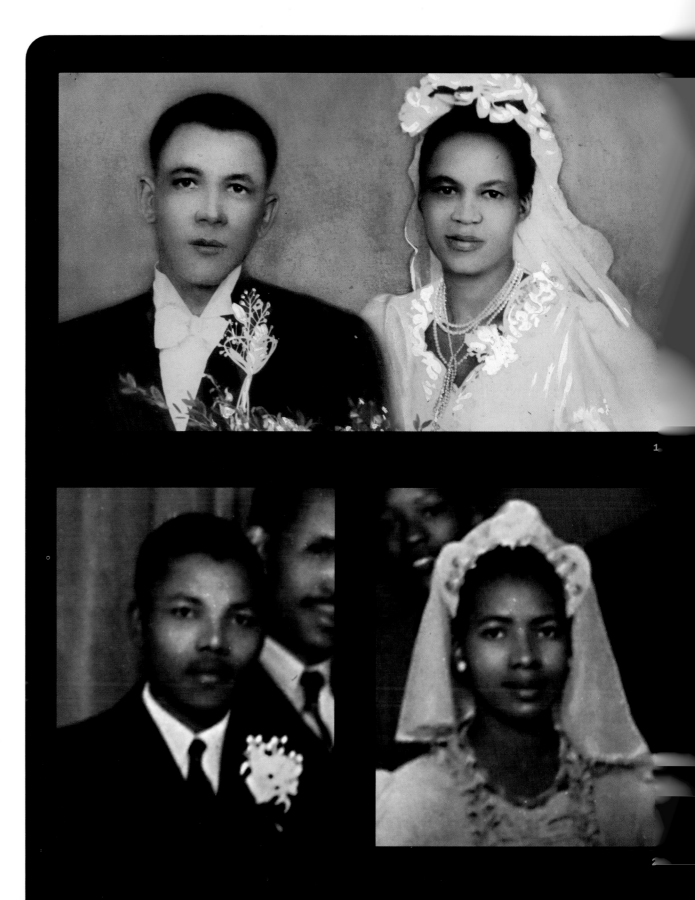

1
The wedding photograph of
Walter & Albertina Sisulu, 1944

2
Nelson Mandela and Evelyn Mase, 1944

The Sisulu home, Orlando West

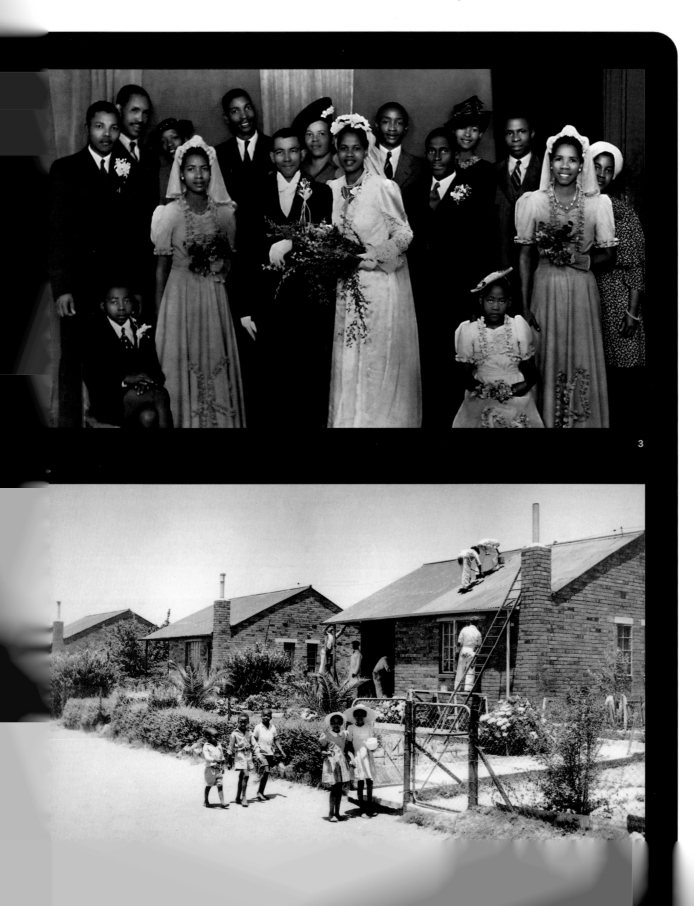

Johannesburg's City Engineer in the early 1930s envisaged Orlando as 'the future great city of Bantudom'. Well-meaning but patronising notions such as this buttressed the development of the apartheid city. In the course of the thirties, black residents in 'mixed' suburbs such as Bertrams and Doornfontein were removed and housed in the sub-economic 'location' of Orlando, which was named after one of the local councillors (white, of course). Building accelerated rapidly as more and more newcomers arrived to find jobs in the growing economy of the Transvaal. At this time, the municipalities, shops and industries in the province required more labour, and so for a while the authorities relaxed the vigorous prosecution of pass infringements, although they implacably continued to control the black population through liquor raids, curfews and other regulations.

In the African tradition, Walter Sisulu's home was also a home for many newcomers. His young wife, Albertina, was as hospitable as her husband, and participated actively in the political discussions that led to the formation of the Youth League. Albertina Sisulu was one of the first women members of the Youth League and also a founder-member of the ANC Women's League. Mandela was charmed by the harmony of values and minds in the Sisulu household, and by the strength of their marriage partnership.

3
The Sisulu wedding, 1944. On the left, Nelson Mandela. The pretty bridesmaid next to him is Evelyn Mase, his future wife.

4
Early Orlando days

'Walter's house was my home from home. For several months in the early 1940s, it actually was my home when I had no other place to stay. The house was always full, and it seemed there

was a perpetual discussion going on about politics. Albertina, Walter's wife, was a wise and wonderful presence, and a strong supporter of Walter's political work.'

Perhaps the warm and supportive relationship between his friends influenced his desire to be married. It was at the Sisulu home that Mandela met and fell in love with Walter's cousin, the quietly spoken, serious and pretty young nurse, Evelyn Ntoko Mase. 'The Sisulus treated Evelyn as if she was a favourite daughter, and she was much loved by them.' In 1946, Nelson and Evelyn were married.

5

Power-station cooling towers serving the needs of white Johannesburg homes and industries loom over the modest houses of Orlando in the 1930s. Fifty years would pass before these houses were provided with electricity.

The couple set up home not far from the Sisulus, at 8115 Ngakane Street in Orlando West. Three children were born in rapid succession — a son, Thembekile, a daughter, Makaziwe, and a second son, Makgatho. The little girl was sickly, and at nine months she passed away. Evelyn, who had tirelessly nursed the child and prayed for her life night after night, was distraught. Six years later, another daughter was born. She was named Makaziwe, in memory of their first baby girl.

Unlike Mandela, Evelyn was not attracted to politics. After losing her baby, she increasingly turned to God for meaning. She was determined to upgrade her nursing qualifications, and for a few months attended a course in Natal, while Mandela's mother and sister cared for the children. But it was Mandela who spent most time away from home. 'My schedule in those days was relentless. I would leave the house very early in the morning and return late at night. After a day at the office, I would usually have meetings of one kind or another.' To Evelyn, these frequent absences because of his political involvement seemed irresponsible.

Evelyn Mase in 1990, when she owned a store in the Transkei. In 1955, under the pressure of Mandela's arrest, the differences between the couple came to a head and their marriage broke down. Years later, despite the vindication of Mandela's success, Evelyn was still critical of his failure to meet his family obligations. 'While he talked about the struggle against apartheid, I had a struggle bringing up our children alone ... I can never forget those years and how different things might have been had he been a husband and father rather than a revolutionary.'

6

Park Station

SITE 15

Commuting to the city

Park Station was the hub of Johannesburg for thousands of white and black commuters, including Mandela. The whites-only concourse, with its impressive barrel-vaulted ceiling and fountain, boasted a collection of fine murals by the South African artist Pierneef, whereas black commuters were relegated to a separate entrance and the most basic facilities. In the eighties, the station became derelict. At night the homeless, mainly newcomers to Johannesburg, crowded onto the platforms in search of a place to sleep. In recent years, the restoration of the fine old features of this major terminal and the modernisation of its facilities have reestablished a significant asset to the city.

1
C.E. Turner's glamorous painting of the (whites-only) concourse in the newly renovated Park Station, 1934

2
President Mandela, Minister of Transport Mac Maharaj (left) and Managing Director of Spoornet Jack Prentiss at the opening of the renovated concourse of Park Station, 1998

Park Station

For black commuters, the train was often an unofficial site of church services, social gatherings and political education, a place where friendships were initiated and networks formed. Mandela commuted daily from Orlando station, travelling in the 'third class' compartment with all other black passengers. Walter Sisulu, one of the first residents of Orlando, recalled making many new contacts and holding fascinating conversations with regular commuters on the eight o'clock train. Some of them subsequently became leading figures in politics – Anton Lembede, Jordan Ngubane, William Nkomo, Mandela.

3
Black commuters, 1942

South African railway stations reveal many layers of history. In apartheid South Africa, where black workers were located in segregated townships far from their workplaces, transport was inevitably a 'site of struggle'. Bus boycotts, political mobilisation on the trains, and later taxi wars over the domination of the commuter market all provide dramatic examples of the politics of transport.

After the release of Mandela in February 1990, 'third force' elements began to foment violence on the trains in an attempt to disrupt the negotiations towards democracy. Over a period of several years, passengers were terrorised, thrown off trains or murdered at the stations. Ethnic differences and divisions between migrant workers and urban people were exploited to fuel the violence. After the elections in 1994 the trains returned to normality. Evidence submitted to the Truth and Reconciliation Commission subsequently revealed how extensively the violence had been orchestrated.

4
Violence on the trains in the early nineties: part of a right-wing strategy to disrupt

Dr Xuma's house

SITE

16

The doctor of Sophiatown

Sophiatown, a cosmopolitan freehold suburb on the west side of town, was one of the oldest black settlements in Johannesburg. It was a brash, vibrant neighbourhood, the crucible in which new urban identities were formed. Can Themba, one of the writers whose name is inextricably linked with the area, summed it up in his *Requiem for Sophiatown*: 'It is different and itself. You don't just find your place here, you make it and you find yourself'.[4] In Sophiatown workers mingled with professionals — teachers, preachers, doctors, journalists and businessmen. Above all, its church and school helped to prepare the young black generation for the rigours of living in a city dedicated to white supremacy.

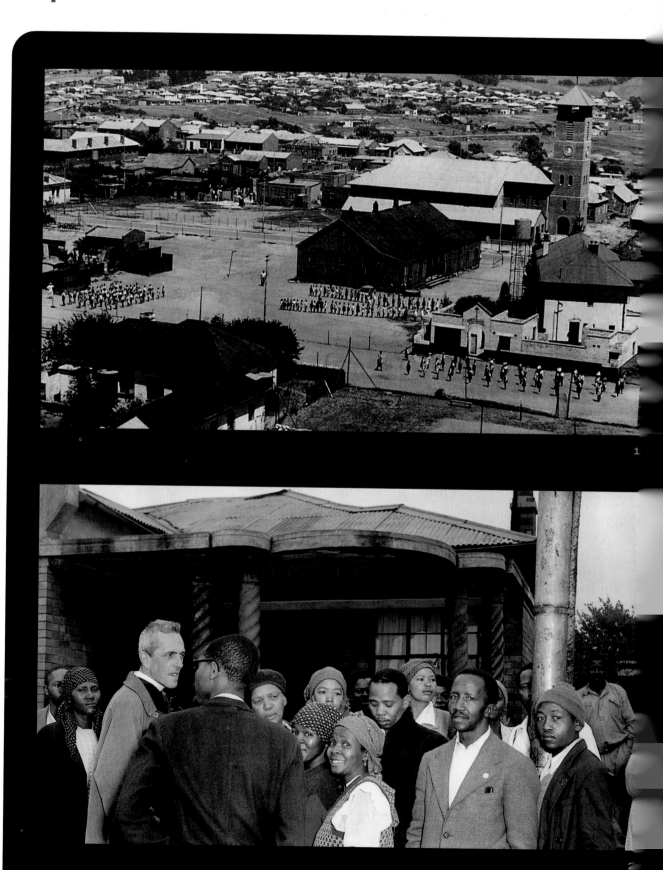

1

Sophiatown in the 1950s

2

Father Trevor Huddleston, who lived in Sophiatown from 1943, and other Sophiatown residents outside one of Sophiatown's 'posh' houses, 1953.

Dr Xuma's house

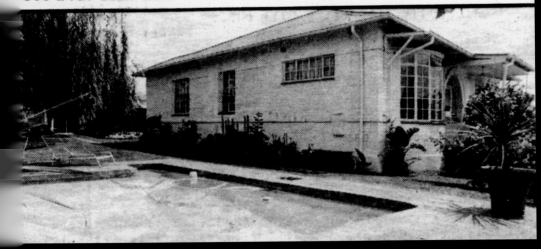

3

3
In 1992, 30 years after the death of Dr Xuma and the destruction of Sophiatown, Xuma's one-time house was up for sale. 'This lovely bit of history' had not always been regarded as such by the authorities. Site 36 continues the story.

4
Dr Alfred Bitini Xuma in the 1930s

4

One of the people who made a place for himself in Sophiatown was Dr A.B. Xuma. In the late fifties, when the residents of Sophiatown were forcibly removed to Meadowlands and most of the suburb razed, Xuma's house was one of the few that escaped demolition.

Graduating from Clarkebury (as we have seen in Site 5), A.B. Xuma became a school teacher. But, he later recalled, 'my mind was in a state of unrest'. Inspired by the return of black lawyers such as Pixley ka I. Seme, John L. Dube and Richard Msimang, and a medical doctor, all of whom had successfully studied overseas, Xuma managed, through sheer hard work and determination, to obtain a bursary at the Tuskegee Institute at Alabama, USA. Working part-time and interrupting his studies to work full-time over the years, Xuma eventually received a Bachelor of Science degree. He took more time off to save money as a waiter, a porter, a farm labourer, a builder and in the coal yards. By 1926, Xuma had graduated as a medical doctor. Determined to specialise further, he then studied at the Women's Hospital in Budapest, Hungary, and then went on to study and practise as a surgeon in Edinburgh, Scotland. In 1929, this highly talented man returned to South Africa, his African American bride on his arm, and set up a practice in Sophiatown, Johannesburg.

In the 1940s, Mandela and other young intellectuals were regular visitors to Dr Xuma's house. Xuma, President of the ANC from 1940 to 1949, was a remarkable figure — a shining, if unattainable, example to the community.

Xuma was particularly admired by Mandela and his peers because he had managed in just a few years to revive the moribund ANC. Under Xuma's presidency, the organisation's membership increased vastly and it became solvent again. Xuma loved to hold discussions and test out his ideas with young intellectuals,

instructing them in the tactics and strategies of politics.

In 1944, he began developing a vision for the future in a document entitled 'African Claims'. He encouraged his young 'graduates', as he called them, to contribute to the preparatory discussions on this document. Mandela, Tambo and Sisulu, and others who founded the Youth League in that same year, were regular participants in these evening deliberations.

5

Dr Xuma in his surgery, around 1943

Xuma's was one of the few middle-class houses in the suburb. In his autobiographical novel *Blame Me on History*, Bloke Modisane, who lived in Sophiatown, recalls the lofty ideals Dr Xuma inspired amongst ordinary people:

'Ma-Willie and I had always pointed with pride to Dr Xuma, the African doctor who had studied in America, Glasgow and London; he had success, wealth, position and respect, and my mother was suddenly seized by the vision of a Dr Xuma in the family. "You will be a doctor," she said, determined.'[5]

City Hall steps

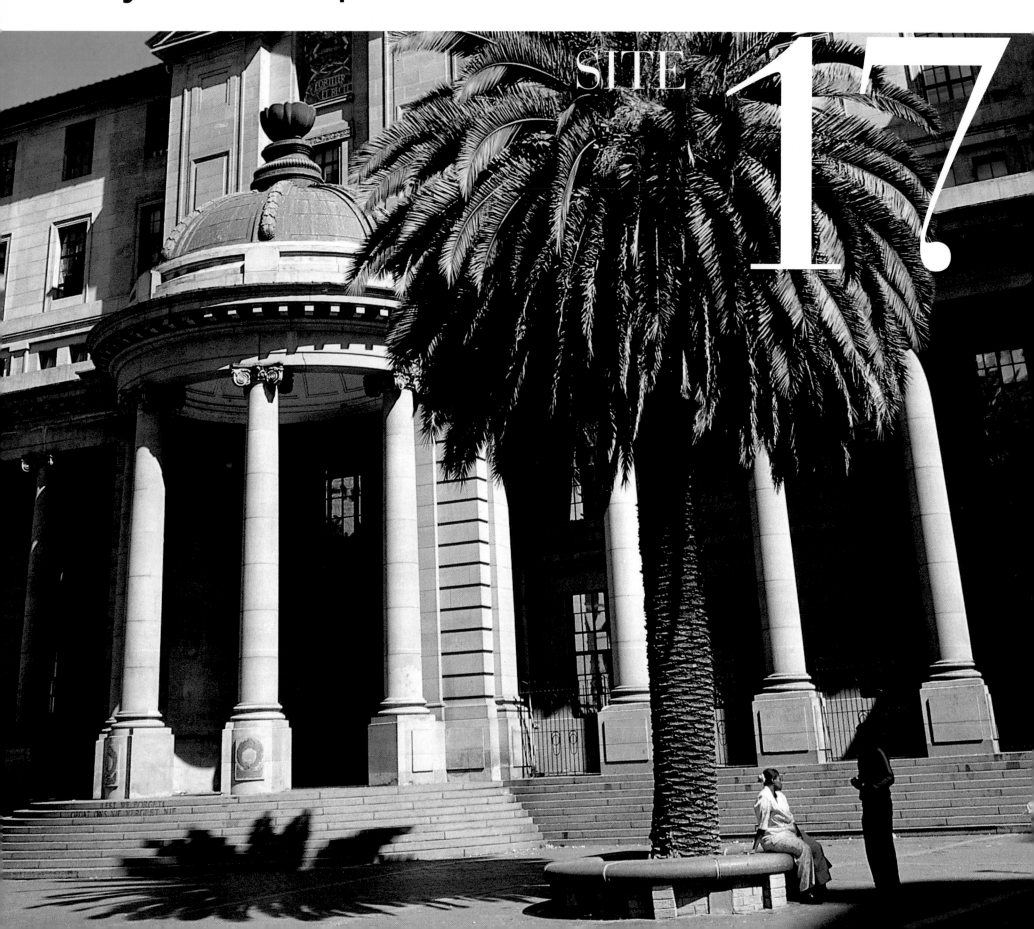

Claiming public space

In 1994, the new democratically elected provincial government of Gauteng, the country's most populous province, based itself downtown in Johannesburg's City Hall. For some time white businesses had been relocating to the prosperous northern suburbs, and so the government's choice of location was a statement of support for the inner city. Almost from the moment it was built in 1915, the area around the City Hall had been a well-used, vocal public space. Officially, it was used regularly for ceremonies, mayoral photo opportunities and for conferring the Freedom of the City to a select few.

Every Sunday, though, the steps became a black or multiracial gathering place for prayers or meetings. Ironically, black people were not permitted inside the building in those days — unless they were cleaners. Today, the fine neoclassical interior of the Gauteng Legislature is enhanced by an excellent collection of South African paintings and sculptures.

1
Informal settlers demonstrate outside the City Hall, 1944.

City Hall steps

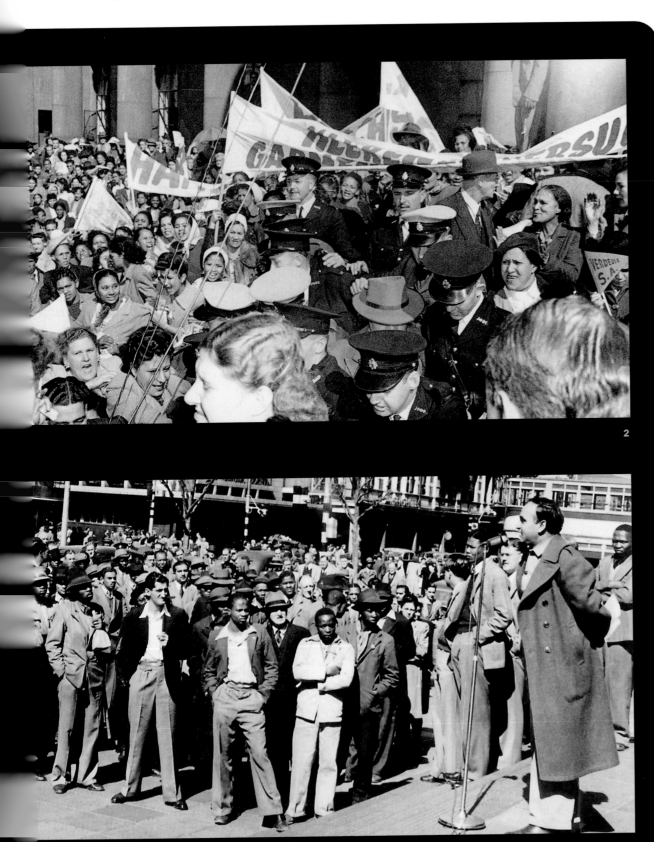

By the 1940s, the City Hall had become an established central venue for Sunday gatherings — open-air sermons, meetings to register protest or mobilise support for campaigns, political education rallies and recruitment drives arranged by the Communist Party. The well-organised protest campaigns he saw in the city, along with events like the Alexandra bus boycotts, influenced the political philosophy of Mandela and his colleagues in the Youth League. The culture of protest made a profound impression on Mandela's personal approach, and inspired him to provide legal assistance to grassroots organisations.

2
City Hall steps, 1953. Police try to disperse a garment workers' protest against the banning of their union's secretary, Solly Sachs. A few moments later, police batons rained down on their heads.

3
Dr Yusuf Dadoo, President of the Transvaal Indian Congress, addresses a meeting from the City Hall steps in 1946 or thereabouts, while a youthful Mandela looks on.

In the years to come, many memorable protests would be staged on the City Hall steps. In 1953, police batons would rain down on the heads of white and coloured women garment workers, protesting against the banning of Solly Sachs, Secretary-General of the Garment Workers' Union, under the Suppression of Communism Act. In 1956, 3 000 women would march here during the anti-pass campaign. In 1959, 10 000 people would gather to protest the banning of ANC President Albert Luthuli and Secretary Oliver Tambo; and in 1962 a march against the 180-day detention clause would draw twice that number. There would be countless other smaller

but no less vocal gatherings. Thereafter, as the opposition movements were crushed, the streets of Johannesburg would fall silent. Only in the late seventies, with the revival of the labour movement, would the city's public precincts be reclaimed as a forum of expression, resounding with the chanting of demands, the rhythmic stamping of feet, and songs of resistance.

In later years, the City Hall became a focal point for white activists. The women of the Black Sash, for instance, often assembled here. This women's organisation was formed in 1955 by a courageous band of middle-class women, to protest against the National Party's abuse of the constitution in its efforts to remove Coloureds from the voters' roll.

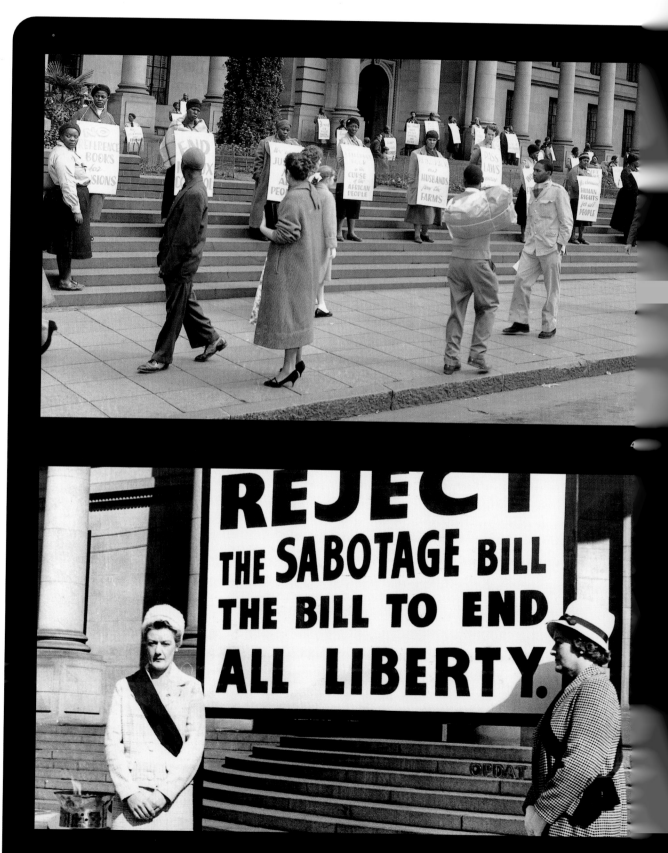

4

A City Hall demonstration against the pass laws in the mid-fifties

5

Black Sash demonstrators at the City Hall, May 1961. The demonstration was in support of Mandela's call for a National Convention of all races to draw up a new constitution for South Africa. It would take thirty years, and a long and bitter struggle, before such a convention was realised in the 'negotiated revolution' (see Site 63).

The Supreme Court

SITE **18**

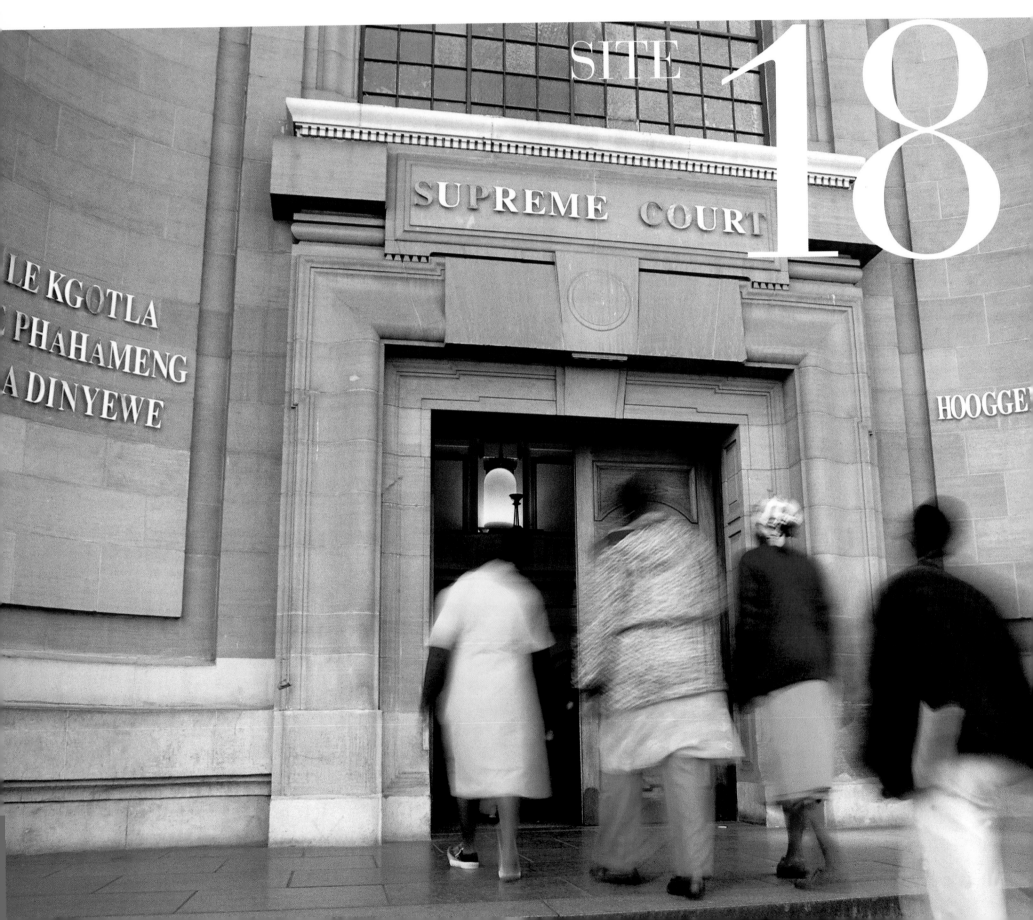

Claiming legal space

The Supreme Court in downtown Johannesburg is the centrepiece of the proposed High Court Precinct bounded by Von Brandis, Pritchard and Jeppe Streets. The plan is to establish a pedestrian area linking the Court to the Innes, Schreiner and Colman Chambers, as well as the Jeppe Street Post Office, a national monument. The area will be distinctively paved and greened, and banners and plaques will identify it as a site of significance in our legal history.

 In the past, few black men and women walked freely through the front portals of the Supreme Court. Most entered, handcuffed and accused, through a side door, delivered by a 'kwela kwela' police van. The Supreme Court, like the lower courts, administered a racially oppressive legal system. As both an attorney and an accused, Mandela became familiar with the High Court from both sides of the dock.

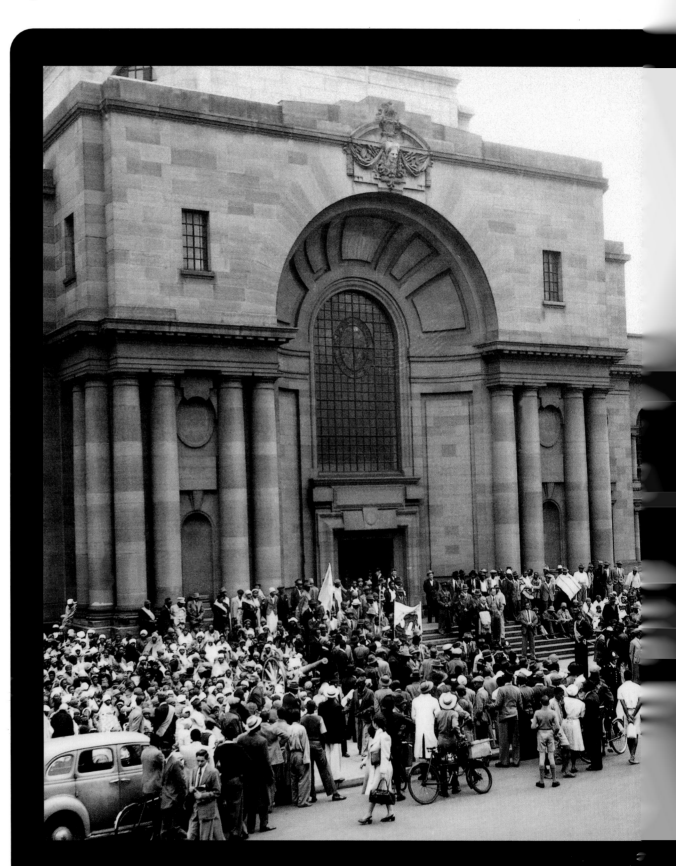

1

Protest march to the Supreme Court, 1945. Squatters were protesting against the removal of their shacks and demanding services from the city council.

The Supreme Court

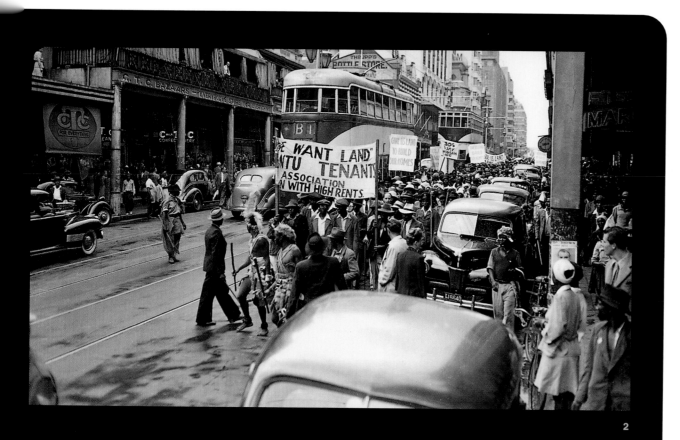

Since 1995, South Africa's advanced constitution has provided strong backing for a host of progressive laws to protect the rights of all its citizens. The composition of the bench and the judiciary is diverse in race and gender.

2

Tenants' associations march to the Supreme Court in 1945, calling attention to the shortage of housing for black people. An even bigger street march occurred during the Alexandra bus boycotts in 1943.

3

Some of the accused in the Defiance Campaign outside the Supreme Court, 1953. From left to right: Yusuf Cachalia, Walter Sisulu, J.B. Marks, David Bopape, Dr J.S. Moroka, James Phillips, unknown, Dr Yusuf Dadoo, Maulvi Cachalia, unknown. Mandela was also an accused in this trial.

The situation could hardly have been more different in the past. For black people, the law provided extremely tenuous protection. Throughout the colonial and apartheid eras, white male magistrates and judges blatantly espoused the perspectives of the white minority. Proceedings were conducted in English or Afrikaans. Black interpreters were themselves intimidated during hearings. Few black accused were acquitted. Apart from the criminal legislation which tended to strike at the poor and displaced, there were countless rules and regulations, like curfews and restrictions on buying liquor, which applied to blacks only. Black people were confined to ghettoes, and prevented by the pass laws from moving and working freely. Black workers were not allowed to join recognised trade unions. These and many other oppressive laws skewed the legal system and made a mockery of justice. Under apartheid South Africa became a police state. It is no

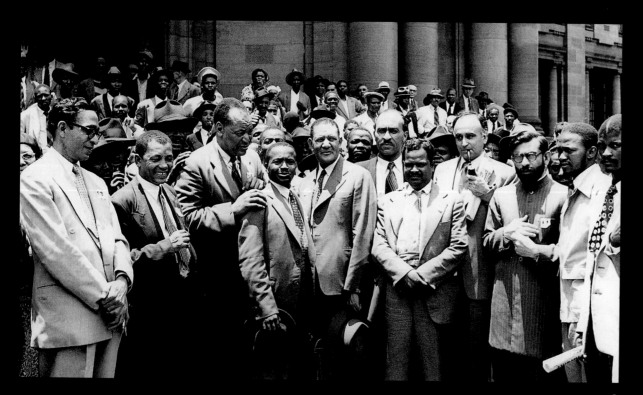

wonder that the courts were described as 'factories for making criminals'.[6]

At the same time, the law courts were also a 'site of struggle', and memorable victories there contributed to the eventual fall of apartheid. Even in the most repressive times, ordinary people boldly took over public space to make their grievances known to the general public, staging marches and demonstrations. Just as protests were often held at the City Hall, the symbolic centre of civic life, so marches often made their way to the Supreme Court, the centre of legal authority. James Mpanza's Sofasonke movement was particularly visible and adept at this strategy, shrewdly employing top lawyers — and accepting the assistance of law student Mandela — to claim the rule of law for the homeless.

Johannesburg's population explosion in the 1940s resulted in a desperate shortage of housing. The general policy of the municipality at the time was that blacks were in the city primarily 'to serve the white man's needs' and so they did little to alleviate the crisis. Homeless people were left with no option but to occupy vacant land. In the 1950s, the Supreme Court became even more familiar to political activists, when it was the venue for the trials following the Defiance Campaign. The whole point of that campaign, like those led by Mpanza, was to refuse to obey 'unjust laws'. In the ultimatum which the organisers of the campaign sent to the Prime Minister, they specifically stated that they were not opposing a race or national group, but the 'unjust laws which keep in perpetual subjection and misery vast sections of the population'.

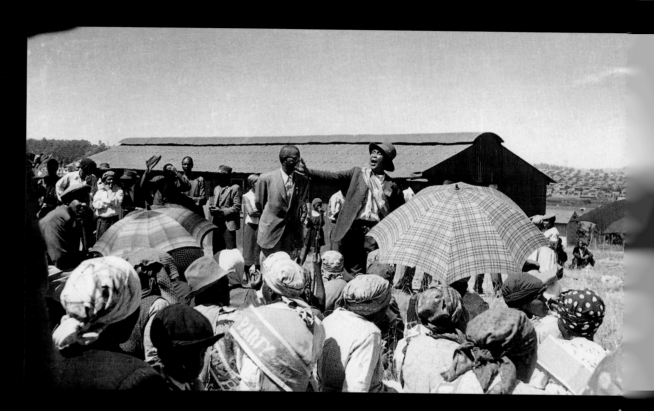

A meeting at James Mpanza's informal settlement. Mpanza (in the hat) was popularly regarded as a champion of the homeless, and particularly skilled at manipulating the legal system.

The leader of the Sofasonke Movement ('We shall die together'), Mpanza was a bold, imaginative, talented and ambitious ex-convict turned religious leader. Mpanza's people had 'invaded' the municipal land adjoining Orlando. His ingenious plan was to generate publicity which would embarrass the municipality and force them to house the black workers and their families who serviced the city. The Youth Leaguers discovered that Mpanza had fallen out with the Communist Party in Orlando, and tried to give Mpanza's movement as much support as they could. Mandela, in particular, assisted by proposing a resolution at a Sofasonke meeting (seconded by Walter Sisulu) that Orlando residents evict their tenants as a strategy to 'invade' the adjacent vacant land. Mandela also gave Mpanza legal advice. Ultimately, after many protests and campaigns, Sofasonke managed to secure a recognised site, including services, from the municipality.

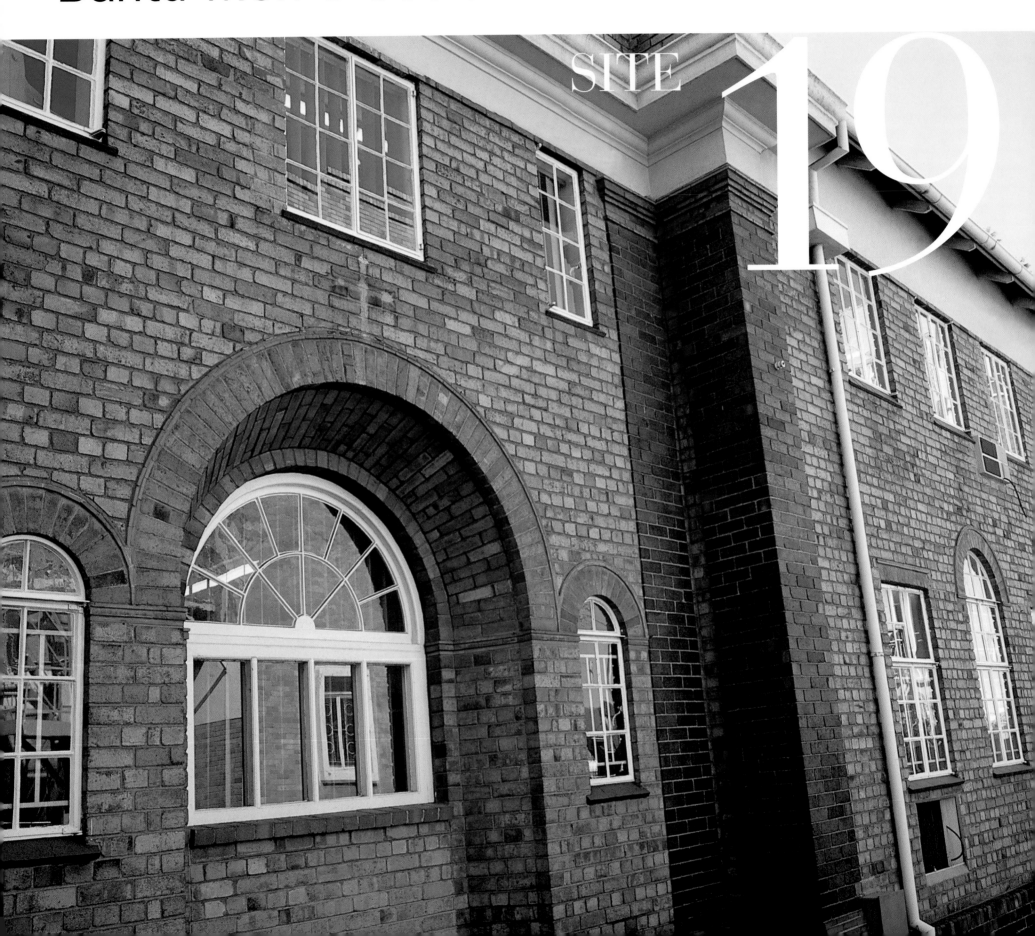

Bantu Men's Social Centre

The founding of the ANC Youth League

For decades, the segregation policies of successive white governments saw to it that the Bantu Men's Social Centre was the only downtown facility for black people. In time, the B.M.S.C. developed into a lively and stimulating place, providing a library, facilities for indoor games and the performing arts, and a tennis court. Lectures, debates, meetings, cultural events such as plays and concerts, as well as dances and weddings were regularly held there. Walter Sisulu, whose own wedding reception was held at the B.M.S.C., recalls that Mandela participated actively in the debates organised there. The Centre was a place where ideas were shared and developed. Sadly, as black people were forcibly removed from the city, its purpose as a community centre fell away. Today the building is part of the Johannesburg Traffic Department.

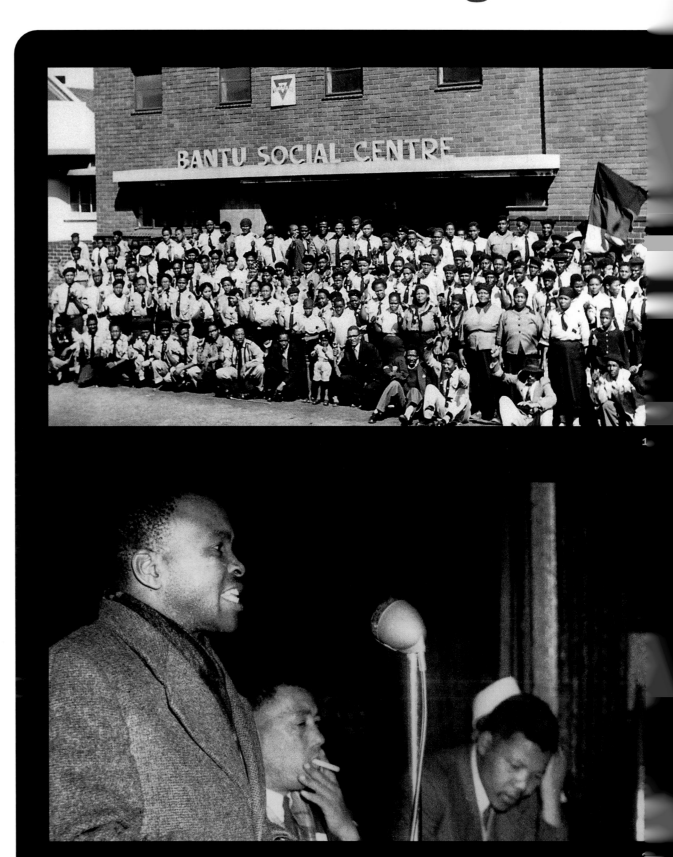

1
The Bantu Men's Social Centre, 1947
2
A meeting of the ANC Youth League: school teacher David Bopape, Walter Sisulu, Nelson Mandela

Bantu Men's Social Centre

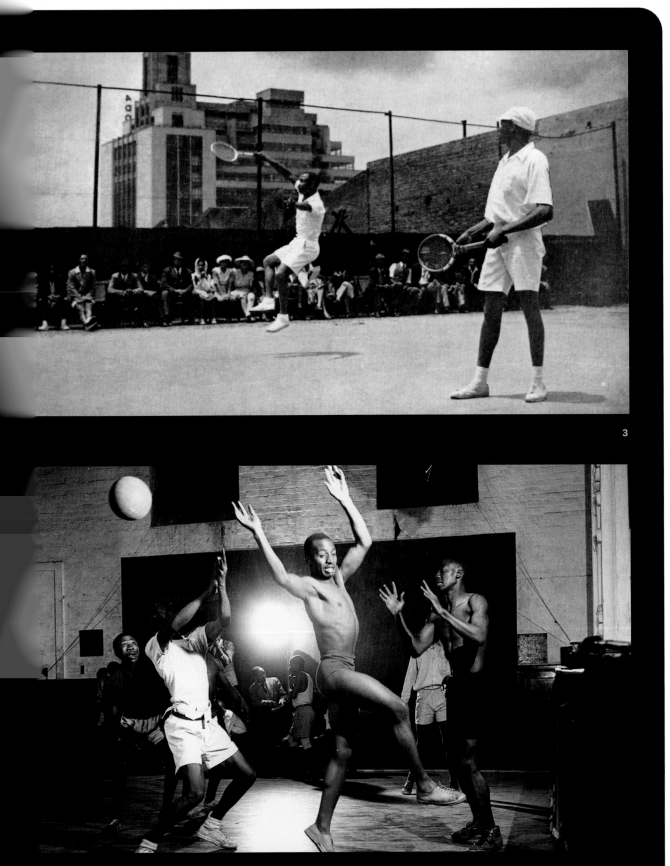

The gathering included teachers such as Oliver Tambo, A.P. Mda, David Bopape and Congress Mbata; lawyer Anton Lembede; journalist Jordan Ngubane; students such as William Nkomo and Nelson Mandela; and mentor Walter Sisulu. This young elite, all regular visitors to the B.M.S.C., had quickly formed a network of individuals determined to use their education and abilities to bring about social change for black people. The members of the Youth League were impatient with the moderate, cap-in-hand approach of their well-spoken predecessors in the ANC. They called for a more militant, mass-based programme. Nevertheless, they agreed that the ANC was the only organisation with the stature and tradition to unite and lead

3
A tennis match at the B.M.S.C.
in the early forties
4
Basketball at the B.M.S.C., 1950s

the African people. The vision of the Youth League was Africanist: attempts by both Ruth First of the Young Communist League and Isaac B. Tabata of the Unity Movement to recruit the Youth League as political allies in their Marxist projects were firmly rebuffed. Rejecting the 'foreign ideologies' of these movements, as well as 'tribalism' — 'the mortal foe of African nationalism' — the Youth League's aim, expressed in their policy document, was to build 'a strong and self-confident nation'. 'We are not against the Europeans as such,' they declared, 'but we are totally and irrevocably opposed to white domination and oppression.' Members of the Youth League became involved in community campaigns and supported workers' struggles, seeking to emphasise racial oppression rather than class struggle.

'We in the Youth League had seen the failure of legal and constitutional means to strike at racial oppression; now the entire organisation was set to enter a more activist stage.'

Before the advent of the Youth League, the ethos of the ANC was moderate and law-abiding. The organisation had a tradition of sending petitions and delegations to successive governments. The historic photograph, shown on page 127, of the 1913 delegation to England, taken prior to their departure, includes Sol Plaatje, a pioneering intellectual and South Africa's first black novelist. The delegates were hoping to persuade the British government to oppose the Union of South Africa's racially discriminatory constitution of 1910, and to stop the Land Act of 1913, which effectively reserved 90 per cent of the country's territory for whites. Plaatje campaigned in Britain against the oppressive conditions in his country. During this time he wrote his famous book, *Native Life in South Africa*.

Anton Lembede

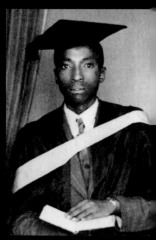

A.P. Mda

Attendance sheet for the Youth League meeting of 24 February 1944. The names from top to bottom are: Walter Sisulu, W.S. Maganda, L. Majombozi, Big Masekela, Oliver Tambo, Nelson Mandela, W.Z. Conco, Anton Lembede, A.P. Mda, Jordan Ngubane, W.F. Nkomo, Congress Mbata.

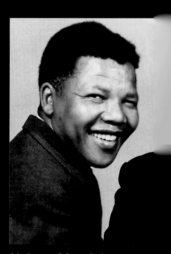

Nelson Mandela

The text of a Youth League leaflet in support of the 1946 mineworkers' strike
'The stings of Colour Bar and race discrimination are felt by Africans in all spheres of life — as mine workers, as municipal workers, as railway workers, as domestic servants, as industrial and commercial workers, as farm workers, as teachers, as business men and Africans ... The African National Congress Youth League calls upon all Africans — in all spheres of life and occupation — and employment — to lend active support to the mine workers' struggle. They are fighting the political colour bar and economic discrimination against Africans. Then, Brethren, on to the struggle! Although we are physically unarmed yet we are spiritually fortified. We are struggling for a just cause, the very fundamental conditions of human existence.'

Walter Sisulu

Dan Tloome

The Planet Hotel

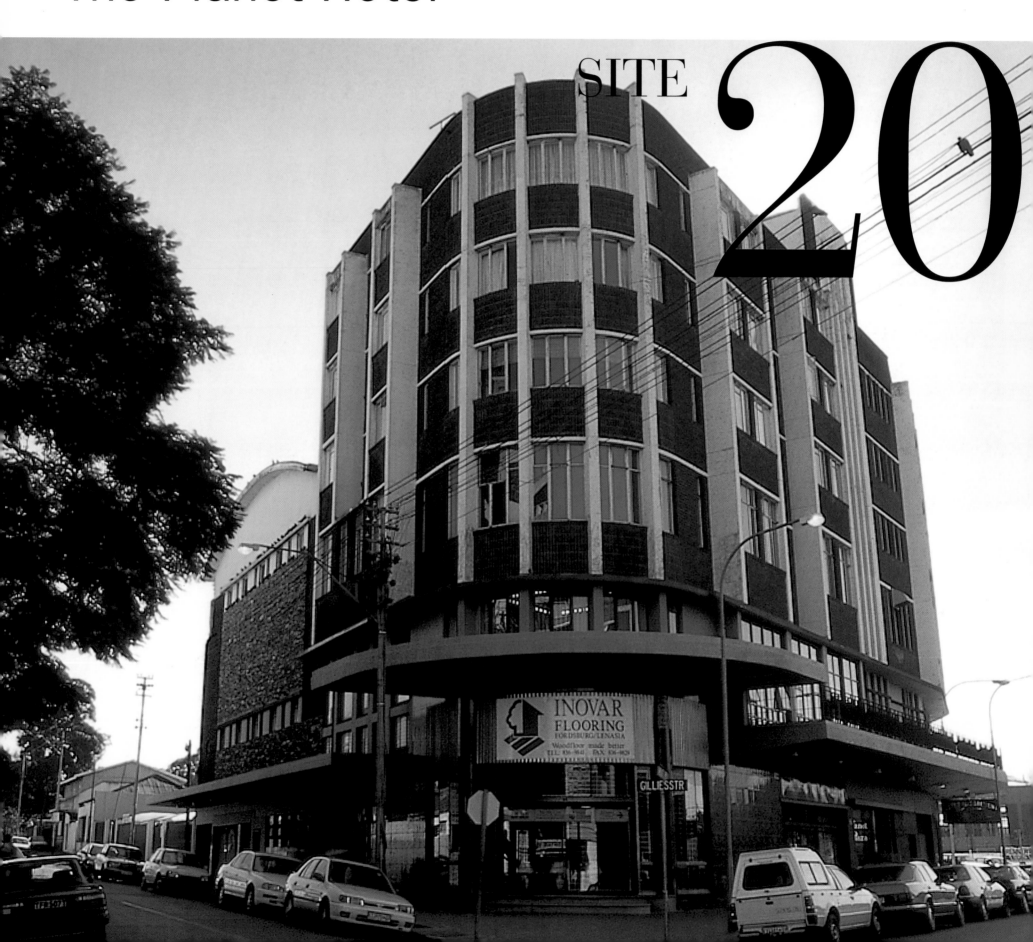

SITE 20

Dancing the night away

The basement of the Planet Hotel was a venue for swish dances and special dinners for black patrons. On a few occasions, Mandela, who was always well groomed and something of a ladies' man, made an appearance at the Planet. But, as Oliver Tambo remarked almost wistfully in an interview with Tom Karis years later: 'We were never really young. There were no dances, hardly a cinema, but meetings, discussions, every night, every weekend.'

The Planet was on the border between the old multiracial suburbs of Fordsburg and Pageview. Under apartheid, the Indian residents of Fordsburg were relocated to the township of Lenasia (see Site 31), while Pageview (popularly known as Fietas) was demolished and rebuilt for white working-class families. Today Fordsburg is largely a light industrial area, while Fietas has again become a multiracial neighbourhood. The Planet itself has been refurbished as a stylish office complex.

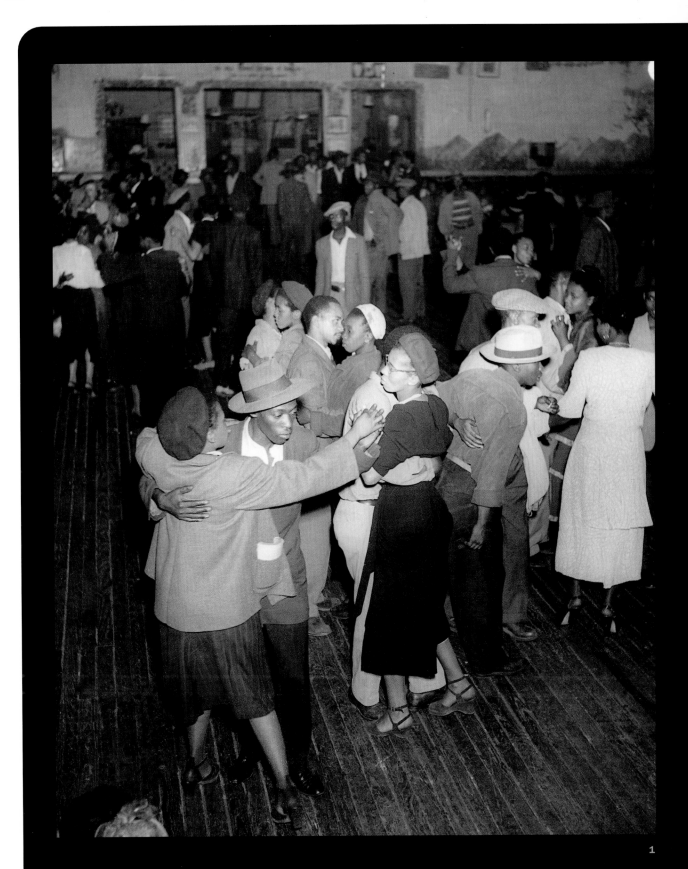

1

Langarm dancing at the Ritz

The Planet Hotel

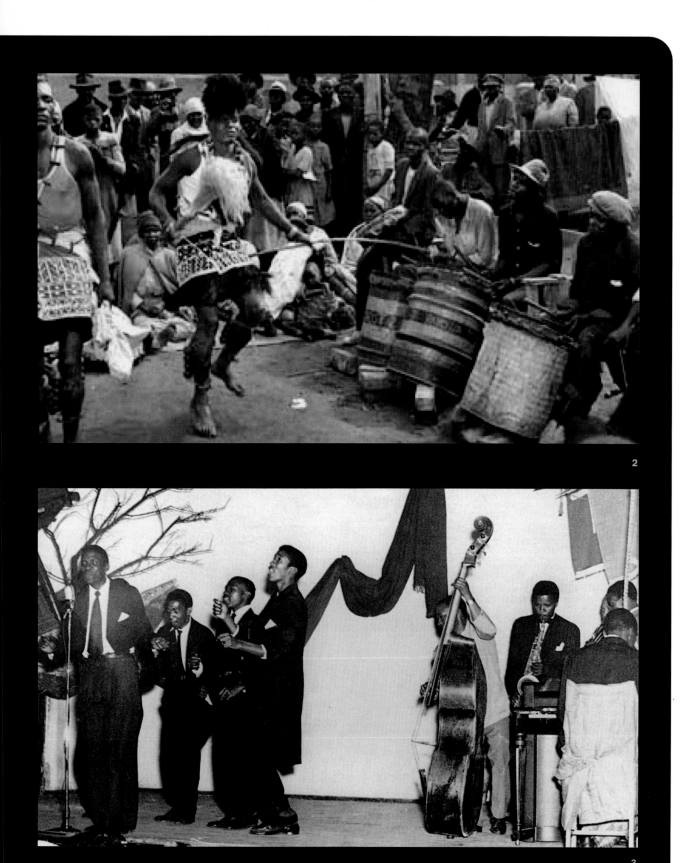

2

3

The entrance to the Planet Hotel was also the foyer of a cinema — or 'bioscope', as South Africans said in those days. There were several black cinemas in the same area. The Majestic, the Lyric, the Avalon and the Planet 'bios' were all within a few blocks of one another. The Good Hope was in Lovers Walk — now the southern entrance to the Oriental Plaza. Fietas boasted the Star and the Taj. Nearby Sophiatown also had a cinema, the Odin, which was used regularly as a community centre. In the apartheid era all these facilities were demolished.

2
Traditional music and dance

Racial discrimination in entertainment did not just involve the venues, it even extended to film censorship regulations: no films that were deemed unsuitable for children under the age of twelve could be shown to black adults either! Despite these restrictions and the desperate poverty of most urban blacks, films were well attended, especially by young people. The 'bios' doubled as social centres, places where you could socialise, find romance, or even pick a fight. Most of all, they offered imaginative escape — 'a world of foreign places and larger than life characters'.[7] Most popular were the matinée serials — Captain Marvel, Zorro, The Drums of Fu Manchu — educational documentaries on scientists like Marie Curie, Louis Pasteur and Albert Einstein, romantic dramas like *Gone with the Wind* and *Rebecca*, cowboy films and biblical sagas. But best of all were the gangster movies — especially if Humphrey Bogart was in them — and the B-grade horror movies blacks were permitted to see, such as *The Walking Dead*. The 'baddies' in particular became role models for aspiring anti-heroes.

3
The Boston Brothers

Most of the townships had groups of young men organised into gangs — the Spoilers, the Americans, Skiet Mekaar ('Shoot Each Other'). The more successful gangs offered a stylish lifestyle acquired with the spoils from pickpocketing, shoplifting, the theft of railway and factory goods, and even burglary in the white suburbs. Members of the Youth League, including Mandela, often targeted their recruiting drives at the township gangs, especially during the mass campaigns of the 1950s, with some success.

The Planet and the Ritz were the two most popular venues for ballroom dancing. The young black elite especially loved to show off their *langarm* ('long-arm') dancing. The international craze for ballroom was picked up in the secondary schools and colleges, and at Fort Hare. The most popular dances were the tango and the waltz, gyrated at a dizzy pace. In the late 1940s, American jazz and jiving reached the smart set of black Johannesburg. But among ordinary people, dozens of innovative popular rhythms and dance steps were evolving. Township musicians and singers drew freely from a range of influences — traditional rural dance, urban jazz and pop, and the marabi music created in the shebeens — to produce new musical forms.

4

The original caption to this picture in *Drum* magazine read: 'BALLROOM ATHLETICS. Johannesburg, November 1955. Ballroom dancing is coming into its own again. A short while ago you felt abashed when you answered "Sorry, I can't do it", to a request for a jive round. But now one is eager to say: "No thank you, I only do ballroom dancing." And snobbery goes into those words. But it's well advised to keep your hot-rhythm sense alive, for when the cycle comes round again, whether it's Mambo, or Jumbo, or creep or sweep, the new thing when it does come will be just as wild as Jive was, and Jitterbug before it.'

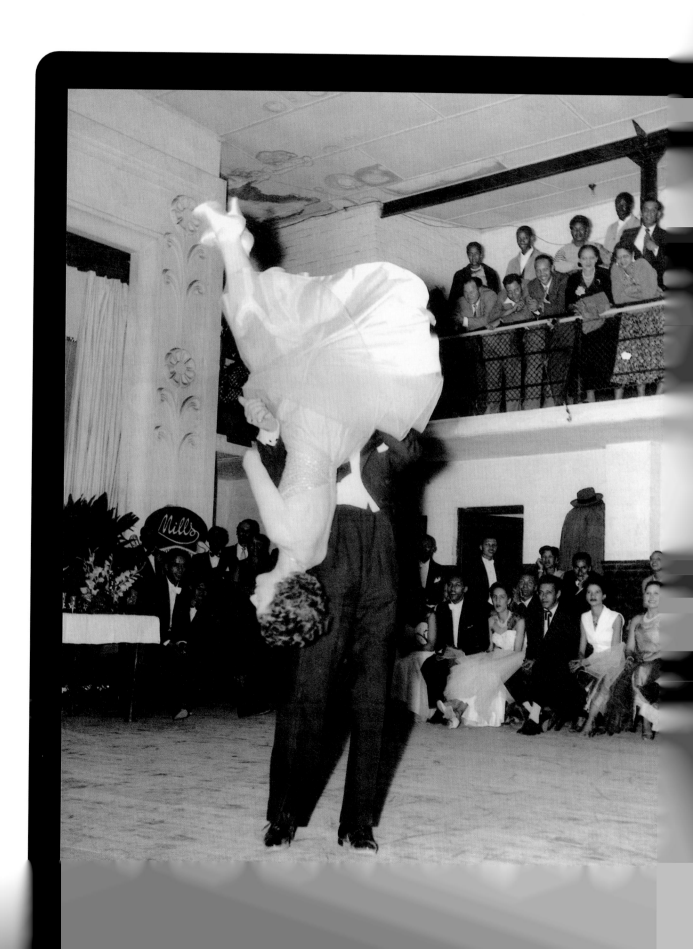

The Donaldson Orlando Community Centre

SITE 21

A sporting chance

The Donaldson Orlando Community Centre (the D.O.C.C.) was named after benefactor James Donaldson of the Bantu Welfare Society. It was built in 1949 next to the YMCA in Orlando. In Mandela's time it was sadly under-equipped, and even today continues to struggle for adequate resources. Nevertheless it remains a vital centre for social, cultural and sporting events. It was at the D.O.C.C. that Mandela found time to enjoy amateur boxing and share the appeal of the ring with his son Thembekile.

The townships had very few amenities, and most sports were street activities. Stick-fighting continued to be popular with young migrant workers seeking to assert their manhood in an oppressive environment. But soccer, imported from Natal in the 1890s, rapidly became established as the 'people's game'.

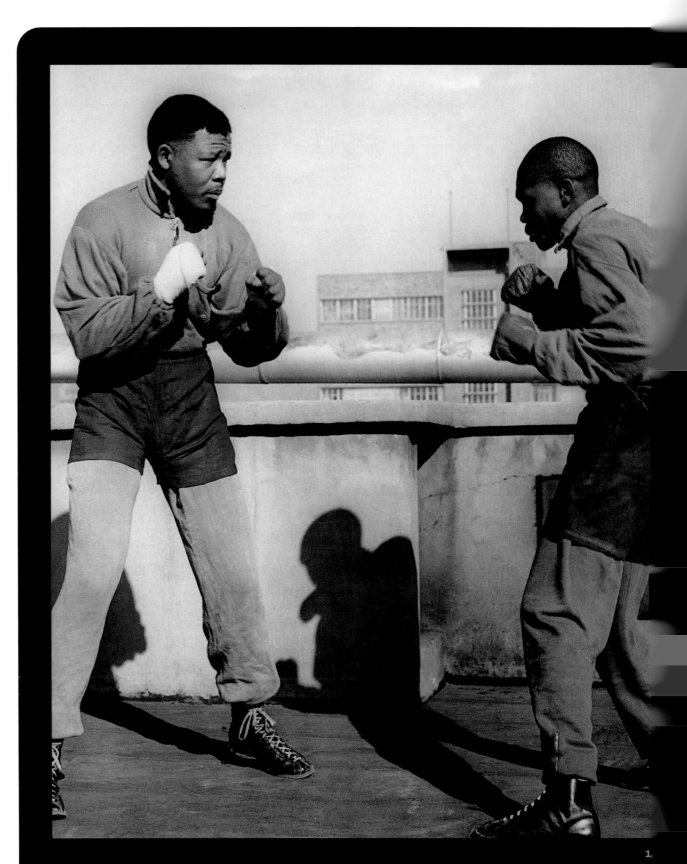

1

Boxing with champion Jerry Moloi, the star boxer of the D.O.C.C. club. This shot by young *Drum* photographer Bob Gosani was taken, not at the D.O.C.C., but on the rooftop of the South African Associated Newspapers office.

The D.O.C.C.

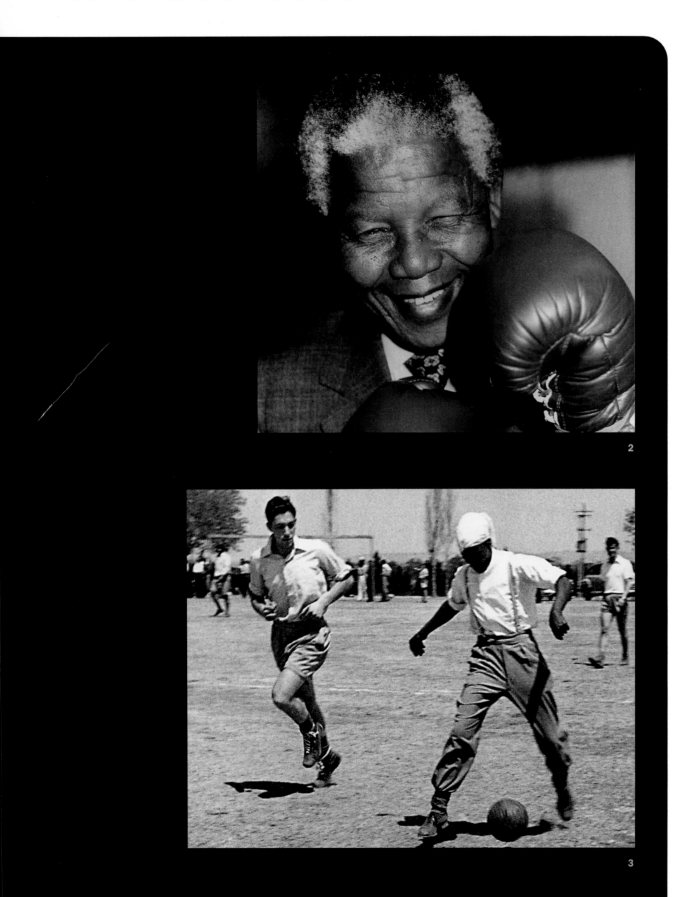

Of all the sports, boxing especially became a symbol for blacks of their ability to fight back. In the early fifties, Mandela joined the boxing club at the D.O.C.C. and trained there almost every evening, taking his son Thembekile along with him. For Mandela, always the politician, the pleasure of the activity lay not in the brute force but in the science of it. *'I did not enjoy the violence of boxing so much as the science of it. I was intrigued by how one moved one's body to protect oneself, how one used a strategy both to attack and retreat, how one paced oneself over a match. Boxing is egalitarian. In the ring, rank, age, colour and wealth are irrelevant. When you are circling your opponent, probing his strengths and weaknesses, you are not thinking about his colour or social status.'* No doubt the ideologues of apartheid were aware themselves of the levelling effect of sporting competition, for racial segregation was extended to sports, and especially contact sports.

2

President Mandela squares up to the camera. 'I never did any real fighting after I entered politics.'

3

An old *Drum* photograph of Oliver Tambo (ANC) and Maulvi Cachalia (SA Indian Congress) playing soccer during a picnic at Mia's farm near Johannesburg.

Early in his life, Mandela had discovered the uplifting effect of physical exercise. *'I have always believed that exercise is a key not only to physical health but to peace of mind. Many times in the old days I unleashed my anger and frustration on a punch-bag rather than taking it out on a comrade or even a policeman. Exercise dissipates tension, and tension is the enemy of serenity. I found that I worked better and thought more clearly when I was in good*

physical condition, and so training became one of the inflexible disciplines of my life.' He had enjoyed running since his days at Healdtown, and he carried on with it in Johannesburg. Years later he recalled the route he would follow from Soweto, past Baragwanath Hospital and the garage at Uncle Charlie's, as far as Langlaagte, where he would turn back.

4

By the 1940s, there were numerous black soccer 'unions' in Johannesburg. The first club, Orlando Pirates, was started around 1938. Prominent ANC sportsmen Dr J. Moroka and R.G. Baloyi donated a large trophy to develop the game. Soccer brought together many diverse people, and helped to form a new culture of the city.

The place of sport in Mandela's own life helped him to grasp its importance as a profound commonality in South African culture, cutting across racial and political divides, and he has used the sporting arena often to promote reconciliation. In 1995, after the lifting of the international sports boycott, South Africa hosted the Rugby World Cup. Through his own support for a team long associated with white exclusivity, support which included the powerfully visible gesture of donning a Springbok rugby jersey, Mandela played a large part in uniting South Africans of all colours behind the team. After their victory in the final, a jubilant captain François Pienaar declared: 'We had the support of forty million South Africans.'

5

Springbok rugby captain François Pienaar accepts the trophy after victory in the World Cup, 1995.

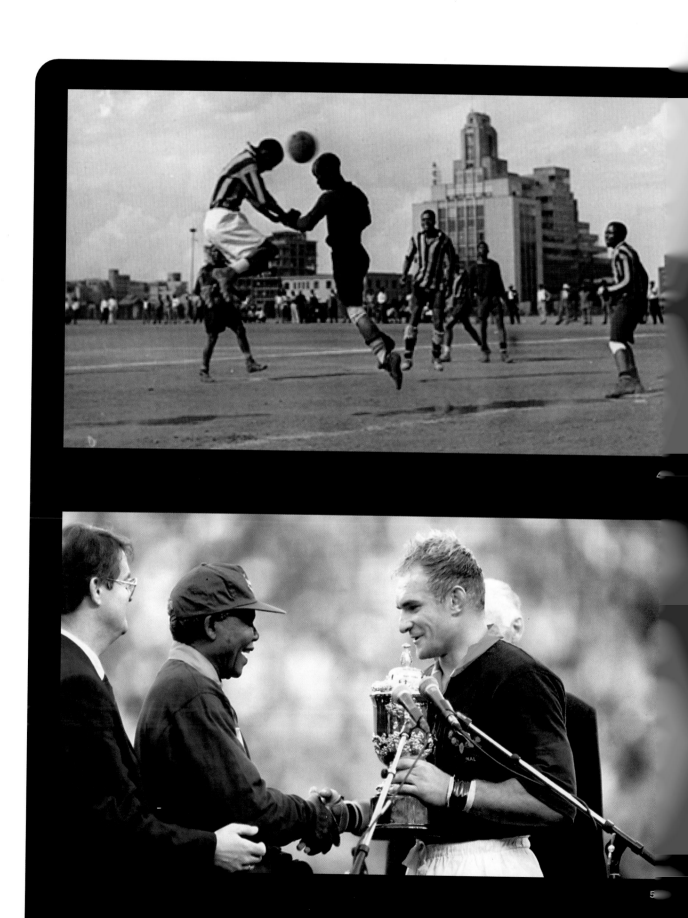

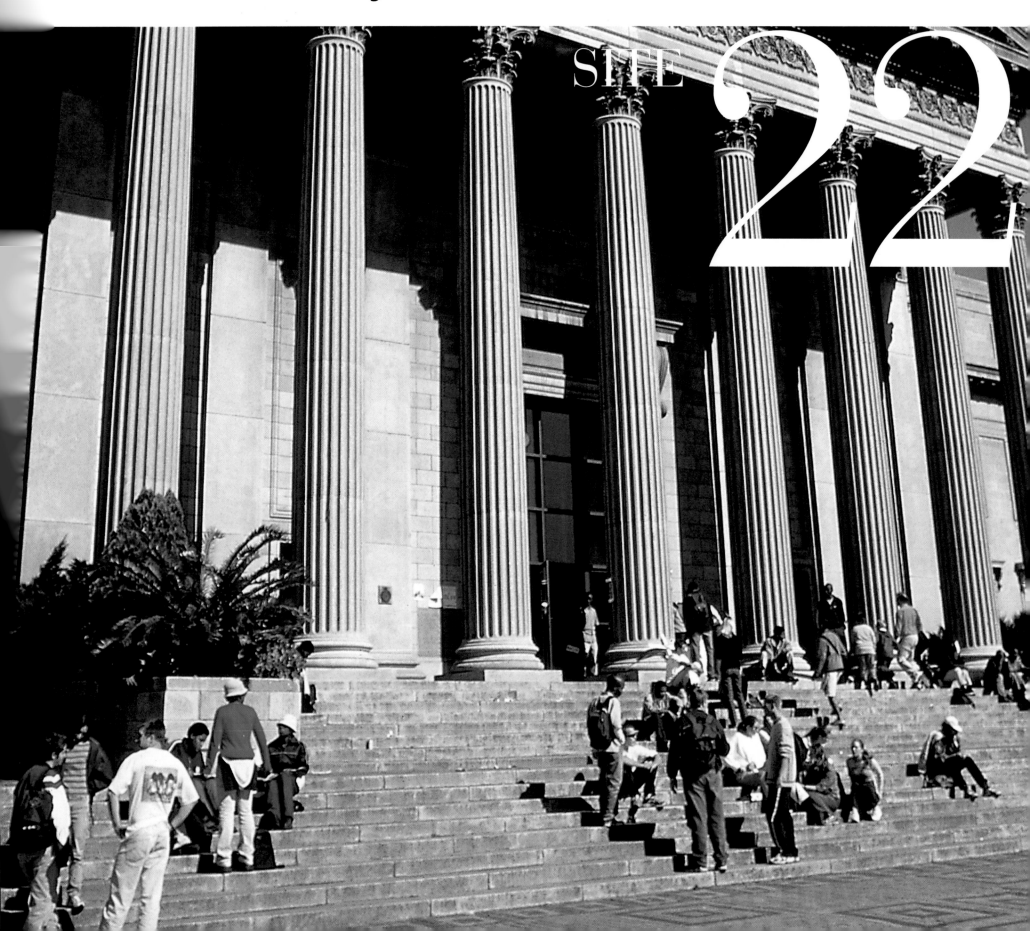

Wits University

SITE 22

A world of ideas

The University of the Witwatersrand (popularly known as Wits) grew out of the South African School of Mines established in 1896, the year in which the industry initiated the sophisticated technology of deep-level gold mining. In 1922 the institution achieved university status, and in the following year moved to its present site in Milner Park. Although in principle Wits was an 'open university' from the beginning, it never practised social integration, and some faculties equivocated on full academic integration. Nevertheless, the university provided space for a non-racial and radical tradition, which had its roots in the 1940s and continues to this day. The institution remains controversial, dismissed by some as a white-dominated beneficiary of apartheid, lauded by others as a pioneer and pace-setter in non-racial tertiary education. The university is widely respected for the standards of its scholarship, and many of its staff are international leaders in their fields.

Wits University campus, 1942

1

2

Witwatersrand University in the 1940s, showing, right background, the power-station cooling towers in Newtown, and the mine dumps beyond. Much of this horizon has disappeared. To the left is the nascent high-rise business district.

Wits University

3

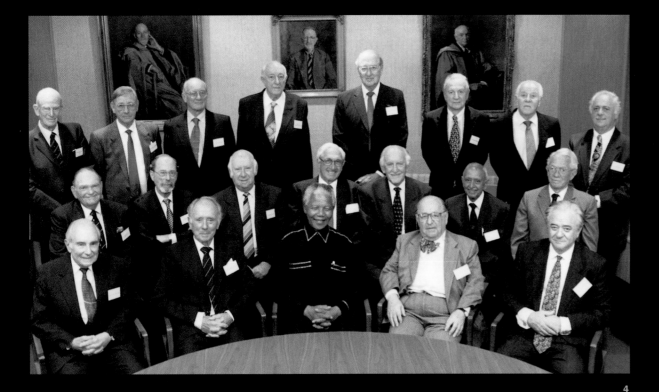

4

The University of the Witwatersrand was founded in 1922, primarily to train engineers for the Transvaal's gold-mining industry. At the time, highly skilled trades and professions were reserved for whites. When Mandela enrolled for a law degree, Wits included only a tiny fraction of black students.

'Despite the university's liberal values, I never felt entirely comfortable there. Always to be the only African, except for menial workers, to be regarded at best as a curiosity and at worst as an interloper, is not a congenial experience.'

3
Mandela and his law class, 1944

After he arrived in the city, Mandela grew increasingly sensitive to the plight of all black people. It became his mission to defend as many black men and women as possible against the barrage of discriminatory laws levelled at them. The problem was to find employment with a law firm, all of which were white in those days. Walter Sisulu was able to secure Mandela a job with Lazar Sidelsky, a sympathetic lawyer who was prepared to give him articles. He was then able to embark on a part-time law degree.

4
Mandela at his class reunion, 1996

Compared with other white universities, Wits University and the University of Cape Town were relatively liberal. But it was only in 1942 that the Wits Medical School admitted its first intake of black students: before then white opinion had been firmly opposed to the idea of blacks examining white patients or dissecting white corpses. By the late forties there were 71 African and 81 Indian students. It was a source of pride to the black community that, against great odds, more than two thirds of the black students in the Medical School graduated as doctors. No special courses were provided for black or second-

language students. In fact, in the Law School where Mandela studied, the professor went out of his way to advise blacks and women that their minds were unsuited to legal studies, and that they should seek alternative careers.

Broader social divisions and tensions were reflected in the student politics of the day. The Wits student organisation had battled to have Fort Hare students admitted as members of the National Union of South African Students (NUSAS), and as a consequence the Afrikaans-speaking universities had withdrawn from the national body. Yet socially, black and white students did not mix at Wits. They had separate and unequally equipped residences, and black students did not participate in student sports or dances.

5

George Bizos with his fiancée, Arethe Daflos. Mandela remembered his fellow student and future colleague as 'a man who combined a sympathetic nature with an incisive mind'.

6

Ruth First — 'an outgoing personality and a gifted writer' ... 'a white girl who'd behave towards you in the same way, whether she meets you privately or in public, in the presence of other people ...'

At Wits, Mandela met a number of left-wing friends — I.C. Meer, George Bizos, Harold Wolpe, Joe Slovo and Ruth First. Although a few years were to pass before Mandela agreed to work with their political organisations, he enjoyed stimulating discussions with them, and they saw one another socially.

'Wits opened a new world to me, a world of ideas and political beliefs and debates, a world where people were passionate about politics ... prepared, despite their relative privilege, to sacrifice themselves for the cause of the oppressed.'

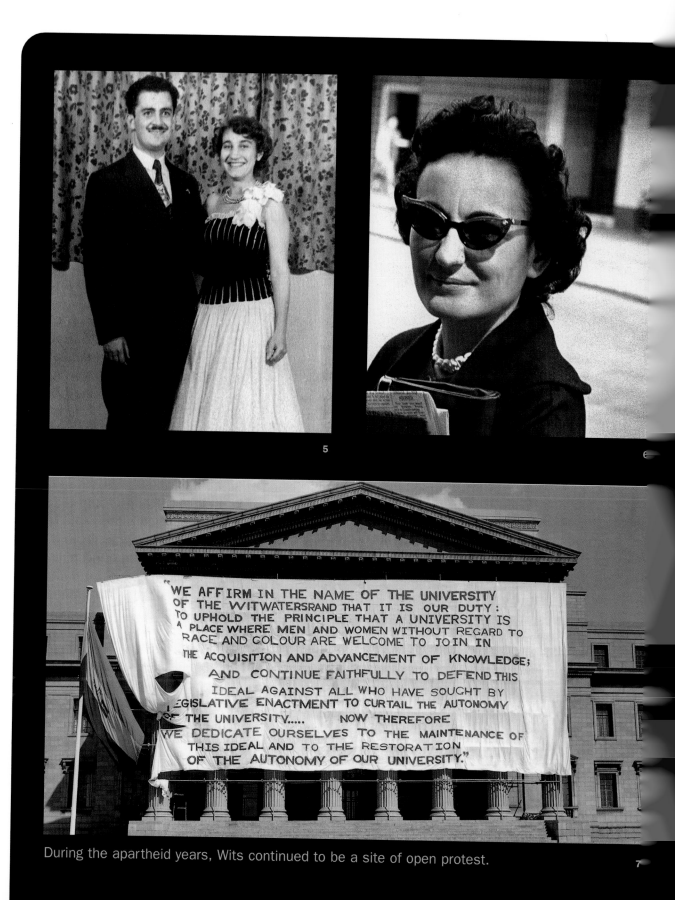

5

During the apartheid years, Wits continued to be a site of open protest.

7

Kapitan's

SITE 23

The politics of eating and drinking

For blacks in Johannesburg, even the daily task of eating and drinking outside one's home was an elaborate political manoeuvre. Kapitan's was virtually the only multiracial restaurant in downtown Johannesburg. It was a few minutes' walk from the ANC office in Diagonal Street, and Mandela was a regular patron, particularly when he was courting Winnie Madikizela. More than four decades later, Kapitan's is still serving some of the best curries in town.

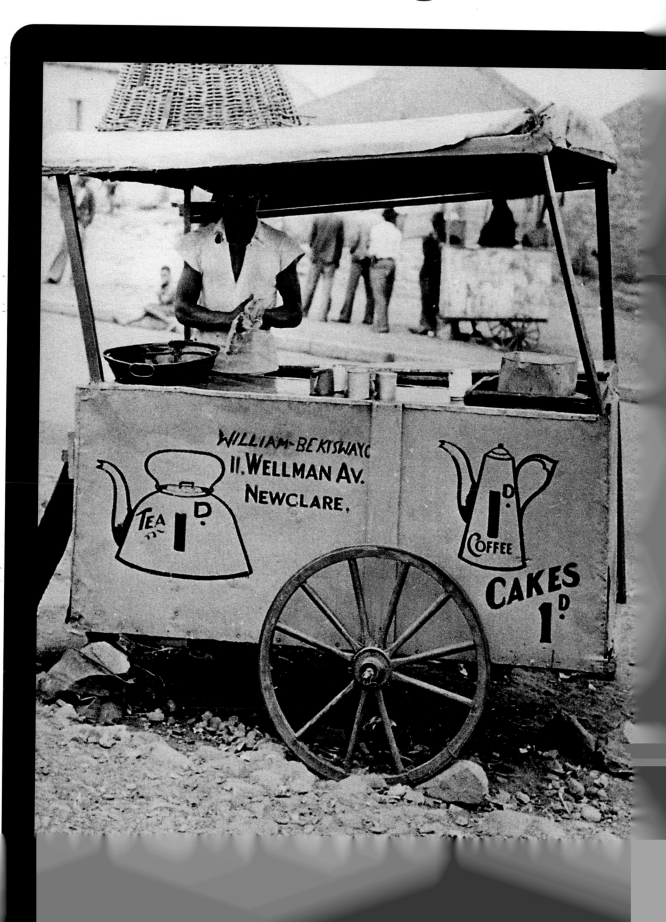

1

A coffee cart

Before he set up his own law practice with Oliver Tambo, Mandela could seldom afford to eat in Kapitan's. Like the vast majority of black workers, a hot snack or bun from a coffee cart in the street was a special treat.

'Past Kapitan's where Mandela and Tambo
Dine on hot curry while plotting a destiny'

— Chris van Wyk
'Face to Face' Taxi Project
July 2000

Kapitan's

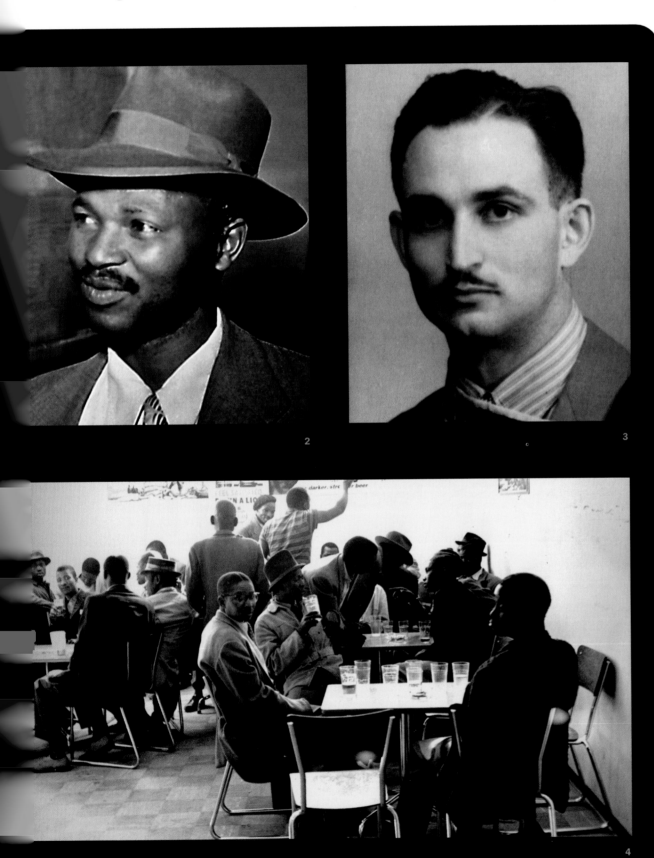

2

3

4

In 1941, Mandela started working for Witkin, Sidelsky and Eidelman, a large law firm near the magistrates' courts. It was one of the very few firms to offer employment to a black articled clerk. At first, Mandela was employed as an agent to bring in customers. Only later was he accepted for articles.

2
Gaur Radebe in 1941

3
Lazar Sidelsky in the late thirties

Gaur Radebe, who worked as a clerk in the same firm, was a member of both the ANC and the Communist Party. An activist, trade unionist, founder-member of the African Mine Workers' Union, Advisory Board member for Western Native Township and fiery speaker, Radebe also helped to initiate the bus boycotts in Alexandra in the 1940s — four in as many years — rallying people with the cry: 'Each one of you is a leader.' In 1959 he was to join the Pan Africanist Congress, which broke away from the ANC on the grounds that it was not militant enough.

4
A township shebeen, 1960s

Mandela was impressed with Radebe's confidence and foresight, and the artful aplomb with which he deflected the everyday slights and humiliations visited on all blacks in the city. On his first morning at work, Mandela was informed by the young white secretary that there was no colour bar in the firm, and that the two black employees would take tea with the secretaries in the morning. 'In honour of your arrival, we have purchased two new cups for you and Gaur,' she added. 'I will call you when the tea comes, and then you can take tea in the new cups.' Of course, Mandela realised that this was merely a ploy on the part of the white office staff to avoid having to use the same cups as the blacks. At teatime,

Gaur Radebe went straight to the tray of cups, carefully selected one of the old cups, ostentatiously poured his tea and drank it 'in a very self-satisfied way'. The young Mandela, though he was delighted with Radebe's nerve, did not have the courage to do the same. He hastily said that he was not thirsty. In future, he drank his tea alone in the little kitchen adjoining the office.

There were no canteens for black workers: most of them simply had their lunch sitting on the pavements. If they could afford it, they might buy something from a 'coffee cart'. Then, with the onset of apartheid, black street vendors were hounded out of the city. Formal eating facilities for blacks were extremely limited. Those with the means popped into the few restaurants like Retsie's for a traditional sit-down meal of pap en vleis — maize porridge, meat and gravy. Retsie's was in the city centre, near the station and bus terminus.

Of course, drinking a beer with your meal was out of the question, as blacks were prohibited from buying alcohol. Despite the risks of arrests and fines, working people continued to frequent shebeens, courting danger in order to enjoy the social pleasures of entertaining conversation, live marabi and jazz, and first-rate singers. The shebeens served up traditional and home-made beer — including some bizarre concoctions with a very strong 'kick' — as well as illicitly bought hard liquor.

Now that restrictions on alcohol are a thing of the past, some of the old shebeens have become conventional restaurants or taverns. Places like Wandie's in Soweto, where visitors can sample local cuisine and hospitality, now evoke the bygone era of the shebeen.

6

Retsie's 'eating house'. As the *New Age* placard demonstrates, politics was an intimate and inescapable part of everyday black life.

Racist signs were common in the city centre long before the apartheid era, which began when the National Party was voted into power by the white electorate in 1948. This insulting lift sign, exposed in the Indian newspaper *The Passive Resister*, dates from 1946. The message is full of thinly veiled code: 'hawkers' refers to Indians; while 'prams' and 'dogs' are shorthand for black domestic workers hired to care for white children and pets. Adult black men, even professionals like Mandela, were automatically relegated to the status of 'native boys', and most white people, including children, unthinkingly assumed the right to address black adults by their first names.

5

'I cannot pinpoint a moment when I became politicised ... I had no epiphany, no singular revelation, no moment of truth, but a steady accumulation of a thousand slights, a thousand indignities and a thousand unremembered moments produced in me an anger, a rebelliousness, a desire to fight the system that imprisoned my people.'

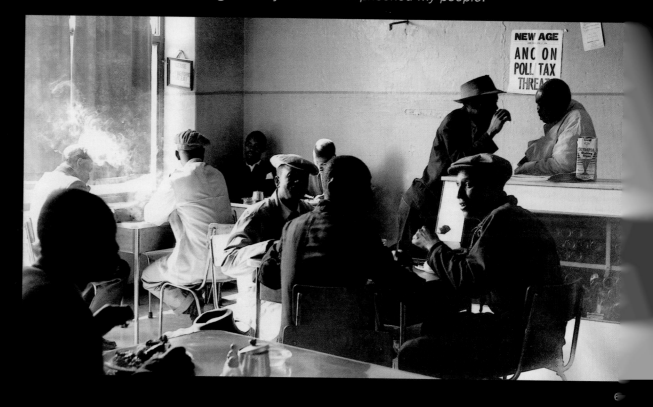

Kholvad House

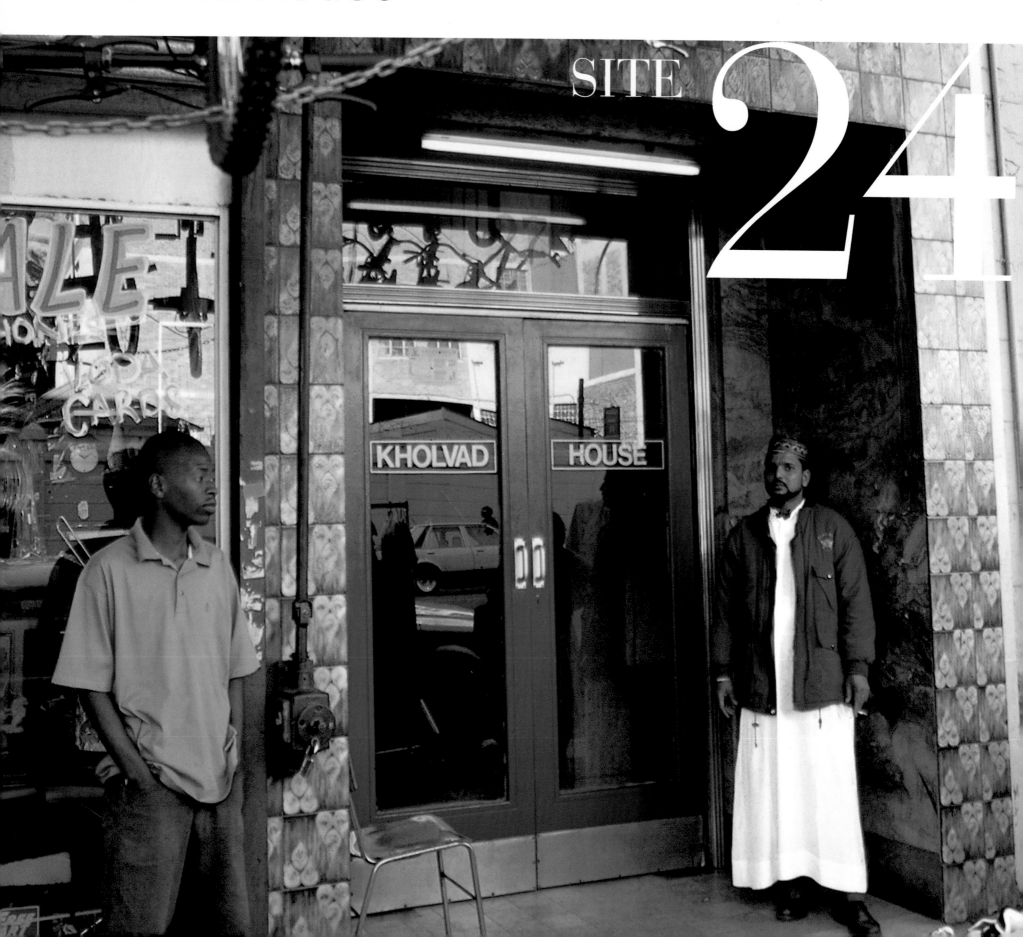

SITE 24

KHOLVAD HOUSE

A gathering place for friends

Kholvad House in Market Street, on the western edge of the central business district, is at the heart of a predominantly Indian area which goes back a hundred years. The West Street area is bordered roughly by Diagonal, Pritchard, Market and Becker Streets. It is a colourful mix of small trading stores selling African dress materials and clothes, Indian cloths and saris, school uniforms, fruit and vegetables, spices and sweetmeats, craft work and religious pictures. Herbalists selling traditional African medicines continue to attract migrant workers and others seeking age-old remedies for the stresses of city life.

Remarkably, the area is one of the few that managed to resist removals during the apartheid era. An Islamic primary school and a beautifully restored mosque nearby survive. Many of the residents of the neighbourhood today are descendants of Johannesburg's early pioneers.

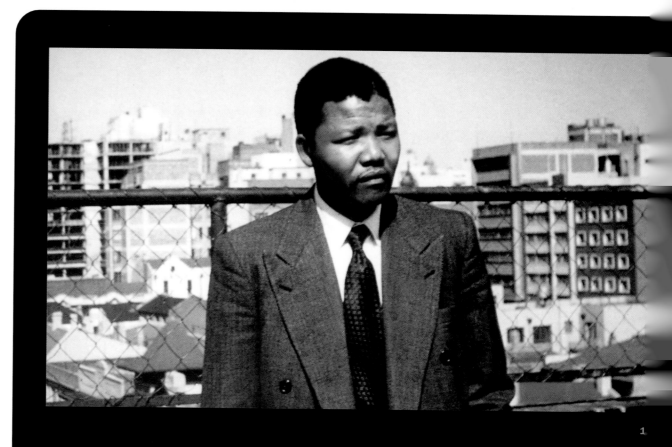

1

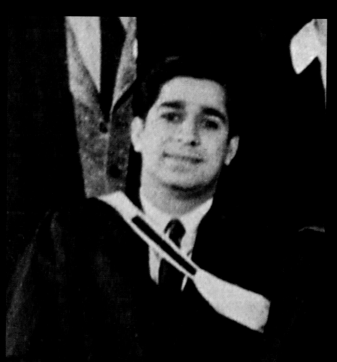

1
Mandela on the roof of Kholvad House in 1953. This rare photograph and the one overleaf were taken by a visiting American journalist. Mandela had to be photographed separately, because at the time he was banned from attending 'gatherings'. A 'gathering' was defined as two or more people

2
I.C. Meer, Mandela's colleague at Wits and a resident of Kholvad House, 1945

Kholvad House

Kholvad House was an apartment building in the multiracial part of Johannesburg's downtown area. It was not far from Chancellor House, where Mandela and Tambo had their legal offices, and was home to a succession of Mandela's Indian friends. I.C. Meer lived there during his student days, as well as Yusuf Dadoo and then Ahmed Kathrada. Mandela, Tambo, Sisulu and others often visited the building and held many clandestine meetings there in the years when they were banned. Looking back, Mandela reflected that it was here, at Kholvad House, that the first seeds of non-racialism were sown and a wider concept of the nation came into being.

3
Ahmed Kathrada with Maulvi Cachalia in the background on the Kholvad House rooftop

In 1960, the firm of Mandela and Tambo was forced to close down as a result of the State of Emergency. Mandela continued to do whatever legal work he could. 'Numerous colleagues readily made their offices, staff and phone facilities available to me, but most of the time I preferred to work from Ahmed Kathrada's flat, No. 13 Kholvad House. Although my practice had dissolved, my reputation as a lawyer was undimmed. Soon, the lounge of No. 13 and the passage outside were crammed with clients. Kathy would return home and discover that the only room in which he could be alone was his kitchen.'

4
A herbalist's shop selling traditional remedies or *muti* in the West Street area, 1940

Other prominent Indian activists were nurtured in the neighbourhood, including Yusuf Dadoo and the Cachalia family. The Pahad family lived in the Dadabhai building in Becker Street. They were keen supporters of the ANC. Mandela ate

many a satisfying meal at Mrs Pahad's table. She was jailed during the Indian Passive Resistance Campaign in 1946 (see Site 30). The calm and determined, non-violent resistance campaign of this vulnerable community deeply impressed Mandela and his Youth League colleagues, and was to influence ANC resistance strategies in the 1950s. Mandela recalled: 'I often visited the home of Amina Pahad for lunch, and then, suddenly, this charming woman put aside her apron and went to jail for her beliefs.' Two of the Pahad sons went into exile in the early 1960s, and returned decades later to become cabinet ministers in the first democratic government.

The entire area is redolent with Johannesburg's early history. Not far from Kholvad House, west of the Magistrates' Courts, is the old Chinatown. The Chinese Club, established ninety years ago, once stood here, and a sprinkling of Chinese restaurants and stores selling imported goods manage to survive. The present parking lot of the court was the site of the original 'Malay Camp'. The camp was demolished and its residents removed first to Pageview (see Site 20) and then to the townships, according to the racial categories established by the Population Registration Act of 1950.

5

A 1946 *Guardian* newspaper photo of Amina Pahad, who was jailed during the Passive Resistance Campaign. In the background, one of her sons, Essop Pahad.

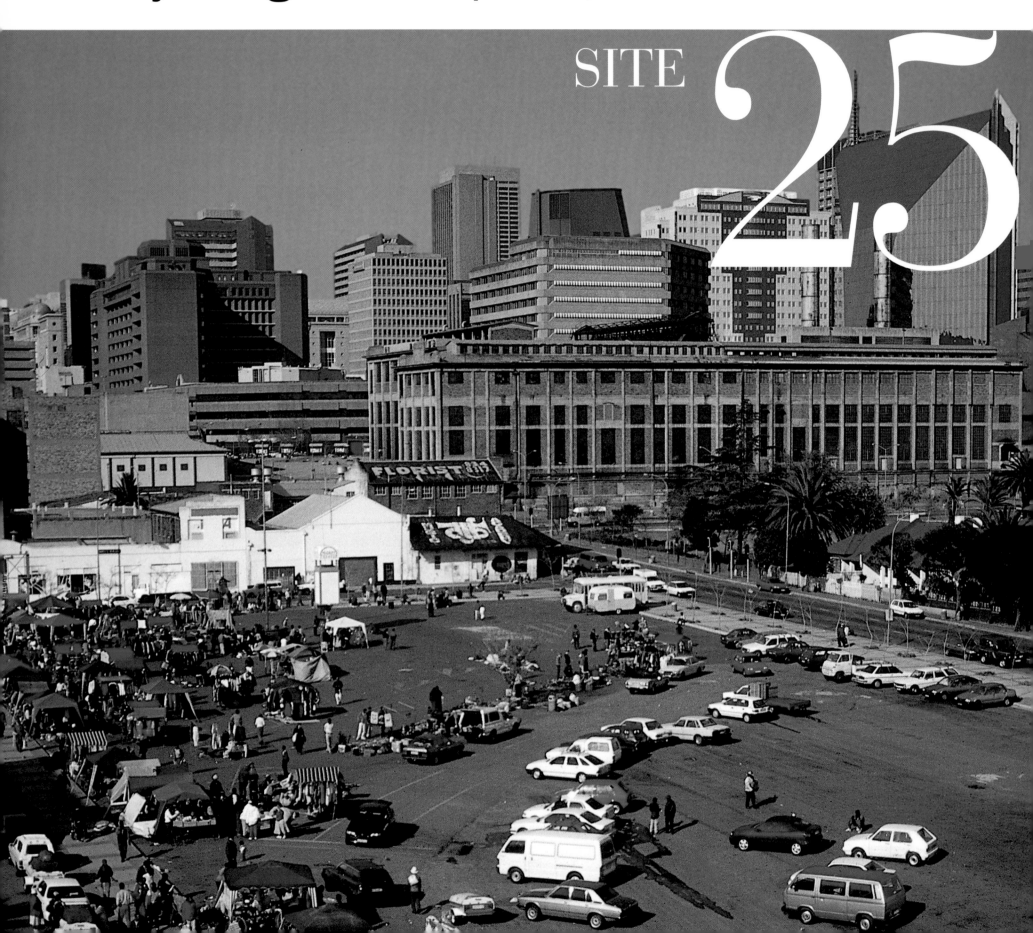

Mary Fitzgerald Square, Newtown

SITE 25

A legacy in the culture of resistance

In 1976, a group of dedicated performers transformed the old produce market in Newtown into the Market Theatre. This complex became renowned for 'protest theatre' staged in opposition to apartheid. Today the Newtown cultural precinct also includes MuseuMAfrica, the Workers' Library and Museum (see Site 10), Kippie's Jazz Bar, and a number of art galleries, shops and restaurants. Every Saturday there is a lively flea market on Mary Fitzgerald Square, where informal performances take place.

In 2000, a new initiative, involving government and supported by the World Bank, was launched to develop the area. There are innovative plans to incorporate housing and reinterpret unused spaces. The precinct will be linked to the northern suburbs by the newly constructed Nelson Mandela Bridge.

1
J.B. Marks, President of the African Mine Workers' Union, meeting with miners on Market Square two days before the historic strike of August 1946.

2
Early Newtown, so named after the old overcrowded, multiracial are was demolished and burnt to the ground following an outbreak of bubonic plague in 1904

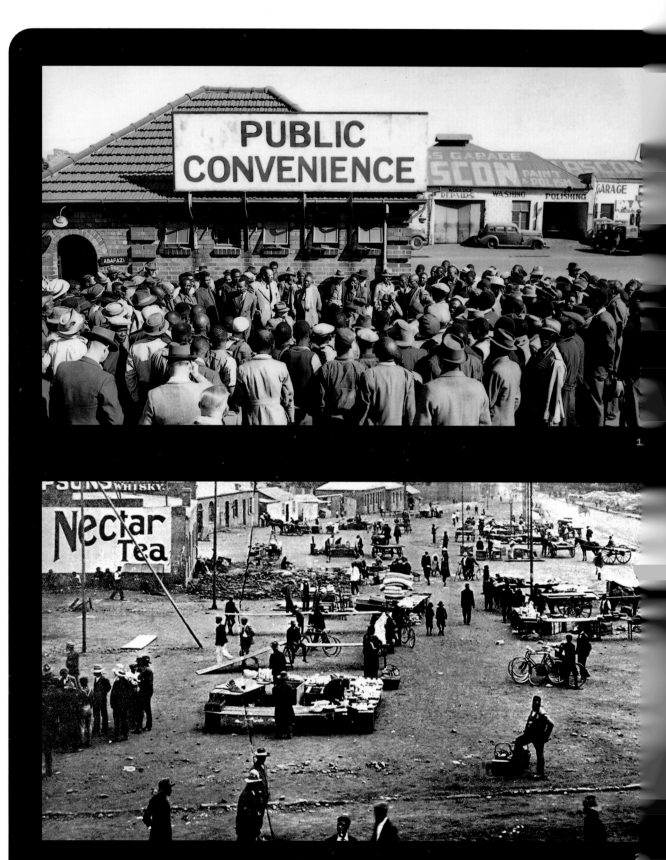

Mary Fitzgerald Square, Newtown

3

Mary Fitzgerald, seen posing here with a pickhandle which a policeman dropped while beating up strikers in Newtown, 1913. An Irish immigrant, Mary Fitzgerald's first job as a secretary in the white miners' union radicalised her. She discovered that scores of miners were dying of a lung disease, inhaling the sharp specks of dust underground. She began to agitate for improved health conditions, and became a prominent figure in the labour movement. During the general strike of 1914, she was seen throwing stones at the police, and was arrested and charged for incitement.

Newtown has always allowed for an interesting blend of culture and politics. For most of the 20th Century, the area revolved around the Johannesburg Market, where farmers, traders, restauranteurs and housewives bought and sold fresh produce. But on weekends, when workers had time off, they appropriated and transformed the market square. Trade union meetings by black and white workers, protest gatherings, cultural performances, and traditional stick-fighting brought new cultural fusions to the city.

Mary Fitzgerald, after whom the square is named, was a militant trade unionist who led the 1914 workers' strike in protest against the appalling death rate of white miners from miners' phthisis. This racking lung disease, caused by breathing in tiny, sharp specks of dust in the underground workings, afflicted drillers especially. The average lifespan of these miners was no more than five years.

The 1946 mineworkers' strike, the largest since 1920, was a symptom of growing poverty in the rural areas, where the miners' families lived. The Second World War had pushed up the cost of living, yet the real wages of miners had not increased in more than fifty years. In the early forties, an African Mine Workers' Union was formed. They called for wage increases, and after months of waiting for a promised government commission on miners' wages, the workers called for a strike. Preparations for the strike were actively backed by the Communist Party of South Africa.

The strike was ruthlessly suppressed by the government. At each mine, the workers were driven underground at gunpoint, stope by stope,

4

The Native Representative Council in the early forties, showing Dr J.S. Moroka (on the right), Prof. Z.K. Matthews (next to him) and traditional leaders

until they reached the workface. Within four days, eighteen workers were killed. Afterwards, several members of the CPSA were charged with incitement. Among them was J.B. Marks, President of the African Mine Workers' Union, and a member of both the ANC and the CPSA. Marks's theoretical grasp of South African society, together with his clear commitment to black liberation, influenced Mandela's own thinking, and the two had long and earnest discussions about politics. Although Mandela and other leading members of the Youth League rejected communism as a 'foreign ideology', they were impressed by the CPSA's dedicated struggle against poverty and their commitment to ordinary working people.

'*During the strike I sometimes went with [Marks] from mine to mine, talking to workers and planning strategy ... I was impressed by the organisation of the union and its ability to control its membership, even in the face of such savage opposition.*'

The miners' strike further radicalised Mandela and his peers, and led them to reject the Native Representative Council. The NRC was a body of traditional leaders and professional men which advised the government on 'native policy'. In the wake of the strike, the Youth League called on the NRC to resign immediately in protest against the brutal treatment of the workers. This the members did, pointing out that the Council was nothing more than a 'toy telephone'.

5

Fifty years later, the historic 1946 miners' strike continues to evoke a rallying cry by the National Union of Mineworkers.

50 NATIONAL UNION OF MINE WORKERS · COSATU

MINEWORKERS STRIKE 1946–1996

50 YEARS FIGHTING CHEAP LABOUR

SAME DEMANDS

1. A living wage;
2. Safe working conditions;
3. 40 hours working week;
4. Abolition of compound system and establishment of villages with schools, hospitals, clinics, recreation and entertainment centres;
5. Abolition of racial discrimination;
6. Payment of compensation on the same basis as that paid to white miners.

THE STRUGGLE CONTINUES!

Part Three

'To be an African in South Africa means that one is politicised from the moment of one's birth, whether one acknowledges it or not.'

'On election day [in 1948], I attended a meeting in Johannesburg with Oliver Tambo and several others. We barely discussed the question of a Nationalist government because we did not expect one. The meeting went on all night, and we emerged at dawn and found a newspaper stall selling the Rand Daily Mail: the Nationalists had triumphed. I was stunned and dismayed, but Oliver took a more considered line. "I like this," he said. "I like this." I could not imagine why. He explained, "Now we will know exactly who our enemies are and where we stand."'

Today, South Africa enjoys an open political environment. While the task of transforming a developing country remains daunting in an increasingly global world, there has been a broad consolidation of democracy through the constitution and social policies that redress the imbalances of the past. As President, Mandela worked actively to reverse bigoted habits of thinking and acting, trying to restore to the heart of public life the concept of ubuntu, which requires that one seek and affirm the humanity even in one's most hostile opponents.

In the past, the terrain of black politics was hemmed in on all sides by restriction, discrimination, harassment and naked hostility. Black people were systematically dehumanised by a white regime terrified of difference, of 'otherness', and the lines of division and confrontation were scored into every aspect of life.

The terrain of black politics

In 1948, white South Africa voted the National Party into power by a slim majority. Most blacks did not think the event very significant: there was not much difference between one white oppressor and another, they were inclined to think.

But within a very short time, new legislation tightened up the old segregation laws and made the whole discriminatory system much more efficient at the expense of black people everywhere. Apartheid, its proponents argued, was designed to give every ethnic group its own land and identity. Each black group could look forward to its own government and its own head of state. In order to achieve this result, massive social engineering would be necessary.

This programme was blatantly dishonest. Whites owned nearly all the land; blacks, who made up more than 80 per cent of the population, owned less than 13 per cent of the land. This meant that in most of South Africa, including the most developed and wealthiest cities and farms, blacks were considered by law to be 'foreigners'. Although blacks outnumbered whites in every province and were the mainstay of the economy, they were allowed in the 'white' areas as migrants for only as long as the white-dominated economy needed them. Then again, whereas black people were divided into nine ethnic groups — Zulu, Tswana, Venda, Sotho and so on — all whites, regardless of whether they spoke English or Afrikaans, or of their precise European descent, were categorised as a single group. Racism, which had been crude and obvious before, now became official policy.

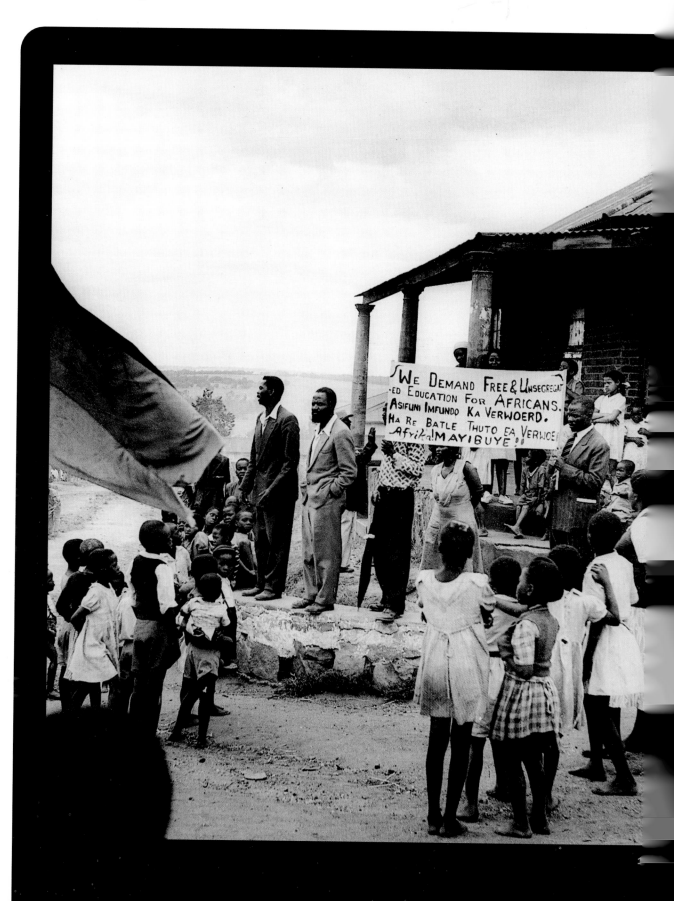

1

In the 1950s, a thicket of laws was established to reinforce racial segregation or 'apartheid'. This meeting in Alexandra township was in protest against Bantu Education, which was specifically designed to train blacks for positions of servitude.

Part Three

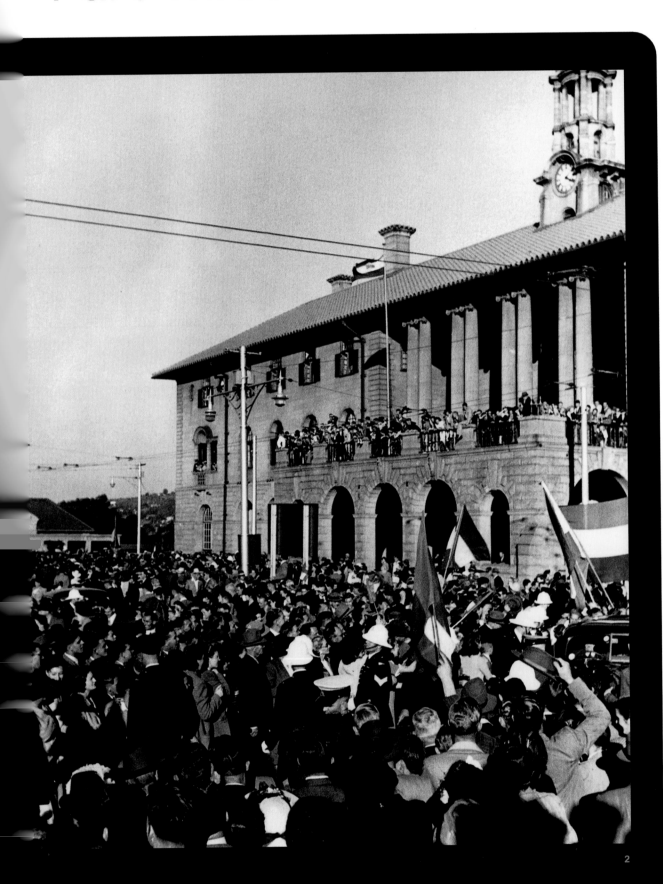

Prime Minister J.G. Strijdom summed up the apartheid system as one of 'baasskap' — total domination by white 'masters'.

This more hostile, systematic racism, which was both more elaborate and more menacing, had a deep effect on the strategies and tactics of black opposition. Over the next fifteen years, Nelson Mandela would play a key part in this opposition. Barely 31 years old, he was already national secretary of the Youth League and on the executive of the ANC itself. In the words of Oliver Tambo, he was a 'born mass leader'.

2

Pretoria Station, 1948. Cheering supporters greet the new National Party Prime Minister, D.F. Malan. 'The outcome of the election has been a miracle,' he proclaimed. 'For the first time since Union, South Africa is our own. May God grant that it always remains our own.' Afrikaner nationalists were driven by a deep sense of grievance about the cultural and economic discrimination they had suffered at the hands of English-speaking South Africans. Yet these very same people would cause the suffering of millions of black South Africans over the next forty years.

3

'Petty' apartheid

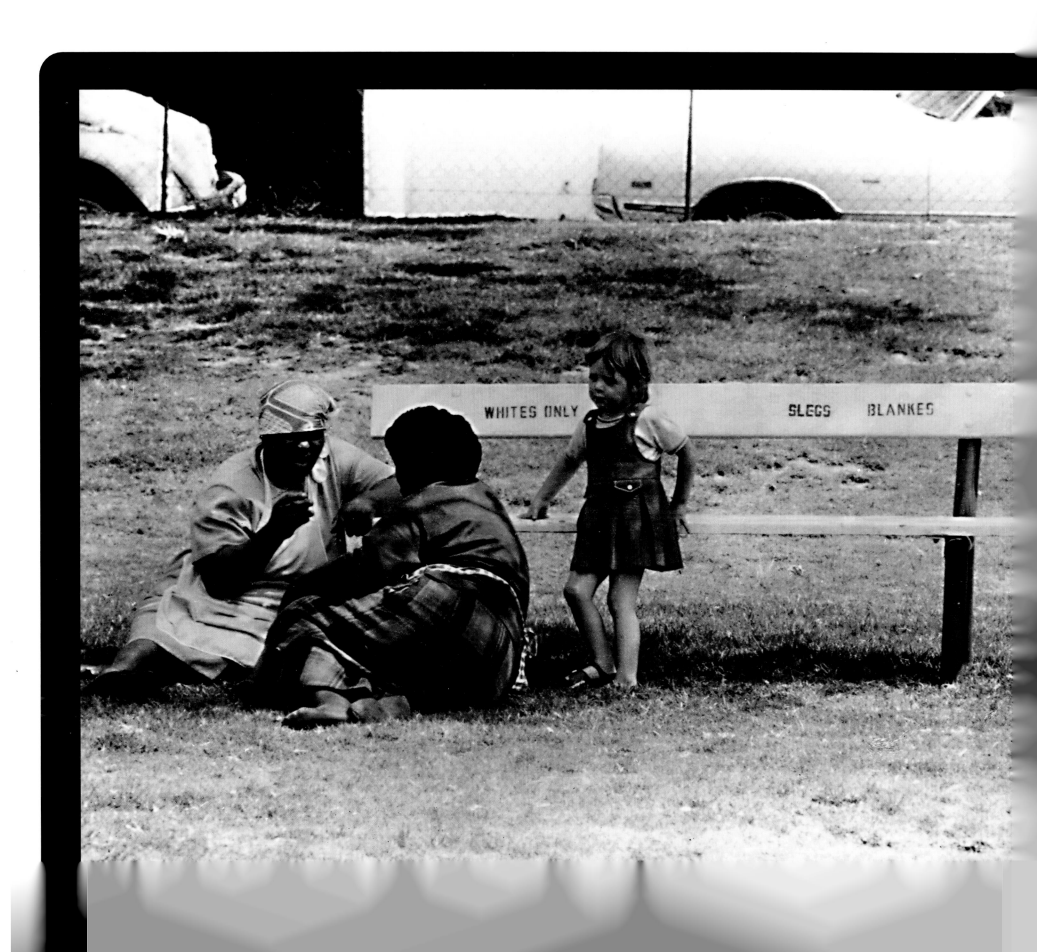

Makgasa Hall, Bochabela

SITE 26

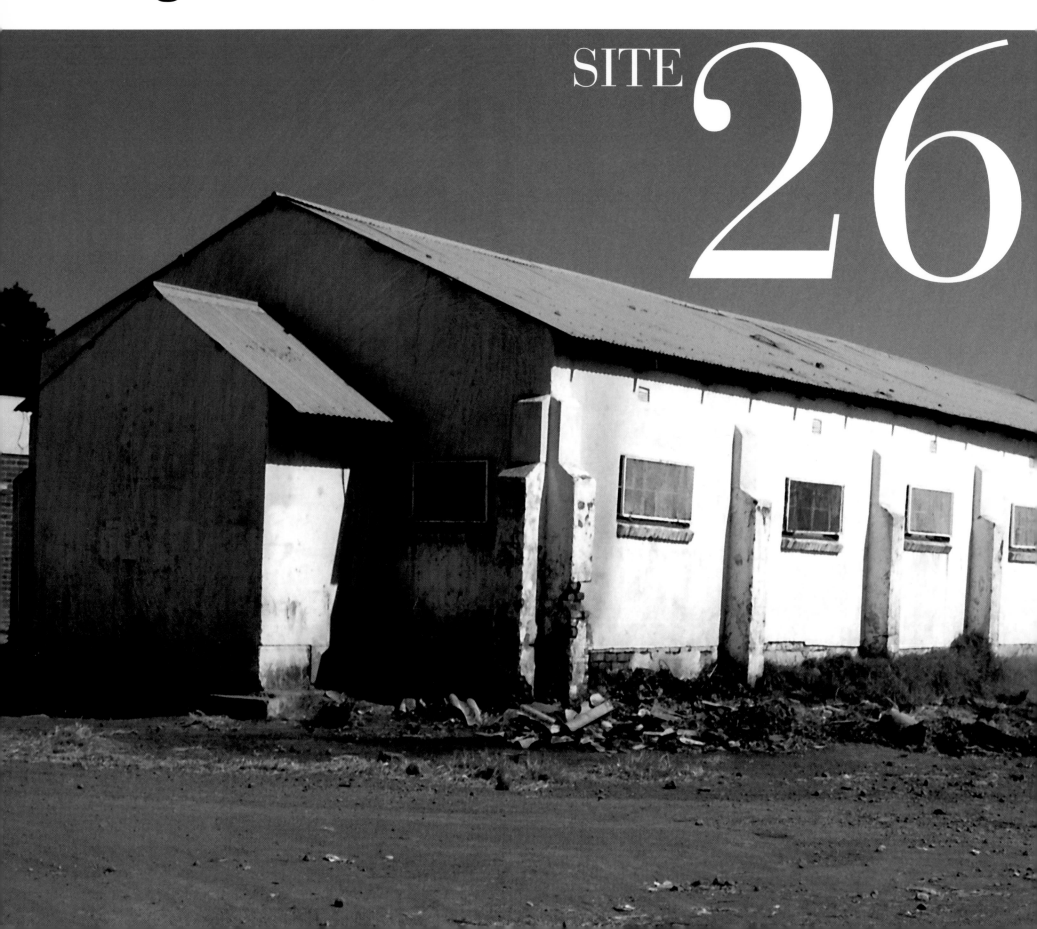

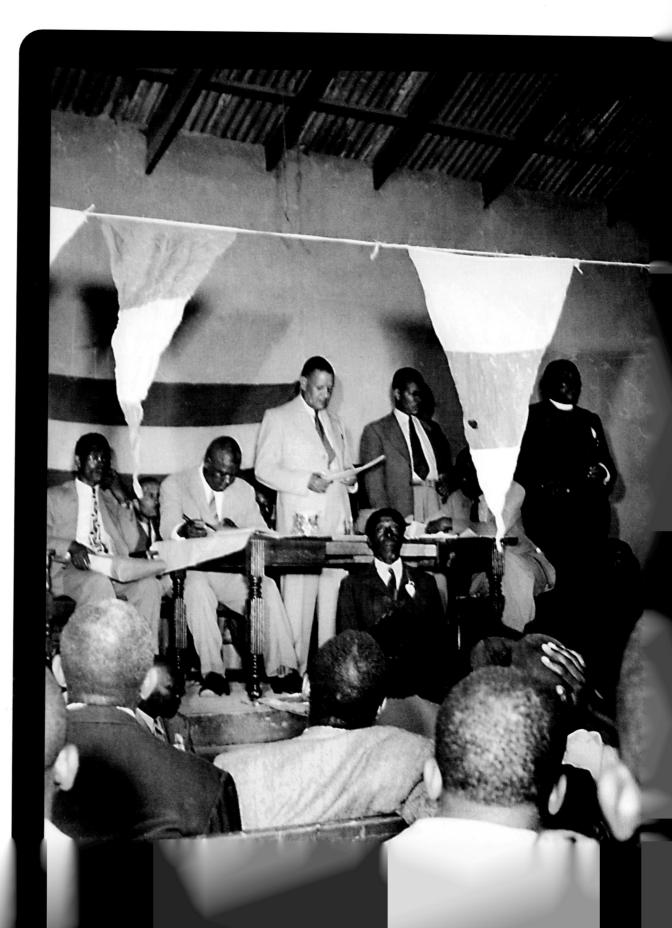

Meeting place of the ANC

Few places in South Africa can claim a closer connection with key moments in the ANC's history than Makgasa Hall in the Bochabela township of Bloemfontein.

It was here that the South African Native National Congress (as it was first known) was formed in 1912. As Bloemfontein (better known as Mangaung to the majority of the population) is more or less a central point in the country, the ANC's national congress tended to take place here. In 1943, the Youth League was formally accepted by the ANC at Makgasa Hall, following a year of lobbying by Walter Sisulu and his slightly younger colleagues. Today it has been declared a national monument.

1

The historic proposal for a civil disobedience campaign against apartheid laws is made in Makgasa Hall in 1951. Standing on the platform are Prof. Z.K. Matthews, Walter Sisulu and the Reverend James Arthur Calata. (The Reverend Calata was the grandfather of Fort Calata, one of the Cradock Four, murdered by the security police in 1985 along with Matthew Goniwe, Sparrow Mkhonto and Sicelo Mhlauli.)

Makgasa Hall, Bochabela

Thomas Mapikela, a successful carpenter, and an active and respected member of the community, built a landmark home in Bochabela (formerly known as Waaihoek). Mapikela was a founder-member of the ANC. In 1936, he was part of an ANC delegation that travelled to Cape Town to speak to Prime Minister Jan Smuts and protest against the proposed removal of Africans from the voters' roll in the Cape. Many senior ANC members recalled staying at Mapikela's house during annual Congress meetings. In 1999, the house was declared a national monument.

It is interesting that both the ANC and the Afrikaner nationalist movement were founded in 1912. The ANC called its first meeting at Makgasa church hall in the Bochabela township of Bloemfontein (or Mangaung) on 8 January 1912. The organisation's immediate purpose was to protest against the proposed Land Act, which set aside 90 per cent of South Africa's land for white ownership. Its longer-term mission was to unite all the black ethnic groups under a national banner. Its first gathering consisted largely of professional people and traditional leaders.

Makgasa Hall became the site of the ANC's annual meetings, and continued to host them until the Congress was banned in 1960. In 1943, the Youth League received formal sanction here. And it was here too in 1949, a year after the apartheid government came to power, that Congress adopted the Youth League's watershed 'Programme of Action'. The drafters of this document, which was pivotal in the political history of the organisation, were the members of the League's executive — A.P. Mda, Nelson Mandela, Walter Sisulu, Oliver Tambo, Dr James Njongwe and David Bopape. The tactics pursued under the Programme of Action heralded a decade of escalating mass action — and increasingly ferocious responses by the apartheid government.

The Programme of Action had been germinating for a few years before the advent of apartheid. Its adoption as official ANC policy was timely, though, for it presented a more vigorous and effective response to apartheid's assault on black South Africans. Citing the ANC's Bill of Rights, the Programme of Action resolved '...to employ the following weapons: immediate and active boycott, strike, civil

2

The Mapikela house in the 1930s

disobedience, non-cooperation and such other means as may bring about the accomplishment and realisation of our aspirations'. It also called for 'preparations and making of plans for a national stoppage of work for one day as a mark of protest against the reactionary policy of the Government'.

Two years later, in 1951, Makgasa Hall witnessed another turning point for the ANC. In keeping with the aims of the Programme of Action, and inspired by the Passive Resistance Campaign which the South African Indian Congress had organised in 1946, Walter Sisulu called for a countrywide mass defiance of 'unjust laws'. The proposal was enthusiastically adopted. Mobilisation, under the leadership of Mandela, began immediately afterwards.

3

One of the newly formed African National Congress's first activities was to send a deputation to Britain to try to prevent the infamous Land Act, which was passed in 1913. From left to right, back: J.C.Gumede, L.T. Mvabaza, R.V. Selope Thema. Front: Sol Tsekisho Plaatje, Rev. H. Ngcayinya.

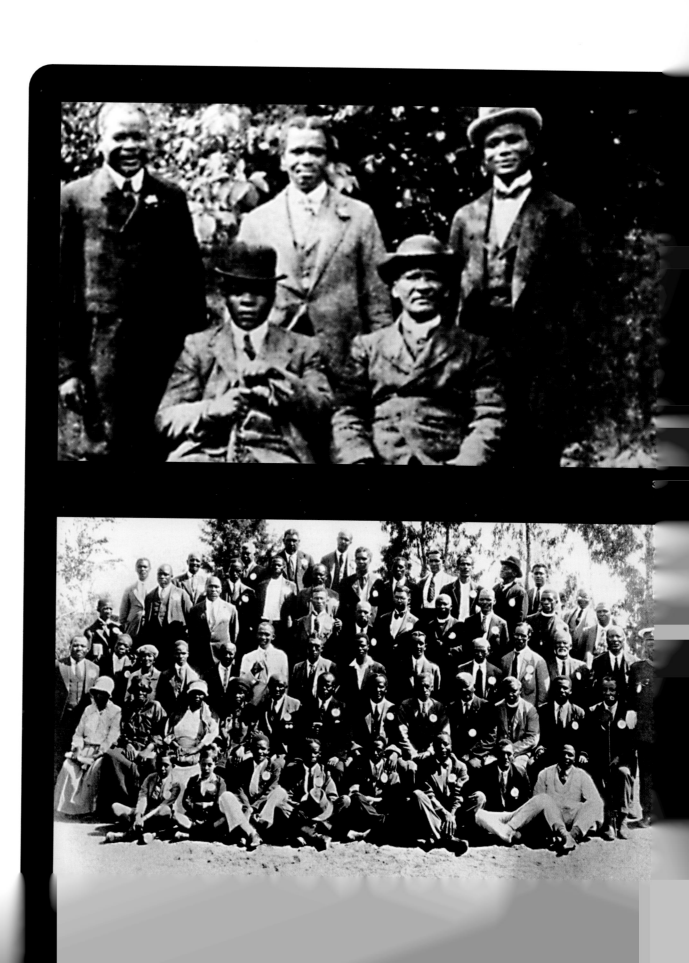

4

The ANC delegation to the Bochabela, Bloemfontein congress, 1925 Thomas Mapikela is in the third row, seventh from the left.

Luthuli House, Plein Street

SITE **27**

The Congress Offices

The photo opposite shows Albert Luthuli House, the ANC's head office in Plein Street, Johannesburg. After the unbanning of the ANC in 1990, returned exiles, released prisoners, and activists from community organisations, the armed struggle and the labour movement converged in this building, then known as Shell House. In the couple of years before the first democratic elections, the building was a buzz of activity — many scores of members were working hard to re-establish branches throughout the country and to redefine the ANC policy with its alliance partners in the new political climate. In March 1993, the entrance to the building was a scene of tragedy when eight members of the rival Inkatha Freedom Party were killed during a tense march to the ANC offices.

Luthuli House, named after the ANC's President during its most challenging period in the 1950s, is now fondly remembered as a place of reunion, where an organisation torn apart by historical circumstances was pieced together again in the 1990s.

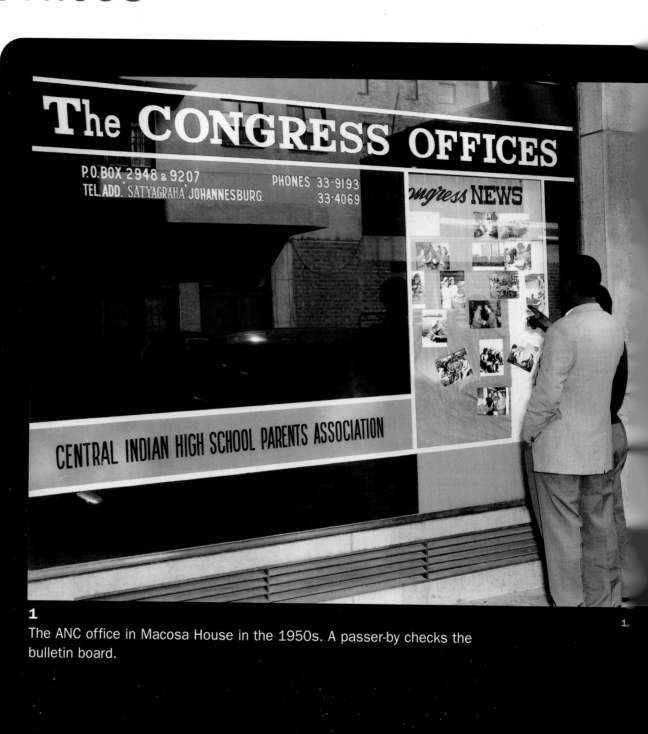

1

The ANC office in Macosa House in the 1950s. A passer-by checks the bulletin board.

Luthuli House, Plein Street

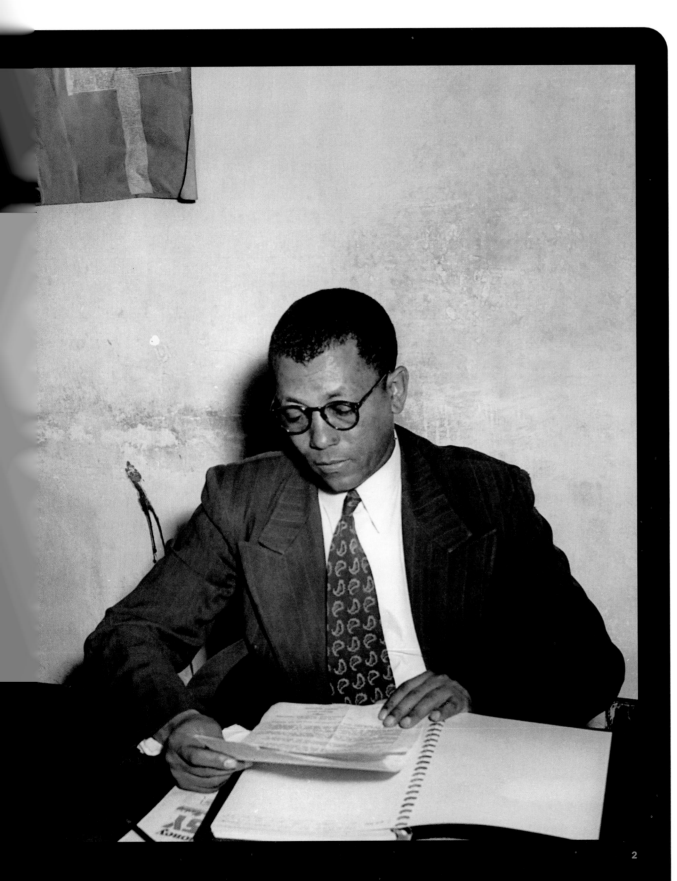

Johannesburg has long been notorious as something of a boom town. Buildings scarcely twenty years old have sometimes been demolished to make way for new office blocks and shopping centres. Much tangible evidence of the city's early years has been destroyed. The ANC's legacy remains not so much in bricks and mortar, but in the popular memory of 'sites of struggle', in photographs, in oral history, in songs adapted to the topical issues thrown up by political struggle, and in the organisations that carried on the traditions of opposition during the thirty years in which the Congress was banned. Some of these organisations have survived, and in their new premises continue to evoke the memories of their political ancestors — their visions, their sacrifices and their successes.

One of the buildings where the ANC had offices, New Court Chambers in Commissioner Street, has since been demolished. Another, Macosa House, on the corner of Commissioner and Bezuidenhout Streets, where the Transvaal Indian Congress also had offices, is described today as 'a ramshackle building in the business area of Johannesburg'. But remarkably, while buildings and venues came and went, the key leadership that emerged in the 1950s returned to provide continuity in the new offices of the ANC — Nelson Mandela, Oliver Tambo, Walter Sisulu, Alfred Nzo, Govan Mbeki, Wilton Mkwayi, Elias Motsoaledi, Thomas Nkobi and many others.

2

Walter Sisulu in his office (probably Macosa House) in the late 1950s

3

Walter Sisulu in his Luthuli House office, 1995

3

Walter Sisulu was elected secretary-general of the ANC at the Congress which adopted the Programme of Action in 1949. His real-estate business had collapsed, owing to new apartheid laws on segregated housing and black ownership of property. Usually the organisation did not have enough money to pay even his modest monthly salary, and his wife Albertina, a nurse, became the breadwinner. Yet his commitment was unshakeable. 'He believed that the African National Congress was the means to effect change in South Africa, the repository of black hopes and aspirations.'

Chancellor House, Fox Street

SITE 28

A haven for victims of apartheid

In 1952, Mandela and Tambo opened a law practice together in Chancellor House, just across the road from the Magistrate's Court. It was the first black law firm in the city. The office stayed open until 1960, when Tambo left the country to head the ANC's external mission. In 2000, squatters had moved into the vacant building. With the absence of electricity accidental fires had burned down parts of the premises. (Opposite, the Magistrates' Court is viewed from the foyer of Chancellor House). Concerned members of civil society together with the National Monuments Council (renamed the South African Heritage Resources Agency in April 2000) were attempting to restore Chancellor House and develop it into a museum and law library.

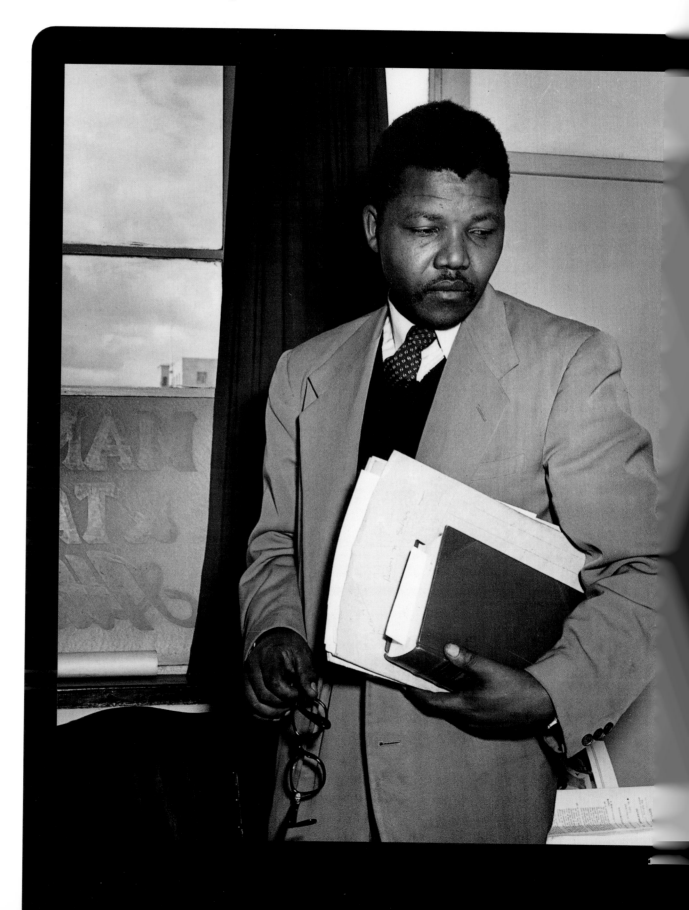

1
Mandela in his chambers at Chancellor House, situated opposite the Magistrates' Court

Chancellor House, Fox Street

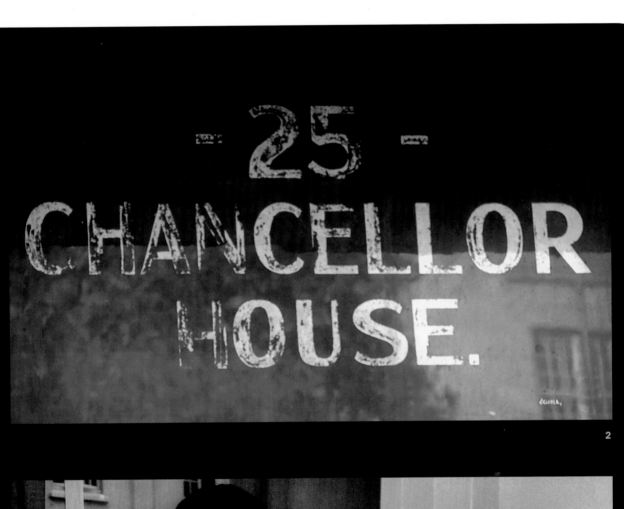

Events such as the black mineworkers' strike of 1946 strengthened Mandela's resolve to set up his own law firm to combat the unjust and racist laws of South Africa. Despite its run-down appearance, Mandela and Tambo's downtown chambers did not come easily to them. They were ordered to move their practice to a 'black' area, but they simply ignored the directive and remained in the inner city. From these chambers, the two friends, backed in later years by a team which included Duma Nokwe, Ruth Mompati, Mendi Msimang, Godfrey Pitje and others continued to challenge apartheid laws, both professionally and politically.

2
The gold lettering that graced the building in the 1950s can still be discerned.

Into their waiting room flocked desperate victims of the apartheid system. The laws on passes, curfews, liquor, residential areas and labour, all applicable only to blacks, criminalised the most respectable men and women. Cases involving law-abiding peasants removed from their land, husbands and wives not permitted to live together, women who brewed traditional beer merely to survive, the hundreds of men arrested day after day in town for not carrying their pass books — all these and many other cases provided evidence of the crude harshness of apartheid.

'Africans were desperate for legal help... it was a crime to walk through a Whites Only door, a crime to ride a Whites Only bus, a crime to use a Whites Only drinking fountain, a crime to walk on a Whites Only beach, a crime to be on the street after 11 p.m., a crime not to have a pass book and a crime to have the wrong signature in that book, a crime to be unemployed and a

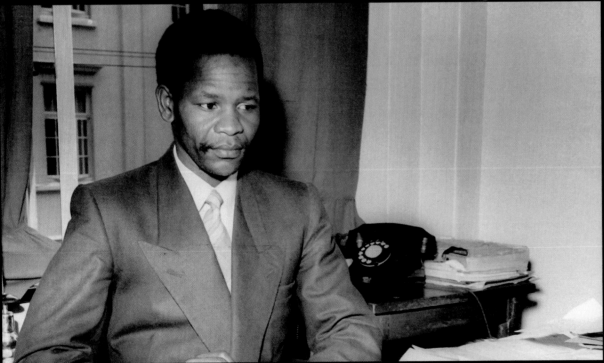

3
Tambo as an articled clerk, in his office

crime to be employed in the wrong place, a crime to live in certain places and a crime to have no place to live... Every day we heard and saw the thousands of humiliations that ordinary Africans confronted every day of their lives.'

Mandela and Tambo became widely known amongst blacks, and were seen as shining role models for young blacks to emulate. Just a fortnight before he was assassinated, Chris Hani, the general secretary of the South African Communist Party, recalled: 'We admired [Mandela and Tambo] because we saw in them a different type of intelligentsia; an intelligentsia which is selfless, which was not just concerned about making money, creating a comfortable situation for themselves, but an intelligentsia which had lots of time for the struggle of the oppressed people of South Africa; how they used their legal knowledge to alleviate the judicial persecution of the blacks. And as we therefore studied, we felt that our priority as probably future intellectuals, should be to participate in this struggle. And I must say my life was shaped by the outlook of people like comrades Tambo, Mandela, Duma Nokwe and others.'[8]

4

The 1950s saw increasing hardships for blacks in the metropolis. As apartheid's social engineering began to be applied with growing determination, removals from multi-racial residential suburbs, pass law offences, prosecutions based on racist legislation, the imprisonment of workers, trade unionists, 'loiterers' or 'cheeky natives' crammed the law courts, and stretched the firm of Tambo and Mandela to its limits.

5

A prelude to arrest and trial — the Special Police identifying speakers and delegates at the Congress of the People, 1955

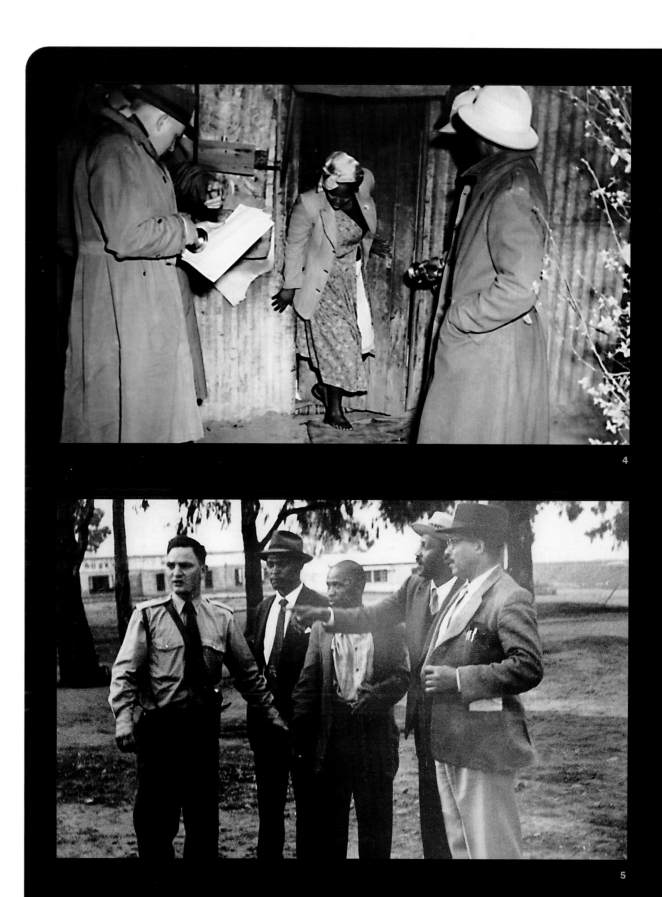

National Acceptances House, Rissik Street

SITE 29

NATIONAL UNION OF MINEWORKER

Office of the South African Communist Party

National Acceptances House became the first home of the South African Communist Party after its unbanning in 1990. The building had a working-class past: for some twenty years, beginning in the 1930s, one of the tenants was the printing firm of a Jewish workers' publication. In the 1980s, National Acceptances House was the head office of the National Union of Mineworkers. It was outside this building that Chris Hani, general secretary of the SACP, narrowly escaped assassination in 1992. Barely six months later he was shot dead at his home in Dawn Park, Boksburg, by a right-wing assassin.

The SACP's head office is now located in Cosatu House, headquarters of South Africa's largest trade union federation (See Site 40).

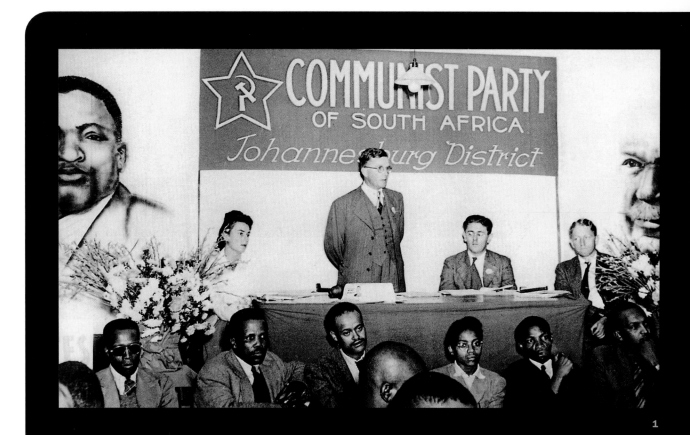

1
A meeting of the Johannesburg branch of the Communist Party, 1946

2
May Day poster, 1950

National Acceptances House, Rissik Street

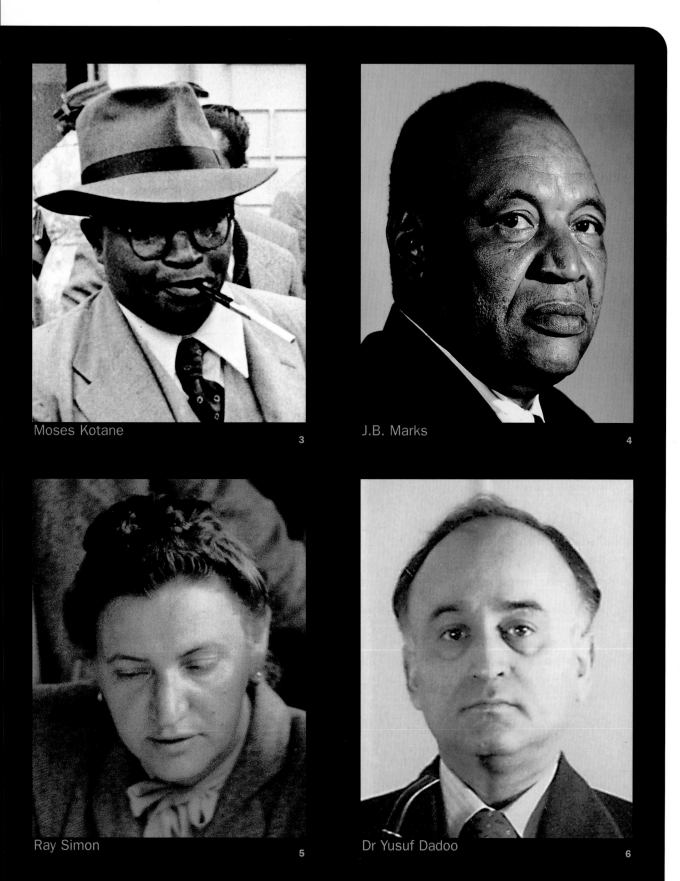

Moses Kotane
3

J.B. Marks
4

Ray Simon
5

Dr Yusuf Dadoo
6

Mandela and other members of the Youth League were suspicious of the Communist Party, partly because of its 'foreign ideology' which emphasised class rather than race, and partly because they were rivals successful in recruiting members. But after 1948, with the introduction of hardline apartheid, political activity became more intense. Ultimately, this resulted in a shift in strategy and a realisation of the need for tactical alliances. This new understanding developed gradually through active experiences of struggle.

One of the first pieces of legislation passed by the apartheid government was the Suppression of Communism Act. This law allowed the government to expel elected communist Members of Parliament Sam Kahn and Ray Simons, and ban dozens of leading trade unionists, as well as activists who may or may not have been members of the Communist Party. The scope of the law was so wide that virtually any extra-parliamentary opposition was considered to be 'furthering the aims of communism'.

Opposite: Some of the stalwarts of the Communist Party of South Africa before its dissolution in 1953

Under the newly adopted Programme of Action, the ANC had planned a countrywide work stoppage or 'stay-at-home' for May Day of 1950. Realising that they were about to be banned, the Communist Party suggested to Dr J.S. Moroka, the president of the ANC, that the two organisations work together. Without consulting his executive, Dr Moroka agreed. The Youth League were furious at what they perceived as a takeover of their campaign. In a series of confrontations, Mandela and other Youth Leaguers loudly and angrily challenged the Communist Party and broke up their meetings. The Youth League then called upon

black workers to ignore the stay-at-home.

In response to the planned stay-at-home, the government slapped a ban on demonstrations and meetings, and on the day deployed 2 000 policemen in Johannesburg. Despite this intimidation, more than half of the workforce stayed away. In several areas, people disregarded the ban. The police response was savage. They broke up a wedding and a funeral; they shot people who did not disperse quickly enough. Mandela and Sisulu, who were rushing around the townships trying to persuade people to go home, narrowly escaped being shot themselves. At the end of it all eighteen people had been killed and more than thirty injured, including three children.

The sorrow at the loss of life and the anger at the brutality of the police produced an unexpected reconciliation between the Communist Party and the Youth League. As Mandela explained it:

'The Suppression of Communism Bill, ...the Youth League immediately realised, was in fact directed at a far greater target than the two thousand odd communists; its object was to crush the struggle for liberty.'

In a cautious follow-up meeting, the ANC called for a national stay-at-home to protest against the government's actions and mourn the dead. The date chosen, 26 June, became symbolic of the vision of freedom, and the anniversary was celebrated for years to come.

7

Hilda Watts, first and only Communist Party city councillor for Johannesburg in half a century, representing Hillbrow, 1945. On the right is the National Party Councillor for Booysens.

8

A few days after his release from prison in 1990, Mandela attended a welcome rally in Johannesburg which drew an ecstatic crowd of over 100 000 people. Here Mandela greets the crowd, along with Joe Slovo, general secretary of the newly unbanned SACP, Jacob Zuma, Alfred Nzo, Andrew Mlangeni and other leaders of the Congress Alliance.

Gandhi Square, Rissik Street

SITE 30

The Mahatma's legacy

Gandhi Hall, a venue fondly remembered by many South African Indians and by political activists of Mandela's generation, was relocated to Lenasia in 1983. The original inner city premises have since been demolished. But Gandhi's presence can still be felt in many parts of Johannesburg. His law firm occupied chambers adjoining Gandhi Square. Originally, this was the site of the Witwatersrand High Court and the Supreme Court. These were demolished in 1948 to make way for the bus terminus, while the courts were located elsewhere (see Sites 18 and 34). Recently the precinct was redesigned and renamed to honour the enlightened philosophies and strategies of opposition and mobilisation that Gandhi bequeathed to the resistance movement. Information panels in the area reveal the Mahatma's connection with other sites in Johannesburg. (Under the Group Areas Act of 1950, all the suburbs where Gandhi and his family resided were subsequently reserved for whites only — with the exception of live-in servants.)

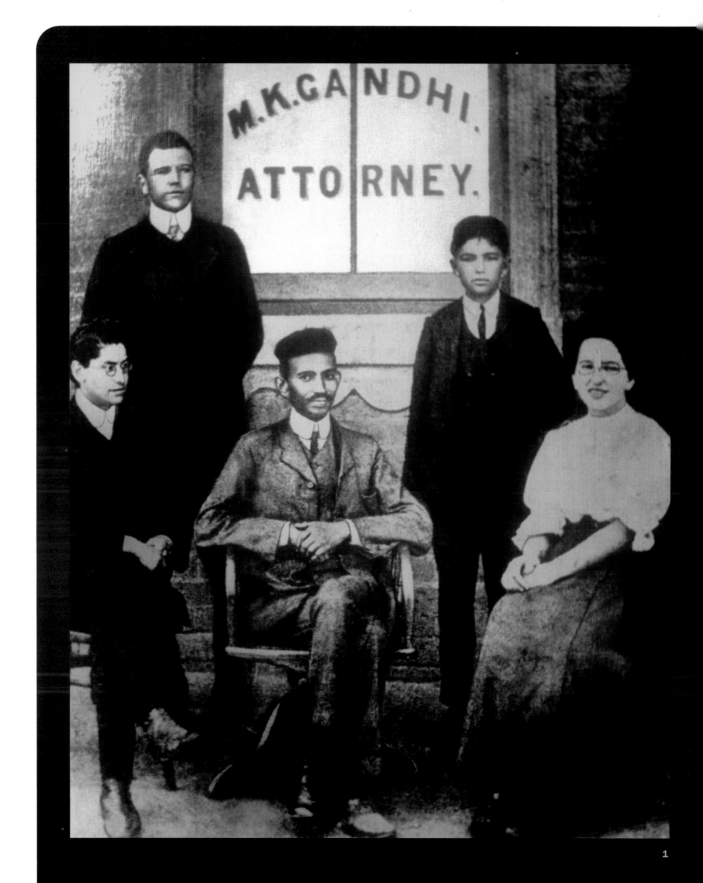

1
Gandhi outside his chambers in Rissik Street

Gandhi Square, Rissik Street

2

Dr Yusuf Dadoo, like Ghandhi a powerful and charismatic leader of the Indian community, was elected president of the Transvaal Indian Congress in 1939. Dadoo came from a middle-class Krugersdorp family. He went to an Indian university and then completed his medical degree in Scotland. By the time he returned to South Africa in 1939, he was a confirmed communist, like so many youthful idealists of his generation.

Mohandas Gandhi served his political apprenticeship in the struggle against racial discrimination in South Africa. He arrived in Durban in 1893 as a young, London-trained attorney, to take up a case for an Indian client. He remained in South Africa for close on twenty years. It was during this period, while leading the resistance against the Transvaal Asiatic Registration Act, that he developed his philosophy of satyagraha. Like Mandela, Gandhi appeared on both sides of the bench in the law courts. In 1907, together with South African companions Tambi Naidoo and Essop Mia, Gandhi urged the entire 'Asiatic' community — Indians and Chinese, Muslims and Hindus, merchants and workers — to unite in their rejection of the Registration Act. Registration would mean the compulsory carrying of passes and an official database of the fingerprints of 'Asiatics'. In December 1907, Gandhi was arrested and ordered to leave the Transvaal. He refused and in the following year was sentenced to two months' imprisonment — the first of many incarcerations. For the rest of his life, Gandhi used his experience in South Africa to promote an international awareness of the evils of colonialism and racism throughout the British Empire.

Gandhi's strategies were not without controversy. He antagonised many of the Natal Indian merchant class when he formed the Natal Indian Association, forerunner of the South African Indian Congress. At times, his subtlety also eluded his followers. In 1908, he and some friends were severely beaten up outside his office by disgruntled radicals, who saw his compromise with the Transvaal government as a sell-out. And by his own admission, he did not have a credible relationship with the African community. Nevertheless, his tactics proved to be an inspiration to the South African resistance movement. The next generation of activists

built up militant Natal and Transvaal Indian Congresses. In 1946, Dr G.M. Naicker in Natal and Dr Yusuf Dadoo in the Transvaal led the Passive Resistance Campaign, in which more than 800 men and women were jailed for their defiance of discriminatory property laws.

Mandela and other Youth Leaguers observed this campaign with admiration. Friendships with activists such as I.C. Meer and Ahmed Kathrada also broke down prejudice and strengthened ties to the Indian community. Years later, during the Treason Trial, Prof. Z.K. Matthews described the Passive Resistance Campaign as the 'immediate inspiration' for the ANC's campaigns from 1949 onwards. The Defiance Campaign of 1952 in particular employed Gandhian tactics.

3

The Special Branch raid the offices of the South African Indian Congress in 1955 (founded by Gandhi sixty years earlier). The raid took place shortly after the Congress of the People. This was a prelude to the Treason Trial.

4

Mandela with Nana Sita, highly respected spiritual leader of the Indian community, whose courage and steady political commitment inspired many otherwise conservative Indians to pursue 'passive' or non-violent resistance.

'The Indian Campaign became a model for the type of protest that we in the Youth League were calling for ... They reminded us that the freedom struggle was not merely a question of making speeches, holding meetings, passing resolutions and sending deputations, but of meticulous organisation, militant mass action and, above all, the willingness to suffer a sacrifice.'

Informal links translated into formal ties. In 1947, Dr Xuma, president of the ANC, Dr Naicker and Dr Dadoo signed the 'Doctors' Pact', which promoted understanding between the ANC and the Indian Congresses. In 1954, the South African Indian Congress joined the Congress Alliance, under the leadership of the ANC.

Red Square, Fordsburg

SITE 31

The launch of the Defiance Campaign

In the 1940s and 1950s, 'Red Square' in Fordsburg, Johannesburg, was a political meeting place. It was especially popular with the Communist Party. Today the site is the parking lot of the Oriental Plaza shopping centre. The history of this centre shows how a community space destroyed by apartheid planners was reclaimed by the people.

Indian people lived and worked in vibrant adjacent, multiracial areas. Then these areas were declared 'white', and Indian residents were moved forty kilometres away to Lenasia.

The authorities grudgingly allowed a shopping centre to be built on Red Square to accommodate evicted Indian traders. Yet the origins of the place have been overcome. The Oriental Plaza has been transformed into an exotic complex of shops, courtyards and restaurants, drawing customers of all classes and colours, lured by the scent of a bargain.

1

A Defiance Campaign meeting at Red Square, 1952. (Many of the mine dumps in the background have been recycled for residual gold, and have since disappeared. In the contemporary photo, opposite, two can be discerned on the horizon.)

Red Square, Fordsburg

One Sunday in April 1952, Dr J.S. Moroka, president of the ANC, and Dr Yusuf Dadoo, president of the Transvaal Indian Congress, addressed a huge crowd at Red Square. In that month white South Africans were celebrating the tercentenary of the arrival of the Dutch at the Cape. Dr Moroka talked of the disillusionment of Africans with the European settlers and their efforts to divide people into ethnic groups. 'You are one race ...' he declared. 'We must come together or we will not live to see the dawn of the day of freedom.' Walter Sisulu then outlined the ANC's strategy of civil disobedience. He called for 10 000 volunteers to make a pledge to resist the unjust laws of apartheid. The Defiance Campaign was launched.

Like the 1946 Passive Resistance Campaign, the Defiance Campaign aimed to disrupt the system by blocking up the prisons with those arrested for defying the law. The ANC selected what it termed the 'Six Unjust Laws' to symbolise the entire oppressive system. Dr S.M. Molema, the ANC treasurer, described them as 'the most diabolical laws which affect and restrict all Non-Europeans together'. These were:
- the pass laws;
- the laws on stock limitation;
- the Group Areas Act;
- the Separate Representation of Voters Act;
- the Bantu Authorities Act;
- and the Suppression of Communism Act.

Mandela, who had just set up his law practice with Oliver Tambo, was elected Volunteer-in-Chief for the Defiance Campaign in the Transvaal region. Acquiring his driver's licence especially for the purpose, he travelled extensively to all the provinces to mobilise both rural and urban volunteers, working closely with Maulvi Cachalia. Part of the historical

2
Defiance Campaigners marching with banners in Fordsburg's Red Square

significance of the Campaign was that it cemented the personal and political links between the ANC and the South African Indian Congress. Members of the Indian Congress demonstrated that they were willing to share their vision and knowledge, and prepared to take risks in opposing apartheid actively together with their black compatriots. In a significant new development, the new leadership of the ANC, which included Sisulu, Tambo and Mandela, supported the proposal for a formal working alliance with the Transvaal Indian Congress and the Natal Indian Congress.

3

Not far from Red Square was the Central Indian High School. When the Indian community was ordered to move to Lenasia under the Group Areas Act, a Parents' Association, under the leadership of the South African Indian Congress, set up a private high school to resist the removal of their childrens' schooling. Many of these children were to become activists in the liberation movement, both inside the country and, after the banning of the liberation movement, in exile.

In the photograph, right, headmaster Michael Harmel is taking assembly. Other activist teachers were Molly Fischer and writer Alf Hutchinson.

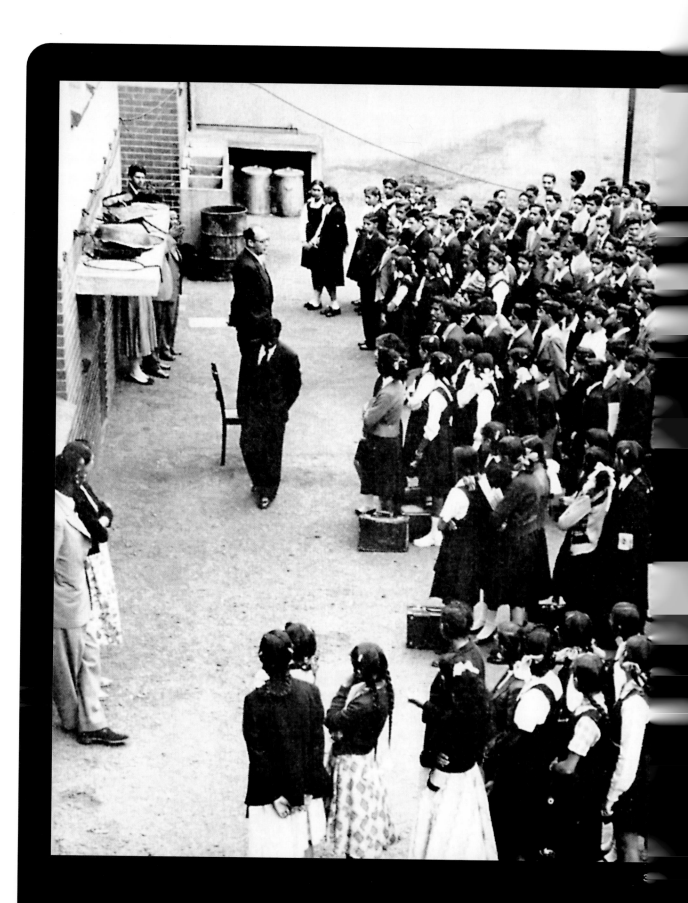

Curries Fountain, Durban

SITE 32

Mass protest in Natal

Curries Fountain's tradition of hosting mass meetings by opponents of segregation goes back at least as far as 1908. In the 1950s, meetings were held here to mobilise people for the Defiance Campaign, for protests against increasingly aggressive apartheid laws and for stay-at-homes. A generation later, in 1975, Curries Fountain hosted another historic gathering, when the Black Consciousness Movement organised a huge rally to celebrate Frelimo's victory over Portuguese colonialism and the declaration of independence in Mozambique and Angola. The organisers were arrested and tried, ironically, under the 'Suppression of Communism Act'. In post-apartheid South Africa there is no shortage of non-racial venues for rallies. These days Curries Fountain — the fountain itself long since demolished — is used as a sports ground for local soccer matches.

1
Meeting at Curries Fountain, 1913. This photograph was reproduced in *New Age* in 1960.

2
Curries Fountain, 1960 — mass prayer meeting of all races to commemorate the centenary of the arrival of Indians in South Africa.

Curries Fountain, Durban

3

As far back as 1908 and 1913, large crowds of Indians met at Curries Fountain to protest against discriminatory tax laws. This prohibitively high poll tax had been designed to make Indians re-indenture themselves to the sugar plantation owners or to force them out of the country. The tax, together with a government decision not to recognise traditional marriages, drew thousands of women into a protest campaign. After a mass meeting at Curries Fountain in 1913, 20 000 Indian workers went on strike. This was followed by a long and hard passive resistance campaign led by Mahatma Gandhi. As a result, laws that discriminated against Indians were eventually repealed — for a few years.

A few days before the launch of the Defiance Campaign in 1952, Mandela, as Volunteer-in-Chief, addressed a crowd of about 10 000 people in Durban. He shared the platform with the president of the ANC in Natal, Chief Albert Luthuli, and the president of the Natal Indian Congress, Dr G.M.Naicker. Mandela's appearance marked a significant shift in the attitude of the Youth League towards working with the Indian Congress. The previous year, Mandela had been elected national president of the Youth League. At first, he expressed reservations about working with Indians and Coloureds on a civil disobedience campaign. He was not sure, he said, that the rank-and-file membership were prepared to work with other race groups. But he was outvoted by the ANC executive, and the Youth League turned out to be quite happy with the idea of a multiracial alliance.

3
Mass meeting at Curries Fountain, 1980s

There was an added incentive to work together. Three years earlier, Durban had been rocked by riots directed against Indians. As *New Age* put it: 'Africans in Durban, responding to the

anti-Indian agitation engendered by white politicians over the years, revolted against their own intolerable conditions by assaulting defenceless and mainly poverty-stricken Indians. Many Indians lost their lives.'

The ANC leadership were horrified at this turn of events. Members of the executive, including Oliver Tambo, went to Durban to release a joint statement with the Indian Congress expressing deep regret at what had happened. They decided to work systematically for a more thoroughgoing political unity. It was against this background that Mandela declared in his Defiance Campaign speech at Curries Fountain:

'We can now say unity between the Non-European people in this country has become a living reality.'[9]

4

The Curries Fountain Legacy continued: a COSATU poster advertising a May Day rally at Curries Fountain, 1988

The Defiance Campaign would prove to be a turning point in the political development and vision of the ANC.

Mandela also revealed a growing awareness and appreciation of a wider community of resistance: 'We welcome true-hearted volunteers from all walks of life without consideration of colour, race, or creed ... The unity of Africans, Indians and Coloured people has now become a living reality.'

The laws defied were mainly those 'petty apartheid' regulations which revealed so much about South African society: people used white facilities at post offices and railway stations, breached curfew regulations, infringed pass laws and entered locations without permits. Magistrates handed out increasingly heavy sentences, even lashes for young people. But almost without exception, volunteers chose to

New Brighton, Port Elizabeth

Acts of defiance

One winter morning in 1952, 25 men and three women walked up the 'whites-only' steps, through the 'whites-only' entrance of the New Brighton township station of Port Elizabeth. 'What have we done, we the African people,' sang a crowd of well-wishers. They were promptly arrested — the first batch of volunteers in the Defiance Campaign. It was in New Brighton that Mandela and other ANC and Indian Congress leaders had formally announced the campaign two months earlier.

Today, as people of all colours pass through the station, it is hard to imagine the symbolic power that the mere act of crossing a threshold had in those oppressive times. The resistance heritage of New Brighton is now being acknowledged. There are plans also to restore the adjoining 'Red Location' — so called because of the distinctive red iron sheets with which the houses were built. A competition for its transformation, incorporating the station, a museum and a cultural centre, is under way.

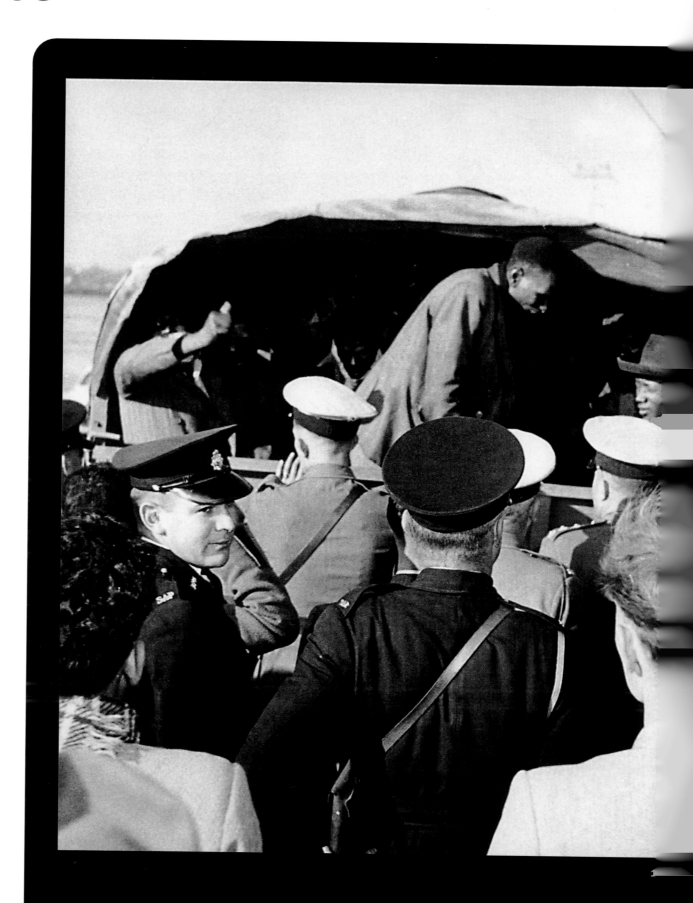

1
Defiers arrested

New Brighton, Port Elizabeth

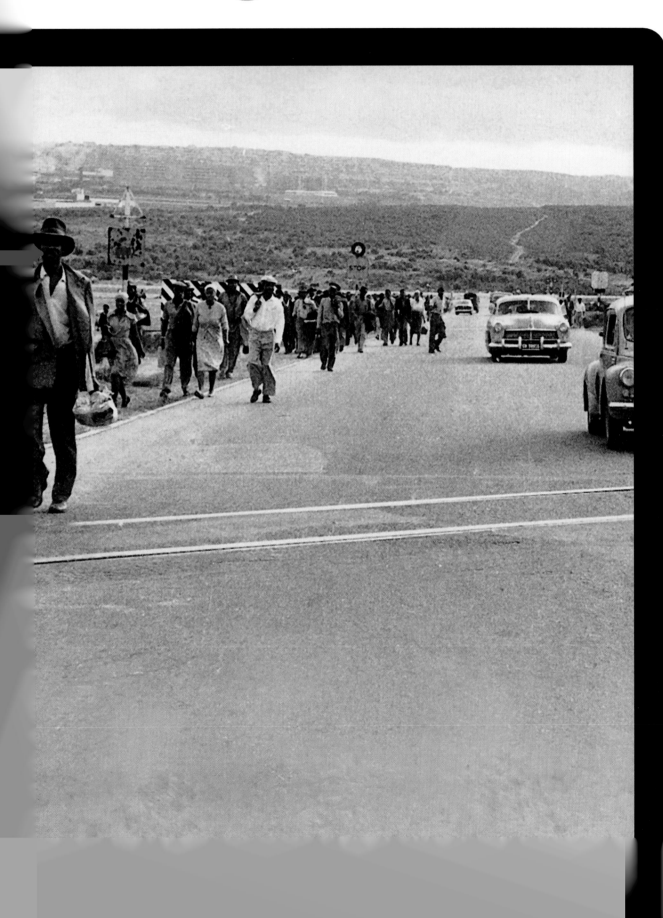

The ANC's strongest branches initiated the Campaign: but the most spectacular levels of resistance occurred in the Eastern Cape, with 2 000 arrests in Port Elizabeth alone. Why was this?

Port Elizabeth had one of the most coherent black communities in a South African industrial centre. The majority of its black workers lived in the township of New Brighton. Its population had grown dramatically after the Second World War, with desperate newcomers streaming in after a series of droughts and the relentless shrinkage of available land. Yet people retained a sense of community. The vast majority of workers spoke the same language, namely Xhosa. Unlike the townships in the Transvaal, New Brighton had no compounds or hostels, as the homesteads were within closer commuting distance. There was also a tradition of local resistance, such as the 1949 bus boycott, led by Raymond Mhlaba and Youth Leaguer Dr James Njongwe. But perhaps black Port Elizabeth's major advantage was a vigorous trade union movement. Worker leaders prominent in the Defiance Campaign were Govan Mbeki, Raymond Mhlaba, Frances Baard, Caleb Mayekiso and A.P. Mati.

2
Bus boycott in New Brighton, 1957

About four months after the launch of the Defiance Campaign, the townships of Port Elizabeth and East London exploded in riots. Deeply threatened by the scale of civil disobedience, police reacted with more than their usual aggression in both cities. In New Brighton one October morning, a policeman shot three men while effecting an arrest, killing one of them. Within an hour an angry crowd had gathered outside the police station. Police reinforcements were stoned as they arrived. They then fired on the crowd, killing several more

people. In the rampage that followed, white property was destroyed and three white bystanders killed. The police killed seven blacks. In East London, police bayoneted a prayer meeting when the gathering failed to disperse, and forced people to retreat at gunpoint. In the angry aftermath two whites, including a Dominican nun, were brutally killed. A church, municipal buildings and a dairy depot were gutted. In both cases, an anger that had long been held in check was unleashed on whites and their property.

Yet there was no direct connection between the riots and the Defiance Campaign. Mandela and other ANC leaders condemned the circumstances that had led to the violence. As it happened, many thousands of defiers were arrested and jailed, and this had the desired effect of choking the jails. The carefully managed Campaign drew an enormous amount of publicity and brought about a huge increase in ANC membership.

But the riots frightened off many white sympathisers. They also gave the government a pretext to pass new repressive measures, imposing harsher sentences on those found guilty of defying the law. The leaders of the Campaign, including Mandela, were arrested and charged under the Suppression of Communism Act. By the end of the year defiance had petered out.

3

Mandela charts the progress of the Defiance Campaign in print.

After the riots, well-known personalities performed a last major act of defiance. In the Transvaal, a multiracial group including Patrick Duncan, the son of the wartime Governor-General of South Africa, Nana Sita, the highly respected Gandhian philosopher, and Manilal Gandhi, son of the Mahatma, were arrested for entering Germiston Location without a permit.

"WE DEFY"

10,000 volunteers protest against "unjust laws": Here DRUM publishes c statement of the campaign's aims

by NELSON MANDELA

OUR Defiance of Unjust Laws Campaign began on the 26th of June. It is going smoothly and according to plan; though there have been minor setbacks, like the arrest of Y. Cachalia, S.A.I.C. general-secretary, and myself, which was not according to plan. And the support we have received from the masses has been most encouraging. At the

moment, for security reasons, I cannot disclose how they are helping the Joint Planning Organisation and its sub-committees to care for the dependents of those Volunteers already arrested.

I would like to emphasise the aims of our Campaign over again. We are not in opposition to any government or class of people. We are opposing a system which has for years kept a

vast section of the non-European people in bondage. Though it takes us years, we are prepared to continue the Campaign until the six unjust laws we have chosen for the present phase are done away with. Even then we shall not stop. The struggle for the freedom and national independence of the non-European peoples shall continue as the National Planning Council sees fit.

(Continued on Page 57)

LEADERS OF THE PROTEST CAMPAIGN IN ACTION ON JUNE 26th

Seasoned volunteer and resister NANA SITA asks the officials to open the location gates at Boksburg on June 26, while his batch of 8 Indian volunteers wait behind him.

C. T. N. NAIDOO, Transvaal Indian Congree vice-president, waits in the background while a police officer warns Yussof Cachalia, S.A. Indian Congress joint-secretary,

From the police troop carrier which took the volunteers to prison WALTER SISULU, African National Congress general secretary, bids goodbye to the crowd of supporters.

MAULVI CACHALIA, Transvaal Indian Congress secretary, stands behind the locked gates of the location and is told he cannot enter without a permit.

As Volunteer-in-Chief, Mandela reported on the Defiance Campaign in *Drum* magazine, presenting its smooth progress in Johannesburg and Port Elizabeth as a prelude to nationwide defiance. The article demonstrated his ability to convey sophisticated political messages clearly and concisely, and marked him out as a leader in future operations. 'We are not in opposition to any government or class of people. We are opposing a system which has for years kept a vast section of the non-European people in bondage. Though it takes us years, we are prepared to continue the Campaign until the six unjust laws are done away with. Even then we shall not stop. The struggle for the freedom and national independence of the non-European people shall continue...'

The Magistrate's Court, Johannesburg

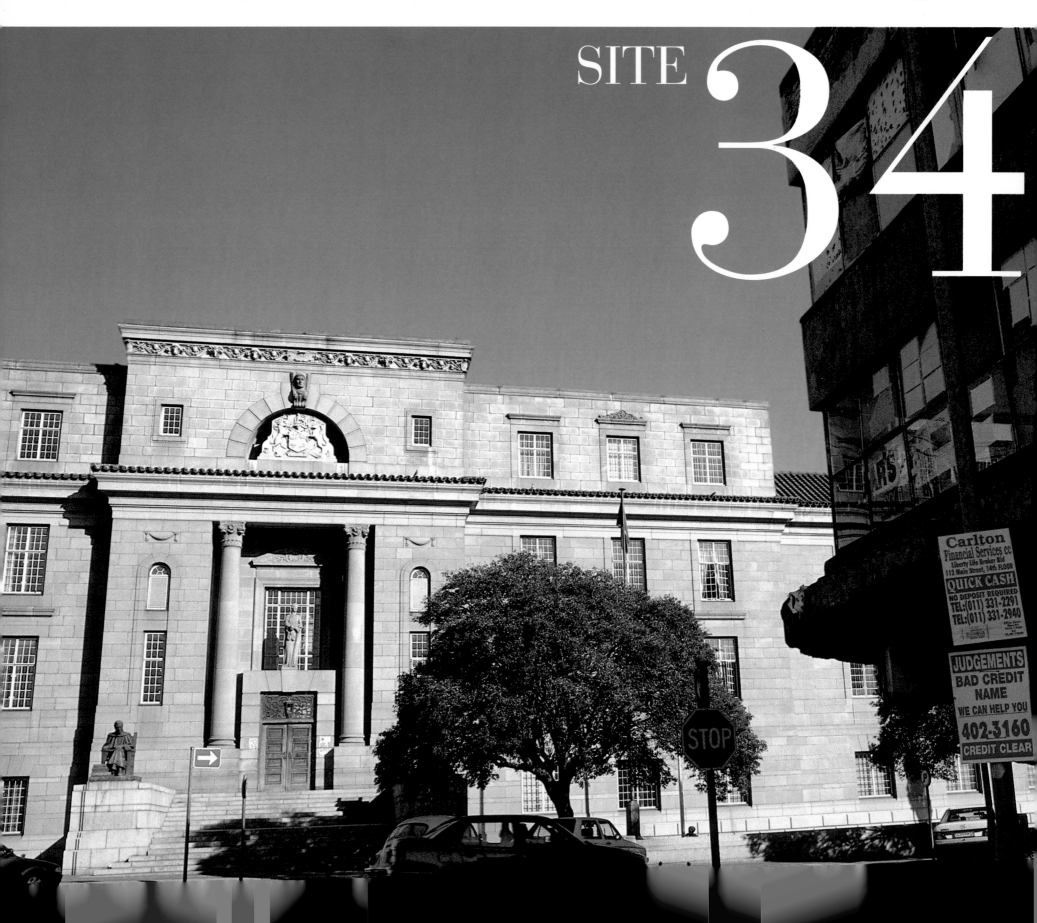

Resistance to unjust laws

Over the years, the Magistrate's Court in Johannesburg passed sentence on hundreds of thousands of men and women who infringed the pass laws and other apartheid regulations. But as the ANC grew into a mass movement, the courts increasingly dealt with political matters. Thousands were sentenced here in the 1952 Defiance Campaign, and many who afterwards broke their banning orders were indicted here. These same courts oversaw the first appearance of the accused in the Treason Trial in 1956, managed sabotage trials, and brought renowned Afrikaner advocate Bram Fischer and others to trial in the 1960s. In the even harsher decades ahead, many of the accused brought into these courts had already endured long periods of detention, solitary confinement and torture. Worse still, new draconian laws ensured that the courts could be by-passed altogether. Detainees could be held in solitary confinement for many months, entitled only to a token visit by a magistrate from time to time.

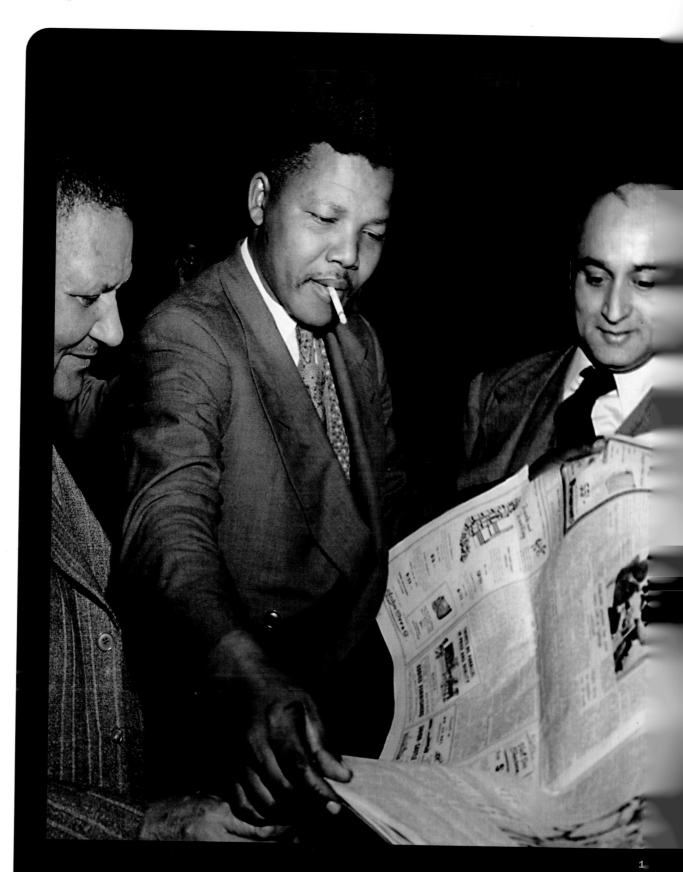

1

Mandela on trial after the Defiance Campaign, shown here with co-accused Dr Moroka and Dr Dadoo

In the 1950s, Mandela was a familiar figure in the Magistrate's Court, both as an attorney and as an accused. In August 1952, twenty African and Indian leaders of the Defiance Campaign, including Mandela, were arrested and charged under the Suppression of Communism Act.

Significantly, this very Act was one of the Defiance Campaign's 'Six Unjust Laws'. The accused were convicted and sentenced to nine months' hard labour, suspended. Effectively, the trial prevented any of them from taking part in Congress activities for two years.

The Defiance Campaign resulted in further legislation to throttle extra-parliamentary opposition. A proclamation in November 1952 imposed a massive fine of 300 pounds on anyone who caused 'Natives to resist or contravene any law'.

Early the following year, two new laws gave more powers to the Minister of Justice, allowing him to suspend any existing law if he deemed the safety of the country to be endangered. And the Criminal Law Amendment Act forbade newspapers from publishing any report of an incident which might encourage black people to resist the law.

2
Drum, 1954

The Defiance Campaign also resulted in a barrage of bannings and confinements. The Suppression of Communism Act or the Riotous Assemblies Act were used to prohibit people from attending gatherings or to restrict them to a certain province, a neighbourhood, or even their own houses.

Some were ordered to resign from their jobs, where these might somehow be used to strengthen black opposition, in the official view. Schoolteachers and factory workers who were also union organisers were among those banned and obliged to find other employment.

DRUM:

Yusuf Dadoo, ex-president, SAIC.

Nelson Mandela, ex-president, Tvl. ANC.

James Phillips, ex-chairman, Tvl. CPAC.

Duma Nokwe, secretary, ANC Y.L.

Walter Sisulu, ex-secretary, ANC.

Albert Luthuli, president, ANC.

Yusuf Cachalia, secretary, SAIC.

John B. Marks, ex-president, Tvl. ANC.

Stephen Sello, ex-Tvl. acting secretary.

David Bopape, ex-secretary, Tvl. ANC.

Moses Kotane, ex-leader, ANC.

Dr. Z. Njongwe, ex-chairman, ANC.

Cassim Amra, ex-leader, Indian C.

Dr. Silas M. Molema, ex-treasurer, ANC.

The Effects of New Laws: 2

BANNED MEN

DURING the last few months, nearly all the non-White leaders in South Africa have been restricted in their movements and activities. Most of them have been called upon to resign their positions in the African National Congress or the South African Indian Congress. Many of them have been forbidden to attend any gatherings, or to enter certain magisterial districts in the Union.

Albert Luthuli, for instance, president of the African National Congress, is forbidden to move away from his own district at Groutville, Natal. He cannot visit the shops in Durban, thirty miles away, or attend the cathedral there.

Most of the bans are in force for two years, after which time they may be renewed: some have already been renewed.

The bans take effect under the Suppression of Communism Act of 1950. This allows the Minister of Justice to prohibit from gatherings or organisations anyone suspected of furthering the aims of Communism. 'Communism' is defined under the act as aiming to bring about social economic or political changes in the country.

Many of those convicted or 'named' under the Suppression of Communism Act are not 'Communists' in the usual sense of the term, but 'Statutory Communists' who come within the definition of the act.

Maulvi Cachalia, ex-secretary, Tvl. I.C.

Dr. Diliza Mji, ex-secretary, ANC.

J. Mavuso, ex-Transvaal ANC leader.

Nana Sitha, ex-president, Transvaal I.C.

Dan Tlhoome, ex-leader, ANC.

Flag Boshielo, ex-leader, Transvaal ANC.

N. Thandray, ex-Tvl. secretary, I.C.

Hosia Seperepere, ex-leader, ANC.

Frank Marquard, ex-president, Cape F.W.U.

Joseph Matthews, ex-president, ANC Y.L.

Robert Matji, ex-secretary, Cape ANC.

MacDon. Maseko, ex-leader, ANC.

Ismail Bhoola, ex-sec., Tvl. Indian YC.

Harrison Motlana, ex-secretary, Tvl. Y.L.

Those arrested for breaking their banning orders — by attending social gatherings, for instance — were charged in the Magistrate's Courts.

A typical banning order from 1953, received by Mandela and scores of other activists, spoke the pompous legalese of the day: 'Whereas I, Charles Robberts Swart, Minister of Justice, find that you arouse animosity between the European section of the Union and another section, i.e. non-European; now therefore by virtue of the powers given to me in subsection 12 of Section 1 of the Riotous Assemblies and Criminal Amendment Act, 1914, as amended, I forbid you, for a period of twelve months...'

In his statement from the dock in 1962, Mandela eloquently expressed the consequences of this tyrannical legal system: 'I was made, by the law, a criminal, not because of what I had done, but because of what I stood for, because of what I thought, because of my conscience.'

By the time of Mandela's trial in 1962 the ANC itself had been banned, and the role of the courts made almost redundant as the state handed over more power to the Special Branch of the police, who could detain activists indefinitely.

3

The trial of the Defiance Campaign leaders, Moroka, Mandela and others, brought hundreds of school children to protest outside the courts. 'South Africa is a vast prison', declared one poster. 'Show your protest. Attend courts', urged others.

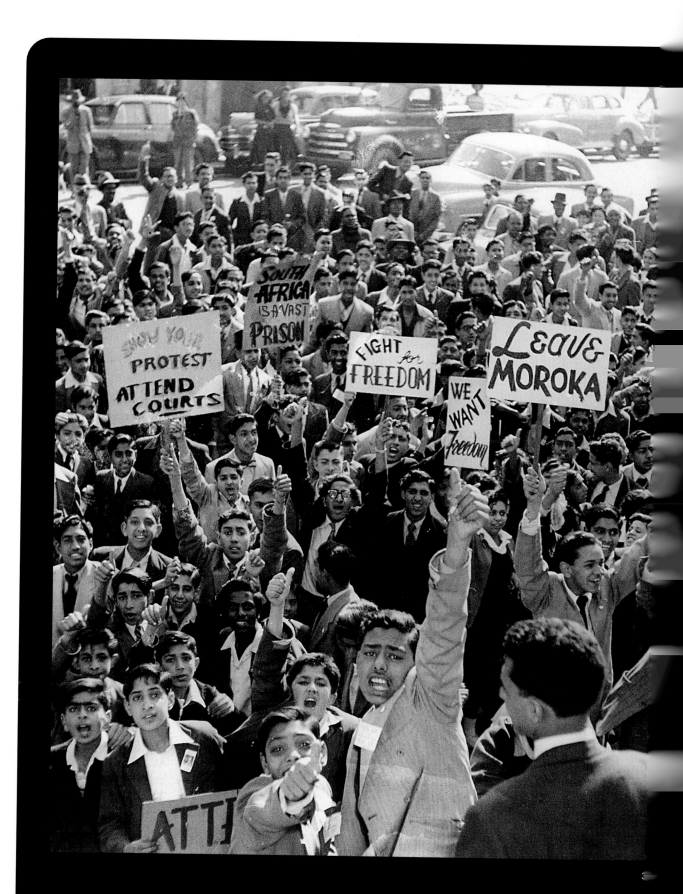

Chief Albert Luthuli's house, Groutville

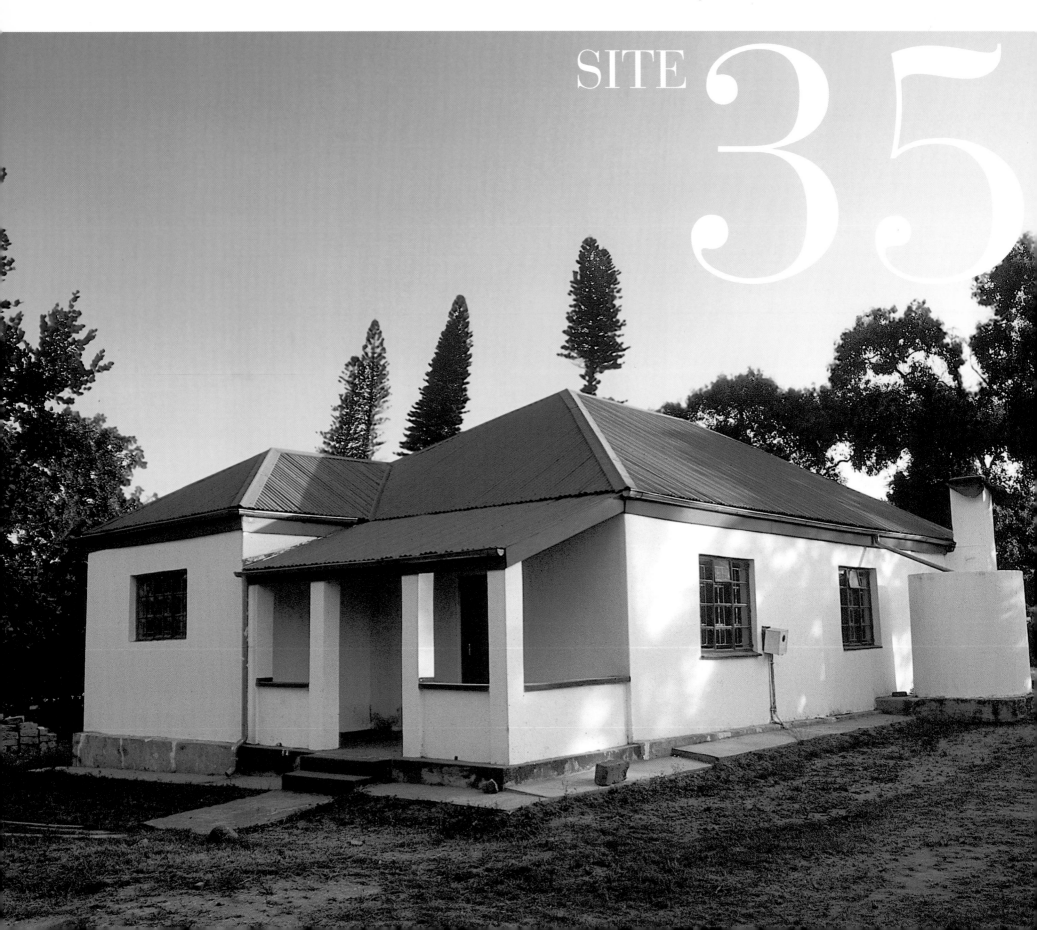

Africa's first Nobel Peace Prize winner

Albert Luthuli was the son of a missionary. The synthesis of cultures that his background involved is reflected in his home, part Western and part traditional. The original house, built before 1905, was built with earth and bamboo. The extension to the house — an indoor kitchen, pantry and sitting room — was added in the early 1950s. Luthuli, a sugar farmer, lived on a few acres of land which included gardens, an orchard and a cattle kraal.

 The Luthuli house has been declared a national monument. During renovations made in 1999, a briefcase was discovered beneath the floorboards. Luthuli had kept a diary and correspondence hidden from the security police. Across the road stands the prefabricated hut occupied by the security police, who monitored all the comings and goings at the house. A museum in honour of Chief Luthuli is being planned.

1

Luthuli and his wife Nokukanya gardening at Groutville. Mrs Luthuli had been a domestic worker in her youth, and at the end of her service brought home a calf, which started the breeding of the family's stock.

Chief Albert Luthuli's house, Groutville

In the election of Chief Albert Luthuli to the ANC Presidency, Mandela and other Youth Leaguers again became kingmakers. They actively promoted Luthuli to supplant Dr J.S. Moroka, who had disappointed the younger ANC leadership by denying responsibility for the Defiance Campaign during the trial. Luthuli, on the other hand, was esteemed for his integrity. In the era of the Bantu Authorities Act, which aimed to control the chiefs, it seemed to Mandela and his peers that many chiefs were failing the nation. Luthuli's principled opposition impressed upon the ANC a strong belief in the morality of its cause.

2

In June 1959, 10 000 people gathered at the Johannesburg City Hall to protest against the banning of Chief Luthuli and Oliver Tambo.

Luthuli was a devout Christian and highly respected teacher, farmer and traditional leader since 1934. In 1952, the apartheid government removed him from the chieftaincy — after he declined to resign from office as the president of the ANC in Natal. He became the model of the traditional leader who refused to be co-opted into the apartheid system. The stirring words in which he responded to his dismissal were often quoted:

'Who will deny that thirty years of my life have been spent knocking in vain, patiently, moderately and modestly at a closed and barred door? What have been the fruits of moderation? The past thirty years have seen the greatest number of laws restricting our rights and progress, until today we have reached a stage where we have almost no rights at all. It is with this background and with a full sense of responsibility that, under the auspices of the African National Congress, I have joined my people in the new spirit that moves them today, the spirit that revolts openly and boldly against

injustice and expresses itself in a determined and non-violent manner.'

Luthuli was immensely popular among ANC members. 'He combined an air of humility,' recalled Mandela, 'with deep-seated confidence.' Luthuli influenced both Mandela and Tambo by his example.

In March 1960, Luthuli gave evidence in the final lap of the Treason Trial (see Sites 44 and 45). Mandela vividly recalled his position:

'The chief testified to his belief in the innate goodness of man and how moral persuasion plus economic pressure could well lead to a change of heart on the part of white South Africans. In discussing the ANC's policy of non-violence, he emphasised that there was a difference between non-violence and pacifism. Pacifists refused to defend themselves even when violently attacked, but that was not necessarily the case with those who espoused non-violence. Sometimes men and nations, even when non-violent, had to defend themselves when they were attacked.'

In 1961, Luthuli became the first South African to be awarded the Nobel Peace Prize, a fact that embarrassed and enraged the apartheid establishment. The Prize was a powerful international endorsement of the ANC's struggle against apartheid.

3

Luthuli accepts the Nobel Peace Prize in Oslo, 1961.

Luthuli led the ANC in the most militant, mass-based era of resistance since its inception, until the apartheid state outlawed the movement and drove it underground. He remained president of the ANC, even after it was banned, until his death. He was killed in July 1967 in Groutville, reportedly struck by a train. Oliver Tambo and others in the ANC believed that he had been killed by an agent of the state.

Sophiatown

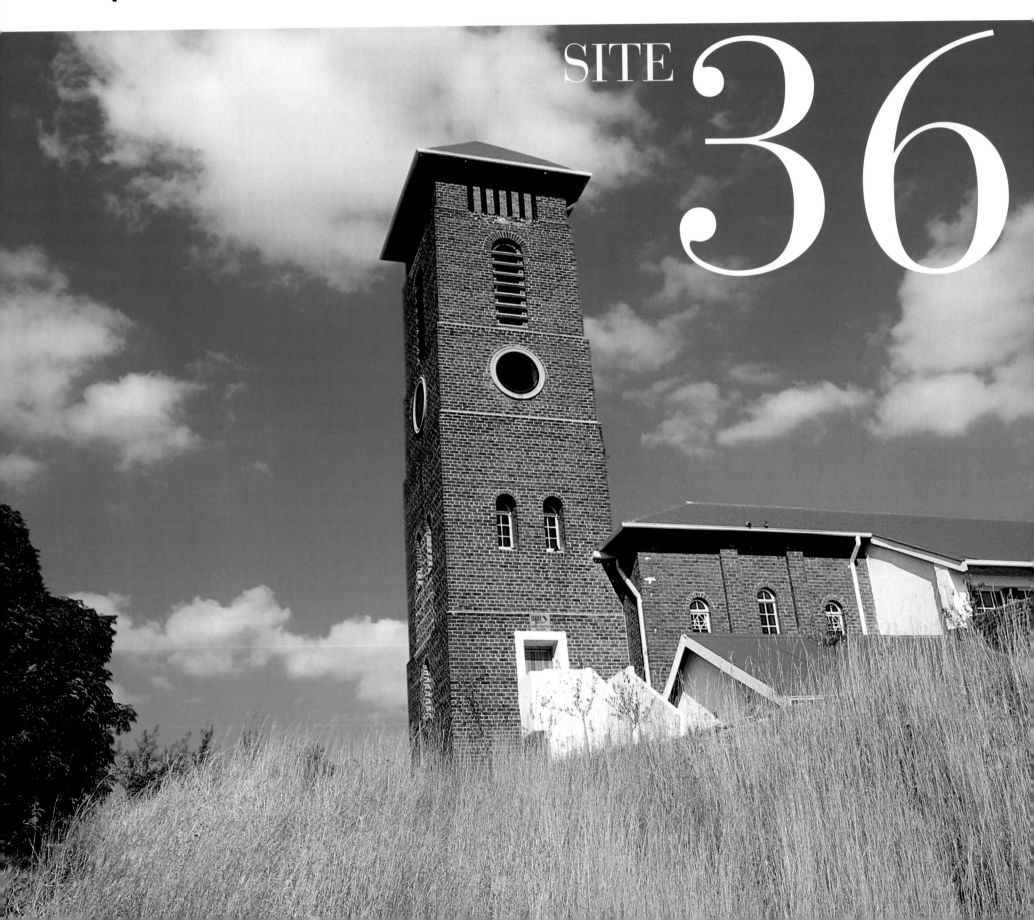

A 'black spot' in 'white' Johannesburg

In the late 1950s the apartheid government forcibly removed the people of Sophiatown, a multiracial suburb of Johannesburg, and razed the area to the ground. They built new houses for working-class whites and renamed the suburb 'Triomf' — 'Triumph'. For more than thirty years, this crude celebration of white supremacy tried, and failed, to obscure the memory of Sophiatown; its legacy lived on in the work of the many artists, actors, musicians, journalists, novelists, poets and politicians who had flourished there, against the odds, in an atmosphere of racial tolerance. In 1996, Johannesburg's democratically elected city council restored the name Sophiatown.

There are plans to create a memorial park, which will include a wall of remembrance and an amphitheatre. There will also be a walking trail offering fine views of the city skyline from the ridge.

1
The tower of Father Huddleston's church keeps watch.

2
Golf in Sophiatown: more sand traps than fairways.

Sophiatown

Gone.
Buried.
Covered by the dust of defeat — or so the conquerors believed. But there is nothing that can be hidden from the mind. Nothing that memory cannot reach or touch or call back. Memory is a weapon.
I knew deep down inside of me, in that place where laws and guns cannot reach nor jackboots trample, that there had been no defeat. In another day, another time, we would emerge to reclaim our dignity and our land. It was only a matter of time and Sophiatown would be reborn.
— Don Mattera[10]

In the 1950s Johannesburg still had pockets of mixed social and residential interaction, particularly in working-class areas. Sophiatown was under-serviced, largely poor, hard-living and dangerous. For blacks, most means of survival were illegal. Beer brewing, a skill which rural women brought with them to the city, had been criminalised. Nevertheless, despite the police raids, fines and imprisonment, the sophisticated Sof'town shebeens were enormously popular places of music and dance, lively conversation and often heated political debate.

'I know Sophiatown at its worst,' Father Huddleston wrote, 'in all weathers, under all conditions, as a slum living up to its reputation. I still love it and believe it has a unique value. But why?... Sophiatown is not a location. That is my first reason for loving it. It is so utterly free from monotony, in its siting, in its buildings and in its people.'[11]

3
There was always music in the air.

4
'Ons dak nie' — 'We won't budge'
Protest meeting, 1953

The apartheid authorities set out to create distance between black, brown and white by carving up the city into racial zones. Sophiatown, adjoining the white area of Westdene, was deemed to be a 'black spot' in 'white' Johannesburg, and the government was determined to rub it out.

There was protest against the planned removals. But the community in Sophiatown was not monolithic.

'This is Dr Xuma's eight-roomed house,' *Drum* commented wryly in January 1958. 'Real comfortable. No wonder he doesn't want to move.' (See Site 16.) But for the many tenants living in overcrowded rooms in backyard shacks, paying high rents, a new, 'matchbox' house could only be an improvement. This ambivalence was reflected in the compliance of many tenants with the police when the trucks came to take them away.

5

A battery of police vans moves in on the first day of the removals.

6

'And still I wander among the ruins trying to find one or two of the shebeens that Dr Verwoerd has overlooked. But I do not like the dead-eyes with which some of these ghost houses stare back at me.'[12]

As president of the ANC in the Transvaal, Mandela noted early in the campaign: 'A political movement must keep in touch with reality and prevailing conditions. Long speeches, the shaking of fists, the banging of tables and strongly worded resolutions out of touch with the objective conditions do not bring about mass action and can do a great deal of harm to the organisation and the struggle we serve.'

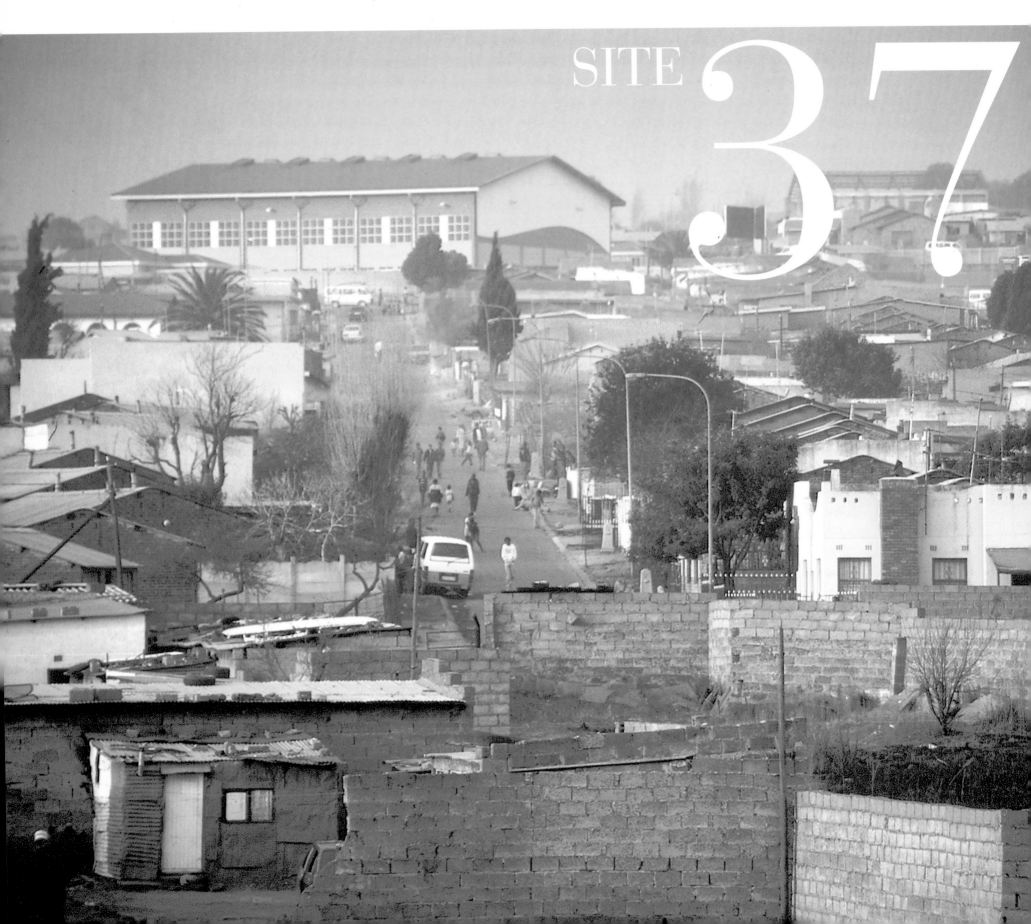

Meadowlands, Soweto

SITE 37

The making of the townships

Meadowlands was a significant step in the grand apartheid plan to fortify the segregated city. A large strip of land now separated the 'white city' from the black locations. But if apartheid's social engineers thought they would crush the vitality and creative resourcefulness of black culture by removing Sophiatown's black residents to Meadowlands, they were mistaken. The strict controls over the movement of black people in the townships served ironically to lock these neighbourhoods together. Over the years they bonded to form well-knit, supportive communities. Burial societies, cooperative savings clubs — known as 'stokvels' — women's charity groups, choirs, and dance, theatre and music clubs all flourished throughout the apartheid years. The members of the Soweto String Quartet, to name just one well-known group, were born and bred in Meadowlands.

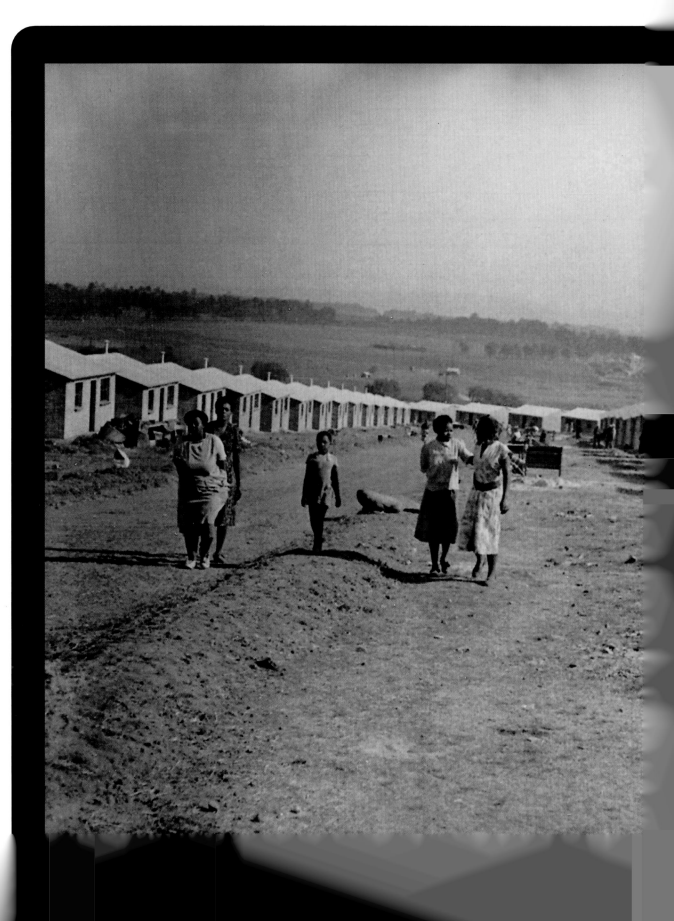

1
The new township of Meadowlands, 1958

THIS IS BOYCOTT MONTH

NEW AGE

Vol. 6, No. 21. Registered at the G.P.O. as a Newspaper

NORTHERN EDITION Thursday, March 10, 1960 6d.

IN SOUTH AFRICA AND ABROAD, FREEDOM FIGHTERS LAUNCHED BOYCOTT CALLS THIS MONTH.

● In Britain the month of March has been set aside for an intensified boycott of all South African goods in protest against apartheid.

● In South Africa the Congress movement has called for a complete boycott of all celebrations connected with the Union Festival.

Father Trevor Huddleston addressing the enormous crowd which gathered in Trafalgar Square, London, to launch the boycott of South African goods.

BRITISH RESPOND TO BOYCOTT CALL

Mass Opposition To Apartheid

From Tennyson Makiwane

LONDON.

DESPITE the attempts of the right-wing press to play down the boycott (and the Mosley fascists to break it up), enthusiasm for the boycott of South African goods is mounting daily.

Seldom has an issue like this been so prominently splashed in the British press, debated on radio and television, and there is no doubt it has made its mark on the British public.

AFTER an impressive march of 1½ miles, thousands of people led by a brass band entered Trafalgar Square here on Sunday, February 28, to support the boycott of South African goods.

At the head of the marchers were Father Trevor Huddleston, who had pinned to his gown the "Isithwalandwe" medal presented to him at the Congress of the People in South Africa in 1955; Labour leader Hugh

Gaitskell and several M.P.s including Jeremy Thorpe of the Liberal Party.

Altogether 8,000 people crammed the square to listen to the speeches. The crowds cheered and raised a forest of hands when the resolution calling for the boycott was put to the meeting. Other resolutions included a message to the British Prime Minister calling on him and his family to boycott South African goods; and also one to the African National Congress and other organisations in South Africa expressing solidarity with them in the struggle against apartheid.

MOSLEY'S FASCISTS

Throughout the meeting 4 or 5 lorries belonging to the Mosley fascists circled the square displaying anti-boycott slogans and generally trying to provoke the crowd. Some Mosleyites carried banners reading "Britons Awake — Be Right, Buy White".

The march to Trafalgar Square started shortly before 2 o'clock. A

(Continued on page 8)

"DON'T TAKE PART IN FESTIVAL OF SLAVERY"

Says Congress

JOHANNESBURG.

"**D**O NOT TAKE PART IN THE OFFICIAL CELEBRATIONS—FOLLOW THE CONGRESS and FIGHT FOR FREEDOM," says the leaflet issued by the Congress movement on the Union Festival celebrations which opened last week with official 'Whites Only' parades in several parts of the Union.

The Government will stage games for school children, says the leaflet but "we demand an end to police oppression and freedom for all".

MOURN FOR THE LOSS OF FREEDOM

Don't Forget To Wear Something Black For The Duration Of The Festival —From Now Until May 31.

By Order of Congress.

50 YEARS OF UNION HAS BROUGHT THIS —

PASS LAWS

GHETTOES

BANTU "EDUFATION"

HUNGER - LOW WAGES

DON'T TAKE PART IN THE FESTIVAL CELEBRATIONS!

The folder is illustrated with drawings of what 50 years of Union has brought:
● Pass laws,
● Ghettoes,
● Bantu Education,
● Hunger, Low wages.

It says: Fifty years ago in 1910 the European governments of the Cape, Natal, the Transvaal and the Orange Free State united to form one central government, the Union of South Africa.

Fifty years ago white supremacy was established by the Act of Union.

What are we to celebrate?
● We have been robbed of our rights to our land.
● We have been given colour bars, pass laws, raids and police rule.
● Our leaders have been banned and banished.
● Our women have been forced to carry the hated pass that brings prison, separation and suffering to all.
● Our children have become victims of Bantu Education, denied the right to proper learning, the universities closed to them.
● We may not live where we choose, work where we choose, move around freely like free men.
● Our cattle have been culled.
● Taxation has been increased and extended to our women to impoverish us.
● Bantu authorities and Bantustans have been imposed on us.

THE UNION FESTIVAL CELEBRATES 50 YEARS OF SLAVERY. BOYCOTT THE OFFICIAL CELEBRATIONS.

Meadowlands was one of the many new black residential suburbs that eventually made up the sprawling 'dormitory township' of Soweto (an acronym derived from South Western Township). Soweto was the largest of the apartheid-era townships, places that were blatantly conceived as mere 'locations' for a black labour supply to serve the white cities and industries. The facilities were minimal: there were hardly any shops, cinemas, clubs or leisure areas, sports fields, community centres or theatres. Yet the apartheid government prided itself on having cleared the urban 'slums' and provided housing for the black population.

As people were resettled, the authorities tried to place them in ethnic areas, endeavouring to keep even the black language groups separate. Eventually, apartheid's architects hoped, all these different ethnic groups would be resettled in their respective ethnic 'Homelands'.

Although present-day Soweto has changed considerably as residents have begun to modify and improve their homes in the post-apartheid era, each suburb displays a distinctive architecture. Often this style is a crude reminder of the period in which the building was done, with entire blocks of identical sub-economic dwellings following the design of the town planner of the day. There were various styles of NE houses — the 'NE' stood for 'Non-European' — some of them fairly bizarre: the pre-cast round-topped concrete 'elephant houses' of the early 1950s; houses in which sheets of corrugated iron were bent to form both walls and roof; 'matchbox' houses (the famous NE 51/9 series) made of brick with asbestos roofs; and houses made of concrete blocks, as in Meadowlands.

2

In March 1960, Father Huddleston called for a boycott of South African goods before a huge crowd in Trafalgar Square.

Father Trevor Huddleston, the much-loved Anglican priest and resident of Sophiatown, sarcastically explained the thinking behind apartheid planning:

'The great advantage of the location is that it can be controlled. People who come to visit their friends for the week-end must have permits before they can set foot upon that arid, municipal turf. It is so much easier, too, to prevent the native feeling himself a permanent resident in our cities if non-payment of rent is a criminal offence, rather than a civil one. The presence, in every location, of a European Superintendent with his small army of officials, black and white, and his municipal police, is a sound and healthy reminder that, in South Africa, the African needs the white man to guide and direct his daily life. And, in the sphere of broader strategy, it is also wiser to have the native living in one large but easily recognisable camp, than scattered around the town in smaller groupings. If there is trouble in Johannesburg, for instance, Orlando can be "contained" by a comparatively small force.'[13]

Thanks in large part to Huddleston's passionate writing, which appeared in both the South African and the British press, the impending removal of Sophiatown received major international attention. After he was recalled to London, Huddleston continued to fight against apartheid. He took up Luthuli's suggestion of an international boycott of South African goods. This initiative continued for many years, and international sanctions eventually helped to bring down the apartheid government.

He died in England in July 1998. In accordance with his will, his ashes were transported to South Africa and buried in Sophiatown.

Archbishop Huddleston, Winnie Madikizela-Mandela and Adelaide Tambo with Mandela. In 1992, Archbishop Huddleston was for the second time awarded the ANC's highest honour, the Isitwalendwe Award. The first was conferred on him at the Congress of the People, in 1955

St Mary's Cathedral, Johannesburg

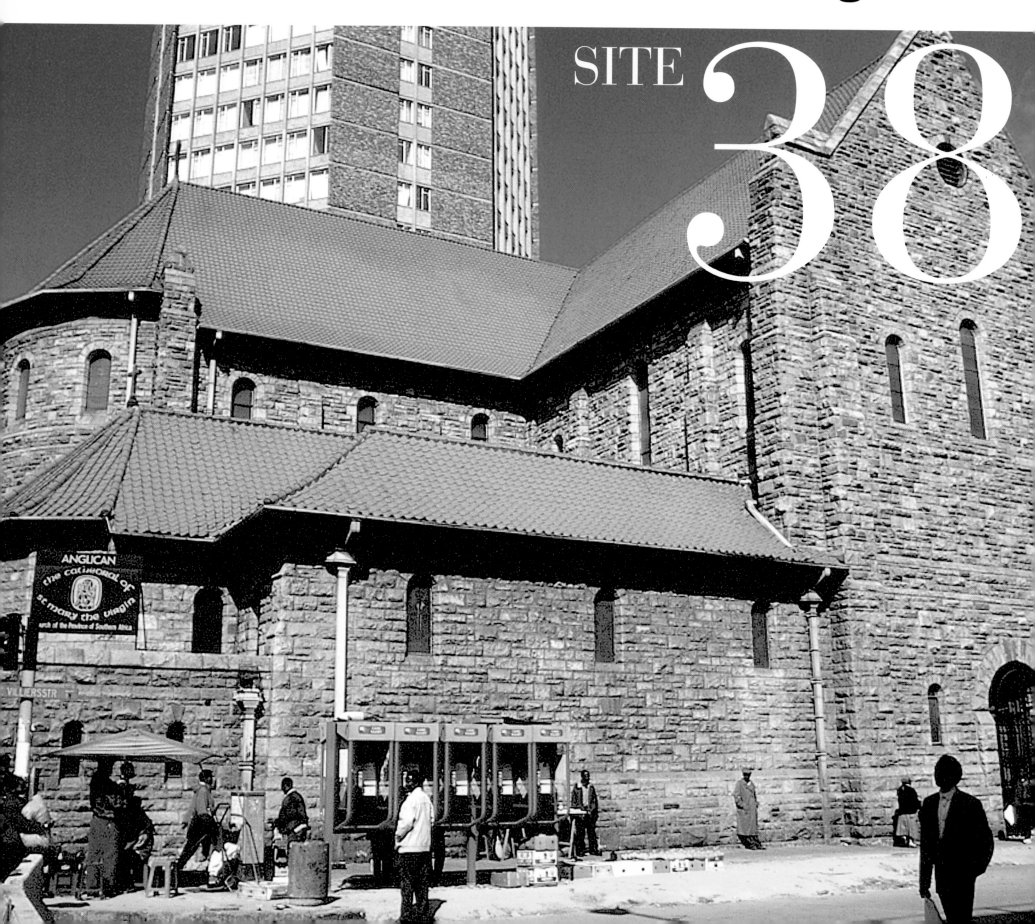

The founding of the Congress of Democrats

In the 1950s, St Mary's Cathedral was one of the few non-racial churches in downtown Johannesburg. After the closing down of St Cyprian's a few kilometres away, the black congregation swelled. Darragh House, an adjoining building (shown opposite, in the background) which belonged to the church, was also made available for non-racial meetings. During the apartheid years, the cathedral hosted many services in support of the struggle, especially in the 1970s and 1980s, when Bishop Tutu, Dean of St Mary's from 1974–76, gave moral and spiritual counselling to the liberation movement.

An informal trading area developed around the cathedral in the 1980s, with the priests offering protection from the local authorities to women selling food. Today, there are plans for traders to move to the specially designed market in nearby Drill Hall

1

A meeting of the COD, Darragh Hall, 1952. Cecil Williams, the theatre producer and left-wing activist, Rev. Douglas Thompson and Bram Fischer are on the platform.

'We saw the COD as a means whereby our views could be put directly to the white public. The COD served an important symbolic function for Africans; blacks who had come into the struggle because they were anti-white discovered that there were indeed whites of goodwill who treated Africans as equals.'

St Mary's Cathedral, Johannesburg

2

A few dozen whites had demonstrated their commitment to democracy in the Defiance Campaign. Some had been members of the recently banned Communist Party of South Africa, and now had no political home. At a meeting in Darragh Hall called by ANC secretary Oliver Tambo in 1952, he urged white democrats to form their own organisation. The Congress of Democrats (COD) was formed later that year. The constitution of the COD was based on the Universal Declaration of Human Rights, and included the principle of one person one vote.

'The members were a mixed bag. They included every kind of person who had contact with Africans — Christian priests, liberal intellectuals, do-gooders and Communists — but when the meeting voted that a European organisation should be set up to work side by side with Congress, the people who gravitated to the committee were the familiar band of white Communists and fellow-travellers who had for years been associated with Congress.'[14]

The first elected committee included Ruth First, Cecil Williams, Rusty Bernstein, Rica Hodgson and Piet Beyleveld, as well as non-communists such as Helen Joseph, Eddie Roux and others. The chairman, Bram Fischer, was banned shortly after his election, as were many other COD members in the months and years that followed.

2
Mandela with fellow accused Ruth First and COD supporter Rose Schlachte at the Treason Trial.

The COD were not the only white opponents of apartheid. The Liberal Party, formed soon afterwards, attracted a greater membership. Its best-known members were probably Alan Paton, the internationally acclaimed writer, and Patrick Duncan, son of a former Governor-General of South Africa. Duncan was the only Liberal

to join the Defiance Campaign. The Liberal Party, however, was unhappy about the ANC's willingness to work with communists.

The COD lasted for ten years as a legal organisation. It acquired a sprinkling of new young members, mostly students, who worked with other young people in the Congress Alliance, adding zest and enthusiasm to the campaigns, demonstrating in public places, painting signs on walls, distributing leaflets and generally manifesting a white presence in the landscape of extra-parliamentary opposition. In the Treason Trial, which began in the Drill Hall in 1957, 23 members of the COD were charged with High Treason, along with Mandela and 132 others.

3

A COD demonstration against removals: Babette Brown, Annie Kotkin, Yetta Barenblatt

Political journalist Ruth First maintained an intellectually stimulating relationship with the ANC leadership. In 1963, First was held in solitary confinement for 117 days, and narrowly avoided a breakdown. In exile, one of her early tasks was to edit a collection of Mandela's speeches and writings, *No Easy Walk to Freedom*. In First's foreword to the 1973 edition, she wrote eloquently about the jailed Mandela as 'the beleaguered revolutionary, fighting on his own battleground'.

Oliver Tambo, Mandela's close friend and partner, who had convened the founding meeting of the COD, eventually succeeded Chief Luthuli as the president of the ANC and led the organisation in exile. Just over forty years after that first COD meeting in Darragh Hall, Tambo came home. Already suffering from the ravages of a stroke, he died in Johannesburg on 24 April 1993. The body of this steadfast Anglican lay in state at St Mary's Cathedral.

4

Oliver Tambo lying in state at St Mary's Cathedral. 'When I looked at him in his coffin, it was as if a part of myself had died.'

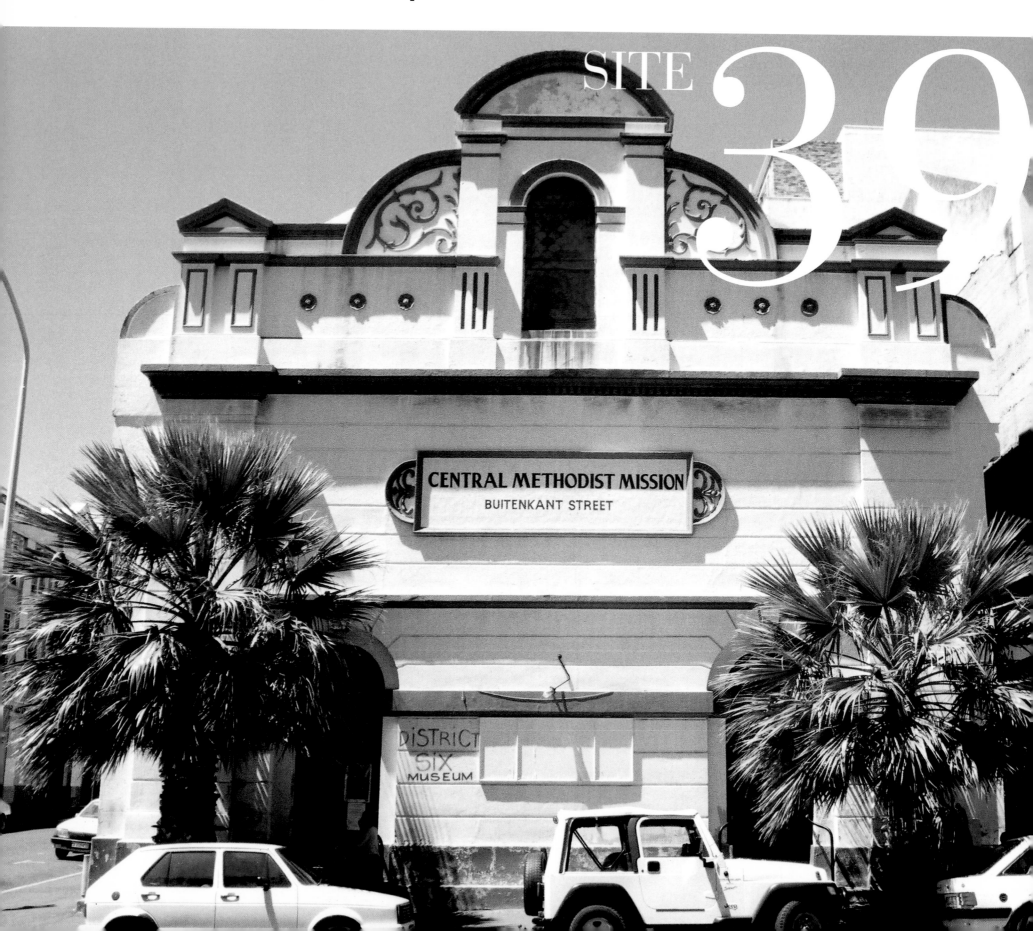

District Six, Cape Town

SITE 39

CENTRAL METHODIST MISSION
BUITENKANT STREET

DISTRICT SIX MUSEUM

The Coloured People's Congress

District Six, a crowded, colourful old quarter on the slopes of Table Mountain, was once the multi-racial heart of Cape Town. But in 1966 according to its 'grand plan', the apartheid government declared the area white. Over the following years the residents were forcibly removed, mainly to distant ghettos on the Cape Flats, and the houses were razed. Almost the only remains are the churches and mosques that once tended to this now scattered community. The former Methodist Mission in Buitenkamp Street, built in 1850 specifically to minister to former slaves, now houses the highly successful, interactive and community-based District Six Museum.

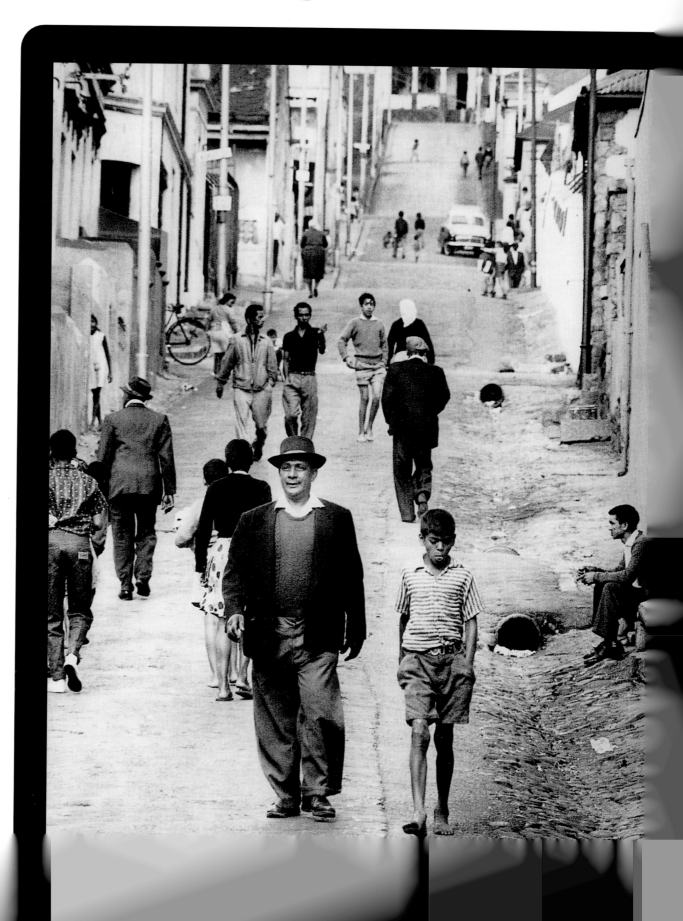

1

'He turned down another street, away from the artificial glare of Hanover, between stretches of damp, battered houses with their broken-ribs of front-railings; cracked walls and high tenements that rose like the left-overs of a bombed area in the twilight; vacant lots and weed-grown patches where houses had once stood; and deep doorways resembling the entrances to deserted castles ... In some of the doorways people sat or stood, murmuring idly in the fast-fading light like wasted ghosts in a plague-ridden city.'[15]

District Six, Cape Town

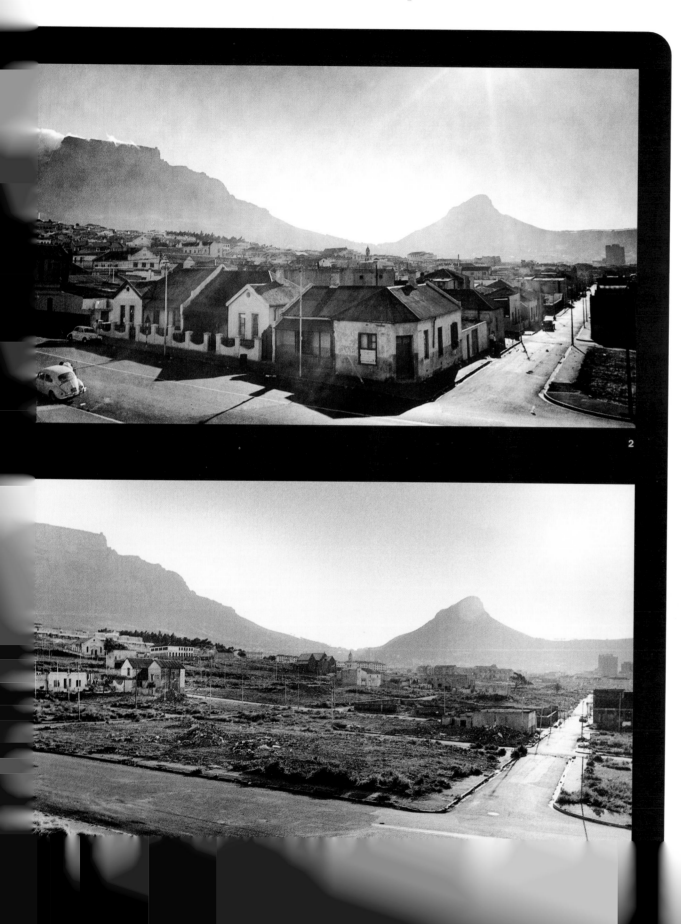

2

Despite being categorised under apartheid as a separate 'race', Coloured people never formed a monolithic group. They lived in communities throughout South Africa and came from a wide variety of backgrounds, cultures and religious affiliations. They were politically diverse too. Among the many well-known political leaders who called District Six home were Clements Kadalie and John Gomas of the mass-based Industrial and Commercial Workers' Union of the 1920s, James la Guma and Moses Kotane of the Communist Party, I.B. Tabata of the Non-European Unity Movement, and Eddie Daniels, the Liberal Party member who served more than twenty years on Robben Island. Nevertheless, Coloured people did endure a distinctive form of oppression: in the highly racist societies of both the colonial and the apartheid eras, they always seemed to be caught between the white oppressors and the black oppressed.

2

Before the removals...

Coloured opposition to racial discrimination in the Western Cape can be traced back to the resistance of slaves and Muslims in the 18th and 19th Centuries. In the 1950s, there was strong opposition to the formation of a separate 'Coloured Affairs Department'. This opposition drew on two different traditions associated with opposing strategies. The Non-European Unity Movement, which steered resistance to the Coloured Affairs Department, mainly used the boycott; whereas the Communist Party, which was led in the early 1950s in the Western Cape by Reggie September, favoured mass civil disobedience. There were attempts to bring the two streams together in the 'Train Apartheid Resistance Committee' when the apartheid government relegated Coloured passengers to

3

and after...

second class, but the organisations failed to agree.

The labour movement was perhaps the most important form of organised resistance in the Cape. The National Party was anxious to avoid an alliance between Coloureds and Africans. Their Coloured Labour Preference Policy for the Western Cape helped to maintain racial divisions in the workplace. However, strong leadership drawn from the Communist Party, until they were banned, and also from the ANC, kept many militant trade unions within the ambit of the Congress Alliance.

4

Cissie Gool was the great-granddaughter of freed slaves. Her father was the great Coloured leader, Dr Abdullah Abdurahman. Born and bred in District Six, she belonged to a more militant socialist generation. From 1938 to the 1950s, she represented District Six in the Cape Town City Council. She was a member of the Communist Party and a founder of the South African Coloured People's Organisation, a partner in the Congress Alliance.

5

Alex la Guma, writer, teacher and activist. In his fiction la Guma describes the vanished world of District Six. Forced into exile in the mid-60s, he died in Cuba in 1985.

6

In 1956, the apartheid government forced through legislation requiring Coloured voters to register separately and elect a white candidate to represent them in parliament. The Unity Movement disagreed strongly with the Communist Party's decision to field white candidates in the subsequent election, as these placards show.

In 1951, the Franchise Action Committee led by Reggie September announced the Defiance Campaign in the Western Cape at a mass rally.

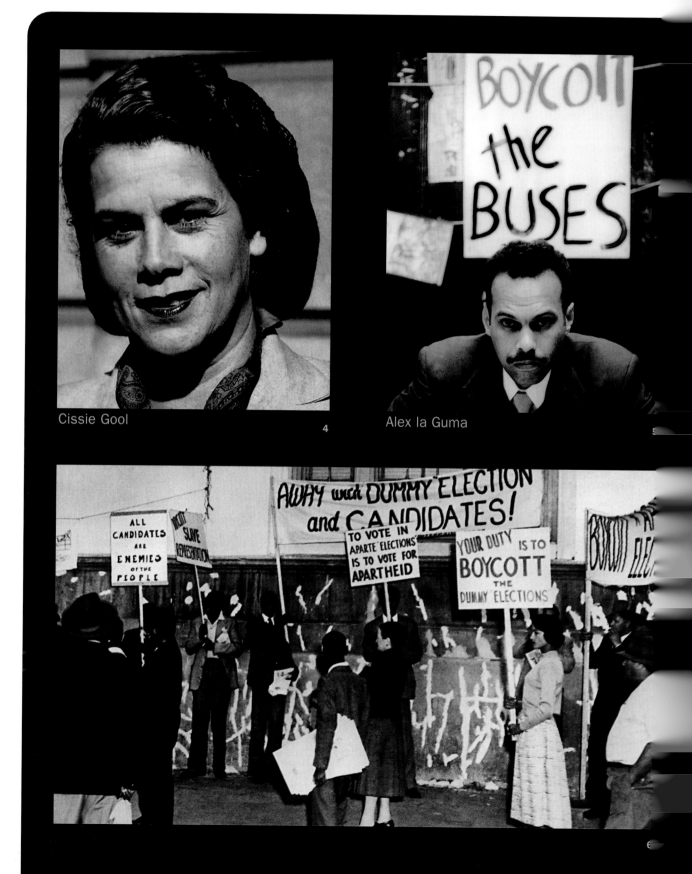

Cissie Gool

Alex la Guma

District Six, Cape Town

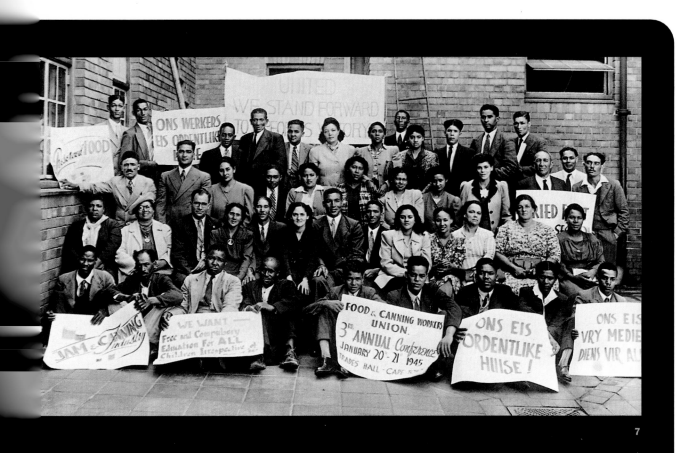

But Coloureds did not face exactly the same problems as black Africans: they did not have to carry passes, for instance, and could therefore move around more easily to sell their labour. The Defiance Campaign was successful only in Worcester, where it focused on wage demands and segregation issues that affected both Africans and Coloureds. In September 1953, the South African Coloured People's Organisation (SACPO) was founded in an attempt to strengthen the Congress presence in the Western Cape. The founding conference was addressed by Oliver Tambo and Yusuf Cachalia.

7
Residents of District Six were key members of non-racial trade unions like the Food and Canning Workers' Union, shown here in 1945.

SACPO had a number of rivals. In the Western Cape the Unity Movement was important. Their highly theoretical, purist approach appealed to many intellectuals. They were to the left of the Communist Party and contemptuous of its adherence to the 'Moscow line'. They were also critical of the ANC's woolly thinking: why, they asked, was the ANC compromising by defining the Congress Alliance in racial terms?

In 1958, in abuse of the 1910 constitution, the government removed all Coloureds from the voters' roll. The Communist Party then fielded white candidates in the 1958 elections. SACPO's view was that a boycott would be negative and shortsighted, but most Coloureds refused to register on a separate voters' roll. After Sharpeville, the arrest and banning of leading figures such as Alex la Guma, George Peake, Reg September and Barney Desai took the power out of SACPO resistance in the Western Cape.

8
Members of the Non-European Unity Movement in the 1950s. Isaac Tabata (third from left in front), one of the movement's leading intellectuals and the author of *The Boycott as a Weapon of Struggle*, corresponded with Mandela in the 1940s, hoping to win him away from the ANC.

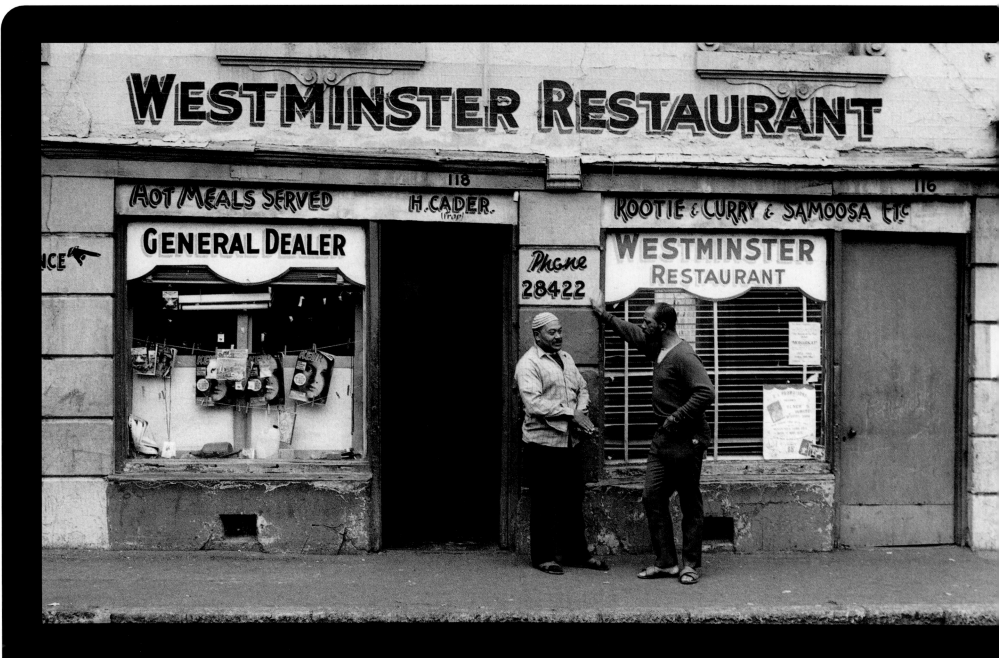

Mandela dined at the Westminster on several occasions. Unhappily, this popular meeting place was demolished during the removals, along with practically every other site of significance. The Crescent Café, where Mandela enjoyed delicious Malay cooking whenever he visited Cape Town, is gone too. In the 1950s, Cape Town was at least two days' journey from Johannesburg by car. Any black traveller, whether a migrant worker or a relatively well-off lawyer, had to make private arrangements for accommodation along the way. Mandela visited Cape Town during the Defiance Campaign, as Volunteer-in-Chief, and several other times besides. According to one observer, his tall, elegantly dressed figure raised the eyebrows of many whites in the city streets.

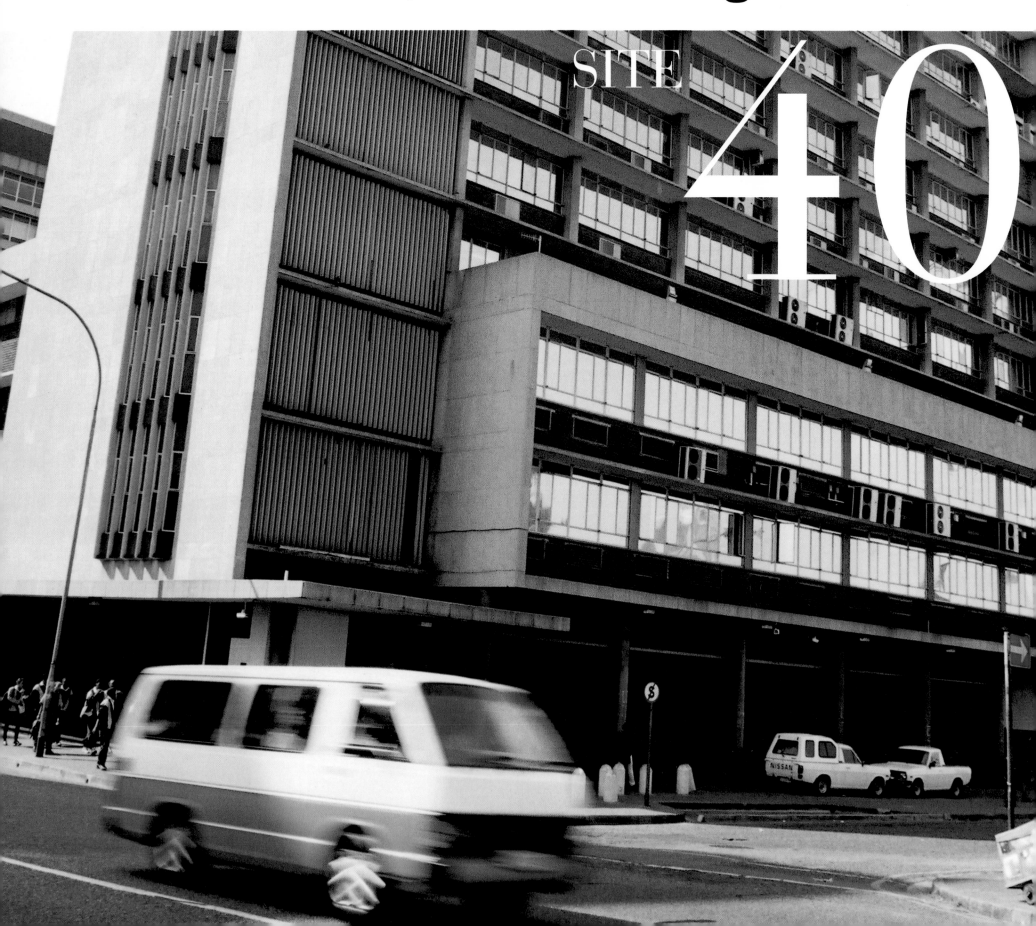

COSATU House, Johannesburg

SITE 40

Workers in the Congress Alliance

COSATU House is the headquarters of the largest trade union federation, the Congress of South African Trade Unions. COSATU was formed in 1985. It emerged from twelve years of building unions on the shop floor, after a wave of general strikes in 1973 in Natal. In 1985 the various democratic trade unions formed a federation, COSATU, to oppose simultaneously labour exploitation and racial oppression. During intense struggle against the apartheid regime in the 1980s, many of its members were detained, tortured and killed. In these years the non-racial labour movement also established a strong culture of participatory democracy, mandated leadership and accountability. COSATU's previous headquarters were bombed in 1987 and had to be demolished. No one was surprised when it was revealed at the Truth and Reconciliation Commission that the perpetrators were security police who had acted with the tacit support of the then prime minister, P.W. Botha.

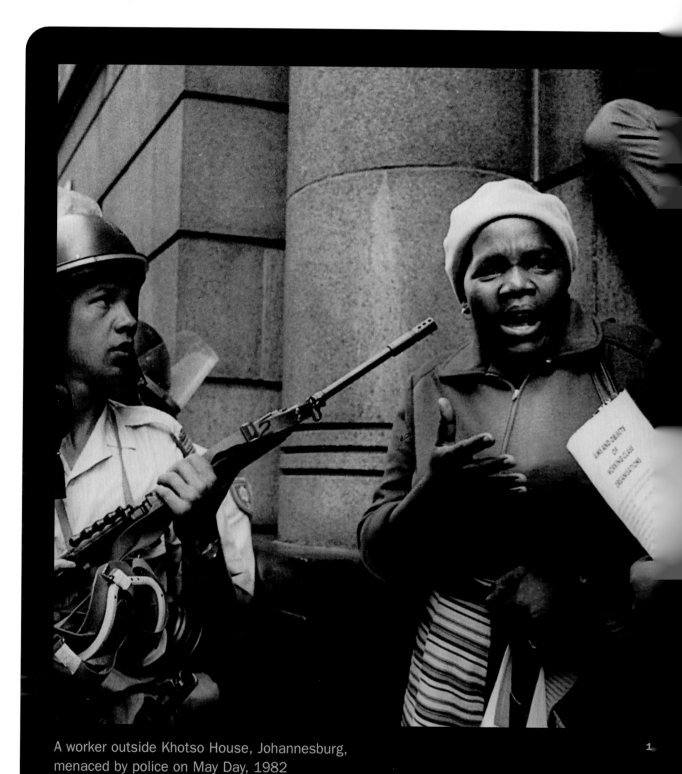

A worker outside Khotso House, Johannesburg, menaced by police on May Day, 1982

COSATU House, Johannesburg

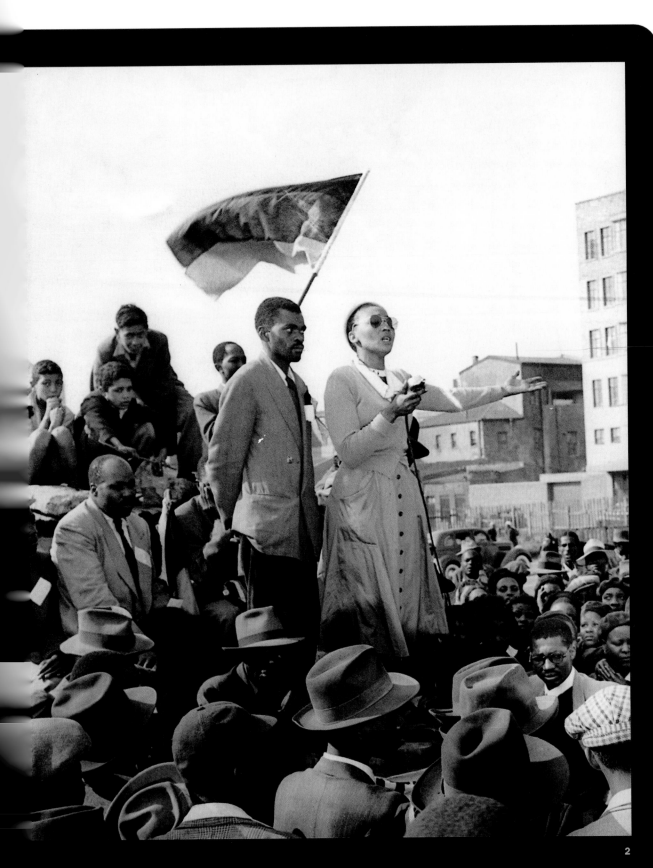

2

'COSATU
Stand up with dignity
March forward
We are raising our clenched fists behind you
Behind us
We call into line
Our ancestors in struggle
Maduna and Thomas Mbeki
Ray Alexander and Gana Makhabeni
JB Marks and hundreds more...'

Mi Hlatshwayo, 'The Tears of a Creator', a praise song performed at the launch of COSATU, 1985

COSATU is the heir to the South African Congress of Trade Unions (SACTU), which was formed as an alliance partner to the ANC in 1955. The emergence of SACTU reflected the ANC's shift towards mass participation. Nationalists in the Youth League, including Mandela, were conscious of the contribution that workers could make to the liberation movement. At the ANC's 1948 conference, David Bopape urged: 'We must use our atom weapon, the withdrawal of labour.' The stay-away was a particularly powerful weapon for workers. As Mandela put it: 'Stay-at-homes allowed us to strike at the enemy while preventing him from striking back.'

2
Violet Hashe, an organiser of the Garment Workers' Union, addresses a Defiance Campaign meeting in Red Square.

The Defiance Campaign especially drew in workers as volunteers. Mandela recognised their potential. 'While Dr Moroka addressed a crowd at Freedom Square in Johannesburg, I spoke to a group of potential volunteers at the Garment Workers' Union.' The alliance was fruitful for both sides. During strikes and boycott campaigns, unionists were able to mobilise in the

ANC branches, and SACTU's membership grew decisively. By the same token, ANC members were educated on the relationship between economic exploitation and racial oppression. The liberation movement was a 'scrambled egg' — one could not separate the struggle for economic justice from the struggle for political rights.

3

SACTU Foundation Conference, Trades Hall, Johannesburg, March 1955

In his address to the Transvaal ANC in 1953, Mandela captured this new understanding:

'From now on the activity of Congressites must find expression in wide-scale work among the masses, work which will enable them to make the greatest possible contact with the working people. You must protect and defend your trade unions. If you are not allowed to have your meetings publicly, then you must hold them over your machines in the factories, on the trains, on the buses, as you travel home. You must have them in your villages and shantytowns. You must make every home, every shack and every mud structure where our people live, a branch of the trade union movement.'

In 1959, SACTU launched a 'pound a day' minimum wage campaign. The very ambitiousness of the demand, and the boldness with which it was expressed, inspired workers. The Campaign did not achieve its ends, but it greatly increased the profile of the trade union movement. It brought the ANC and the labour movement together, and left a legacy of worker organisations linked to the demand for social change.

The strikes which swept through Natal in 1973 were 'the SACTU legacy come home to roost.'[16]

4

Mandela and COSATU's Mbhazima Shilowa, 1998

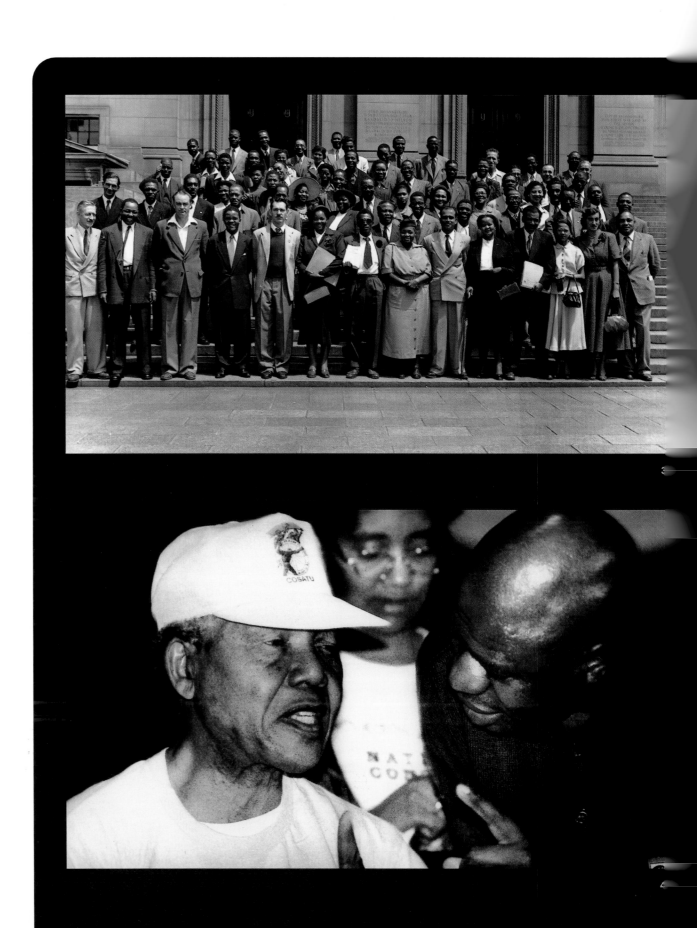

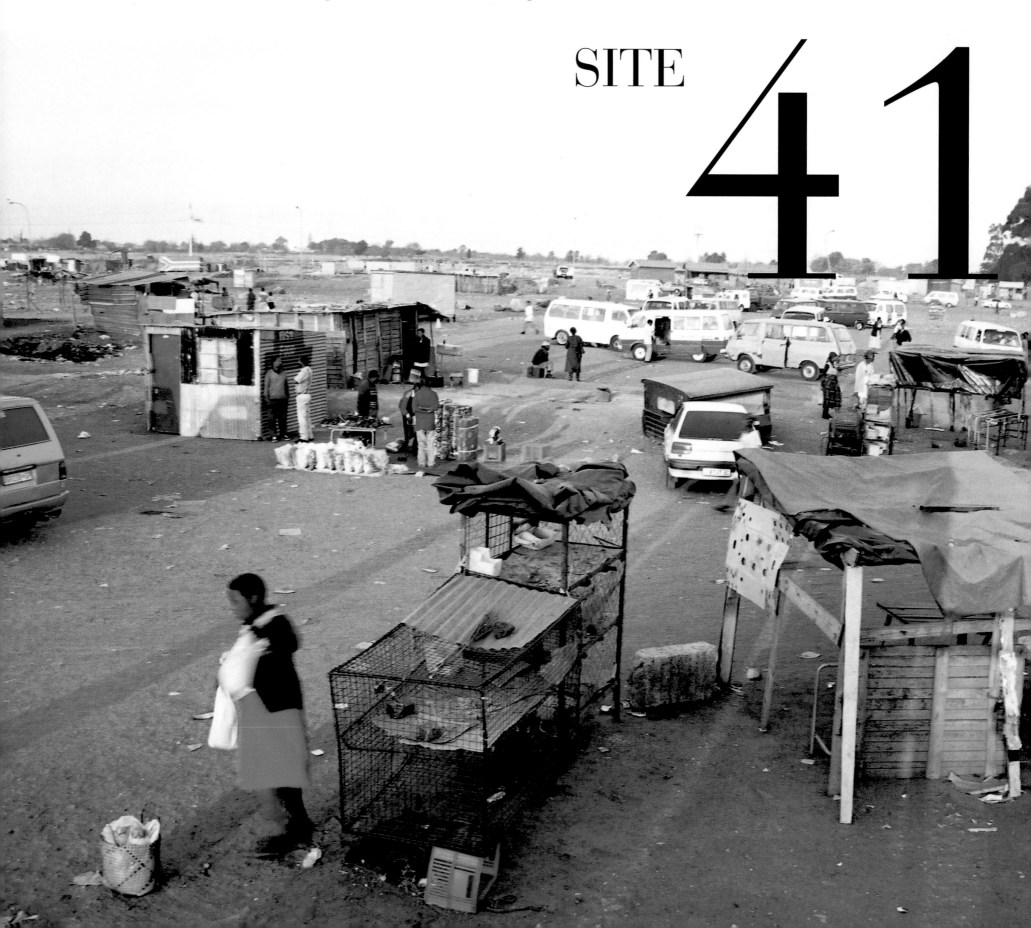

Freedom Square, Kliptown

SITE 41

The signing of the Freedom Charter

Freedom Square, off Union Street in Kliptown, Soweto, is a site of major historical significance. It was here, on 26 June 1955, that the Congress of the People approved the Freedom Charter. Thanks to apartheid restrictions in the township, Union Street has not changed much in the last fifty years. Shops and houses in the vicinity still have an air of the 1950s, and the precinct has now been declared a national monument. An international competition is being planned to find a design for the commemoration of the Congress of the People, in consultation with the Kliptown community. In addition to the monument itself, the development will include rehousing residents of the surrounding informal settlements and providing facilities for the community, as well as a museum to acknowledge the national significance of this site.

1

Popularising the Charter. Top: Chief Albert Luthuli, Father Trevor Huddleston and Dr Yusuf Dadoo (all recipients of the ANC's highest honour, the Isitwalendwe Award). Bottom: Moses Kotane, George Peake, Walter Sisulu, Piet Beyleveld, Stanley Lollan

2

An extract from Mandela's hand-written statement to court, 1962

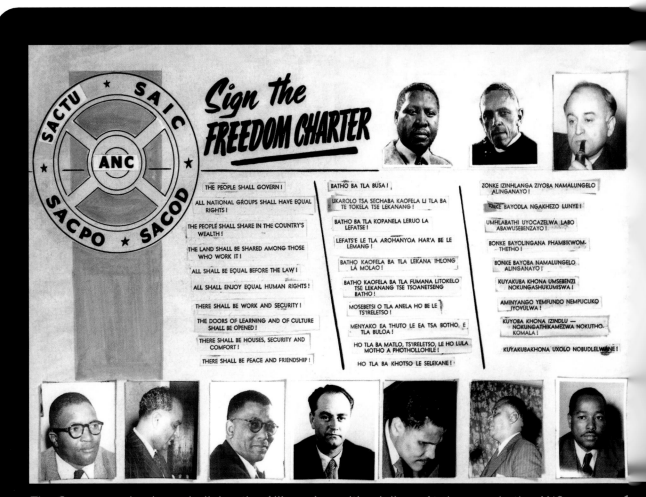

The Congress wheel, symbolising the Alliance's multiracialism. At the core is the ANC. The spokes are the South African Congress of Trade Unions, the South African Indian Congress, the South African Congress of Democrats and the South African Coloured People's Organisation.

1

'But the most important political document published by the ANC is the Freedom Charter which was adopted by the ANC in 1956. It contains a detailed statement of principles of government for which the ANC fought. It declares that South Africa belongs to all who live in it and that only a democratic state based on the will of all the people can secure to all their birthright...'

2

Freedom Square, Kliptown

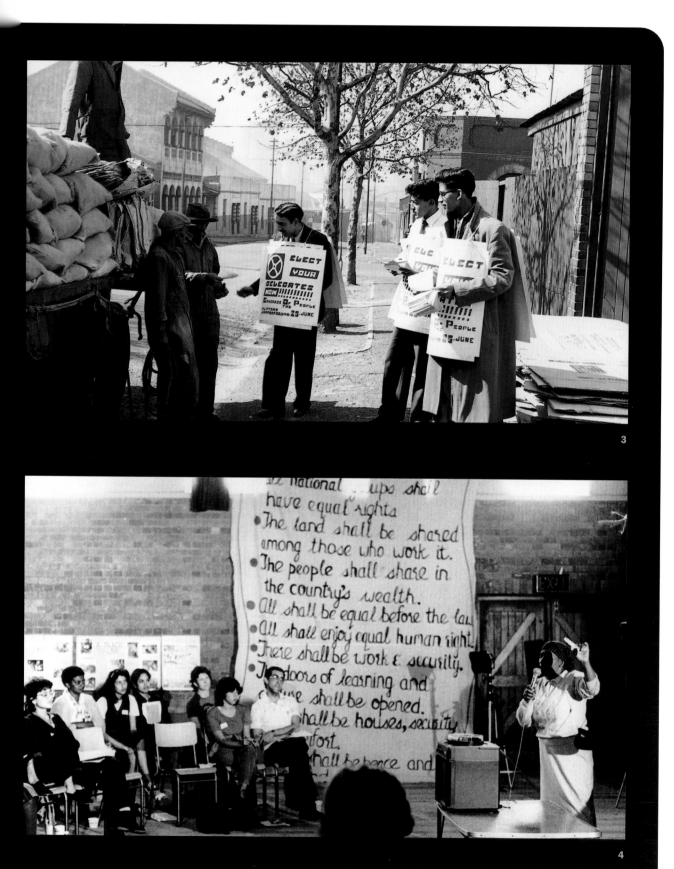

We, the people of South Africa, declare for all our country and the world to know:

That South Africa belongs to all who live in it, black and white, and that no government can justly claim authority unless it is based on the will of the people;

That our people have been robbed of their birthright to land, liberty and peace by a form of government founded on injustice and inequality;

That our country will never be prosperous or free until all our people live in brotherhood, enjoying equal rights and opportunities;

That only a democratic state, based on the will of the people, can secure to all their birthright without distinction of colour, race, sex or belief;

And therefore, we the people of South Africa, black and white, together equals, countrymen and brothers, adopt this Freedom Charter. And we pledge ourselves to strive together, sparing nothing of our strength and courage, until the democratic changes here set out have been won.
— The Preamble to the Freedom Charter, 1955

3
Volunteers canvass working people in Fordsburg, Johannesburg.

4
A generation later, a new audience is introduced to the vision of the Freedom Charter at a meeting of the Johannesburg Democratic Action Congress.

The idea for the Freedom Charter, a document expressing the people's vision of a free South Africa, came from Prof. Z.K. Matthews [see p.118 for his photograph]. For almost two years, hundreds of Congress volunteers went out to speak to people throughout the land, in rural villages and urban townships, on buses and trains, in factories and churches, at trade unions, cultural societies and sports clubs, asking them to formulate their demands for a free and

democratic society. Ordinary men and women were urged to spell out their vision of a time 'when all South Africans will live and work together, without racial bitterness and fear of misery, in peace and harmony'.

5

Banners displayed at the Congress of the People in Kliptown highlight the main tenets of the Freedom Charter.

The culmination of this process was the Congress of the People, which became, in the words of Prof. Matthews, 'a people's parliament'. On 26 June 1955, the Freedom Charter was presented to an audience of 7 000, including 2 884 elected delegates. Mandela, who was banned at the time, hid behind the fence of a neighbouring house to observe the proceedings, and slipped away when the police arrived.

After the Congress of the People, there were report-back meetings throughout the country. There was also a campaign to popularise the Charter and obtain national endorsement of its demands by collecting one million signatures.

Not all ANC members agreed with the Charter. Some of the more radical Africanists objected to the first clause: 'The land belongs to all who live in it, black and white...' They argued that indigenous African people, who had been dispossessed by white oppressors, had a prior claim to the land. In 1959, these members broke away to form the exclusively black nationalist movement, the Pan-Africanist Congress (see Site 46).

6

KwaZulu-Natal women delegates at the Congress of the People

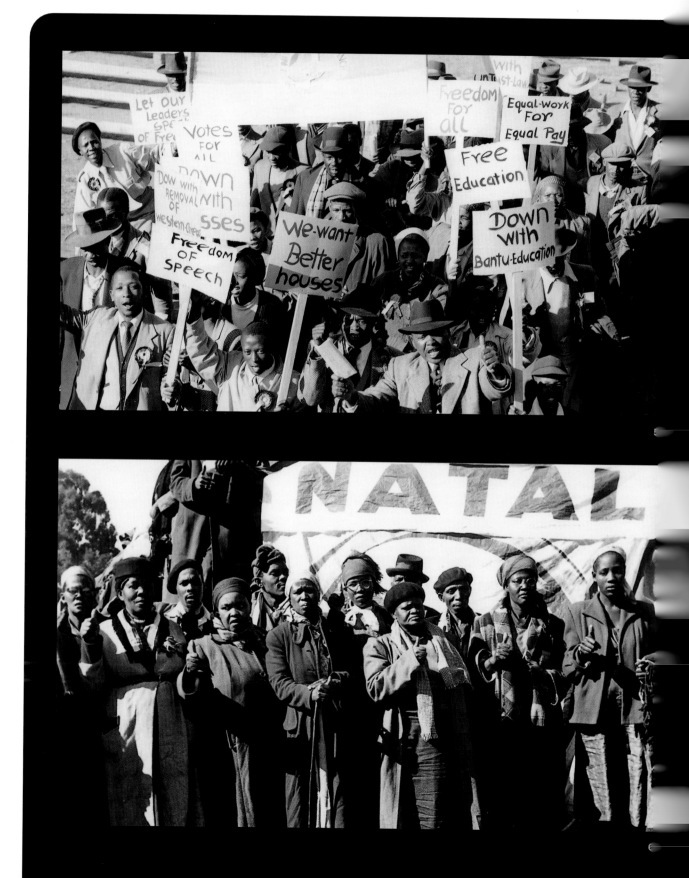

Union Buildings, Pretoria

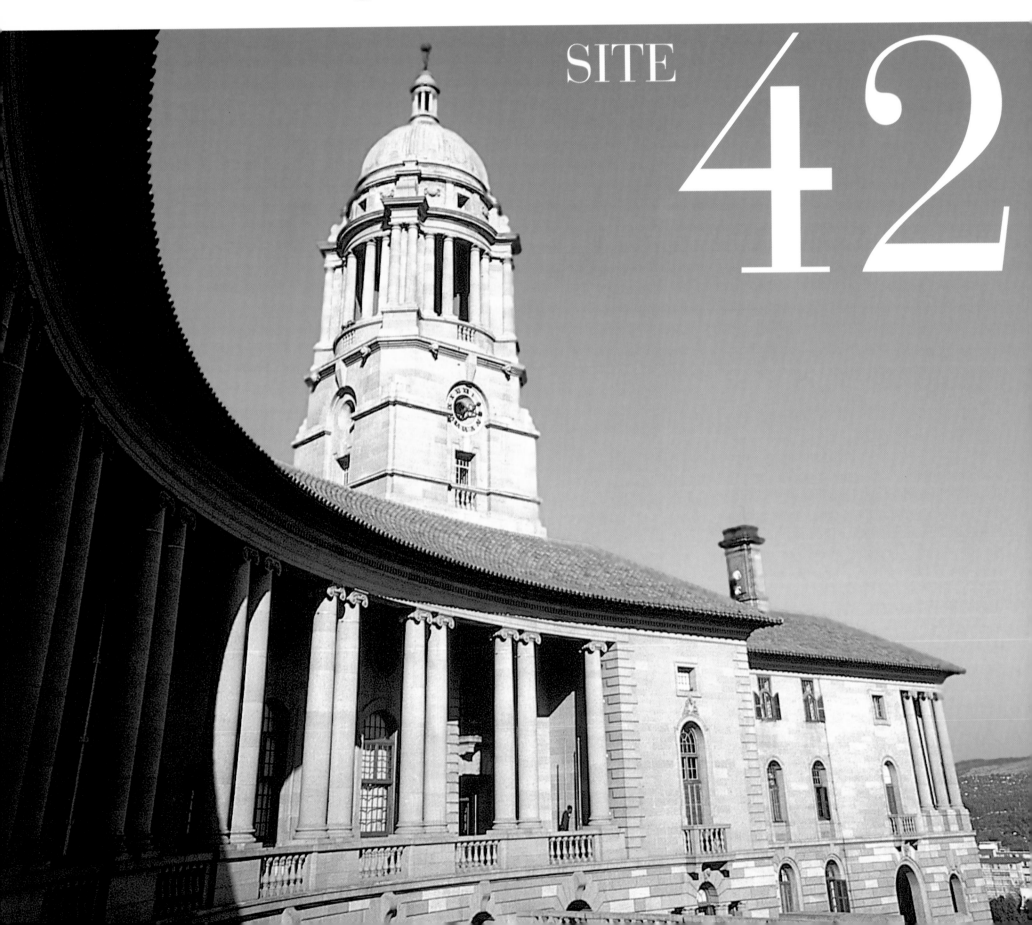

SITE 42

The woman say 'No' to passes

The Union Buildings were designed by Sir Herbert Baker and completed in 1913. They housed the government of the new Union of South Africa, which brought the Boer Republics and the British colonies into a single (white) nation after the South African War. Under apartheid the buildings came to represent the implacable bureaucratic might of the National Party government. Yet on one spectacular day in 1956, black women of South Africa, the most oppressed section of the population, occupied this hallowed site and made it their own. They staged a massive protest against the pass laws.

On 9 August 2000, a monument commemorating this event, and honouring women more generally, was unveiled at the Union Buildings. The centrepiece, a traditional grinding stone or *imbokodo* used for preparing food, symbolises the strength and the qualities of endurance and nurturing required of women in their daily lives.

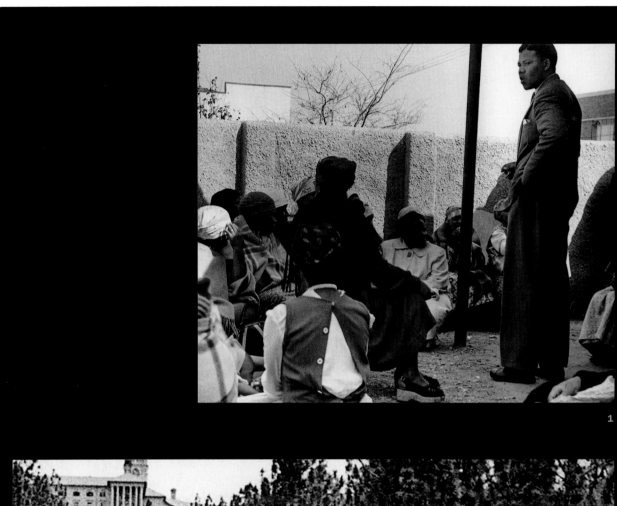

1

Mandela addresses women before the march.

2

In the grounds of the Union Buildings, 9 August 1956

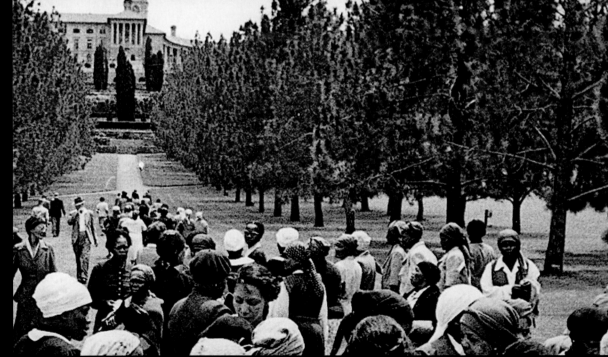

Union Buildings, Pretoria

"You have tampered with the women, You have struck a rock (*imbokodo* or grinding stone). Strijdom, you will be crushed."

This song, composed by the Women's League in Durban, became the theme song of the campaign. The voices of women uttering these words form part of the Women's Monument at the Union Buildings.

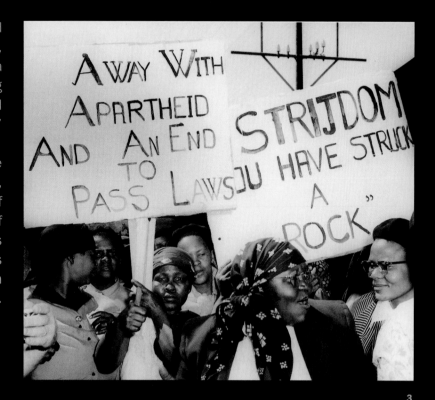

3

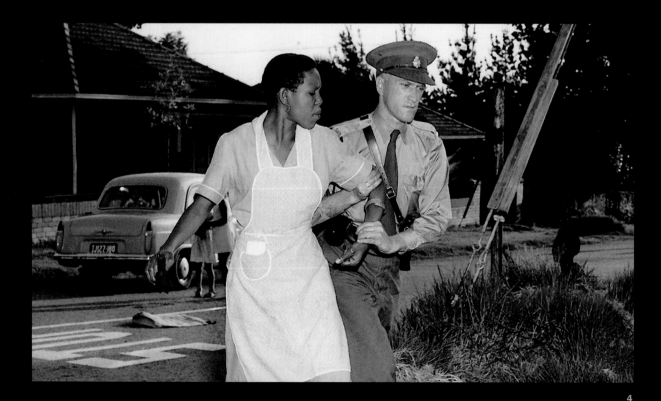

4

In 1952, the apartheid government announced that it would be introducing passes for women. This was part of their plan to control all urban blacks and ultimately remove from the cities those who did not 'serve the white man's needs' (see Site 11).

There was a storm of protest from women. Meetings were called throughout the country, in big cities and remote towns, and drew thousands of protestors. Ordinary women, along with leading activists such as Frances Baard and Lilian Ngoyi, made speech after speech denouncing the pass laws. 'The Pass Laws mean the death of our children,' 'The oppression of the Pass Laws is going to bring destruction to our homes.' Mandela, then deputy president of the ANC, travelled widely to encourage and support these initiatives.

The leadership of the non-racial Federation of South African Women and the ANC Women's League made the most of this groundswell of popular feeling. Inspired by grass-roots participation in the making of the Freedom Charter, and building on the anti-pass protests of the white women's organization, the Black Sash, they began to organise a countrywide petition of women's signatures.

4

Woman arrested

On 9 August 1956 an estimated 20 000 women converged on the Union Buildings. Many were poor and overworked, and had risked much to be there. Some had been scraping their pennies together for months, so that they could travel to the capital by train, bus or car, jeopardising their jobs and even their marriages. During the morning, the women gathered in the manicured gardens, many with babies on their backs. They filled the amphitheatre to overflowing. Nine spokeswomen, led by Lilian Ngoyi, Helen Joseph, Raheema Moosa and Sophie Williams, entered

the Union Buildings, carrying piles of petitions with hundreds of thousands of signatures of protest. They knocked on the Prime Minister's door. But Strijdom was not there. He had fled through a back entrance and been whisked away in a helicopter.

The women then stood in silence for 30 minutes as a sign of protest. The only noise in the whole amphitheatre was the cry of babies. 'Then we went home and organised in our communities,' reminisced Dorothy Sihlangu many years later.[17]

5

The Federation of South African Women, August 1955

The turnout had been impressive. 'No Nannies Today' read the headline of one major newspaper. For the next two weeks, the firm of Mandela and Tambo worked round the clock preparing bail for the women in the overflowing jails.

In the end, after five years of marches, public meetings and exhortations, passes were forced upon black women. As more and more women entered the formal sector — as domestic workers, office cleaners, factory workers — they found they could not survive without a pass.

The women's march was an event that was to resonate for many generations. During the dark decades of hardship, bannings and intensified struggle that lay ahead, the women's march remained one of the inspiring memories of history.

6

Raheema Moosa, Lilian Ngoyi, Helen Joseph and Sophie Williams lead the way to the Prime Minister's office

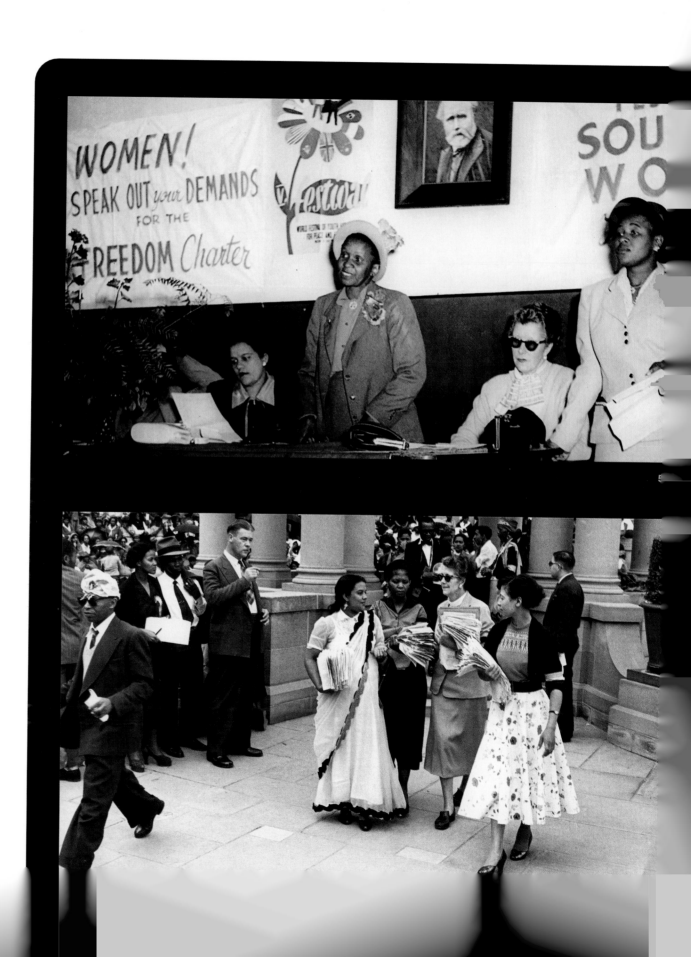

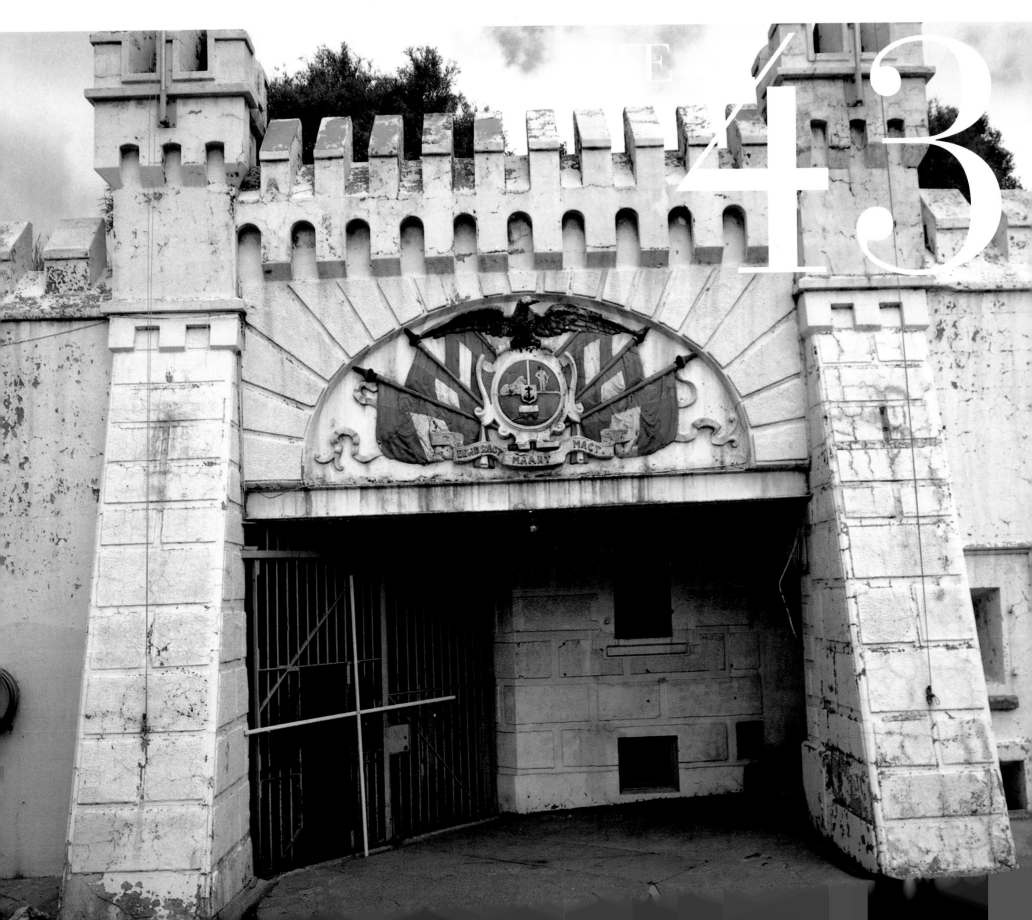

The Old Fort, Johannesburg

43

High treason

The Old Fort was built in 1895, initially to defend the new mining town of Johannesburg, and then to accommodate the growing numbers of prisoners in an unruly frontier society. Today the Fort stands on the edge of Hillbrow, South Africa's most densely populated residential area. Because of its powerful historical symbolism, the country's eleven constitutional judges selected this site for their Constitutional Court. In 1998, an international competition awarded a firm of South African architects the task of transforming a place long associated with tyranny and abuse into a symbol of the new, democratic South Africa. The preamble to South Africa's present democratic constitution acknowledges its debt to past struggles with which the Old Fort is associated. Other tenants in this mixed-use site include the Human Rights, the Gender and the Youth Commissions, as well as the President Mandela Library.

1

'A nation should not be judged on how it treats its highest citizens, but its lowest ones — and South Africa treated its imprisoned African citizens like animals.'

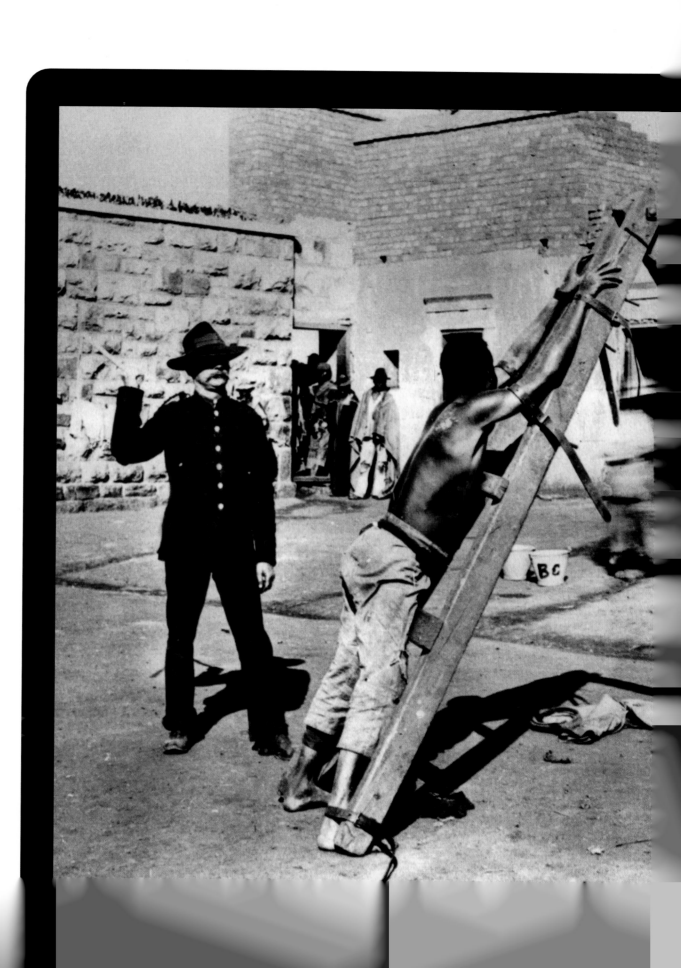

The Old Fort, Johannesburg

We, the people of South Africa,
Recognise the injustices of our past;
Honour those who suffered for justice
and freedom in our land;
Respect those who have worked to build
and develop our country; and
Believe that South Africa belongs to all who
live in it, united in our diversity.
We therefore, through our freely elected
representatives, adopt this Constitution as
the supreme law of the Republic so as to
– Heal the divisions of the past and establish a
society based on democratic values, social justice
and fundamental human rights;
Lay the foundations for a democratic and open
society in which government is based on the will
of the people and every citizen is equally
protected by law;
Improve the quality of life of all citizens and free
the potential of each person; and
Build a united and democratic South Africa able
to take its rightful place as a sovereign state in
the family of nations.
May God protect our people.
Nkosi Sikelel' iAfrika.
Morena Boloka setjhaba sa heso.
God seën Suid-Afrika. God bless South Africa.
Mudzimu thatutshedza Afurika. Hosi katekisa
Afrika.
— The Preamble to the Constitution of South
Africa, 1996

2

The cage in the Awaiting Trial Block. Visitors
were expected to communicate through thick
wire mesh. The building was partially
demolished to make way for the Constitutional
Court, but the cage will be preserved as a
powerful memory of the criminalising of
ordinary black men and women going about
their daily business.

Before sunrise on 5 December 1956, the police descended on more than one hundred households throughout South Africa to make arrests on charges of high treason. The Special Branch had been gathering information for years. The Congress of the People had provided the Attorney-General with sufficient evidence, he believed, to prove that the accused aimed to overthrow the government by unlawful means.

Men and women, black, white and brown, opponents of apartheid and members of the Congress Alliance, were brought together from all over the country and incarcerated in the Awaiting Trial Block at the Old Fort. While all the leaders were known to one another, it was the first time many had met, all together, in person. The leaders of 'South Africa's real opposition', as journalist Anthony Sampson termed them, now found time for much animated discussion on how to take the struggle forward.

Over the decades, hundreds of thousands of ordinary people had been locked up in the Fort, criminalised in many cases for simply going about their daily business. Pass offenders, 'loiterers', beer brewers, pilferers, youngsters apprehended at the whim of a policeman, were locked up with hardened criminals and murderers. Blacks were segregated from white convicts and held in the notorious Section 4, the 'Native Gaol', popularly known as 'Number 4'. When Umkhonto we Sizwe, the armed wing of the ANC, set up its own detention camp in Angola years later, they named it Quatro — the Portuguese word for 'Four'.

3

The 156 accused of High Treason

Among the accused were Chief Luthuli, Prof. Z.K. Matthews, Walter Sisulu, Oliver Tambo, Lilian Ngoyi, Rev Douglas Thompson, Helen Joseph, Joe Slovo, Ruth First, Nelson Mandela and Ahmed Kathrada. The charges were clearly based on what was deemed to be the treasonable aims of the Freedom Charter, which the ANC had formally adopted.

The Old Synagogue, Pretoria

SITE 44

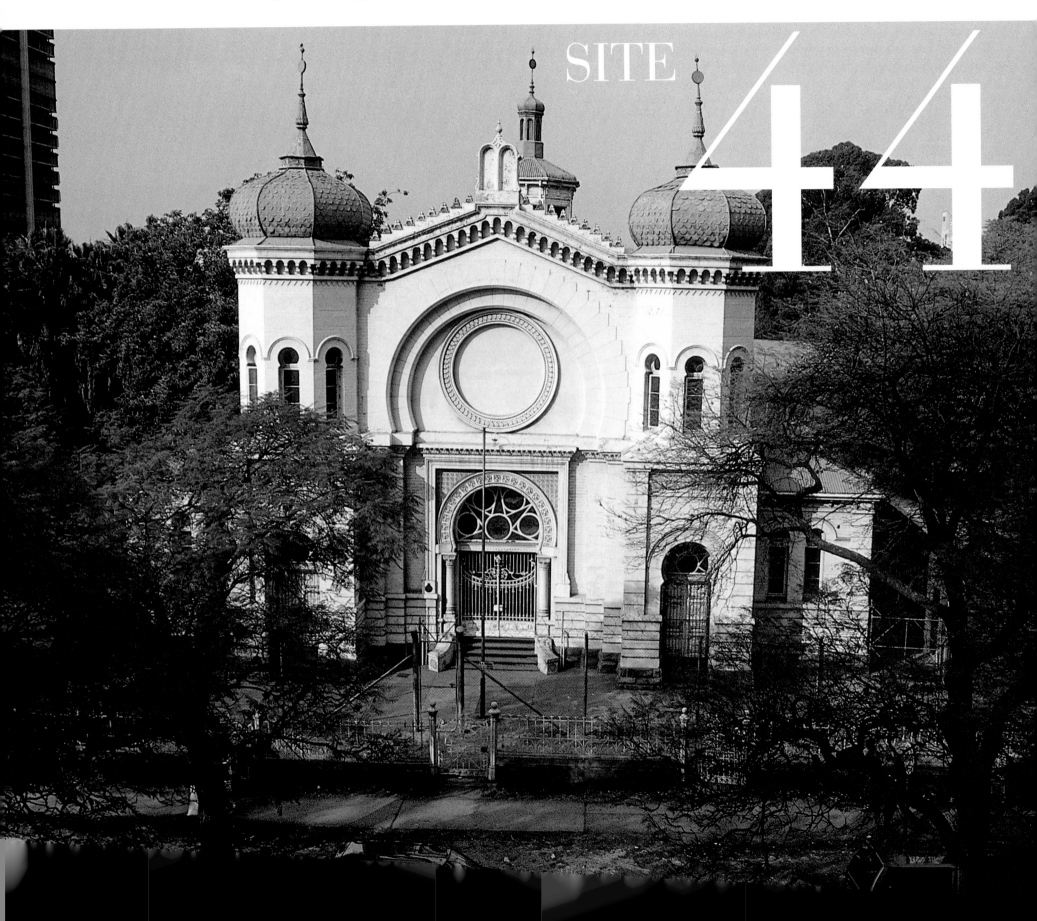

The final acquittal

The treason trial lasted for four years. After twelve months of ponderous argument, the Attorney-General withdrew charges against 64 of the accused. The case was shifted to Pretoria, to avoid the huge crowds that had gathered every day outside the Drill Hall in Johannesburg. The venue chosen was the Old Synagogue.

The building, a handsome example of late-19th-Century east European design, was commissioned by Pretoria's Jewish community during the Kruger Republic era. As Pretoria grew and developed, many members of the community moved from the inner city to the suburbs where new synagogues were built. By the mid-fifties, the Old Synagogue's congregation had dwindled to a mere handful. The handsome old building was deconsecrated and then sold. In 1978, the venue was used for the inquest on the death of Steve Biko.

1

Supporters outside the Old Synagogue.
'Changing the venue was an attempt to crush our spirits by separating us from our natural supporters. Pretoria was the home of the NP and the ANC hardly had a presence there.'

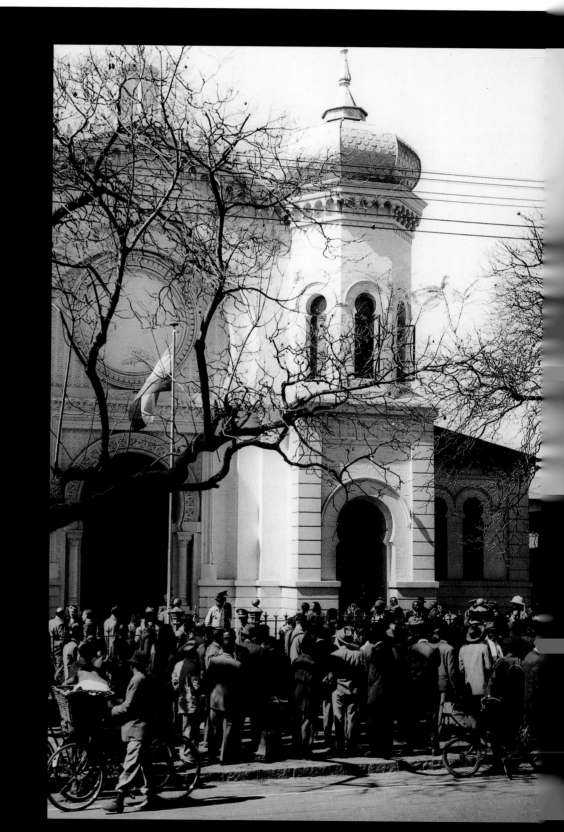

The Old Synagogue, Pretoria

2

In Pretoria's Old Synagogue the tone of the trial changed. After the rowdy scenes outside the Drill Hall earlier, the focus shifted to 'scintillating legal arguments' (*Drum*, October 1958). Issy Maisels, the leader of what Mandela called a 'brilliant and aggressive defence team', began the proceedings by demanding that two of the three judges recuse themselves because they were not impartial. One of the judges was duly replaced. Years of long, detailed and dreary evidence followed. The state called some 210 witnesses, '200 of whom were members of the Special Branch [the security police]… We used to joke that between the poor acoustics of the hall and the confused and inaccurate reports of the Special Branch detectives, we could be fined for what we did not say, imprisoned for what we could not hear and hanged for what we did not do.'

2
Chief Luthuli at the courthouse gates. Having been acquitted in the first round of the trial, Luthuli now had to show his pass in order to gain admittance to the gallery.

3
Relaxing during a recess: (left to right) Nelson Mandela, Sonia Bunting, Maulvi Cachalia, Ben Turok, Ahmed Kathrada

After two months of questioning on the indictment, the prosecution suddenly dropped the charges, only to reword them and bring the accused back to trial in three batches. A convoluted set of court cases followed, focused mainly on thirty of the accused, including Mandela. Finally, a verdict was unexpectedly reached on 29 March 1961. The judges found the accused not guilty and discharged them. By then, the ANC was banned, and the political landscape had changed irrevocably. Mandela had gone underground. Within a few months the movement would make the crucial decision to take up arms.

Was anything gained by the trial? It brought

together leaders, many of them banned, who would not otherwise have had the chance to meet. The image of the ANC leadership on trial for high treason gave the movement a boost. And there was some opportunity for the defendants to put their case to the public through reports of their evidence in the press. But all in all, the trial was a setback for the ANC. Leaders were tied up in a long, drawn-out court case. Their arrest and trial rudely interrupted their links with grassroots supporters. What with having to be in court day after day for years, the accused who were not banned were unable to address meetings, mobilise support or give tactical guidance to campaigns. Mandela himself was acutely aware of this problem in his assessment of various unsuccessful campaigns, such as the failure to stop the Sophiatown removals, the absence of strong leadership in the Evaton bus boycott, and the inability to oppose the Bantu Education Act effectively.

4

Mandela with Moses Kotane on the day when the last of the accused were finally acquitted.

5

Another layer of history for the Old Synagogue: lawyers George Bizos (third from left) and Shun Chetty (back to the camera) at the Steve Biko Inquest, November 1977. On the left, the young men who sang protest songs throughout the inquest.

'I did not regard the verdict as a vindication of the legal system or evidence that a black man could get a fair trial in a white man's court. It was the right verdict and a just one, but it was largely as a result of a superior defence team and the fair-mindedness of the panel of these particular judges.'

The court system, however, was perhaps the only place in South Africa where an African could possibly receive a fair hearing and where the rule of law might still apply.

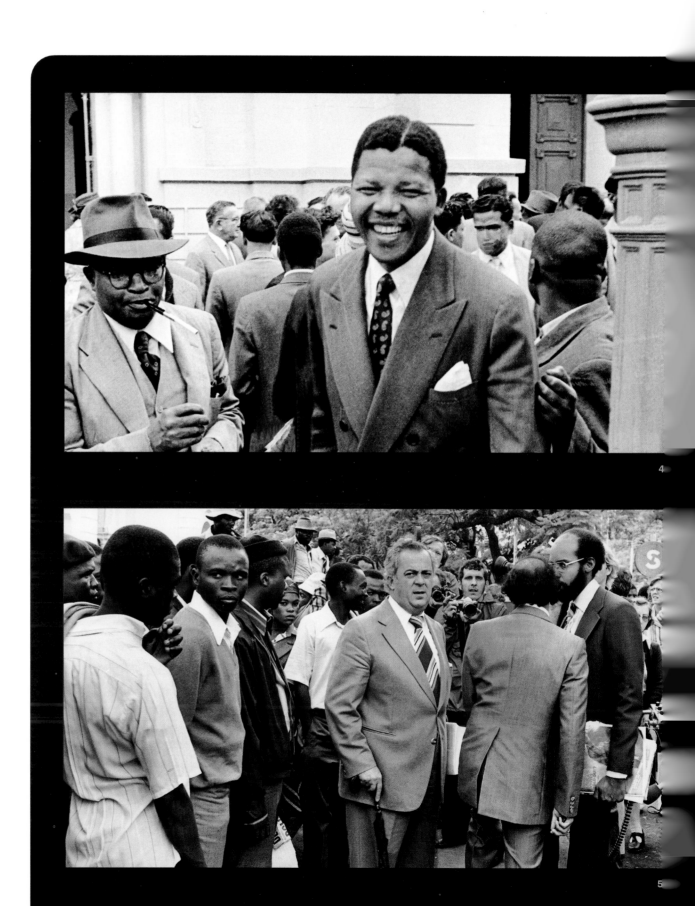

Orlando Hall, Soweto

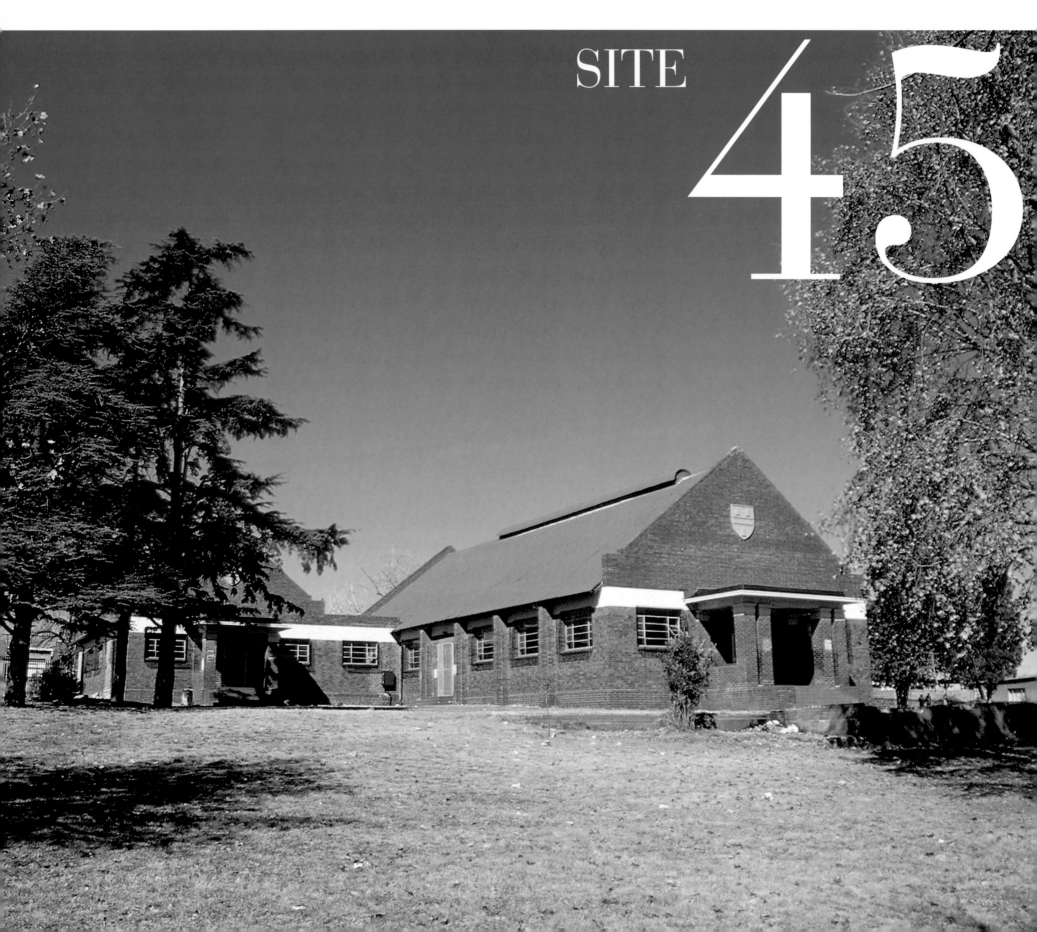

SITE 45

The breakaway of the PAC

Orlando Hall, the regular annual meeting place for the Transvaal region of the ANC in the 1940s and 1950s, is in one of Soweto's oldest suburbs (or 'locations' as they were then called). It was important enough to be placed on the itinerary of King George VI and his family when they visited South Africa in 1947. In recent years the Hall has been overtaken by a host of other venues which have been renovated to accommodate larger gatherings. It is now used mainly for smaller community occasions, wedding receptions, school events and church services. Nearby stands the colourful home of James Mpanza, leader of the Sofasonke movement which 'invaded' the land across the stream. Mpanza's famous concrete lions can still be seen at the entrance to the house (see Site 18).

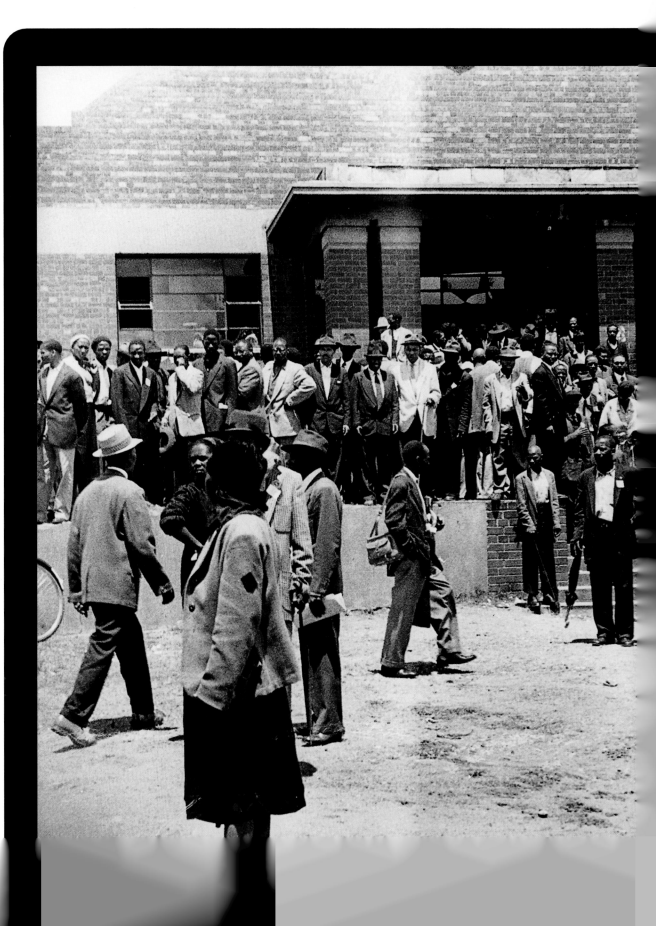

1

The Africanists cut loose. Here they are ejected from a meeting at Orlando Hall in November 1958. Six months later they would meet here again to form the Pan-Africanist Congress.

Orlando Hall, Soweto

The Africanists within the ANC had never been happy with the opening clause of the Freedom Charter: 'South Africa belongs to all who live in it, black and white...' This principle, they argued, would prevent the redress of more than three centuries of colonialism, dispossession and racial oppression. They retorted with their own slogan: 'Izwe lethu' — 'The land is ours.' In their view, the ANC leadership was already failing to lead communities effectively in their struggle against apartheid.

2

Robert Mangaliso Sobukwe at Orlando Hall, November 1958

The Africanists also strongly disagreed with the formation of the Congress Alliance, which included the Coloured People's Organisation, the Indian Congress and the tiny white Congress of Democrats.

They contended that the Alliance gave these groups an equal say in the affairs of Congress despite their much smaller numbers. Further, many of those in the other Congresses had belonged to the Communist Party before it was banned, and the Africanists objected to the official insertion of communists into the affairs and policies of the ANC. Ironically, it was Sisulu, Mandela and Tambo — the hardline founders of the Youth League — who were now encouraging collaboration with other races and with the communists.

3

Sobukwe's house in Galashewe, Kimberley. He was isolated on Robben Island for six years, and then only allowed to rejoin his family in Kimberley under stringent restrictions, including a 12-hour house arrest and banning. Sobukwe died an untimely death, of cancer, in 1978.

At a particularly acrimonious meeting of the Transvaal region held at Orlando Hall and chaired by Oliver Tambo, a scuffle took place and the Africanists were ejected. Realising that they would not be able to depose the ANC leadership, they decided to break away and form their own organisation. In April 1959, the Pan-Africanist Congress was launched at the Orlando Hall under the leadership of the brilliant scholar, Robert Sobukwe (also a Healdtown old boy).

The PAC's very first campaign — and specifically the response to it at Sharpeville — would change the course of the liberation struggle.

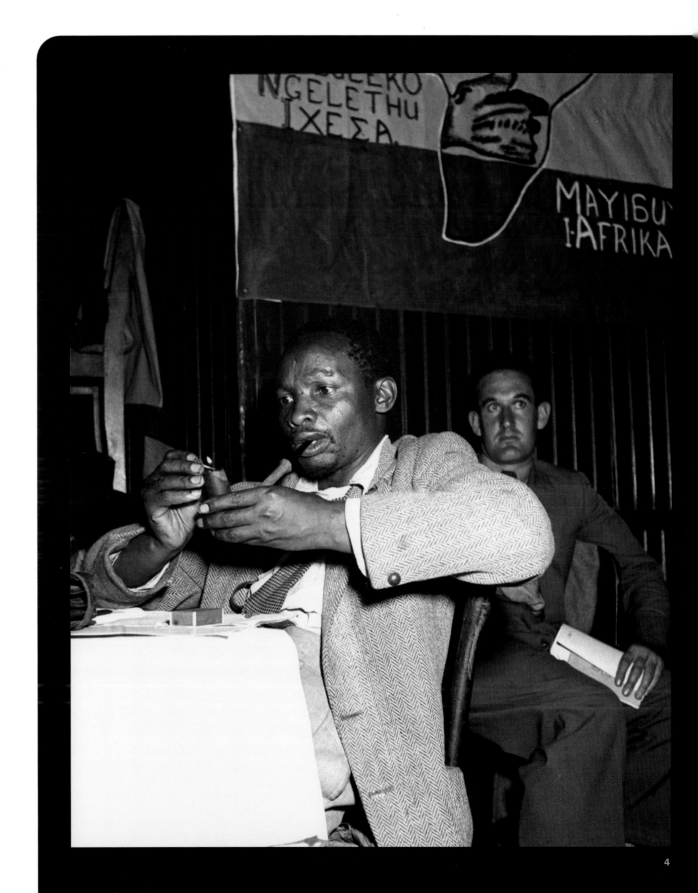

4

PAC leader Peter Raboroko, at the PAC launch, described by Mandela as a 'friend and colleague'.
In the backround, *Drum* editor Anthony Sampson. In a *Drum* article of April 1960, B. Dyantyi gives us an amusing glimpse of the militant young Africanist:

'Leaning out of a car as we travelled through Orlando, Raboroko cried out as we passed a white's posh car: "We'll be riding around in cars like that soon, my boy." He waved his pipe, sucked on it, and he added: "Well, I'm pleased the whites are so proud of the houses they built for us in Meadowlands. It's a good job because," and he took another suck at his pipe, "BECAUSE THE WHITES ARE GOING TO BE LIVING IN THEM, AND WE'LL BE LIVING IN LOWER HOUGHTON, MAN!"'

Part Four

'I have chosen this course... to live as an outlaw in my own land... I shall fight the Government side by side with you, inch by inch, and mile by mile, until victory is won... Only through hardship, sacrifice and militant action can freedom be won. The struggle is my life. I will continue fighting for freedom until the end of my days.'

– Mandela's statement from underground, 26 June 1961

'The time comes in the life of any nation when there remain only two choices: submit or fight. That time has now come to South Africa. We shall not submit and we have no choice but to hit back by all means within our power in defence of our people, our future and our freedom...'

– From the leaflet announcing the formation of Umkhonto we Sizwe

On 21 March 1960, in the township of Sharpeville near Johannesburg, the police fired on an unarmed crowd protesting against the pass laws, and killed 69 people. On the evening of that same day, 1 500 kilometres away in Langa township outside Cape Town, a mass march ended in rioting, and the police killed two men.

Sharpeville and Langa marked a turning point in the history of the ANC and the newly formed PAC. In the turmoil that followed these massacres, the government banned the African National Congress and the Pan-Africanist Congress organisations, and imposed a State of Emergency. The struggle entered a new phase.

The terrain of black politics

When the government declared the ANC an illegal organisation, it effectively criminalised its members. 'We were now all of us outlaws,' Mandela later said. Like many other ANC, PAC and trade union leaders, Mandela went underground, living in hiding in various places around Johannesburg. During this early period the ANC announced that it had turned to armed struggle, and the sabotage campaigns began.

Ironically, this was to initiate a period when Mandela increasingly came into the spotlight. Early in 1962, he went abroad. He made appearances in various African countries and in London, raising support for the ANC's new armed wing and explaining the decision to take up arms. Not long after his return to South Africa later that year, he was arrested, tried and imprisoned. He had just begun to serve his sentence when the arrests at Lilliesleaf Farm in Rivonia signalled the beginning of a state onslaught that would see him and his colleagues on trial for their lives.

Immediately after Sharpeville and shortly before the ANC was banned, Oliver Tambo was sent abroad to head the ANC's external mission. His brief was to publicise the organisation's cause in Africa and the rest of the world, gather support, and promote international sanctions against the apartheid system. He expected to be away for two or three years — but thirty would pass before he came home again.

1

Mandela's vow from underground reported in *New Age*, July 1961

2

State of Emergency, 1960. South Africa becomes a police state.

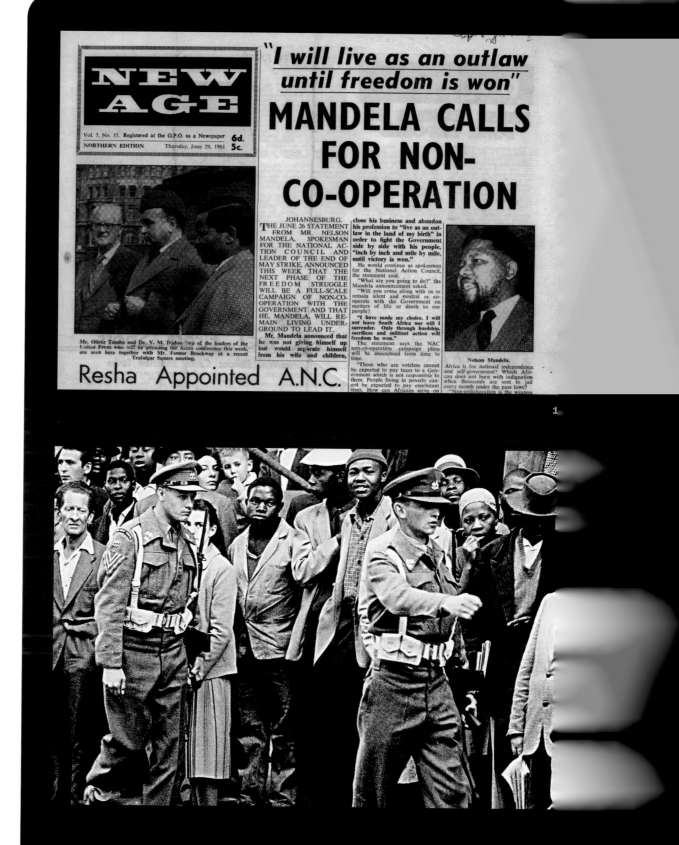

Sharpeville

SITE

46

The price of freedom

The Sharpeville massacre is imprinted in the minds of millions around the world. Although it was not the first time innocent black South Africans had been shot by the police, the scale of the killing had a powerful impact locally and internationally. In the decades ahead, the name of Sharpeville became synonymous with the brutality of apartheid. For many years the anniversary was commemorated as Sharpeville Day: in the democratic South Africa it is now Human Rights Day. A simple memorial was erected to honour those who died. The picture shows a homeless man tending to the memorial.

By the year 2000, a Sharpeville Memorial Project had plans to construct a major memorial and museum to commemorate the massacre.

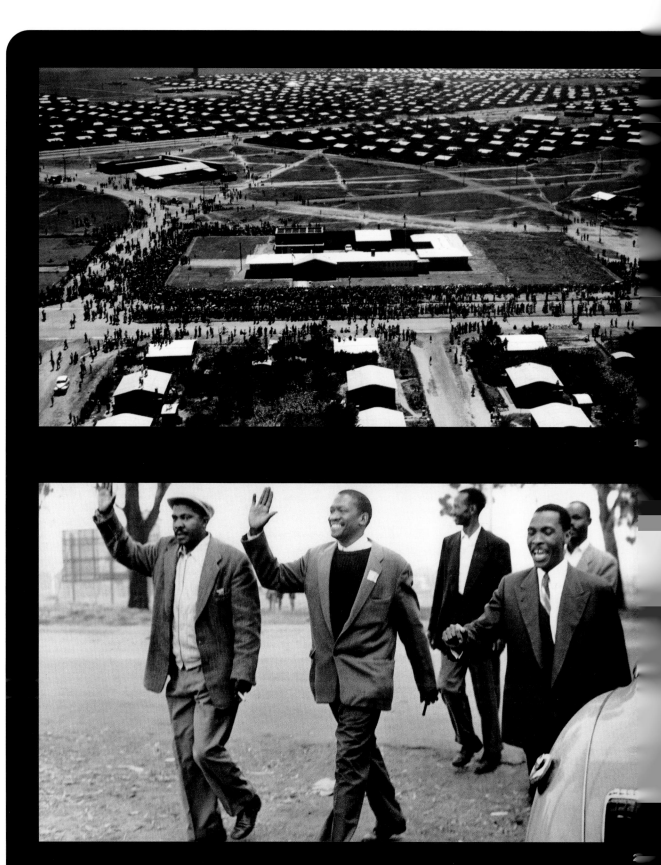

1
An aerial view of the crowd gathered at the Sharpeville police station to hand in their passes.

2
Robert Sobukwe and other PAC leaders walk to Orlando police station to surrender their passes on 21 March 1960. It was to be Sobukwe's last walk as a free man.

Sharpeville

By 1958, nearly one and a half million Africans were being convicted under the pass laws annually. That year at its December conference the ANC, led by Luthuli and Tambo, resolved to embark, if necessary, on a 'long and bitter struggle' against passes. In the ensuing year, following the expiry of his banning order, Chief Luthuli undertook a national tour which drew enormous popular support. His speeches, reasonable, humane, and sensitive to white fears but firm in rejecting white domination, received standing ovations. In Sophiatown, just as he was about to speak, the Special Branch stepped forward and handed him another five-year banning order. At the next conference, a delegate rose to urge immediate and direct action. The meeting decided on an anti-pass day to be held on the last day of March 1960, to be followed by mass demonstrations in May and June.

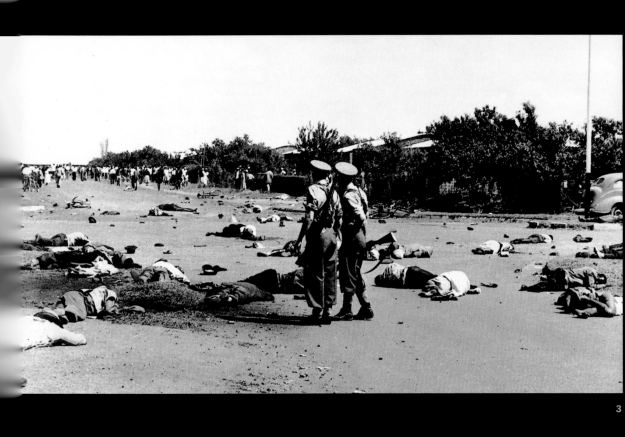

3

The aftermath of a peaceful demonstration

A week after the ANC made this decision, the PAC held its first conference and resolved to launch an anti-pass campaign of its own. The guiding principle would be: No Bail, No Defence, No Fine. On 18 March, PAC leader Robert Sobukwe announced that their anti-pass campaign (which would also call for a minimum wage of 35 pounds a month) would begin within 72 hours. In this way, the PAC shrewdly pre-empted the ANC's campaign by ten days.

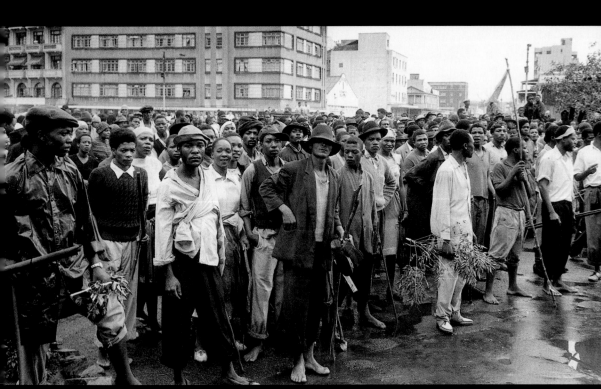

4

The ANC's anti-pass campaign, Durban, 31 March 1960, as planned four months earlier

On 21 March 1960, in response to the PAC's call, several thousand people gathered outside the Sharpeville police station, demanding to hand in their passes and be arrested. In the early afternoon there was a scuffle at the fence surrounding the police station and the crowd

pressed forward, curious. Without warning, the police opened fire. Although the crowd scattered, the police carried on shooting. When it was over, 69 people were dead and nearly two hundred wounded. Most of those killed had been shot in the back as they tried to flee.

5

Mandela prepares to burn his pass.

ANC leaders were anxious to channel the anger and grief that the massacre unleashed. They also wanted to regain the political initiative, which the PAC had snatched from them. On 26 March, Chief Luthuli publicly burnt his pass as a gesture of protest against the massacre. Hundreds of pass burnings by ANC members followed. Luthuli also called for a national day of mourning, and on the appointed day, 28 March, several hundred thousand people stayed away from work.

6

Mandela honours the Sharpeville martyrs, September 1996

The massacre attracted acutely critical international attention and produced unprecedented protest at home. The country seemed to be slipping out of the government's grip. After an initial period of panic, they cracked down and a State of Emergency was declared. The ANC and the PAC were banned. Thousands of government opponents, including Mandela, were locked up. Within five months, the apartheid government had demonstrated that it could curb its troublesome black opposition. International investment began to trickle back into the country. The detainees were released, but many were placed under house arrest or served with banning or banishment orders, which effectively silenced them.

5

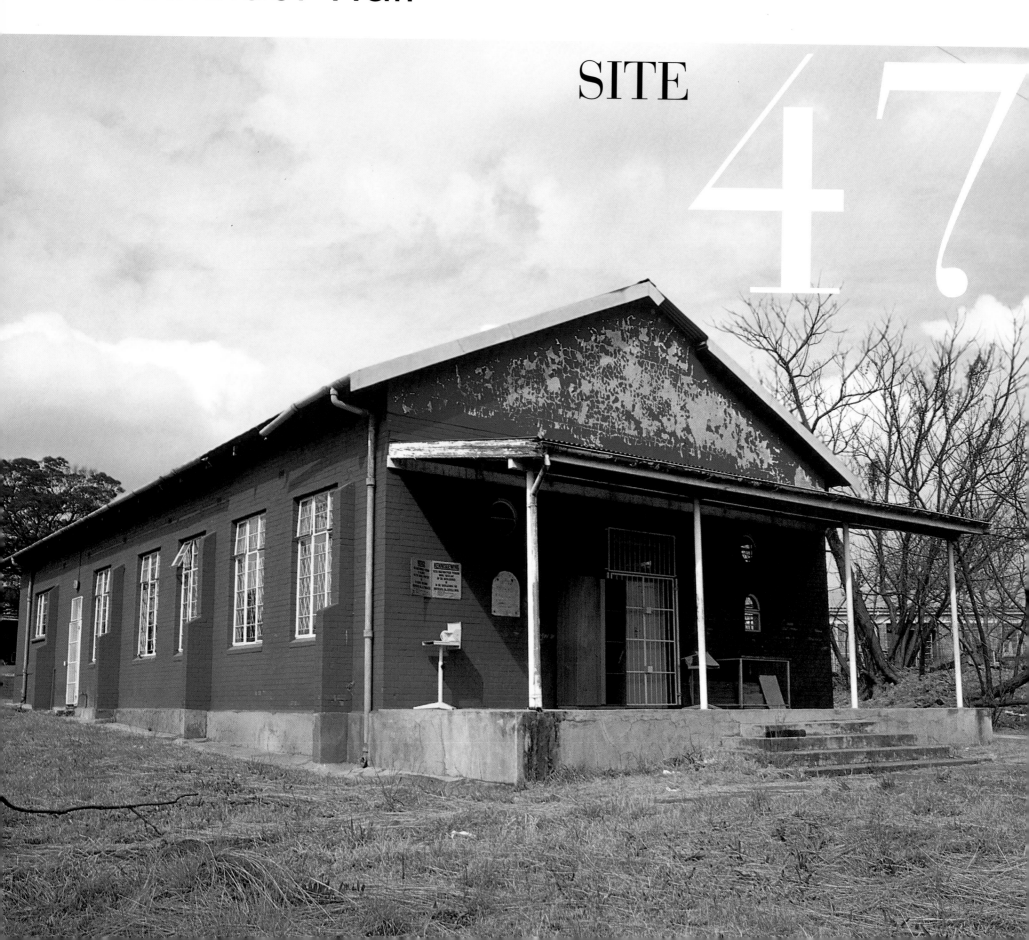

Plessislaer Hall

SITE 47

Mandela takes the baton

The small settlement of Plessislaer lies on the Duzi River. It was once the Edendale Methodist mission station, providing medical care for people who had come to find work in Pietermaritzburg. The mission also provided a building for the educational circuit in the area.

At the time of the All-in Conference in 1961, when Mandela made a surprise visit to the Plessislaer Hall, apartheid policy was catching up with Pietermaritzburg. A systematic programme was underway to resettle people in racially restricted areas. The black township of Imbali was established next to Plessislaer, which was then incorporated as an African area, while Coloured and Indian residents were removed to the east of the town. Today Plessislaer Hall is in the grounds of Zibukezulu High School. The old neighbouring white working-class area has become a multiracial suburb.

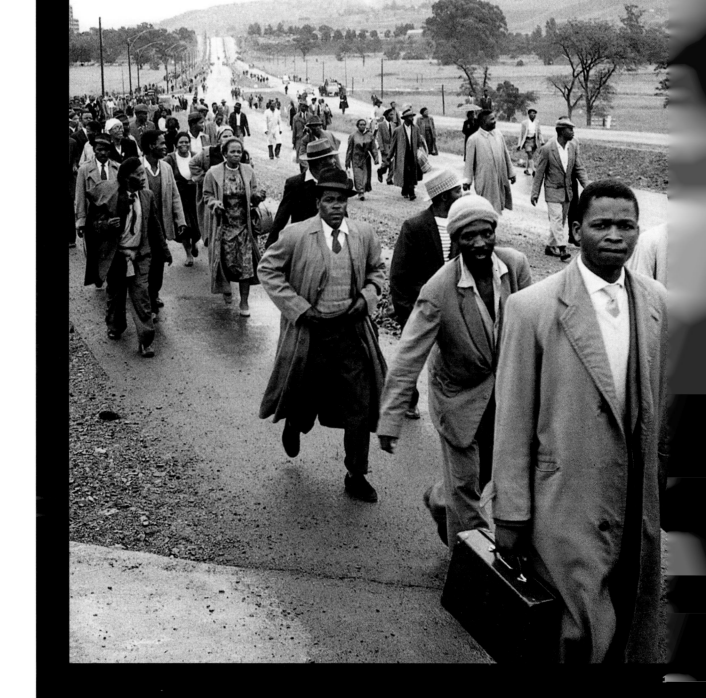

1

Discovering that the original venue for the Conference is bugged, delegates walk to Plessislaer.

Plessislaer Hall

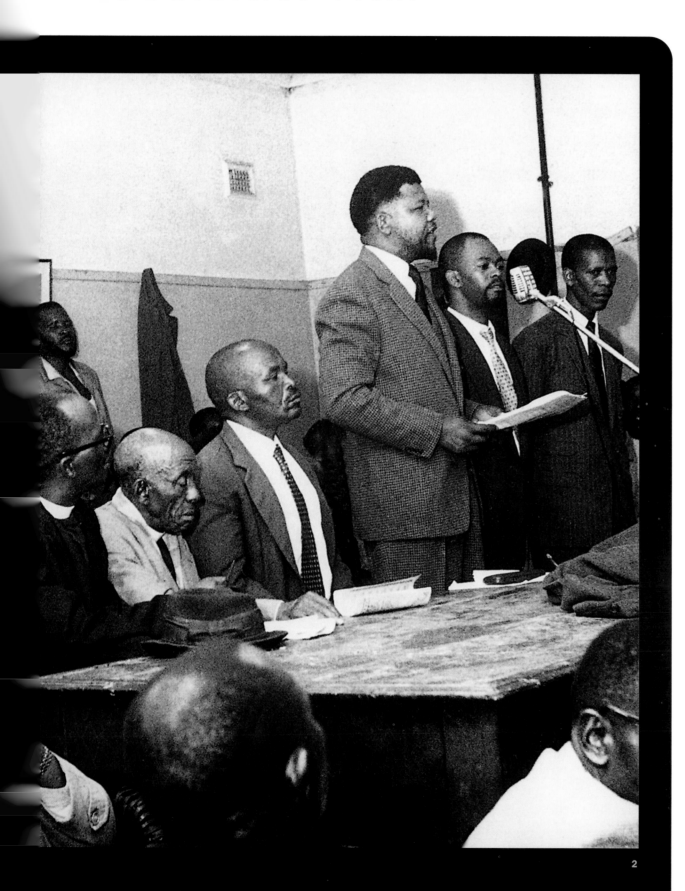

In a referendum in October 1960, the majority of white South Africans, united in the face of world condemnation of apartheid, voted to establish a republic. Against this background, the 'Continuation Committee of African Leaders' called on 'Workers, Sportsmen, Churchmen, Professional Men, Musicians, Students, Peasants, Housewives' to prepare for an 'All-in African Conference' on March 25 and 26 1961 at the Pietermaritzburg City Hall.

In the end, the All-in Conference did not take place at the City Hall. At the last minute it was discovered that the venue was bugged, and so delegates walked several kilometres to a new venue in the township of Plessislaer. The Plessislaer Hall was then a Hindu temple, and those who made it available as a meeting place were members of the Natal Indian Congress. An audience of over 1 400 people were surprised and delighted when Mandela, with the aim of misleading the Special Branch, arrived unannounced. In his talk, Mandela said the people faced two choices. They could either accept discrimination, humiliation, betrayal and appeasement — or they could stand firm for their rights. Following a proposal from Mandela, the conference passed a resolution demanding that a 'National Convention of elected representatives of all adult men and women on an equal basis irrespective of race, colour, creed or other limitation be called not later than May 31, 1961'. It would be more than thirty years before such a convention took place in South

2
Mandela addressing the All-in Conference, at Plessislaer Hall, 1961

Africa.

The All-in Conference proved fairly successful. But it failed to draw representatives from the other two opposition groupings — the PAC and black members of the Liberal Party, under the

leadership of Jordan Ngubane. These critics variously suspected that communists were contributing to the funding of the gathering, disliked the fact that the ANC dominated the planning, and resented the publicity given to Mandela by the *New Age* newspaper.

In the year or so after Sharpeville, Mandela's profile was greatly enhanced. Luthuli was still banned, Tambo had left the country. The treason trial had ended in acquittal. Black readers had eagerly followed the press reports on Mandela's handling of his defence, and his clear explanation of the political philosophy and policies of the ANC: 'His political maturity was noted: the articulate attack of his evidence, as one of the defence team put it; but there was something more profound: a question of growth under challenge. His stature was a measure of the calibre of the ANC's top leadership.'[18] Mandela was emerging as the national leader.

With the ANC banned, Mandela had become secretary of the 'National Action Council of South Africa'. In this capacity he called for a three-day national stay-away at the end of May 1961, to coincide with white Republic Day celebrations. The government responded with the biggest military call-up ever seen in peacetime. Citizen forces and commando units were mobilised in the cities. White women took shooting practice, helicopters hovered over the townships, and police vans patrolled the streets, warning black workers that if they went on strike they would be sacked and 'endorsed out' of town. Despite this intimidation, opposition from the PAC, and propaganda from the newspapers, the majority of workers responded to the call in Johannesburg and Port Elizabeth.

3

Mandela's report on the stay-away concluded that the apartheid state was blocking the means of peaceful protest

general strike
by NELSON MANDELA
(Secretary, National Action Council of South Africa)

A REPORT OF THE 3-DAY STRIKE IN SOUTH AFRICA (MAY 29, 30, 31, 1961)

Ngquza Hill, Pondoland

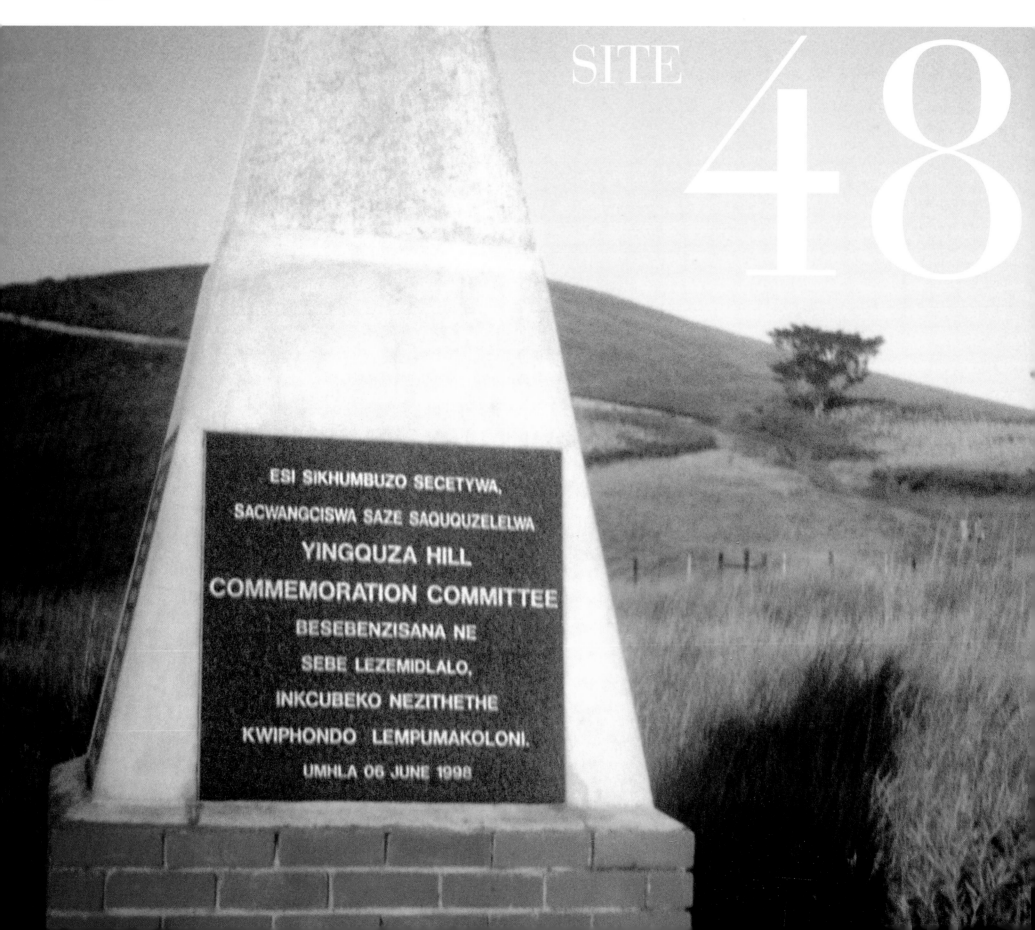

SITE 48

ESI SIKHUMBUZO SECETYWA,
SACWANGCISWA SAZE SAQUQUZELELWA
**YINGQUZA HILL
COMMEMORATION COMMITTEE**
BESEBENZISANA NE
SEBE LEZEMIDLALO,
INKCUBEKO NEZITHETHE
KWIPHONDO LEMPUMAKOLONI.
UMHLA 06 JUNE 1998

The beginnings of the armed struggle

Ngquza Hill in Pondoland, the region of the Transkei where Oliver Tambo and Winnie Madikizela-Mandela and a number of other activists were born, has come to symbolise the Pondoland uprising. This popular revolt, which lasted for nine months in 1960, was directed against chiefs who were considered to be collaborating with the apartheid state under the Bantu Authorities Act. The huts of suspected collaborators were burned down, and some traditional leaders and their headmen were even killed. The state struck back. On 6 June 1960, a special force of policemen fired on a protest meeting at the foot of Ngquza Hill, killing 11 men. The Ngquza Hill Memorial, near the town of Flagstaff, now commemorates this massacre.

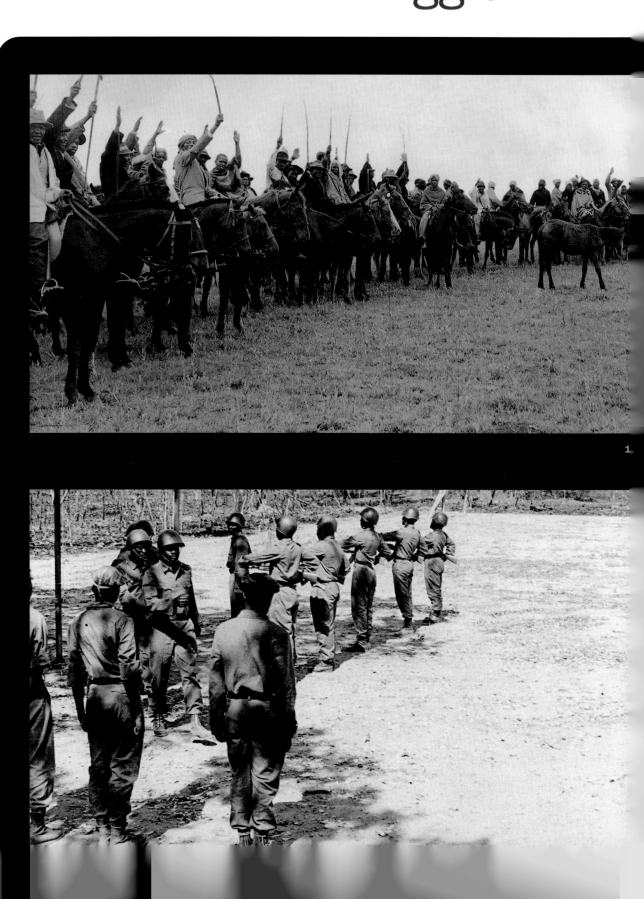

1
Amapondo peasants during the rebellion against the 'Bantu Authorities Act'
2
Military training begins, somewhere in Africa

Ngquza Hill, Pondoland

3

4

5

The ANC's decision to take up arms was a long time coming. During his visit to China in 1958, Walter Sisulu had been mandated to explore the feasibility of armed struggle, but concluded that this step was premature. In 1961, after the banning of the ANC, Mandela was given the task of forming Umkhonto we Sizwe — the Spear of the Nation. 'I, who had never been a soldier, who had never fought in battle, who had never fired a gun at an enemy, had been given the task of starting an army.' He publicly announced the start of the armed struggle after the stay-away on 16 December 1961. Ironically, Chief Luthuli had just returned from Oslo, where he had received the Nobel Peace Prize.

3
Mandela, thinly disguised by a revolutionary-style beard — 'hunted underground, yet in the midst of his people.'

4
Smoke rises from sabotaged transformers at the Camden power station near Ermelo, July 1981. The sabotage of government property, avoiding the taking of life, was initiated in 1962. Twenty years later, apartheid personnel were targeted.

'One of the lessons I took away from the failed Western Areas anti-removal campaign was that it is the oppressor who defines the nature of the struggle; in the end, we would have no alternative but to resort to armed struggle.'

5
Tambo and Mandela at the formation of the Organisation of African Unity in Addis Ababa

Umkhonto we Sizwe — MK for short — was conceived in the first instance as a weapon of 'armed propaganda': it would inspire the masses to continue their struggle against oppression and, in the words of Mandela, 'scare away capital'.

Initially, electricity pylons, apartheid buildings and other symbolic sites were targeted. 'Strict instructions were given to its members right from the start, that on no account were they to injure or kill people.' This policy of sabotage as a 'warning to bring white South Africa to its senses' was observed for many years, despite the increasing brutality of the apartheid system. There were scores of instances of sabotage. The security police tactic of planting agents provocateurs soon bore fruit, and dozens of trials followed. Among those convicted and served with long sentences were Indres Naidoo, Sharish Nanabhai and Mac Maharaj. The terms of the Sabotage Act of 1962 were so sweeping that even strikes were defined as sabotage. Between 1960 and 1966, 160 leading figures in the South African Congress of Trade Unions were arrested for sabotage, most of whom were convicted and sent to Robben Island.

6
Mandela talks to military strategists in Algeria, where he himself received training.

7
Thirty years later, the new integrated national army on the march, 1995

Early in 1962, Mandela left South Africa illegally. His purpose, as supreme commander, was to raise support for the new liberation army and explain to the external wing of the ANC the decision to take up arms. He toured African countries, received some military training in Algeria, and addressed European audiences.

8
General Constand Viljoen, Chief of the Army in the second half of the 1970s and of the Defence Force in the first half of the 1980s, salutes his commander in the democratic South Africa. Shortly before the first democratic elections in 1994, Viljoen formed the Freedom Front to campaign for an independent Afrikaner state.

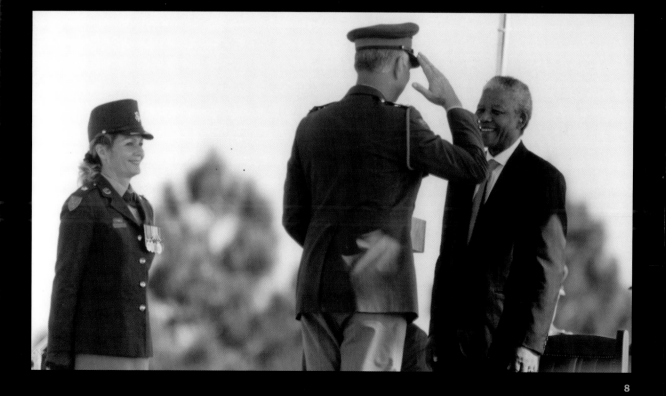

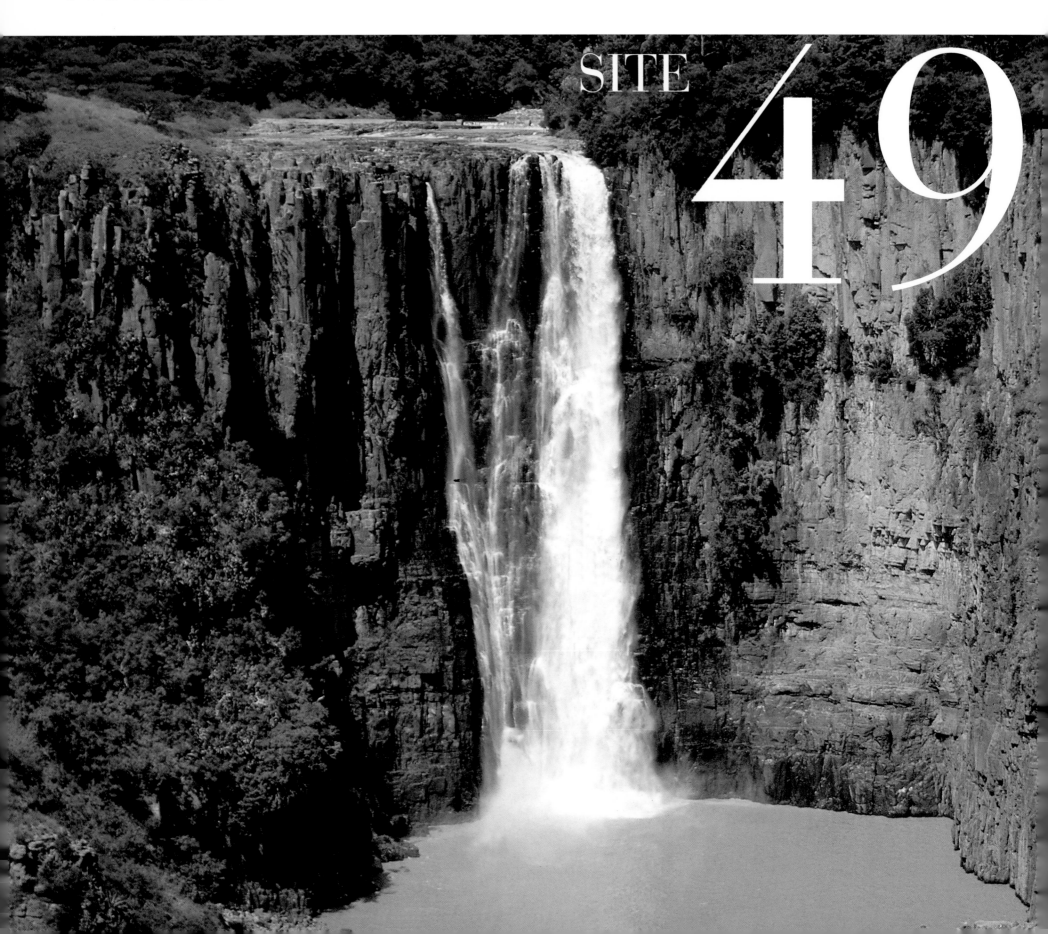

Howick

SITE 49

Arrest and trial

Howick was named after the home of Earl Grey, the British colonial secretary, by the first settlers in the area. The town is known for its spectacular waterfall, called kwaNogqaza — 'place of the tall one' — by local people. Many travellers were swept over the falls in the past; a pile of stones at the foot of the 95-metre drop marks the grave of an early settler.

In 1985, Sarmcol plant workers went on a trade union recognition strike, which became the longest strike in world history. The 13-year strike decimated Mpophomeni township, and eventually was a trigger for the civil war that erupted in KwaZulu-Natal in the late 1980s. The local museum includes displays on the strike and other aspects of local history.

Mandela was arrested near Howick in 1962, not far from the Plessislaer Hall in Pietermaritzburg, where Mandela and others attempted to continue above-ground opposition to apartheid. In 1994, he unveiled a plaque to mark the site of his arrest.

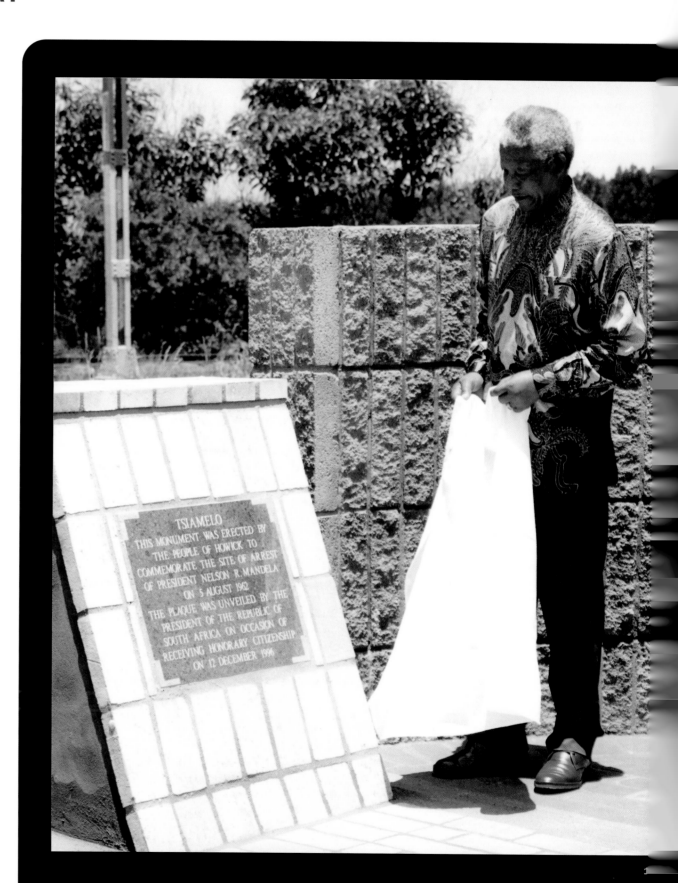

1

Mandela unveils a plaque to mark the spot of his arrest near Howick in 1962.

Howick

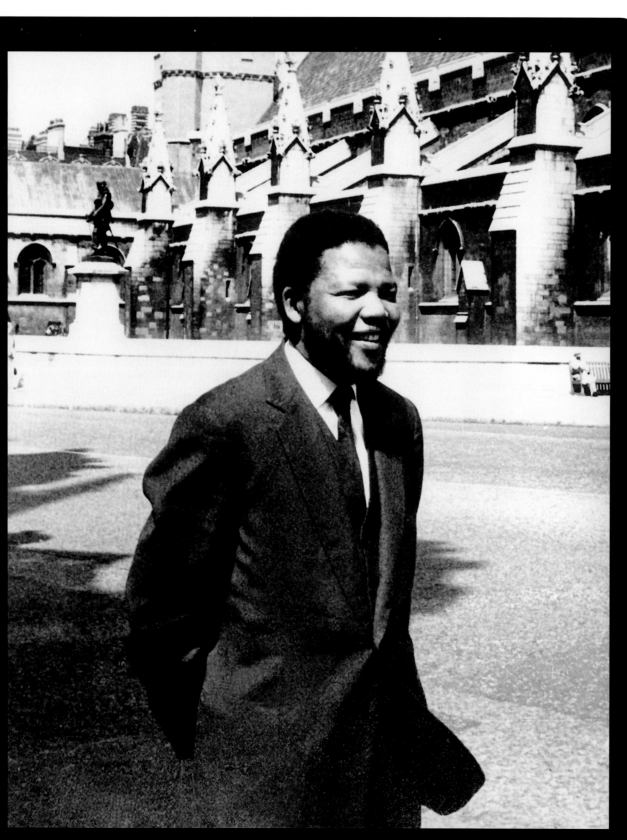

2

As soon as he returned from abroad, Mandela travelled to Groutville to report to Chief Luthuli. He used a cover that had come in useful before, posing as David Motsamayi, chauffeur to the white theatre director and Congress of Democrats member Cecil Williams. On the way back from Natal, three cars full of white policemen waylaid them near the town of Howick, after a tip-off by an informer. Mandela was arrested, still dressed in his chauffeur's white dust-coat.

2
'Clothes make the man': Mandela in suit and tie on his illegal visit to England. 'The best way to receive protection against British settlers in any colony is to go to London,' he declared.[19]

After more than a year on the run, the 'Black Pimpernel', as Mandela was known, had been captured. He was put on trial for inciting people to strike and for leaving the country without a passport. On the first day of the hearing at the Old Synagogue in Pretoria, which he knew well from the treason trial, Mandela electrified the court by wearing a traditional Xhosa leopard-skin kaross instead of a collar and tie.

'I had chosen traditional dress to emphasise the symbolism that I was a black African walking into a white man's court. I was literally carrying on my back the history, culture and heritage of my people. That day, I felt myself to be the embodiment of African nationalism, the inheritor of Africa's difficult but noble past and her uncertain future. The kaross was also a sign of contempt for the niceties of white justice. I well knew the authorities would feel threatened by my kaross as so many whites feel threatened by the true culture of Africa.'

Winnie Mandela, who was under her first banning order, was eventually given permission to attend the hearing provided that she 'refrained

from wearing traditional dress'. The harassment of Winnie Mandela had begun as soon as her husband went underground.

'Growing up in that tribal set-up in the countryside seemed to give him his background; he is a traditionalist. I don't mean it in the stifled, narrow sort of way. Rather in the sense that what he is in the struggle, he is because of his roots.'[20]

Mandela was found guilty of the charges against him and sentenced to five years, the heaviest sentence yet imposed for a political offence. The state was closing in. More and more activists were leaving the country, including trade unionists and young people, determined to receive military training and return to fight against apartheid. Within South Africa's borders, an underground High Command had been set up. From a radio transmitter at a secret hideout, Walter Sisulu called on the people to resist.

3

3

A publicity photo of Mandela taken while he was underground in 1961. At the time he was hiding out in Wolfie Kodesh's bachelor flat in the Johannesburg suburb of Berea. Mandela made a point of wearing traditional dress, as he would do again during his trial the following year. The 'traditional' cloth in this case was Kodesh's candlewick bedspread!

4

Winnie Mandela and Albertina Sisulu, wearing traditional dress leaving the court. The man behind them is Wolfie Kodesh.

Rivonia

SITE 50

The Trial of Life or Death

After being banned, the ANC set up its underground headquarters at Lilliesleaf Farm in Rivonia. Arthur Goldreich, a Congress of Democrats and MK member, and his family became the official tenants. Before he went abroad, Mandela hid out here, wearing blue overalls and posing as a servant. Key figures who stayed at the farm were Raymond Mhlaba and Michael Harmel, while Winnie and her little girls made several secret visits.

In the early sixties, Lilliesleaf Farm was a rural retreat. Today the farm has been swallowed up in the suburban sprawl of Johannesburg. The Gauteng Heritage Agency has plans to commemorate the site.

1
The rural retreat of the Rivonia farmhouse, Lilliesleaf

2
One day in 1991, the Schneider family, who then occupied the Lilliesleaf house, received an unexpected visitor. It was Nelson Mandela, asking if he could look around. The excited family followed him about, sharing his sentimental journey. 'This is where we hid our papers; that is where I slept; that is where we buried our cache of weapons.' In the photograph, the Schneiders join a reunion of some of the Rivonia comrades: Ahmed Kathrada, Rusty Bernstein, Nelson Mandela, Andrew Mlangeni and Walter Sisulu.

Rivonia

I suggest that paragraph 75 be replaced with paragraph 167 of the draft ..

** It is an ideal for which I have lived; it is an ideal for which I still hope to live and see realised. But if I should be. I am prepared to die for it is an ideal for which I am prepared to die.

During my lifetime I have dedicated my life to this struggle of the African people. I have fought against White domination, I have fought against Black domination. I have cherished the ideal of a democratic and free society in which all persons live together in harmony and with equal opportunities. It is an ideal which I hope to live for, and to see realised. But my lord, if needs be, it is an ideal for which I am prepared to die.

NRMandela.

On 11 July 1963, scores of policemen swooped on Lilliesleaf Farm. Most of the ANC's key leaders were captured, as were several minor figures who happened to be there at the time. The biggest 'catches' were Walter Sisulu, who had been mesmerising black South Africa with his secret radio broadcasts, and Wilton Mkwayi, the new commander of MK. The newspapers reported that the arrest of 'six Whites and twelve non-whites' was 'a major breakthrough in the elimination of subversive organisations'.

All those arrested, along with Mandela who was already in jail, were subsequently put on trial for plotting violent revolution against the state. It seemed very likely that they would receive the death sentence. But Mandela remained defiant. 'It is not I but the government that should be in the dock,' he declared in court.

Mandela prepared his own final statement before sentencing. In the conclusion he wrote that he cherished the ideal of a free and democratic society: 'It is an ideal which I hope to live for, and to see realised. But my lord, it is an ideal for which I am prepared to die.' At the urging of his lawyers, he was eventually persuaded to soften the declaration by inserting the phrase, 'if needs be'.

3
Mandela's statement from the dock ended with these words, which reverberated around the world.

The trial provoked countless demonstrations, not just in South Africa but around the world, and drew intense international pressure. Letters to the government came from the Russian Prime Minister, members of the US Congress, and the US representative to the United Nations. It was rumoured that the British foreign secretary had exerted pressure behind the scenes. Oliver Tambo, leader of the ANC's external mission, was permitted to address the United Nations,

and described the conditions for black people under apartheid. The UN responded with a formal condemnation of South Africa.

Sentence was passed on 12 June 1964. Rather than the death penalty, for which Mandela and the other accused had prepared themselves, they were sentenced to life imprisonment. Defence attorney Joel Joffe observed: 'The heart and kernel of this case was not in the courtroom but in the world outside.'[21] In his Introduction to Mandela's *No Easy Walk to Freedom*, Oliver Tambo expressed the same view: 'I am convinced that the world-wide protests during the Rivonia trial saved Mandela and his fellow-accused from a death sentence.'[22]

Bram Fischer, Queen's Counsel, Afrikaner revolutionary, Communist and Mandela's advocate in the Rivonia trial. Mandela called Fischer 'one of the bravest and staunchest friends of the freedom struggle'.

Just two years after Rivonia, Fischer himself was sentenced to life imprisonment for his political activities. Most white South Africans regarded him as a traitor, but for some he became an enduring symbol of an alternative path for whites, and especially Afrikaners. The brave stand taken by Fischer and a handful of other Afrikaner political prisoners — Marius Schoon, Breyten Breytenbach, Carl Niehaus, Derek Hanekom — enabled succeeding generations to identify with the struggle for the liberation of all South Africans.

'As an Afrikaner whose conscience forced him to reject his own heritage and be ostracised by his own people, he showed a level of courage and sacrifice that was in a class by itself. I fought only against injustice, not my own people.' — Nelson Mandela

4

5

Rivonia trialists in 1989, released after more than a quarter of a century in jail. Flanked by trade unionists Cyril Ramaphosa (left) and Jay Naidoo (second from right) are Raymond Mhlaba, David Bopape (who was not jailed), Andrew Mlangeni, Walter Sisulu, Ahmed Kathrada, Elias Motsoaledi and Wilton Mkwayi. Govan Mbeki is not shown here. Dennis Goldberg, kept separately from his black comrades in Pretoria Central Prison for 22 years, had been released five years earlier.

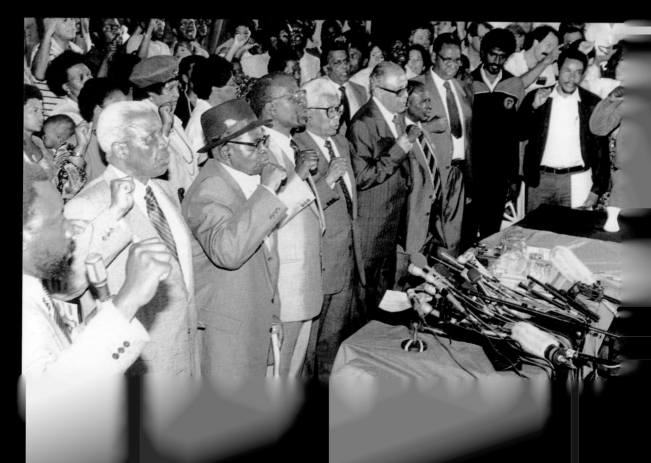

Part Five

'Time may seem to stand still for those of us in prison, but it did not halt for those outside.'

'Ultimately, we had to create our own lives in prison. In a way that even the authorities acknowledged, order in prisons was preserved not by the warders but by ourselves.'

During the 27 years of Mandela's incarceration South Africa itself became a vast penitentiary. The black townships and compounds had always been places of harsh social control. But gradually, despite — or perhaps because of — the stifling of black opposition, an ominous sense of impending retribution became palpable amongst many white South Africans. As the years passed, the struggle for liberation intensified, and South Africa came under increasing international pressure. Boycotted, censured, targeted by the international anti-apartheid movements, and refused visas to travel, white South Africans felt that they were living in a beleaguered country. Robben Island, a prison within a prison, came to symbolise apartheid South Africa.

A prison within a prison

Mandela and six of his fellow accused in the Rivonia trial — Walter Sisulu, Raymond Mhlaba, Govan Mbeki, Ahmed Kathrada, Andrew Mlangeni and Elias Motsoaledi — were flown to Robben Island on Saturday 13 June 1964. On the way to the military airport, a friendly warder joked with them that they would not be in prison long, as the demand for their release was so great: in a few years, they believed, they would return, amid cheering crowds, as national heroes.

In the early prison years, it was assumed that the struggle would soon be won. The PAC had identified 1963 as the 'Year of Liberation'. Mandela himself, in a press statement following the 1961 stay-away, had said: 'I am confident that if we work harder and more systematically, the Nationalist Government will not survive for long.' As a rapid succession of African states were liberated from colonialism, the 1960s appeared to herald a new and glorious era for the continent of which South Africa was an integral part. 'In many ways we had miscalculated,' Mandela later admitted in his autobiography. '[W]e had thought that by the 1970s we would be living in a democratic, non-racial South Africa.'

But there was to be no glorious uprising, and no grand liberation army backed by an outraged international community. In the West, the indignation aroused by the Sharpeville shootings soon died down. Reassured that the apartheid government had black opposition under control, the Western countries began to invest in South Africa again. The economy prospered. Indeed it experienced an unprecedented boom. The government, strengthened by this support, became more and more oppressive.

Mandela and his fellow inmates observed the slow and uneven political developments from inside. Information trickled in: the whispers of newly arrived prisoners or friendly warders,

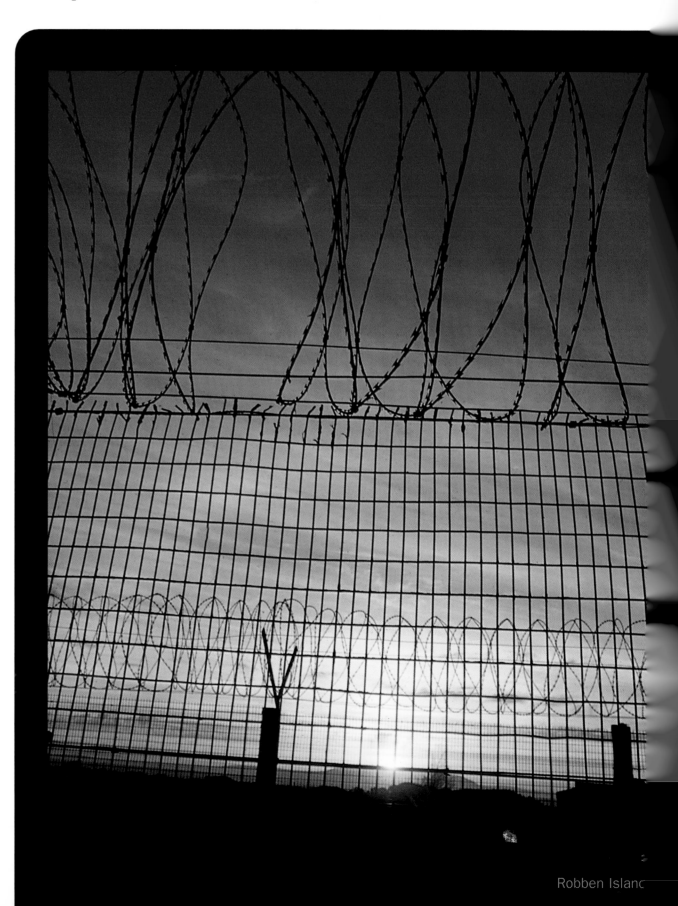

Robben Island

Part Five

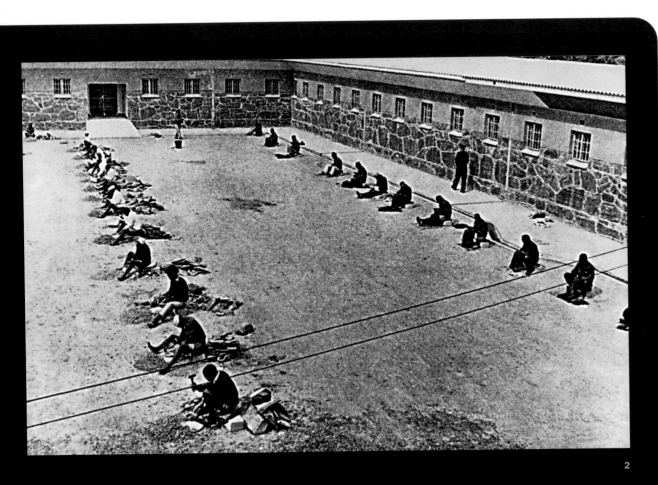

2

'*While we will not forget the brutality of apartheid we do not want Robben Island to be a monument of our hardship and suffering. We would want it to be a triumph of the human spirit against the forces of evil; a triumph of wisdom and largeness of spirit against small minds and pettiness; a triumph of courage and determination over human frailty and weakness.*'

— Ahmed Kathrada, 1993

smuggled notes from outside, old newspapers. Sometimes the news was inaccurate or incomplete; but slowly, painstakingly, the prisoners pieced together the events unfolding in South Africa and the wider world.

Mandela remained on the Island until April 1982. Then he and four of his closest comrades were moved to Pollsmoor, a maximum security prison near Cape Town. As the campaign for his release escalated, the government moved him into a private cell. Finally, in December 1988, he was sent alone to Victor Verster Prison.

Mandela's increasing isolation, a deliberate tactic by the apartheid state, threatened to undermine his national and world-wide status as a hero of the liberation. It would require all Mandela's strategic skills and political acumen to remain in touch with his people, the movement, and the far-flung leadership of the ANC in exile.

2
As the years went by, thousands of lesser-known political prisoners filled the cells of Robben Island.

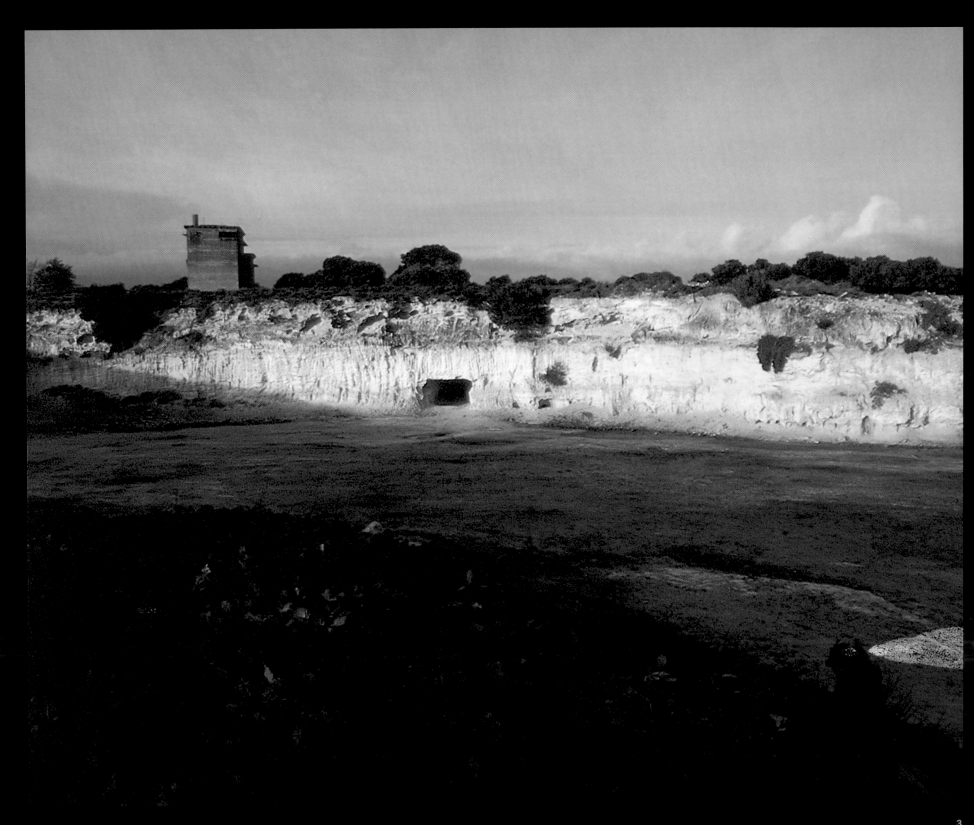

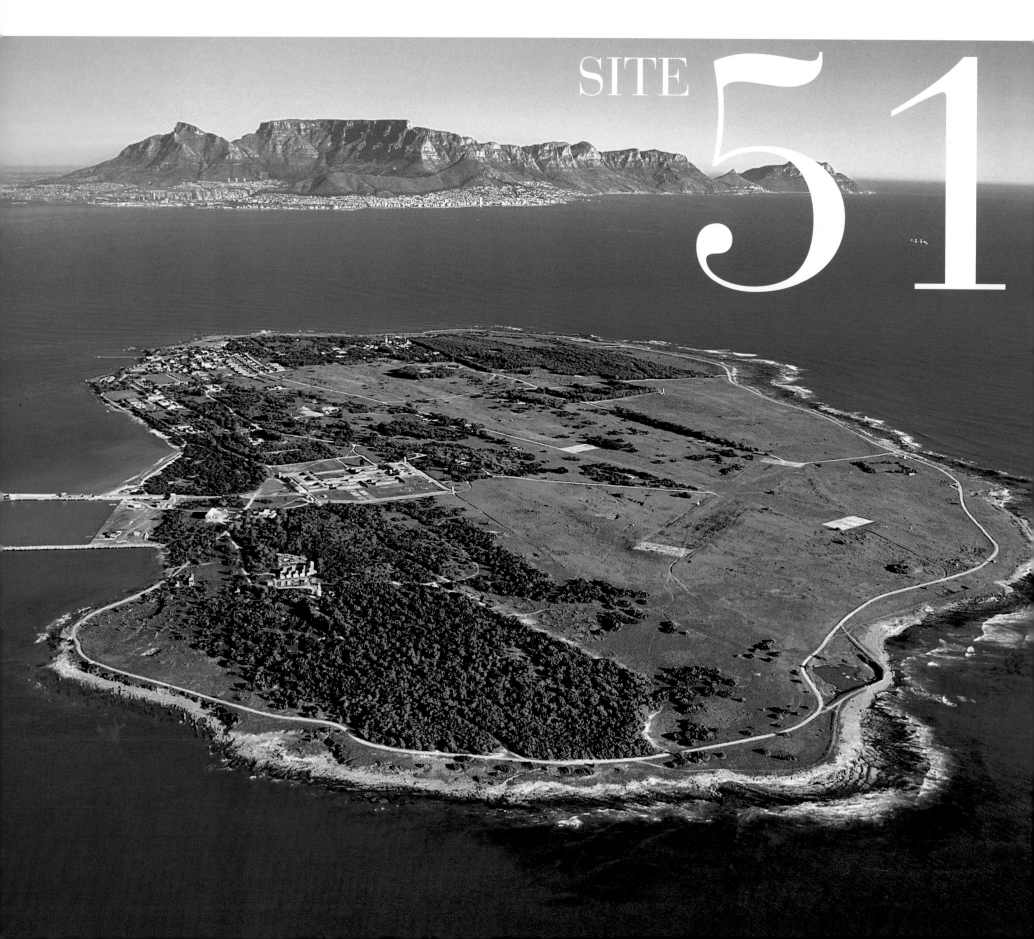

Robben Island

A sustaining myth in the struggle

'Today, tourists and journalists visit the Island. From Cape Town docks the boat steams past seals on its way to the flat rocky outcrop. From the Island's jetty a coach conveys nature lovers in search of ostriches and bontebok, springbok and penguins. Journalists are officially conducted through the prison. They see the small cells in which Mandela and Sisulu and their comrades spent almost twenty years. The lime quarry remains a dazzling white monument, and rainwater hides the depths of the stone quarry. Table Mountain appears tantalisingly close. All around the ocean threatens, its breakers thunder against the Island's shores. The cries of Makana, of Christiana Brown, of slaves and lepers and sheiks, resound in the imagination as do powerful voices, the unexpected laughter and the singing of modern men who so arduously struggled for the freedom of their people.'[23]

1

A group of teachers on their way to a weekend workshop on Robben Island, 1998, with Cape Town harbour and Table Mountain in the background.

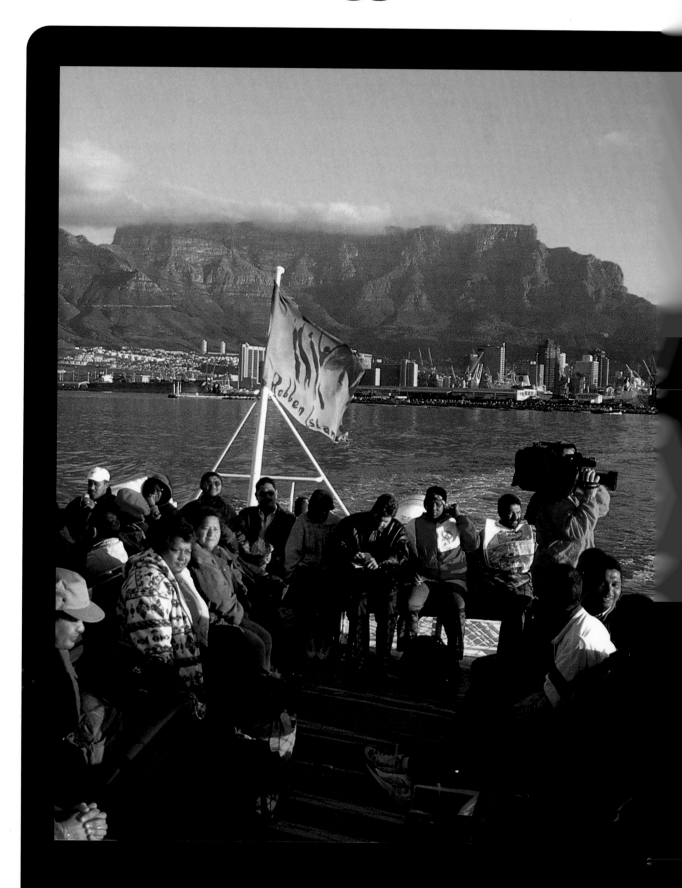

Robben Island

New Age reports on the government's plans for Robben Island. In 1959, Minister of Justice John Vorster announced that Robben Island would become a maximum security prison for black prisoners. No ship was to be allowed within a mile radius.

WHO WILL BE KEPT ON ROBBEN ISLAND?

CAPE TOWN.

The Minister of Justice, in past announcements about the conversion of Robben Island into a prison station, has emphasised that it is to be a maximum security prison for the most hardened and dangerous criminals.

But in the Government Gazette last week the Minister's proclamation merely states that the island and all buildings on it have, as from April 1, 1961, been established as "a prison and prison premises for the reception, detention, confinement, training and treatment of persons liable to detention in custody, whether under sentence of court, or prior to sentence, or otherwise requiring by law to be detained, confined or treated."

From the earliest colonial years the Island was a penal camp, first for unruly sailors and later for indigenous rebels. Slave labourers were also put to work there quarrying lime and bluestone. During the 18th and 19th Centuries, political prisoners banished to the Island included dissidents from the East, who resisted the colonisation of their land by the Dutch East India Company — Muslim priests, Madagascans, Indian slaves, Chinese labourers — along with Khoisan agitators. Also exiled there were a succession of black rulers who resisted colonialism. Their names are inscribed in an ancestral roll of honour: Makana, Maqoma, Siyolo, Ndhlambe, Mhala, Langalibalele...

In the 19th Century the British colonial authorities used Robben Island to segregate hundreds of men and women, rejected by society because of their disfiguring disease of leprosy. Also sent there were the 'chronic sick, lunatics and paupers' of all races. And so it was that over the years the place became associated with inhumanity, rejection and abandonment.

2
In the 19th Century Robben Island was a leper colony.

Mandela and his comrades arrived on Robben Island in midwinter. His cell, typical of those for political prisoners, was seven foot square and lit by a dim bulb. For a bed, there was a thin mat on the floor with three flimsy, worn blankets. The Western Cape's winter rainfall made for bleak, bitterly cold and dank cells. Even in the new, separate quarters for political prisoners, the walls were perpetually damp. 'I was forty-six years old, a political prisoner with a life sentence, and that small cramped space was to be my home for I knew not how long.'

The regulation uniform was an ill-fitting pair of shorts which, Mandela recognised at

2

once, was there to remind them that they were 'boys'. He protested from the beginning. Within two weeks he was issued with a pair of long pants. 'No pin-striped three-piece suit has ever pleased me as much.' Before he accepted the trousers, though, he insisted that the other prisoners be issued with them too. 'My dismay was quickly replaced by a sense that a new and different fight had begun.'

Apartheid distinctions applied on the Island too. Because he was Indian, Ahmed Kathrada had been issued with long pants and socks from the outset. Indian and Coloured prisoners were also given extra rations. These were meagre in the extreme — a spoonful of sugar and a slice of bread — but they served to maintain the apartheid division between the 'races'.

When Winnie Mandela made her first visit to Robben Island, she had already travelled 1 500 kilometres by train with Albertina Sisulu. At the docks they met up with Chief Luthuli's daughter, Dr Albertina Ngakane, whose husband was serving a sentence. On the Island, they were marched along a high wall into a waiting room, where they were warned that only English or Afrikaans might be spoken, and that the conversation should be confined to news of immediate family members. Any infringement would terminate the visit. The visit would last exactly half an hour. They were to speak through a telephone controlled by a warder. As they entered the visiting room the prisoner, with his shaven head and short trousers, was already seated, surrounded by three or four uniformed men. A small, thick, smudged window divided them.

As the political prisoners' elected spokesperson, Mandela began to develop a code of behaviour and cooperation which took ten years of grim endurance and patient discussion to establish amongst both prisoners and warders. Confrontations were 'avoided and never

3

In the spring of 1968, Mandela received a visit from his mother, whom he had not seen since the end of the Rivonia trial. 'My mother had lost a great deal of weight, which concerned me. Her face appeared haggard... As with most visits, the greatest pleasure often lies in the recollection of it, but this time, I could not stop worrying about my mother. I feared that it would be the last time I would ever see her.' A few weeks later, a telegram came from his son Makgatho: his mother had passed away. He was refused permission to attend her funeral. The photograph shows Nosekeni Mandela at her son's trial in 1962.

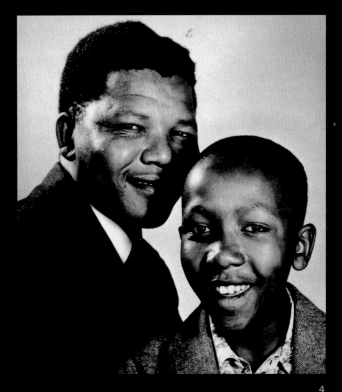

4

One cold morning in July 1969, Mandela received a telegram consisting of a single line: his son Thembekile had been killed in a car accident in the Transkei. 'I do not have words to express the sorrow, or the loss I felt. It left a hole in my heart that can never be filled. I returned to my cell and lay on my bed. I do not know how long I stayed there, but I did not emerge for dinner. Some of the men looked in, but I said nothing. Finally, Walter came to me and knelt beside my bed, and I handed him the telegram. He said nothing, but only held my hand...'

Robben Island

provoked ... Civility and dignity are insisted upon, also voluntary discipline. On the other hand, no semblance of servility is tolerated. Rudeness is rebutted firmly but politely, as far as possible.'

Robert Sobukwe had been arrested on the day of the Sharpeville massacre and sentenced to three years' imprisonment. But the government was so anxious about the newly established PAC and its armed wing Poqo, which had been responsible for the murder of a white family camped on the banks of the Mbashe River, that they passed special legislation to imprison him indefinitely. When his sentence was over, he was moved to a separate house on the Island.

5
This unique photograph, taken surreptitiously in the early 1970s, shows Mandela with the Namibian resistance leader Toivo ja Toivo. After a long battle, Mandela was eventually issued with sunglasses to protect his damaged eyes.

Several times during his first sentence, Mandela had been abruptly parted from cell mates whom he had got close to. They were simply taken away and he never saw them again. He learned that one of the dehumanising effects of prison life was that it forced one 'to adapt by becoming more self-contained and insulated'. The circumstances of the political prisoners on Robben Island were different, and bonds of friendship could be formed there. 'The prisoners developed close bonds with one another,' Jacob Zuma recalled. 'If one prisoner had a visitor, that person would have to repeat the entire experience to the other prisoners after the warders had locked up for the night.'[24]

This is not to say that there were never tensions or differences, even involving Mandela. As the years wore on, disagreements arose at a senior level over the tactics and strategies of the political prisoners. What was the best approach?

Should the imprisoned leaders send a clear message that they were continuing the struggle by openly confronting the authorities? Or should they pursue the trickier tactic of courting the warders, and use the small spaces opened up in this way to improve the conditions of the prisoners and their communication with the outside world?

Mandela and the other leaders imprisoned with him were prepared for setbacks, including the sacrifice of their lives if necessary. They consciously acted out for their liberation movement a life of risk and dedication. Their isolated circumstances strengthened their bonds. Unlike ordinary prisoners, they could take consolation in the knowledge that they were proven leaders with a mass following. As the years went by, they received news as they had hoped, that their example was proving to be an inspiration for the next generation.

The decade went by. News filtered through, via a steady stream of new prisoners, that an attempted invasion of South Africa through the former British colony of Rhodesia (now Zimbabwe) had inflicted casualties on the enemy, but had failed to even reach the South African border. It gradually became clear that liberation would be a long struggle.

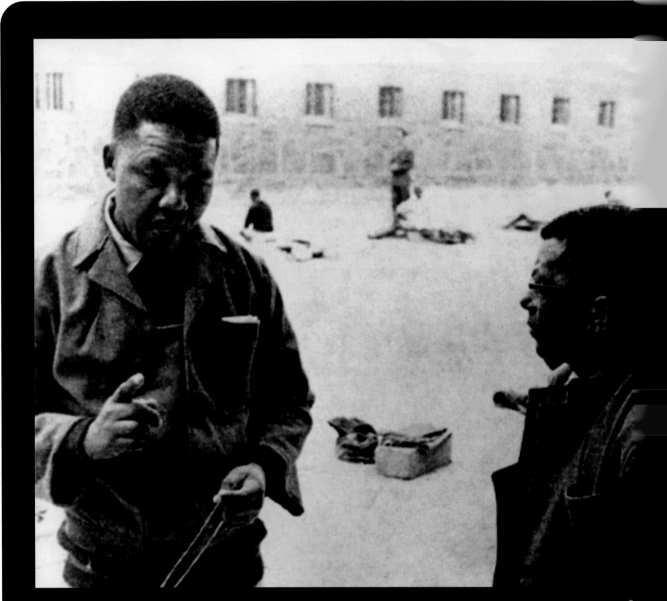

In the early months of their imprisonment, a British journalist took this photograph of Mandela and Sisulu on Robben Island. It was the only time they ever consented to be photographed as prisoners.
'On Robben Island the warders were drawn from a community which has always treated blacks like pieces of rags, and all the prisoners were black. Everything which enhanced your worth as a human being was suppressed... brutally suppressed.'[25]

8115 Ngakane Street, Orlando West

SITE 52

The home of Nelson and Winnie Mandela

Mandela's old house in Soweto has become a tourist attraction. The interior is now a museum, and an outbuilding displays mementoes, craftwork and artifacts for sale. The matchbox house, which has been altered somewhat since the early days, holds many memories for Mandela. He was living here when his and Evelyn's baby daughter died; and when Mandela was arrested and charged with high treason. When he married for the second time, Mandela brought his new bride Winnie to 8115. The umbilical cords of their daughters are buried in the garden. After Mandela was imprisoned, the house came to be associated with Winnie. In 1992, Mandela purchased the property. He later donated it to the Soweto Heritage Trust.

1

8115 Ngakane Street, Orlando West

2

Two days after Mandela was released, crowds gathered outside No. 8115, to greet the world's most famous prisoner, come home at last.

8115 Ngakane Street, Orlando West

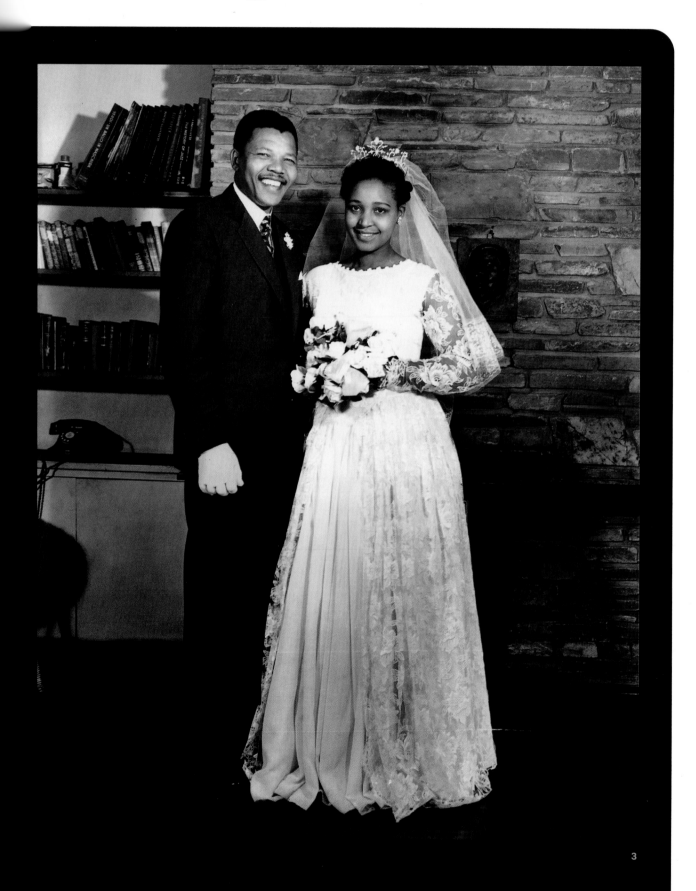

3

Mandela first caught sight of Winnie Madikizela, waiting for a bus outside Baragwanath Hospital on the road to Orlando. It was inevitable that they would meet again: Winnie came from a prominent family in Bizana, Oliver Tambo's home town. Furthermore, as a social worker, she was staying at the same hostel — 'The Helping Hand' — as Adelaide Tsukudu, Tambo's fiancée, a nurse at Baragwanath. A few weeks later, as Mandela was buying something to eat at a café, in walked Adelaide, Oliver and the beautiful stranger, Winnie. The two were introduced, and the courtship never looked back. '*[T]he moment I first glimpsed Winnie Nomzamo, I knew that I wanted to have her as my wife.*' The next day, Mandela called her at the hospital on the pretext that he needed help with fund-raising for the treason trial, which he was then caught up in. He invited her to join him for a spicy meal at Kapitan's (see Site 23). Everything about her charmed him — even the fact that she had never tasted curry before and kept drinking water to cool her palate.

'Over the next weeks and months we saw each other whenever we could. She visited me at the Drill Hall and at my office. She came to see me work out in the gym; she met Thembi, Makgatho and Makaziwe. She came to meetings and political discussions; I was both courting her and politicising her.'

3
The marriage of Nelson Rolihlahla Mandela and Nomzamo Winnifred Madikizela

On 14 June 1958, the couple were married in Bizana, Pondoland. Nelson had obtained his divorce from Evelyn, and paid the traditional *lobola* for his new bride. He had also had his banning order lifted for six days so that he could leave Johannesburg to attend his own wedding. Afterwards, the couple returned to Johannesburg, where Winnie went back to work and Nelson to

the treason trial.

The following February, a baby girl, Zenani, was born to them. Twenty-two months later, Zindziswa arrived. By then the ANC was banned, and Mandela hardly ever at home. His underground work, around the country and abroad, would finally culminate in arrest and a life sentence. The couple had spent barely three years of married life together.

Winnie visited Mandela for the first time in August 1964, when he had been on the Island for three months. 'I could see immediately that Winnie was under tremendous strain… Winnie I later discovered, had recently received a second banning order and had been dismissed from her job at the Child Welfare Office… The banning and harassment of my wife greatly troubled me: I could not look after her and the children, and the state was making it difficult for her to look after herself. My powerlessness gnawed at me.'

It would be two years before he saw Winnie again. After the second visit, she clashed with the police at the docks. She was charged and sentenced to a year's imprisonment, suspended. As a result, she was dismissed from her second job as a social worker. It was clear to the authorities that Winnie Mandela had no intention of discontinuing her husband's political mission.

4

Winnie and her children, Zeni and Zindzi. Daddy was underground.

Winnie was subjected to a string of increasingly severe banning orders. Passionate — indeed 'headstrong', according to her husband — she made no attempt to hide her contempt for the police, who regularly dropped in at her home to taunt her. Her second banning order restricted her to Orlando, prohibiting her from entering factories or schools. Zeni and Zindzi were sent to

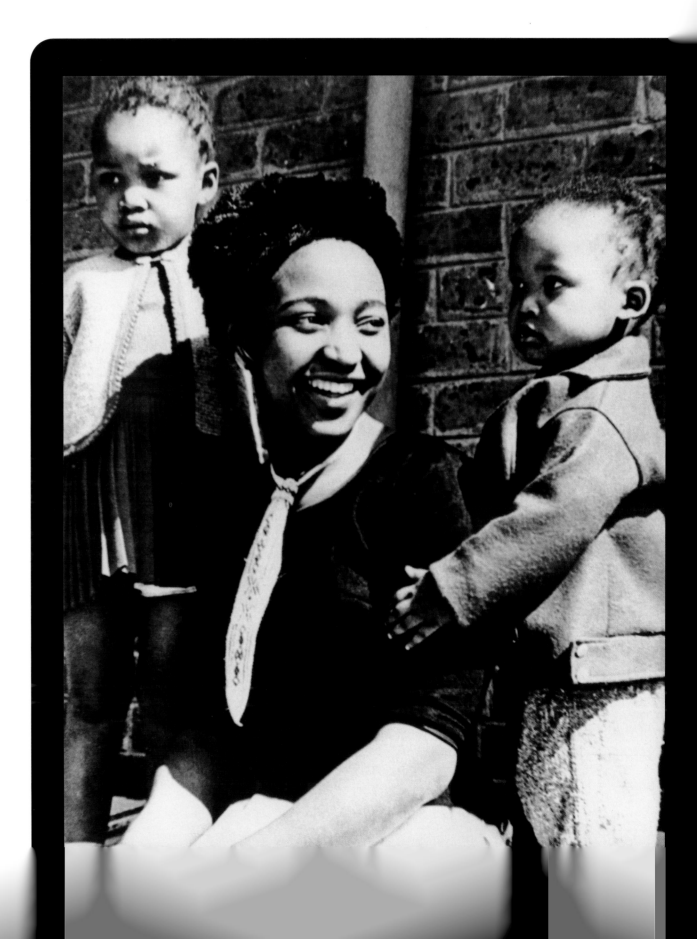

8115 Ngakane Street, Orlando West

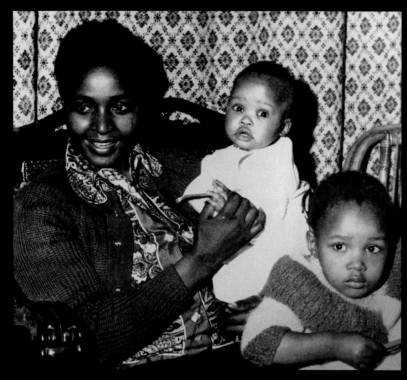

Winnie consoles her younger daughter, Zindzi, before leaving for Robben Island. In 1975, Mandela saw Zindzi for the first time since she was three. Prison regulations did not permit visits from children under the age of sixteen. In fact, Zindzi only turned fifteen that year, but the family altered her birth certificate so that she could see her father a year early.

5

school in Swaziland. 'I was never there as a mother to hold my little girls' hands, take them to school and introduce them to their teachers, as is the glory of every mother when her children are starting school.'[26]

Over the years, the harassment intensified. She was arrested twice in 1967 for contravening her banning orders. In November 1975, a second five-year banning expired.

Then came the Soweto uprising of 16 June 1976. Winnie swiftly became involved in the turmoil that followed. She became a major figure in the Black Parents' Association, set up to act as a mediating body between the students and the authorities. In August 1976 she was detained and held at the Fort for five months (see Site 43).

During this period, Zeni and Zindzi, who were now teenagers and still at boarding school, stayed with Helen Joseph during the holidays, at the request of their father. A close friend of the Mandelas, Helen Joseph had been the first person in South Africa to be placed under house arrest, that is, confined to her house outside of working hours. The girls visited their mother in detention once a week. At the end of the year, Winnie was released and again banned, and house arrested between 6 p.m. and 6 a.m. every day. She had spent a total of 471 days in detention.

6

Winnie in a confrontation with police, 1985

In May 1977 Winnie was banished to Brandfort, a small town in the Orange Free State with a bleak ghetto of 700 tiny houses. Without warning, she was simply taken one day to the local police station. Her home in Orlando West was stripped by four policemen. Then she and Zindzi were driven hundreds of kilometres to a strange township, and left there. The house had three small rooms, and no lights or water.

6

Despite her enforced residence in Brandfort, and police intimidation of the community, Winnie soon developed a relationship with her new neighbours. She set up gardening projects and a créche, and worked in other ways to empower the community. The state's petty vindictiveness did not stop. She was arrested several times and charged with breaking her banning orders. Four white friends, including Helen Joseph, who at different times came to visit her in Brandfort, were jailed for three to six months for refusing to give evidence against her.

7

Helen Joseph, under house arrest, at the gate of her cottage in Norwood, Johannesburg

In 1985, the Brandfort house was burned down. Winnie and Zindzi returned to Orlando, openly refusing to move back to the Free State. By this time, she was an internationally renowned figure. A number of clashes between her and the police were captured by television screens around the world. The authorities were obliged to begin treating her with more caution.

In 1976, in the wake of the Soweto uprising, Mandela had a recurring nightmare. He dreamt that he had been released from prison. There was no one to meet him. After walking for many hours, he arrived at No. 8115. 'Finally I would see my home, but it turned out to be empty, a ghost house, with all the doors and windows open but no one there at all.'

Throughout the years, home for him was Ngakane Street. *'That night, I returned with Winnie to No. 8115 in Orlando West. It was only then that I knew in my heart that I had left prison. For me, No. 8115 was the centrepoint of my world, the place marked with an X in my mental geography.'*

8

Winnie Mandela, at the edge of 'white' Brandfort, under house arrest every night, weekend and public holiday

'Voortrekker Straat... connected the *dorp's* amenities for the two thousand whites... A rough track, watched over by the Bantu Administration office, led to the location, Phathakahle... Here the amenities for nearly three thousand blacks were a Bantu store and a beerhall.'[27]

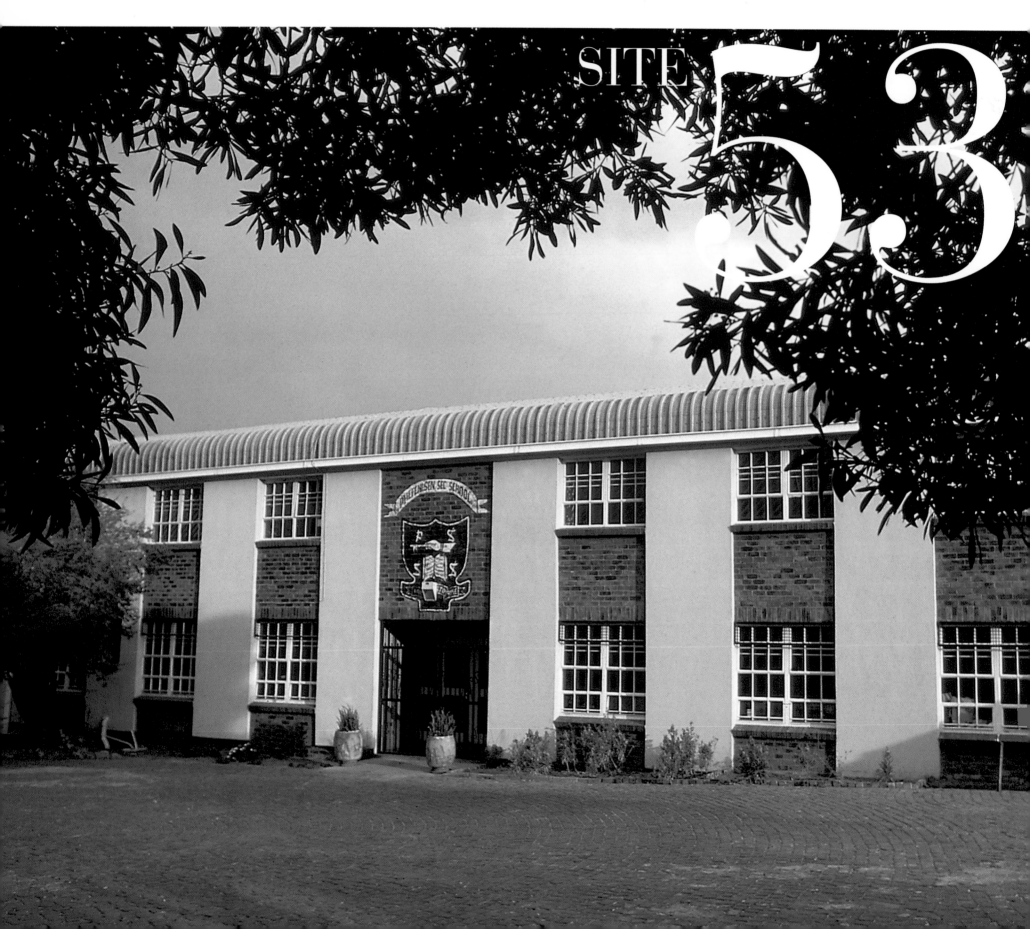

Phefeni School, Orlando West

SITE 53

The Soweto Uprising of 1976

Contrary to conventional wisdom, the student uprising which began in Soweto on 16 June 1976 was initiated by the young pupils of Phefeni Secondary School.[28] Students in the eighth and ninth grades initiated a 'go-slow strike' in protest against having to study in Afrikaans — the language of the oppressor, as they saw it — and a march began outside their school. Like the Sharpeville protest, it began almost light-heartedly. But the brutal police response against schoolchildren sparked an outraged rebellion which spread throughout the country. Today, Phefeni is part of an historic precinct which includes the Hector Peterson Memorial, and the houses of Mandela and Tutu — both Nobel Peace Prize winners — and of Walter and Albertina Sisulu.

1

On the twentieth anniversary of the Soweto uprising, Mandela unveiled the Hector Peterson Memorial in Soweto. Peterson, a 12-year-old Meadowlands boy, was the first casualty of the uprising. This unpretentious monument pays homage to the many young lives cut short in the liberation struggle.

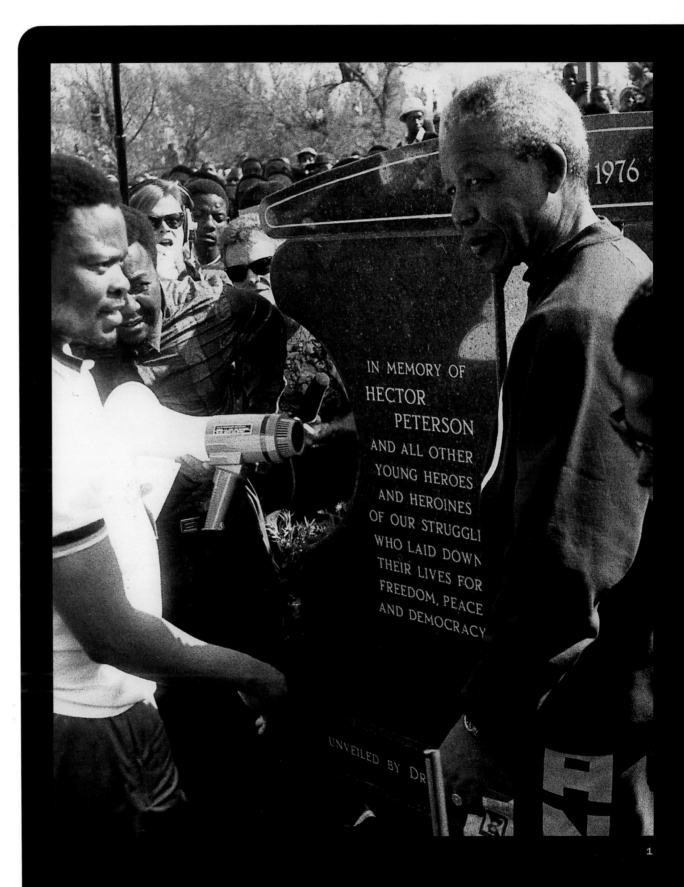

Phefeni School, Orlando West

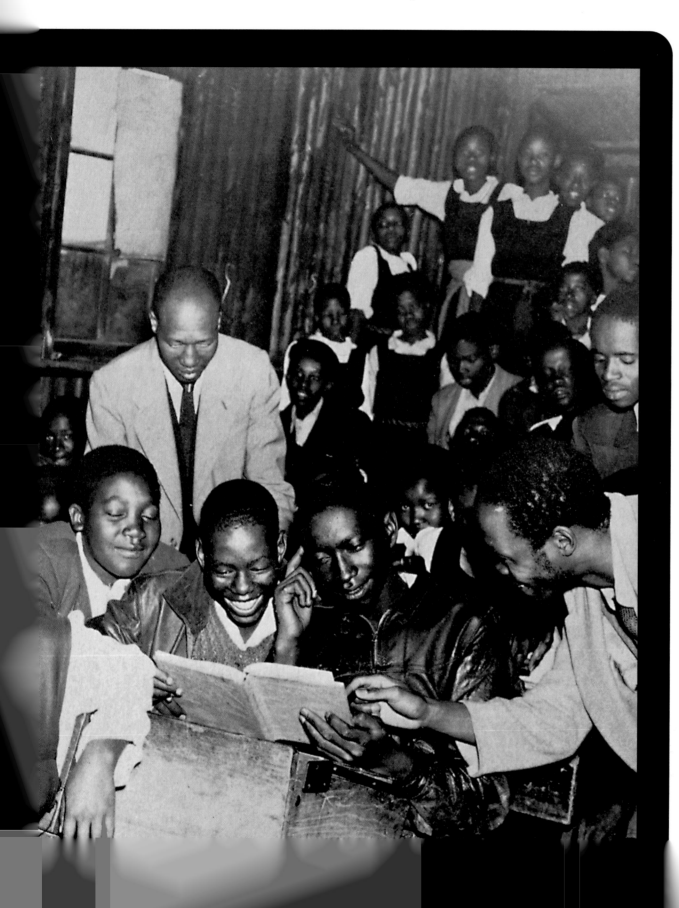

'What is the use of teaching a Bantu child mathematics when it cannot use it in practice?' Verwoerd notoriously stated when his government introduced Bantu Education.

The ANC had long opposed this 'education for servitude'. In his speech to the Transvaal region of the ANC in 1953, Mandela had urged: 'You must defend the right of African parents to decide the kind of education that shall be given to their children. Teach the children that Africans are not one iota inferior to Europeans.'

In the end, however, the ANC lost this battle. The new legislation forbade unlicensed teaching. 'People who believe in equality are not desirable teachers for Natives,' declared Verwoerd in 1954, when he was Minister of Native Affairs.[29] Black parents, who placed great value on education, had no option but to send them to Bantu Education schools. Here the curriculum emphasised manual labour and only enough literacy and numeracy to make useful semi-skilled factory workers, delivery men and domestic workers.

2

When the government introduced Bantu Education in the early 1950s, the ANC supported a boycott. This alternative school or 'cultural club', as it was called, was set up by the ANC in Germiston. Teachers who had resigned from their posts were serving there voluntarily.

It would be more than twenty years before the consequences of this crude racist approach were tragically manifested. By 1976 the number of black secondary school students in the country had increased fivefold.

In March, 1976, the scholars at Phefeni Junior Secondary School began to hold meetings to discuss a new directive that social studies and mathematics should be taught in Afrikaans. In May, they decided to embark on a go-slow

protest. Other schools joined them. By the beginning of June, seven schools had joined the strike, including nearby Morris Isaacson High School. Tsietsie Mashinini, president of the school's South African Students' Movement chapter (SASM), began to direct operations. On 16 June, thousands of school children converged in Vilakazi Street, outside Phefeni. As they marched, thousands more from other schools joined the throng, past the emblematic Mandela house, past the Sisulu house.

By the day's end, 38 children were dead, as well as two adult men, one black and one white. Student protest spiralled rapidly into a nationwide movement. Like Sharpeville, a point of no return had been reached. From then on, young people were to be in the forefront of an escalating struggle. Within a year, thousands had been detained by the police, and many tortured; thousands more left to join the exile movements, in particular the ANC's armed wing, MK. A few years later, some began to trickle back into South Africa, hoping to mobilise the township communities into armed rebellion. MK cadre Solomon Mahlangu, executed in 1979 at Pretoria Central Prison, was a product of 1976.

3

'To hell with Afrikaans!' Soweto, 16 June 1976. Mandela sent a message supporting the revolt: 'Unite! Mobilise! Fight On! Between the anvil of united mass action and the hammer of armed struggle we shall crush apartheid!'

'In September, the isolation section was filled with young men who had been arrested in the aftermath of the uprising. Through whispered conversations in an adjacent corridor we learned first-hand what had taken place. My comrades and I were enormously cheered; the spirit of mass protest that had seemed dormant during the 1960s was erupting in the 1970s.'

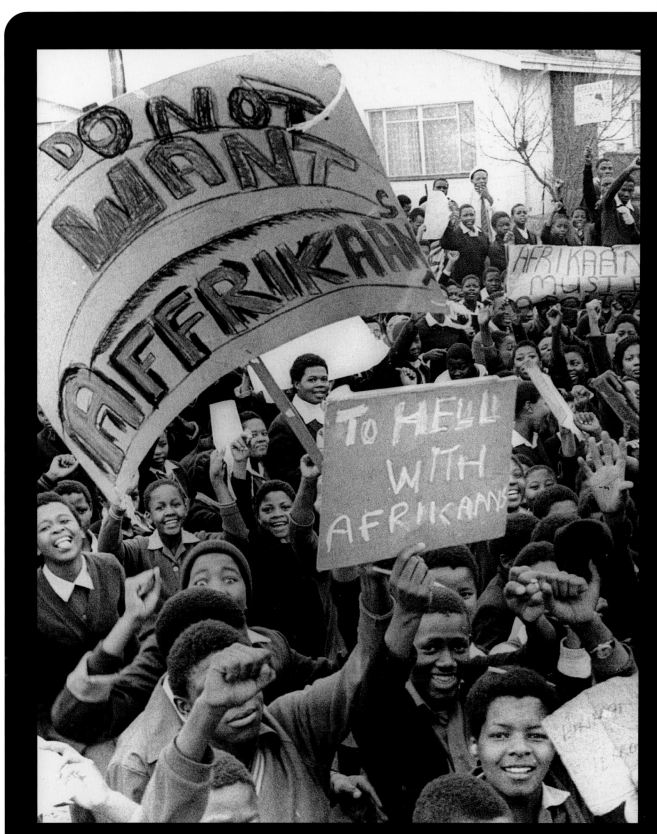

3

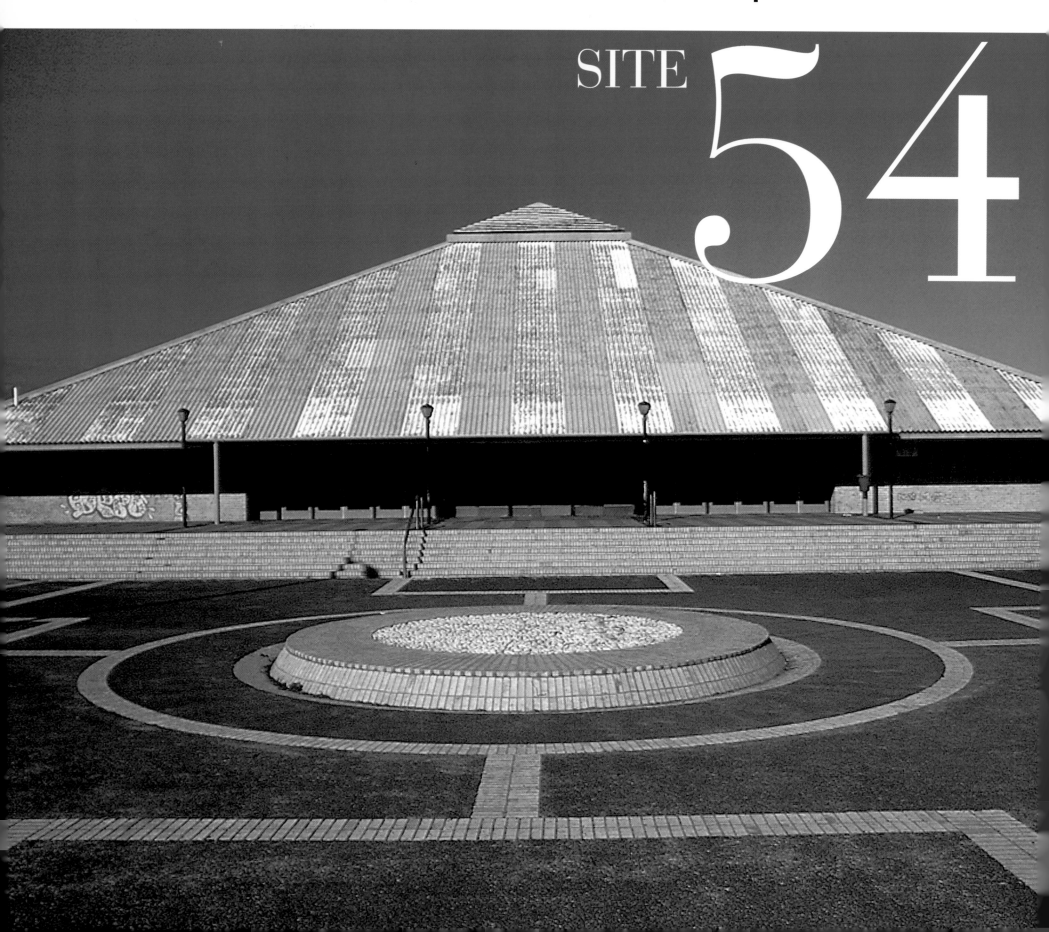

Rocklands, Mitchells Plain, Cape Town

SITE 54

The United Democratic Front

The United Democratic Front (UDF) was a popular mass movement that grew up under conditions of repression in the 1980s. It was launched at a large, enthusiastic rally in Rocklands, Mitchells Plain, in 1983. That was the year in which the government imposed the tricameral constitution on South Africa, giving parliamentary representation to Coloureds and Indians, but excluding the majority, black Africans. On the platform stood the icons of past struggles, Albertina Sisulu and Helen Joseph, and the powerful orator, Allan Boesak. The UDF was a broad coalition of some 700 affiliates, which together claimed two million members. The democratic trade union movement, which had been revived in the 1970s, became an integral part of the political struggle — 'all democrats regardless of race, religion or colour'.

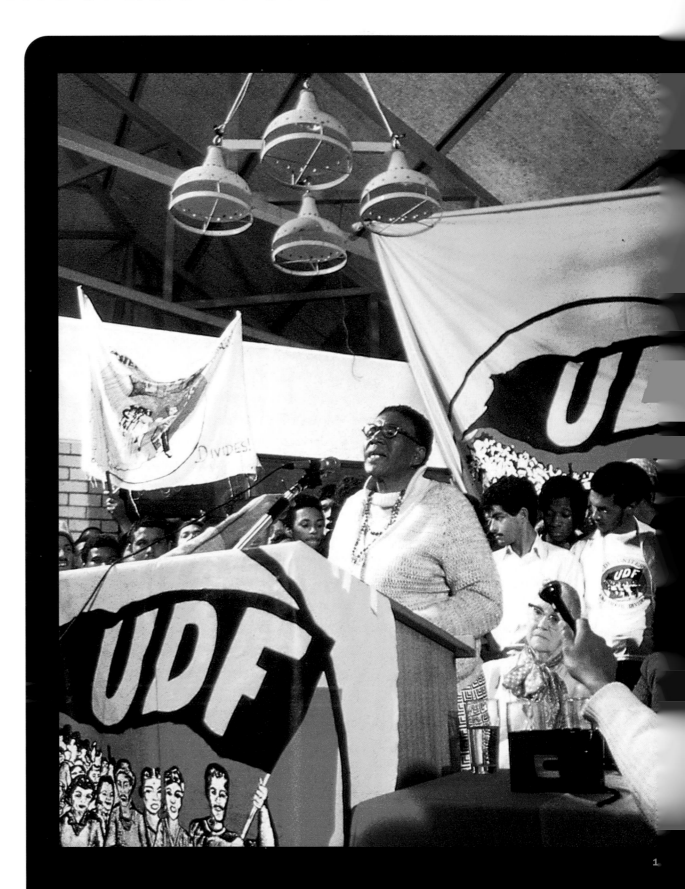

1

Francis Baard, veteran SACTU trade unionist and ANC activist, addresses the UDF launch. Helen Joseph sits behind her (right).

Rocklands, Mitchells Plain, Cape Town

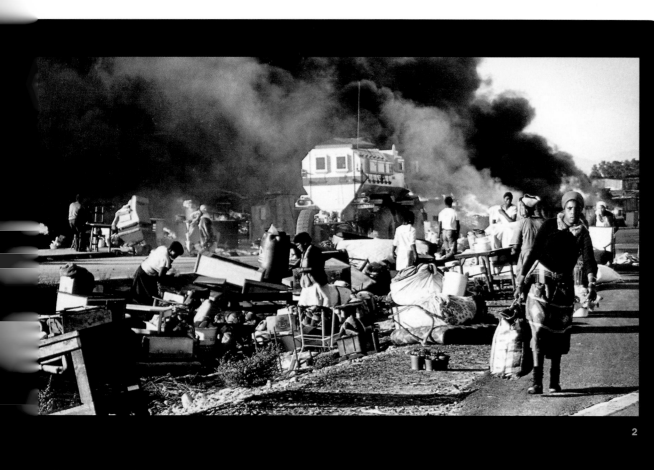

2

In the wake of the 1976 uprising, the banning of the Black Consciousness Movement and the death of Steve Biko, a more openly militant culture took root in the black community. The strong labour movement had a great influence on resistance, providing an example in their methods of mobilising, organising and report backs, and demonstrating the effectiveness of the old ANC tactics of boycotts and stay-aways. By 1980, organised black opposition embraced a wide variety of groups. Men and women who had been activists in the fifties were often in the forefront of civic associations, such as Soweto's Committee of Ten. The Black Consciousness leadership also became more directly active in the community. Women's leagues, savings clubs, burial societies, self-help projects, religious and sports organisations, student organisations, all became more politicised.

2
A burning landscape. Township residents became familiar with the thud of rubber bullets and the smell of tear gas.

3
Soldiers inured to death in the streets take a smoke break, while the body of a protestor lies at their feet.

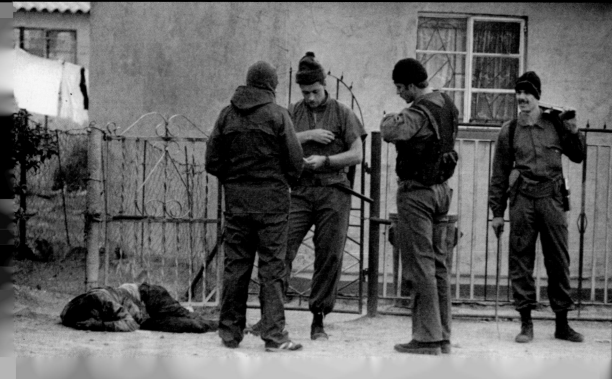

In the student movement, Coloured and Indian activists became more prominent. The old Congress Alliance organisations reappeared in modified form. Small groups of white activists were formed in the bigger cities, while Indian congresses were revived in the Transvaal and Natal. Above all, the youth and students were emerging as a vanguard. As more and more individuals were banned, organisations of civil society, such as the South African Council of Churches, the Call of Islam and the South African Congress of Sports, began to voice their protest.

P.W. Botha's government responded with a double strategy: increased repression and 'reform'. The 1982 Bantu Local Authorities Act gave new powers to the highly unpopular, and mostly corrupt, township governments. Then Botha unveiled the tricameral plan, which gave parliamentary representation to Indians and Coloureds only, arguing that black Africans already had political expression in the ethnically based homelands.

4

Regular funerals in the townships mobilised more and more mourners, and escalated the clashes with the authorities.

The UDF attracted the rapidly mushrooming civic associations, which mobilised around day-to-day local grievances such as the desperate shortage of housing, the lack of municipal services, transportation and rents. These 'civics' were organised on a street-committee basis, reminiscent of Mandela's M-Plan during the late fifties. They were particularly strong on the Witwatersrand and in the Cape. The UDF also successfully utilised the symbols, ideology and tactics of the ANC, openly invoking the Freedom Charter.

5

By the late 1980s, UDF members were openly invoking the ANC, at the risk of harsh penalties and even death.

As the tempo of popular resistance escalated, so did the government's assault on extra-parliamentary opposition. In 1985, four leading UDF activists, including the much-loved headmaster, Matthew Goniwe, were found murdered. A period of heightened resistance, savage repression and violent confrontation followed, changing dramatically the landscape of the townships.

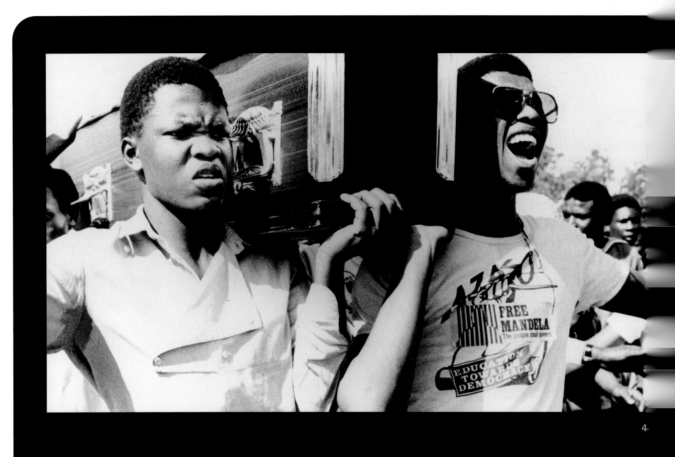

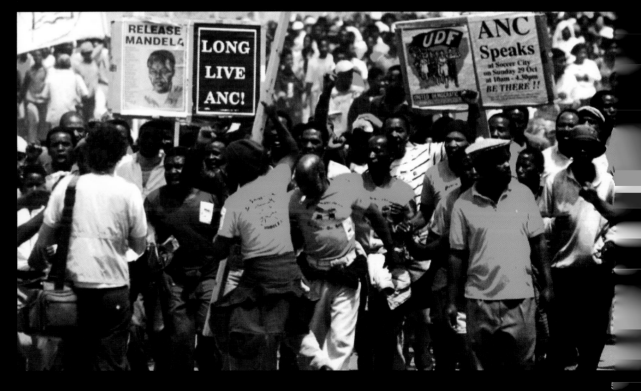

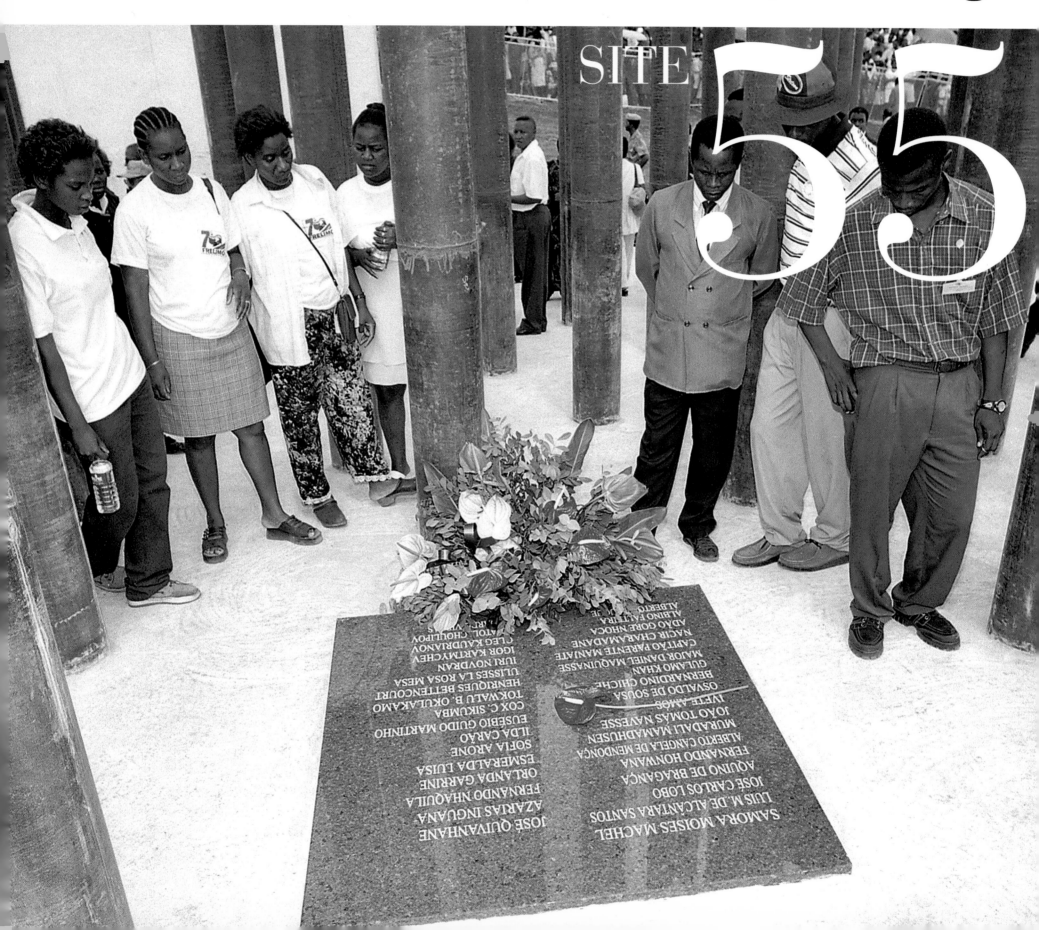

Machel Monument, Mbuzini, Mpumalanga

SITE 55

The war in the region

Just off the highway to Maputo, in the province of Mpumalanga, lies the fertile village of Mbuzini. On one of its hillside slopes, a remarkable, Mozambique-designed memorial is revealed. It is a memorial to the Mozambican president, Samora Machel, and 34 others who were killed in October 1986 when their plane bound for Maputo crashed into the Mbuzini cornfields. The monument was unveiled by President Mandela in January 1999.

Significantly, the monument stands at the junction of three national borders — Swaziland, Mozambique and South Africa — an enduring reminder of the artificial colonial states created in southern Africa during the 18th and 19th Centuries. The highway itself is part of a development project called the Maputo Corridor, which aims to stimulate the economies of the surrounding communities. Silulu, for example, with its distinctive beehive dome, is a cultural centre that promotes the province's rich craft tradition. The centre is also used for functions, conferences and festivals.

1
The SADF lands in Angola, 1975

Machel Monument, Mbuzini, Mpumalanga

2

Samora Machel, commander of the liberation army Frelimo, led Mozambique to independence from Portugal in 1975. The newly elected Frelimo government proved to be very supportive of the liberation movements in the region. Despite hardship and hostility from their apartheid neighbour, they generously allowed the ANC to set up offices on their territory — and paid dearly for this solidarity. In the following years the South African Defence Force launched a series of cross-border raids on neighbouring countries that harboured guerrillas, including Mozambique. Many civilians lost their lives in these attacks.

In the 1980s, dozens of exiled activists were stalked, abducted or assassinated. In 1982, Ruth First was blown up by a parcel bomb in Maputo. A few years later, ANC member Jeanette Schoon and her little girl Katryn were blown up in their home. Dulcie September, the ANC representative in Paris, was killed and so was Joe Gqabi in Zimbabwe. Military raids on South Africa's neighbours resulted in hundreds of fatalities, and many more were maimed and disabled.

2
Julius Nyerere, Oliver Tambo and Samora Machel. Both Tanzania and Mozambique provided hospitality and resources to the ANC in exile. The Machel Monument is also an enduring acknowledgement of the heavy sacrifices made by independent states in the entire region to support the liberation movements in their struggle against apartheid in South Africa.

In March 1984, Presidents P.W. Botha and Samora Machel signed the Nkomati Accord, an agreement that neither country would allow hostile forces to use their territory to attack the other. Mozambique agreed to expel the ANC and South Africa agreed to cease supporting Renamo, the rebel group fighting the Frelimo government.

It gradually became evident that South Africa was not keeping its side of the bargain. The Mozambican decision had an ironic outcome: deprived of bases in Mozambique, the ANC began to intensify its struggle within South Africa itself.

Given this history, it is not surprising that many observers thought the crash that killed Machel had been contrived by his enemies.

On learning of Machel's death, Nelson and Winnie Mandela sent a telegram to his widow, Graça Simbine Machel: 'Never before have we made application to leave South Africa. Today we believed that our place was to be with you physically. Each one of us is imprisoned in different jails. We were prevented from being present with you today to share your sorrow… We must believe that his death will strengthen both your and our resolve to be finally free. For you, victory over immoral surrogate bandits. For us, victory over oppression. Our struggle has always been linked and we shall be victorious together…'

A decade later, Graça Machel, who married Nelson Mandela in 1999, gave evidence to the South African Truth and Reconciliation Commission. She expressed her deep unease about the circumstances of the crash and called for an official inquiry.

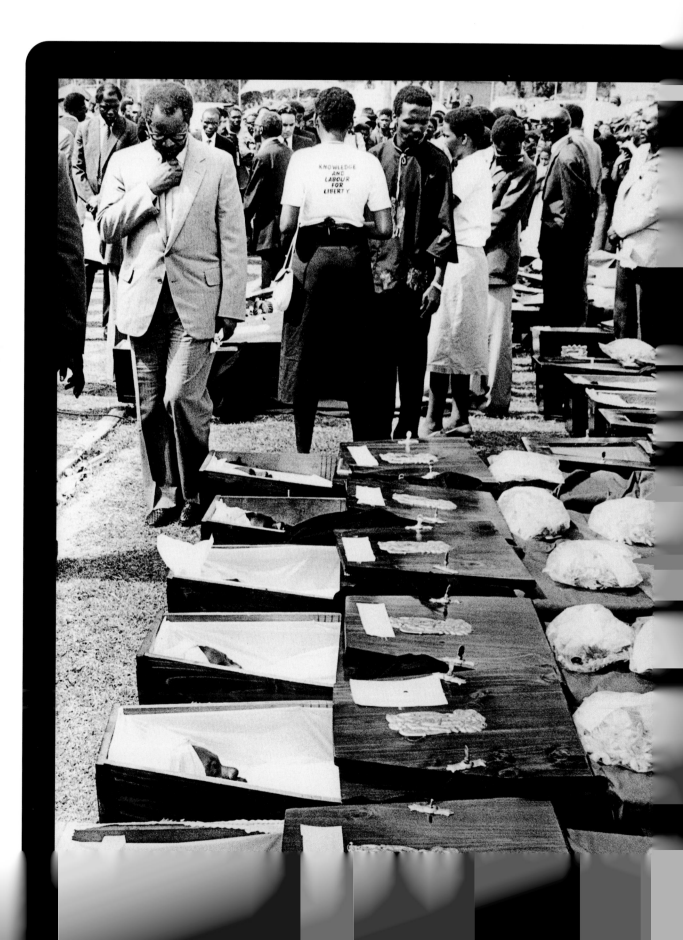

3

Oliver Tambo, exiled president of the ANC, mourns the death of 42 comrades and innocent civilians in a SADF raid on Lesotho, 1982

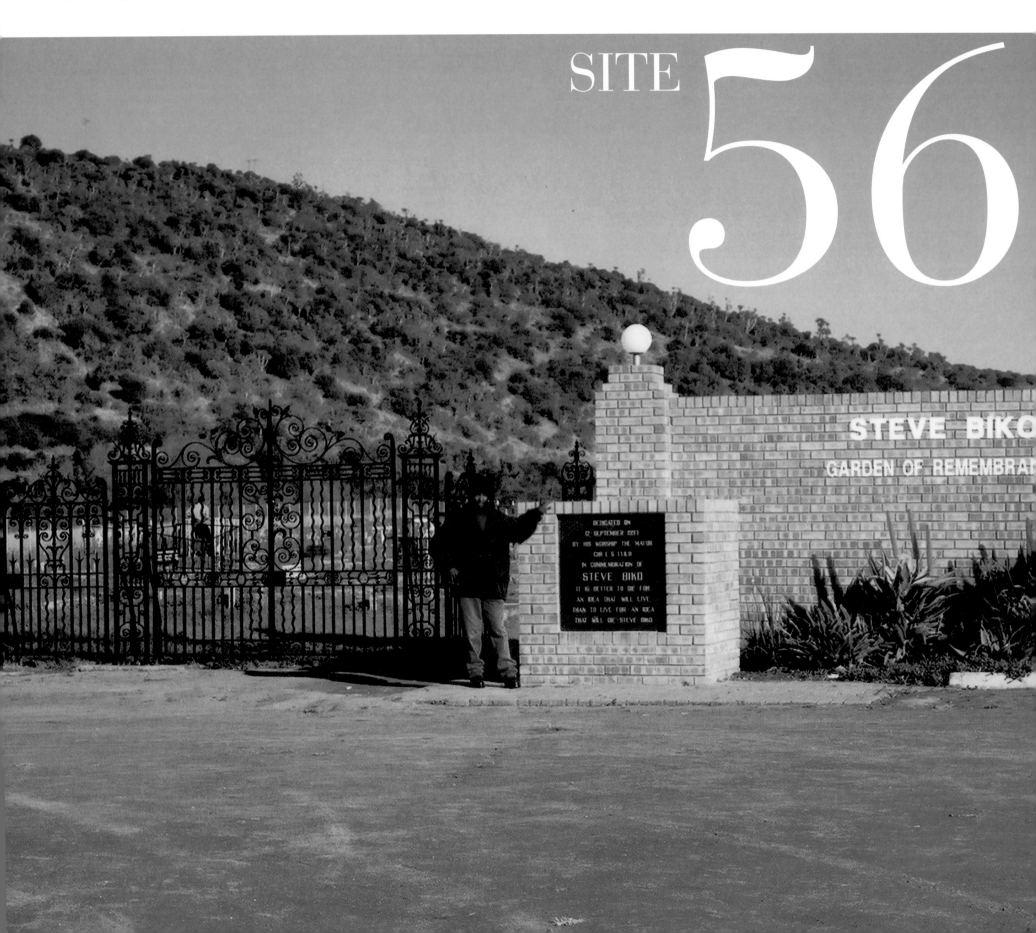

The Steve Biko Garden of Remembrance

SITE 56

The Black Consciousness Movement

In 1977, South Africa was shaken to the core when Steve Biko, the brilliant young leader of the Black Consciousness Movement, died in detention. Biko had already made a major contribution to the philosophy of black liberation, encouraging black people to free themselves from dependency on whites and develop self-reliance and pride in their own culture. Despite overwhelming evidence of the brutal abuse he had suffered at the hands of the security police, the initial inquest into Biko's murder in November 1977 found that he had died accidentally. A decade later, the policemen who murdered Biko applied to the Truth and Reconciliation Commission for amnesty for their crime. It was refused. A museum in Steve Biko's home in Ginsberg, King William's Town, celebrates his life.

The Steve Biko Garden of Remembrance, where Biko is buried, is close to the main road into town.

1

Mandela unveils a statue of Steve Biko in East London, 1997.

The Steve Biko Garden of Remembrance

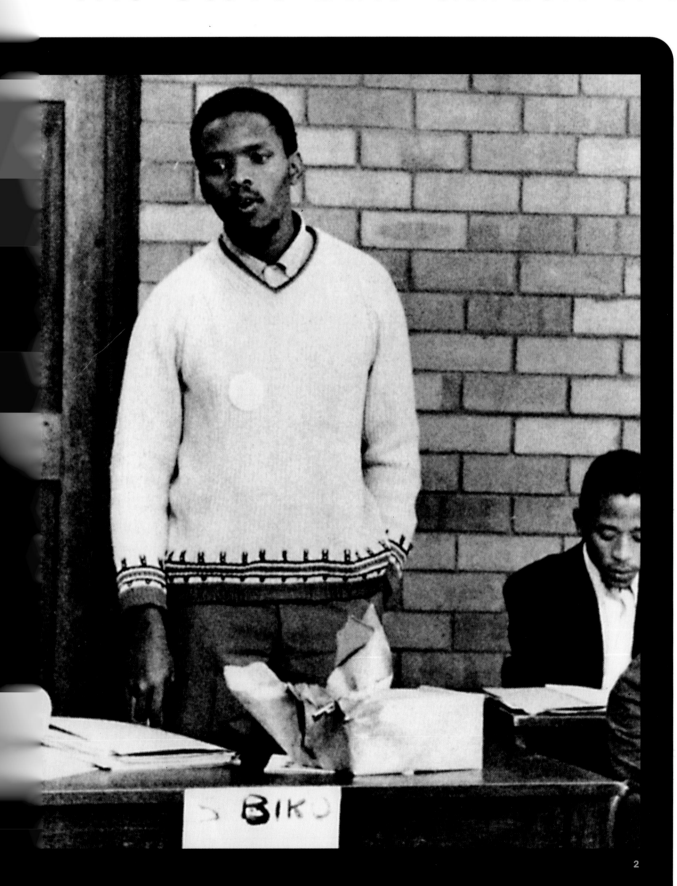

2
Biko at a student conference in the early 1970s.

In 1969, Steve Biko and his associates (including Barney Pityana who now chairs the Human Rights Commision), led black students out of the multiracial but predominantly white Students' Union. They formed the black 'South African Students' Organisation', with Biko as the president. From this base, Biko developed his ideas about Black Consciousness.

The major innovation of the new thinking was perhaps its expanded definition of black identity to include African, Indian and coloured South Africans in one united black domain, and its emphasis on self-help.

On the night of 18 August 1977, Biko and two colleagues were apprehended at a roadblock near Grahamstown in the Eastern Cape. They were detained in police cells in Port Elizabeth, where Biko was beaten so violently that he sustained brain damage. Naked, manacled and unconscious, he was driven in a police Land Rover more than a thousand kilometres to Pretoria. On 12 September he died.

Biko was not the first person to die violently at the hands of the state, nor would he be the last. In 1980, trade unionist Neil Aggett was detained, and found dead in his cell a few weeks later. In 1981, the mutilated body of Griffiths Mxenge, an attorney who appeared for the families of detainees, was found in a Durban stadium. A year later his wife Victoria, also an attorney, was stabbed and bludgeoned to death. Hundreds of lesser-known figures were murdered.

Prime Minister P.W. Botha was preoccupied with the danger posed by the ANC — the old *swartgevaar* [black peril] combined with the threat of communism. Together these two threats — embodied in Umkhonto we Sizwe — amounted to a 'total onslaught'. The state response was a 'total strategy'. In practice, this

meant increased repression, intimidation, spying, phone-tapping, attacks on houses and buildings, the theft of documents, indefinite detention, torture and death in prison, and finally assassination by death squads.

It was common knowledge that torture was used to extract information from detainees. Scores of activists died in detention. Yet when there were inquests and court cases, magistrates and judges routinely found that 'no one was to blame'[30]

On the Island, Mandela and the others were able to piece together these developments by debriefing newly arrived prisoners, smuggling messages through their lawyers, deciphering coded news from visitors, or odd scraps of newspaper.

As more young men arrived, the leadership on the Island learned of the development of the Black Consciousness Movement and its efforts to unite the two 'mother bodies', the ANC and the PAC. This was close to Mandela's heart. Beginning with Black Consciousness student leader Mosiuoa 'Terror' Lekota — he was a 'terror' on the soccer field — the ANC won many new members. The ANC leaders smuggled them notes of welcome — the ANC was a 'great tent that could accommodate many different views and affiliations'. Many prisoners who came in after 1976 were released again within a few years and rejoined the struggle. There were, of course, others who maintained a distinct identity in the Azanian People's Organisation, a Black Consciousness body founded in April 1978. During the eighties, AZAPO often came to blows with the UDF. AZAPO boycotted the first democratic election in 1994, as it could not countenance the ANC's policy of reconciliation, but participated in the second election in 1999.

They died in detention

Looksmart Ngudle was found hanging in his cell, September 1963.

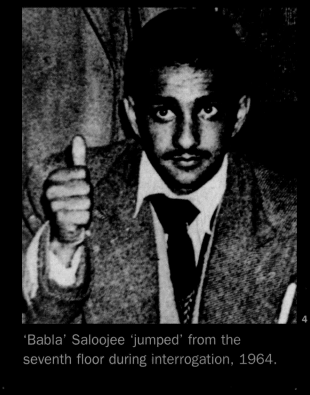

'Babla' Saloojee 'jumped' from the seventh floor during interrogation, 1964.

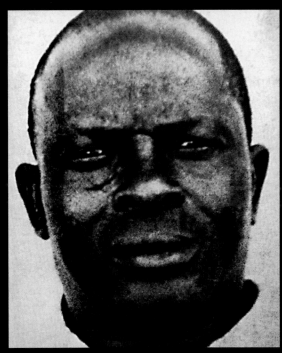

Joseph Mdluli died after 'bumping into a chair' during interrrogation, 1978

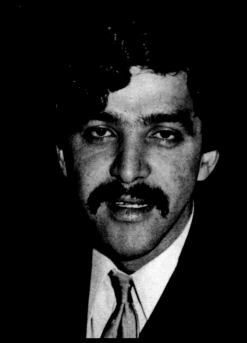

Ahmed Timol 'jumped' from the tenth floor during interrogation, 1971.

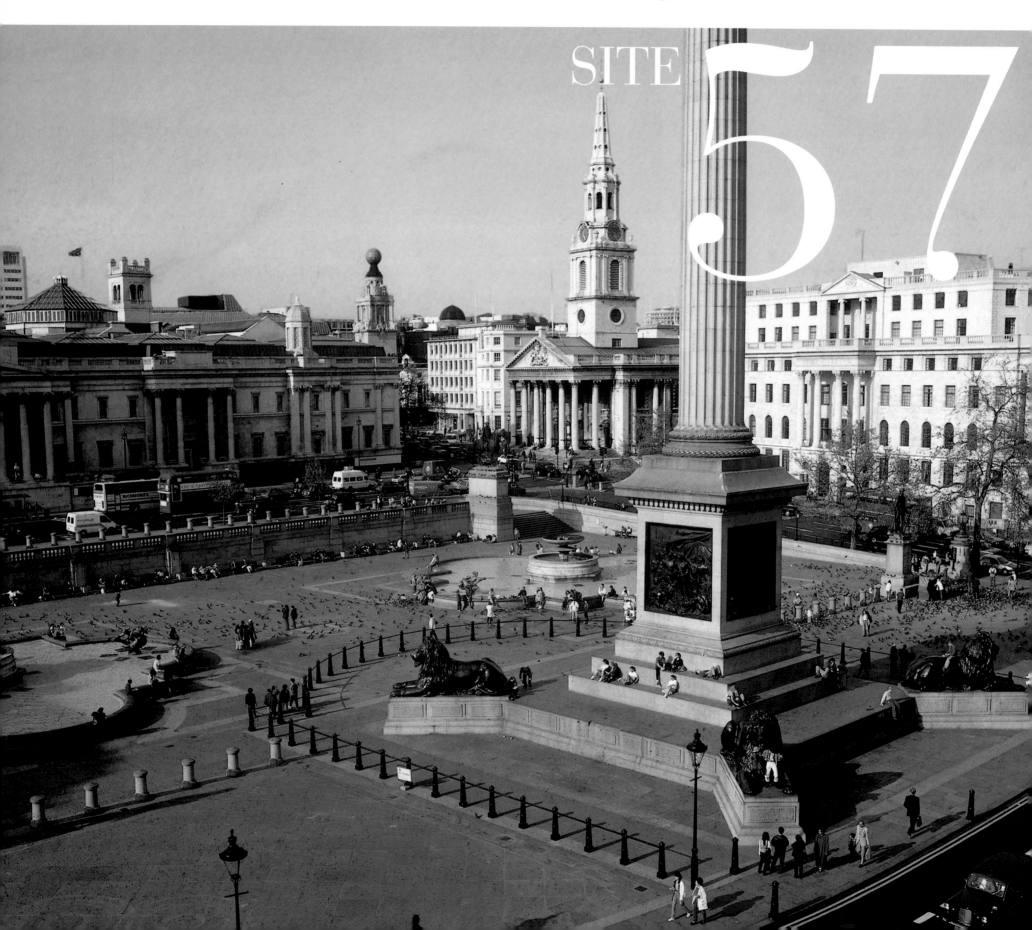

South Africa House, Trafalgar Square

SITE **57**

Mandela's growing reputation

Today Nelson Mandela's face is one of the most recognizable icons in the world, yet a few short years ago, it was virtually unknown. This was especially true in South Africa, where his and other prisoners' images were forbidden by law. In other parts of the world, photographs of Mandela and his comrades taken before their imprisonment were often reprinted, and their cause promoted by the spread of anti-apartheid movements world-wide.

Trafalgar Square, opposite the imposing South Africa House in London, became a site of protest well-known to the media; a symbol of international indignation against apartheid and its supporters, demonstrated in various parts of the world; on student campuses, outside South African embassies and multinational headquarters, and various related public spaces – in the Netherlands, Sweden, Norway, Denmark, and other parts of western Europe, the USA, India and countries in Africa.

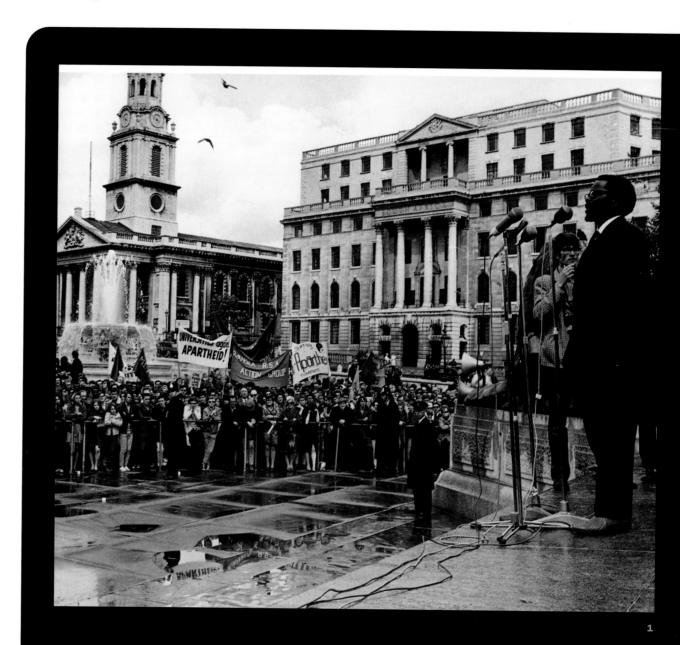

1

Oliver Tambo, head of the ANC mission in exile, addresses the anti-apartheid movement rally in Trafalgar Square to mark South Africa's Freedom Day, 26 June, 1968.

South Africa House, Trafalgar Square

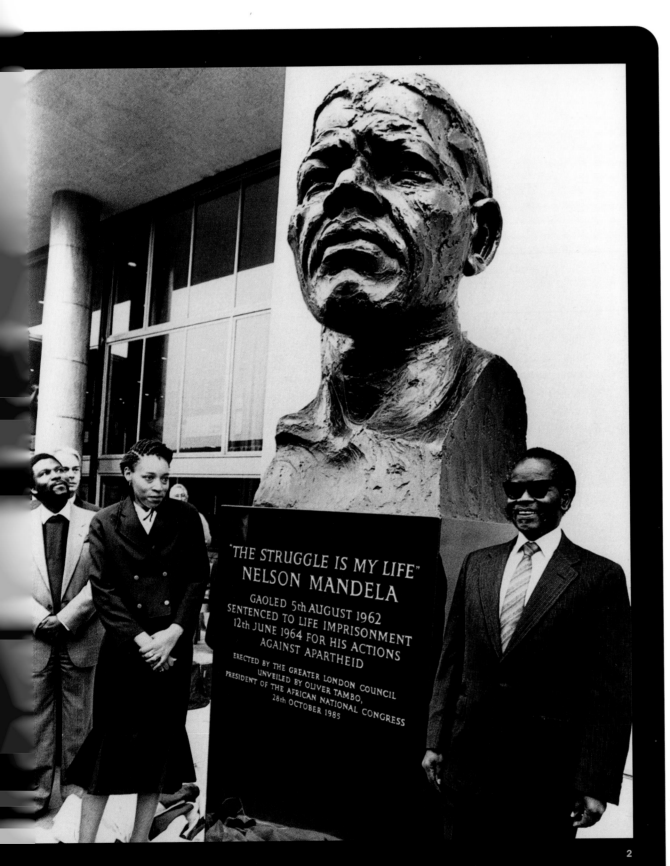

'THE STRUGGLE IS MY LIFE"
NELSON MANDELA

GAOLED 5th AUGUST 1962
SENTENCED TO LIFE IMPRISONMENT
12th JUNE 1964 FOR HIS ACTIONS
AGAINST APARTHEID

ERECTED BY THE GREATER LONDON COUNCIL
UNVEILED BY OLIVER TAMBO,
PRESIDENT OF THE AFRICAN NATIONAL CONGRESS
28th OCTOBER 1985

2

'The making of a people's hero... A man they name streets after.'[31]

As the decades passed, the prisoner Mandela was becoming internationally known. He had not been entirely unknown in the outside world at the time of his arrest in 1962. Only weeks earlier, he had returned from a well-publicised, illegal trip abroad. In London, he had been interviewed on film. This footage would be shown again and again in later years. Before his arrest, the stay-at-home had dramatically raised his profile, as had his appointment as commander of MK. Mandela's speech from the dock in the Rivonia trial was reported internationally, inspiring people everywhere: as the military plane transporting him and his co-accused landed on Robben Island, London University students were electing Mandela as their honorary president. Already, he personified resistance against apartheid.

2
Tambo unveils a statue of Mandela in London.

One of the ANC's greatest assets was the calibre of its leadership on Robben Island. Oliver Tambo and the external mission made a determined effort to communicate this to the world. As soon as Mandela was sentenced, the ANC in exile started preparing a book of his speeches and other writings to publicise the political maturity and insight of the movement and its leaders. They realised that their cause would be best served by putting forward a charismatic leader, someone who would capture the imagination and symbolise in his own person the struggle against apartheid. Barely a year after Mandela was sentenced, the ANC published *No Easy Walk to Freedom*. In his introduction, Oliver Tambo commented on Mandela's 'tall, handsome bearing', and 'natural air of authority', and pronounced him a 'born

mass leader'.

Ironically, the apartheid regime itself contributed lavishly towards the myth of Mandela. Journalist Douglas Brown wrote: 'If he languishes indefinitely in prison, Nelson Mandela will become the most effective martyr in the history of Africanism.' The government's treatment of Winnie Mandela also kept his name vividly alive. Every act of public persecution she suffered reminded people of Mandela and the other freedom fighters imprisoned on Robben Island.

In 1980, the Free Mandela Campaign was launched. 'The idea had been conceived in Lusaka by Oliver Tambo and the ANC, and the campaign was the cornerstone of a new strategy that would put our cause in the forefront of people's minds. The ANC had decided to personalise the quest for our release by centering the campaign on a single figure... There was a handful of dissenting voices on the island who felt that personalising the campaign was a betrayal of the collectivity of the organisation, but most people realised that it was a technique to rouse the people.' The Campaign did indeed capture the world's imagination. Artists, actors, musicians, writers and journalists contributed their talents. On Mandela's seventieth birthday, London put on a massive pop concert.

In India, Scotland, England, the Netherlands, Russia, East Germany, Cuba, streets and squares, university residences and public buildings were named after him. He received honorary doctorates and chancellorships. Leeds University named a nuclear particle after him; Rome and Florence made him an honorary citizen. Support for the families of political prisoners, bursaries for the young refugees of apartheid, food and clothing for exiles were offered in his name.

3

Anti-apartheid protests outside South Africa House, 1988

Pollsmoor Prison, Cape Town

SITE 58

The road to reconciliation

In 1982, Mandela, Sisulu, Mhlaba, Kathrada and Mlangeni were abruptly transferred to the mainland prison of Pollsmoor, near Cape Town. Mandela and the others were now cut off from their fellow political prisoners. They also missed the Island's views, and the presence of nature, the swooping seabirds and the ocean. Although Pollsmoor is set amid vineyards and overlooked by Table Mountain, it is a harsh place. 'Pollsmoor had a modern face but a primitive heart,' Mandela said.

The prison complex took its name from a farm called 'The Moor'. It was first used as a prison in 1948, while the current buildings were completed in the late 1970s. The complex is made up of five prisons, none of them maximum security. The largest, the Admissions Section, was where Mandela was held. The prison's capacity is 3 500, but it currently is grossly overcrowded, with 7 860 inmates.

1
The communal cell occupied by Mandela and his fellow inmates, until he was moved to his own cell.

Pollsmoor Prison, Cape Town

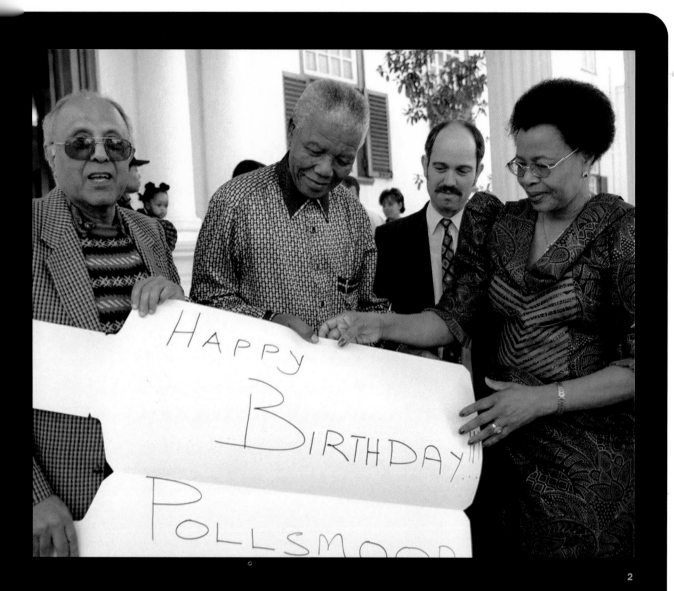

2

When Mandela celebrated his eightieth birthday, the prisoners and staff of Pollsmoor sent him a gigantic birthday card in the shape of a bottle. This was a reference to his favourite hair oil: it was a discontinued line and Superintendent Brand of Pollsmoor had to scour Cape Town to find it for him. In 1998 Mandela's comrades in the Pollsmoor days flew Mr Brand himself up to Johannesburg as a surprise. Seen here with President Mandela are Ahmed Kathrada, Mr Brand and Graça Machel.

The living conditions at Pollsmoor were an improvement. The prisoners had real beds to sleep on, with sheets and blankets. '[A]fter years of eating pap [maize porridge] three meals a day, Pollsmoor's dinners of proper meat and vegetables were like a feast.' They were also allowed to read newspapers and listen to the local radio. They were able to monitor the escalation of struggle — the SADF raids on Maputo and Maseru, and MK's retaliatory attacks, including a car bomb in Pretoria in May 1983, in which nineteen people were killed, including civilians.

The Pollsmoor prisoners surmised that the move was strategic: '[W]e believed the authorities were attempting to cut off the head of the ANC on the island by removing its leadership. Robben Island itself was becoming a sustaining myth in the struggle, and they wanted to rob it of some of its symbolic import by removing us.'

In 1977, the then Minister of Defence P.W. Botha had offered Mandela his freedom on condition that he renounced the use of violence and was willing to settle in the Transkei. Mandela dismissed the offer: the violence of the regime and the apartheid system itself would have to end before he could renounce armed struggle. Mandela saw in these offers 'not efforts to negotiate, but attempts to isolate me from my organisation'.

In his own mind, Mandela had been formulating a strategy based on the African philosophy of *ubuntu*. As the struggle intensified and became more brutal, he often thought of the commanding officer in the seventies, who had imposed a brutal regime and was perhaps 'the most callous and barbaric commanding officer we had had on Robben Island'. Yet, when this man left the Island he seemed sincerely to wish them well. 'It was a useful reminder that all men, even the most seemingly cold-blooded,

have a core of decency… His inhumanity had been foisted upon him by an inhuman system. He behaved like a brute because he was rewarded for brutish behaviour.'

In 1977, Mandela wrote in a secret paper titled 'National Liberation': 'Honest men are to be found on both sides of the colour line and the Afrikaner is no exception.'[32] This was an admission that many political prisoners might have rejected had it not gone hand in hand with a decision by the Island leadership: to make strategic compromises in order to increase control over their day-to-day lives.

In 1984/1985, Mandela received visits from prominent European and American statesmen, sanctioned by the new Minister of Justice, Kobie Coetzee. Mandela interpreted these visits as 'feelers' put out by the apartheid state. In January 1985, P.W. Botha challenged Mandela to renounce the armed struggle as a precondition for his release — an offer he rejected.

Later in 1985, Mandela was taken to hospital for a minor operation. On his return to Pollsmoor, he was placed in a separate wing — three damp rooms with their own toilet. What was the significance of the move? 'The change, I decided, was not a liability but an opportunity … my solitude gave me a certain liberty, and I resolved to use it to do something I had been pondering for a long while: begin discussions with the government.'

'I told them I believed in the Freedom Charter, that the Charter embodied principles of democracy and human rights, and that it was not a blueprint for socialism. I spoke of my concern that the white minority should feel a sense of security in any new South Africa. I told them I thought many of our problems… could be resolved through actual talks.

'While I was not yet willing to renounce violence, I affirmed in the strongest possible terms that violence could never be the ultimate solution … Men and women by their very nature required some kind of negotiated understanding.'

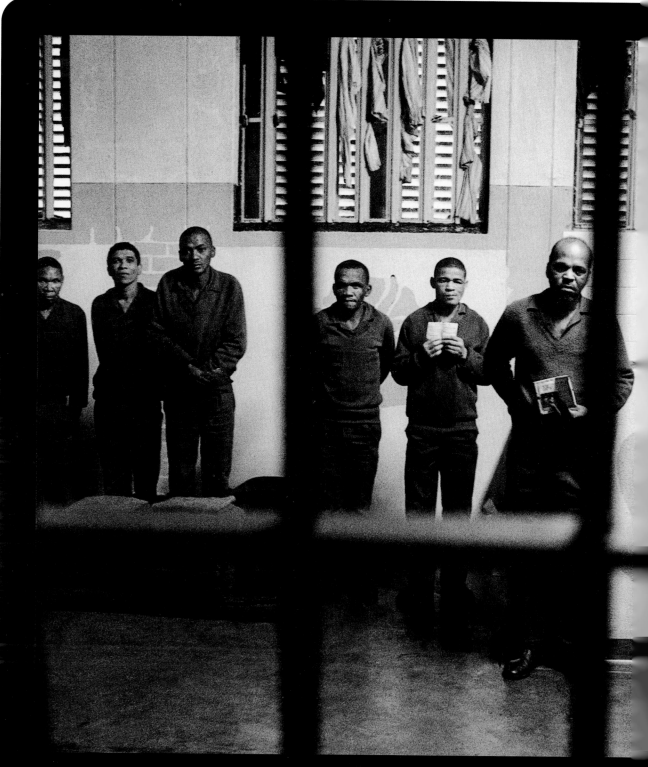

Pollsmoor prisoners, 1990.

3

Jabulani Stadium, Orlando

SITE 59

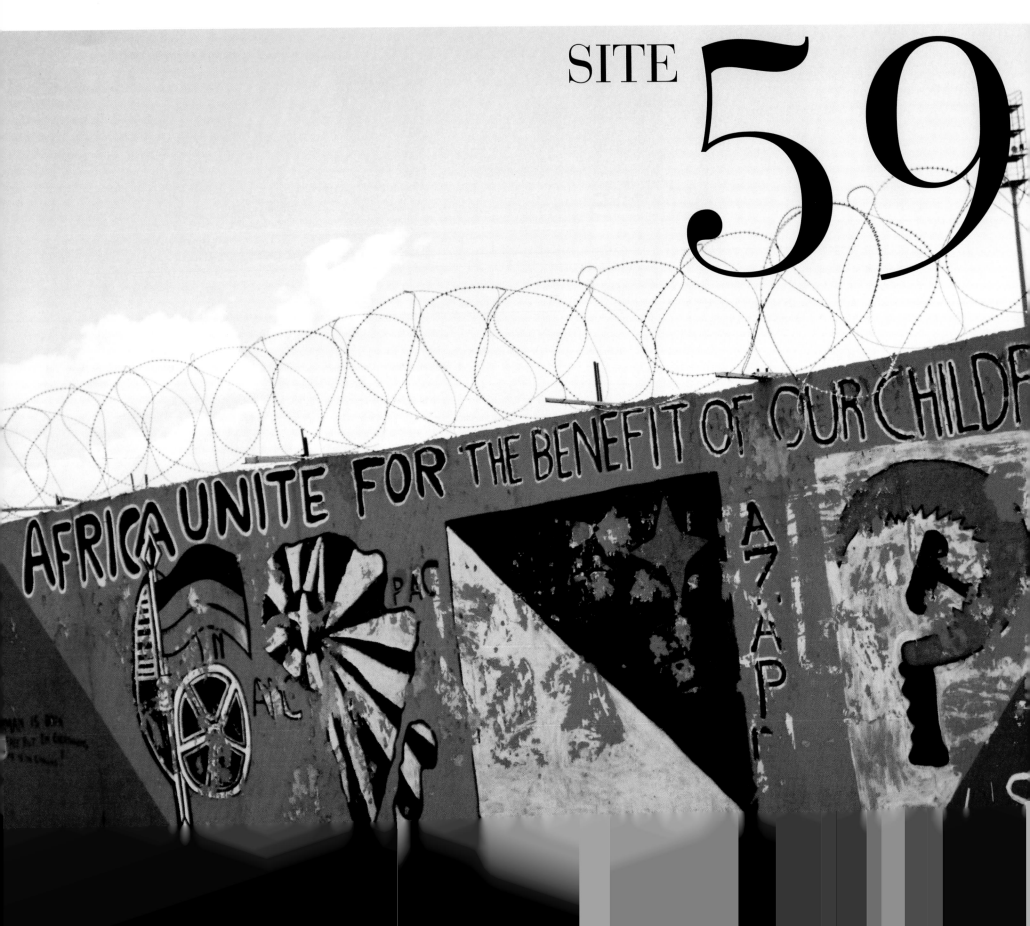

A message to the people

One of the few leisure facilities in Soweto in the apartheid years was the Jabulani sports stadium. Described as 'the cradle of South African football', the stadium regularly drew capacity crowds from this soccer-mad township. The stadium was also used for high-profile funerals and in later years for political rallies. By the nineties, larger and more modern venues such as Soccer City (the First National Bank Stadium at Crown Mines) and Ellis Park had eclipsed Jabulani, and it was sadly neglected. But in preparation for the All Africa Games the stadium was revamped and is now back to its best.

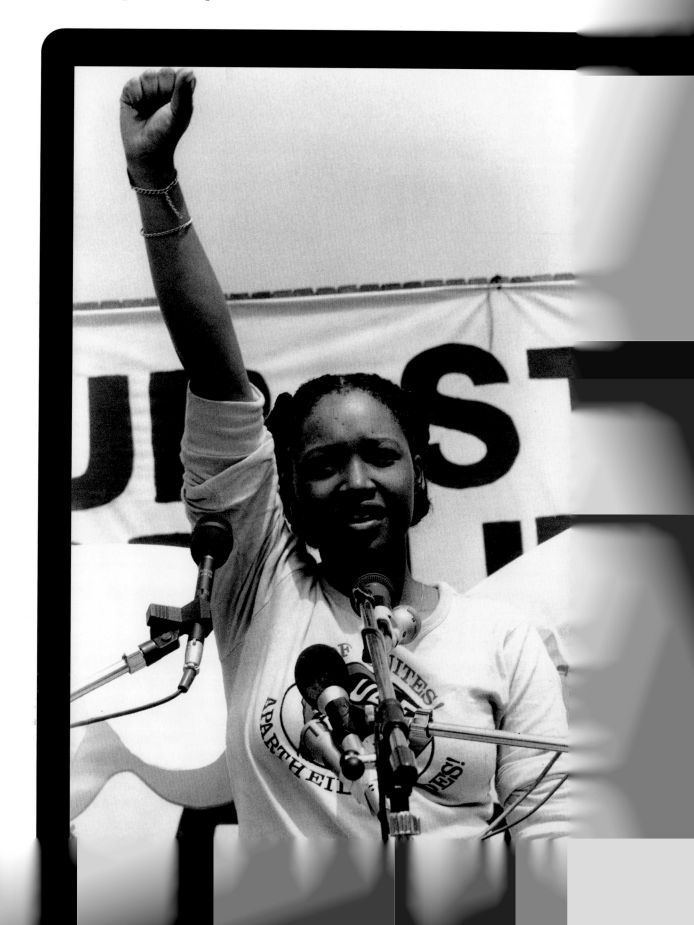

1

Zindzi Mandela reads her father's speech to an ecstatic crowd at Jabulani Stadium.

Jabulani Stadium, Orlando

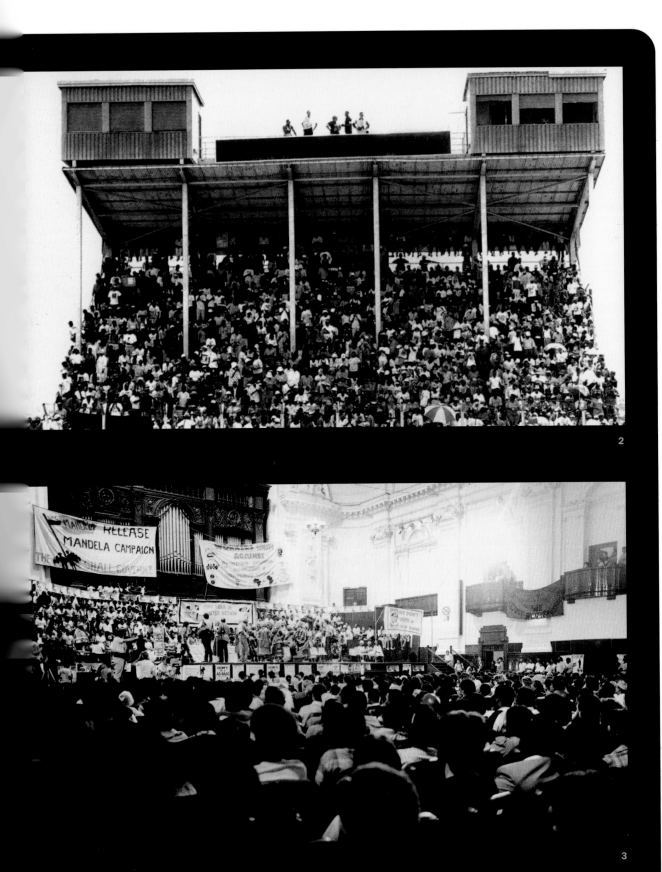

2
The crowds gather to hear Mandela's message.

3
A meeting of the Release Mandela Campaign in the Johannesburg City Hall, 1989. In the eighties mass action had chipped away at 'petty apartheid': just a few years earlier a multiracial gathering such as this would not have been possible, because the hall was then open to whites only.

The decade after the Soweto uprising was marked by escalating resistance to apartheid (see Site 55). Prime Minister P.W. Botha's 'reforms', notably the tricameral parliament, had been rejected by the majority of South Africans. On Radio Freedom Oliver Tambo had called on the people to 'make the townships ungovernable', and young people especially — the 'young lions' or 'comrades' as they became known — responded with a vengeance. Hesitantly, the apartheid government began to look for ways out of its growing dilemma.

On the last day of January 1985, Botha threw down a challenge to Mandela in the most public arena — during a parliamentary debate. 'If Mr Mandela unconditionally rejects violence as a political instrument,' he announced, 'I would be prepared to release him … It is therefore not the South African government which now stands in the way of Mr Mandela's freedom. It is he himself.' Mandela afterwards calculated that this was the sixth conditional offer of release the government had made in ten years.

The ANC leadership had always been a collective, but contact with Tambo and the others in exile was irregular and difficult. Mandela was aware that his isolation from his fellow prisoners by the authorities might have fuelled fears that he had 'gone off the road'; there were already rumours in the outside world

that he was softening his stance on the apartheid enemy. He therefore prepared a public response.

'Botha's offer was an attempt to drive a wedge between me and my colleagues by tempting me to accept a policy the ANC rejected. I wanted to reassure the ANC in general and Oliver Tambo in particular that my loyalty to the organisation was beyond question.'

Mandela rejected the conditions for his release. On Sunday 10 February 1985, Zindzi Mandela read this message from her father at a UDF rally at Jabulani Stadium. For the first time in more than two decades Mandela's words were spoken in public. He began by asserting his undying loyalty to the ANC, and then questioned the conditions the government sought to impose on him. The ANC had only turned to armed struggle when other forms of resistance had been barred to it. He suggested that it was Botha who needed to demonstrate his good faith: 'Let him renounce violence. Let him say that he will dismantle apartheid. Let him unban the people's organisation, the African National Congress. Let him free all who have been imprisoned, banished or exiled for their opposition to apartheid. Let him guarantee free political activity so that the people may decide who will govern them.'

After remembering all those who had suffered and died, he made it clear that he could claim no spurious freedom while the fundamentally unjust restrictions of apartheid continued.

'Only free men can negotiate... I cannot and will not give any undertaking at a time when I and you, the people, are not free. Your freedom and mine cannot be separated. I will return.'

4

Mandela's image was banned in South Africa. This portrait was constructed from the verbal descriptions of released prisoners and the few others who had been permitted to visit him.

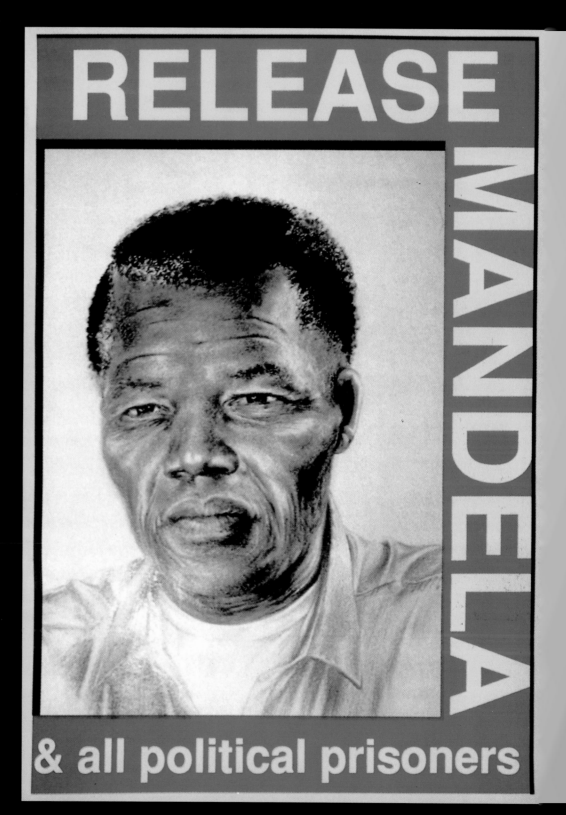

RELEASE MANDELA

& all political prisoners

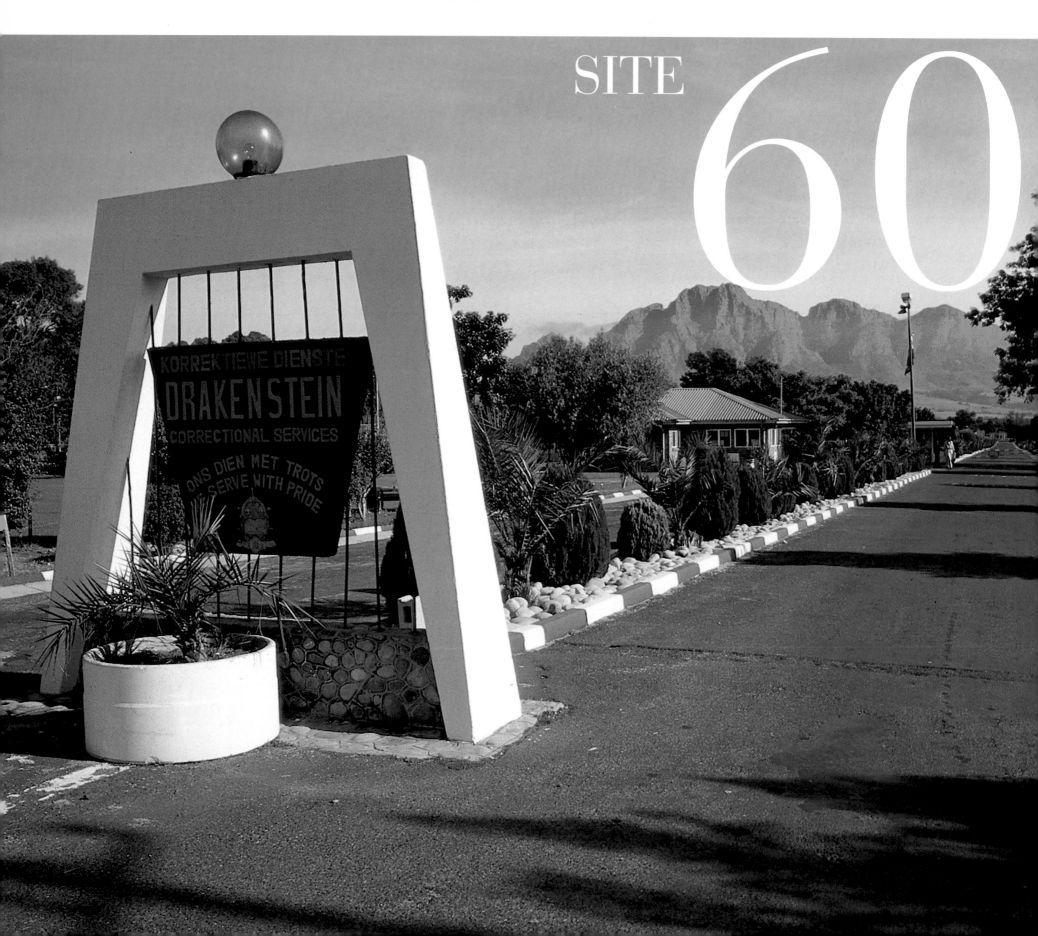

Victor Verster Prison

SITE
60

Between prison and freedom

Victor Verster is a prison-farm near Paarl, a quiet town surrounded by mountains in the heartland of the Cape's wine-growing district. It was from here that Mandela was finally released on 11 February 1990. On that day, thousands of excited onlookers and hundreds of journalists and photographers from around the world gathered to watch the most famous prisoner in the world take his first steps to freedom.

Millions around the world watched the event on television. The house in which Mandela stayed at Victor Verster is now a declared national monument.

The prison itself has been renamed Klein Drakenstein.

1

Cape Town, 5 July 1989: General Johan Willemse, Mandela, Niel Barnard, President Botha, Minister of Justice Kobie Coetzee. After months of preparatory talks and memoranda from Mandela, he finally met with P.W. Botha at Tuynhuis. Six months earlier, Mandela had written: 'I must point out that the move I have taken provides you with the opportunity to overcome the current deadlock and to normalise the country's political situation … I hope you will seize it without delay.'

Victor Verster Prison

In December 1988, Mandela was separated from his comrades and moved to Victor Verster, a 'model prison' not far from Cape Town. His new companions were the warders, a cook and a housekeeper. The prison warder's house he occupied was the first spacious and comfortable home in which he had ever lived. It had a lounge and three bedrooms, even a swimming pool! He soon adjusted to these new surroundings and the courteous, respectful staff, and came to associate the place with a necessary period of preparation for the transition to liberty.

After twenty years, he had to continue his journey without his closest comrades. Yet the separation also freed him in important ways. He could pursue the implications of the simple yet profound realisation of *ubuntu*, a way of thinking which he considered his birthright. 'There is a streak of goodness in men that can be buried or hidden and then emerge unexpectedly.' He was also freed to explore a strategy which he well knew many of his comrades would find unpalatable. If he should fall into a trap, the failure would be his own, and not that of the liberation movement. '[M]y isolation furnished my organisation with an excuse in case matters went awry: the old man was alone and completely cut off, and his actions were taken by him as an individual, not a representative of the ANC.'

2

A free Mandela, relaxed and 'at home' in his former prison

In 1989, Eric Molobi, who had spent seven years on the Island in the 1970s, returned to consult with Mandela as a delegate of the UDF. He was taken aback by the change in Mandela's circumstances in prison. The meal served by the special chef was delicious. A bottle of wine stood on the well-appointed table. What a contrast to the harsh years on the Island! Who could ever

2

forget the contempt, the ill-will, the brutality, the constant hunger for a piece of meat, for female company, for the sound of children's voices? Yet Molobi decided to put his trust in Mandela's integrity and judgement, as a member of a highly respected, collective leadership.

'As a leader, one must sometimes take actions that are unpopular, or whose results will not be known for years to come… This is particularly true of prison, where you must find consolation in being true to your ideals, even if no one else knows of it.' (Interview with author, 1998).

3

The dining room where Mandela was served his meals

In January 1989, after discussions with his comrades at Pollsmoor, Mandela wrote to P.W. Botha, proposing a way out of the political impasse — a discussion to create the proper conditions for negotiations. In July 1989, Mandela finally met Botha.

4

Mandela with De Klerk. Both men had led the way, ahead of their constituencies.

Yet Botha was not the man who would see this historic process through. In August 1989, F.W. de Klerk took over as president. A pragmatist, he grasped the necessity of taking the strategic initiative. He released the Pollsmoor prisoners. He also began to dismantle 'petty apartheid'. The Immorality Act and the Group Areas Act were rescinded; street marches were allowed to go ahead. At the opening of parliament in February 1990 De Klerk made his historic announcement; he unbanned the ANC, PAC, SACP and dozens of other organisations, and released political prisoners.

'It was a breathtaking moment, for in one sweeping action he had virtually normalised the situation in South Africa. Our world had changed overnight.'

Part Six

I need today oh so very badly
Nelson Mandela
out of the prison gates
to walk broad-shouldered
among counsel
down Commissioner
up West Street
and lead us away from the shadow
of impotent word-weavers
his clenched fist hoisted higher
than hope
for all to see and follow

Sipho Sepamla
What is History?

'As I finally walked through those gates... I felt — even at the age of seventy-one — that my life was beginning anew. My ten thousand days of imprisonment were at last over.'

At the moment of his release, Mandela crossed a spectacular Rubicon — from the isolated, essentially unknown prisoner of 27 years, to a status of possibly the century's most inspiring national and international statesman, a role which was to define the remainder of his life. On the day of Mandela's release, apartheid South Africa was still kicking. As if to reflect the many troubles to come, three young men were killed by police in a clash in Barkly East even as Mandela walked to freedom. A memorial has since been erected to honour them. A thousand miles away, in the offices of the Pretoria security police, four shredders (it was rumoured) were burned out, working day and night throughout the weekend destroying sensitive documents. A tumultuous end to the century lay ahead — contradictory, devious and uneven. Filled with anticipation, Mandela and the people of South Africa were treading a rocky new road.

Free at last

On 11 February 1990, millions of television viewers around the world, captivated by the unfolding drama, waited for the release of Nelson Mandela. After 27 years' incarceration he was to be released from Victor Verster Prison. It would be a public event: he would not be flown secretly to his home in Soweto, as President F.W. de Klerk would have preferred. Audiences waited for hours, glued to their screens, while the charter flight bringing Winnie, Walter Sisulu and others from Johannesburg was delayed. Outside Victor Verster, the atmosphere was electric. An SABC television commentator had the monopoly of that historic day. Lacking information about this world-famous figure whose image, life story, words, thoughts and politics had been grimly criminalised for decades in South Africa, the journalist struggled to find something enlightening to say as the hours ticked by.

Suddenly, there was a flurry. Someone glimpsed Mandela's tall elegant figure emerging from a car in the driveway of the prison. He walked towards the gate hand in hand with his wife. His face was inscrutable.

'[When] I was within 150 feet or so, I saw a tremendous commotion and a great crowd of people: hundreds of photographers and television cameras and newspeople as well as several thousand well-wishers. I was astounded and a little bit alarmed. I had truly not expected such a scene...' He raised his fist, and the crowd roared. 'I had not been able to do that for twenty-seven years and it gave me a surge of strength and joy.'

This was one of the defining moments of the century. Many factors had combined to make it possible — including the collapse of the Soviet Union and the economic pressure the West had

1

Mandela's 'clenched fist hoisted higher than hope' at his first rally in Johannesburg.

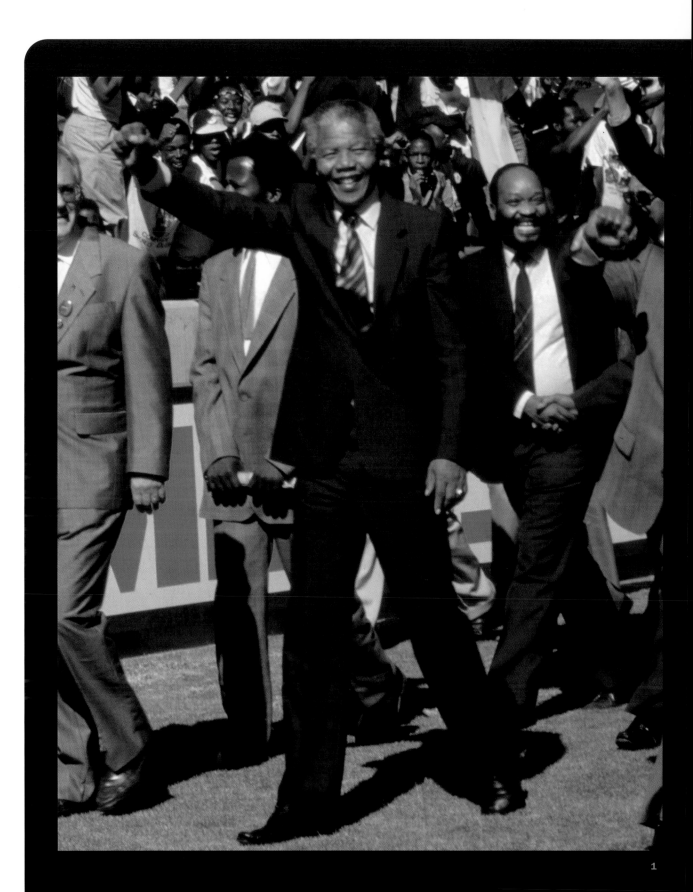

1

Part Six

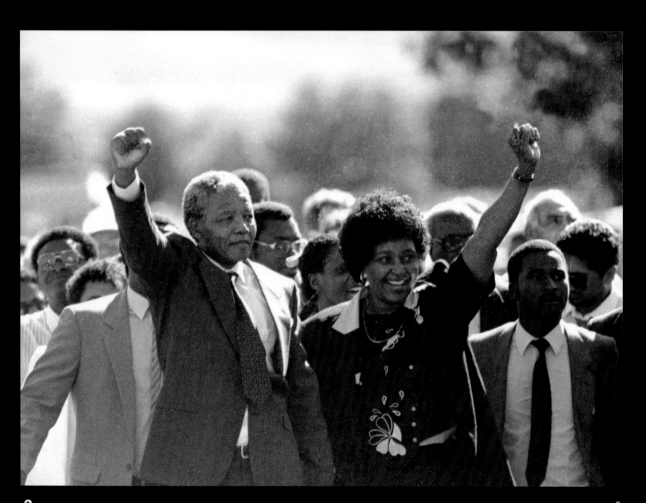

2

Nelson and Winnie Mandela greet the crowds and cameras moments after his release.

been exerting on South Africa. The apartheid government had reached an impasse. The townships were burning, yet there seemed no prospect of a military victory for the ANC. In response to these conditions, and guided by Mandela, in the honourable tradition of skilled diplomacy associated with African strategists such as the 19th-Century King Moshoeshoe of Lesotho, the ANC was to shift from armed struggle to negotiation. Mandela's task, as elected leader of the ANC from 1991, was to coax the people of South Africa, step by bumpy step, towards a shift in mindset — away from the planned revolutionary takeover, and towards reconciliation and inclusive nation-building.

'Who would have thought that we would be living witnesses to the collapse of the former Soviet Union? Who would have speculated on the swiftness with which the United States of America would consolidate its hegemony over the world? Suffice to say that we are living in a world in which the project of revolutionary transformation has become a much more difficult one. To recognise these changes does not for one moment imply that the prospects for and the commitment to democratic transformation have diminished... If we allow our difficulties to drive a wedge between us, the only victors would be those who have oppressed, exploited and brutalised us for so many decades... We must end the violence, the death and destruction, the oppression and exploitation, and build a secure future for us all in peace and democracy.'[32]

Opposite: On the day of Mandela's release, jubilant crowds take to the streets of Hillbrow, Johannesburg.

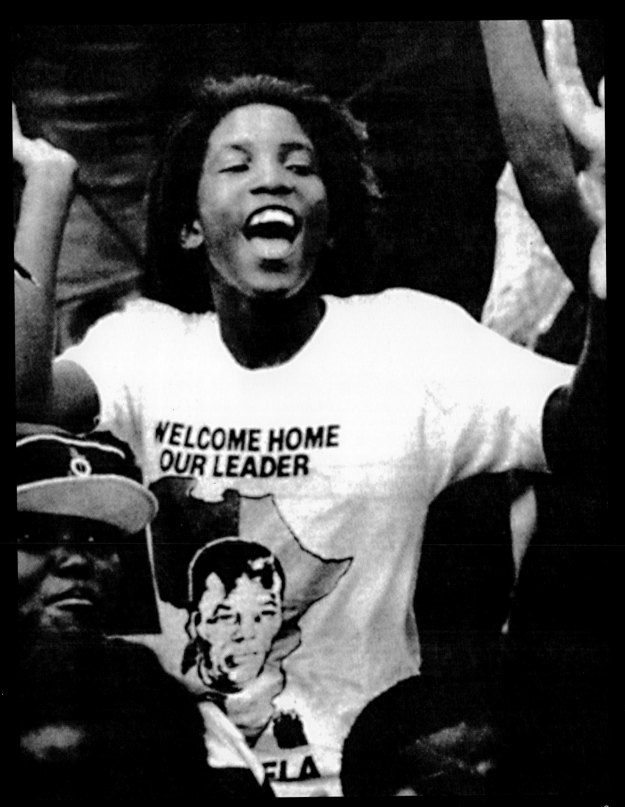

3

4

Grand Parade, Cape Town

SITE 61

The first public speech

The Grand Parade, a huge open square in front of the old City Hall in Cape Town, has a long history as a gathering place. The Dutch settlers who founded the city in the 1600s used the land stretching to the Table Bay shoreline as the garrison parade ground. In the 1800s it became a green pasture, crossed by several streams flowing from the mountains to the sea and surrounded by beautiful oak trees. This and other colonised land was soon forbidden to the indigenous Khoi-San who roamed the fields and mountains for millennia. Today, building encroachment has halved its original size, but it is still Cape Town's largest open area in the inner city. Throughout the apartheid era, Cape Town's trade unions and political and professional associations mobilised their members here — although gatherings were often banned. These days the Parade serves mainly as a market place, and it is usually crowded with informal traders and customers.

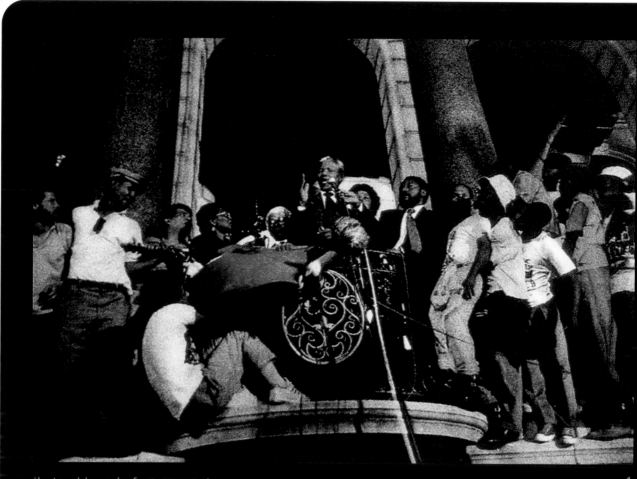

'I stand here before you, not as a prophet but as a humble servant of you, the people. Your tireless and heroic sacrifices have made it possible for me to be here today. I therefore place the remaining years of my life in your hands.'

1

The City Hall, Cape Town, 11 February 1990

Grand Parade, Cape Town

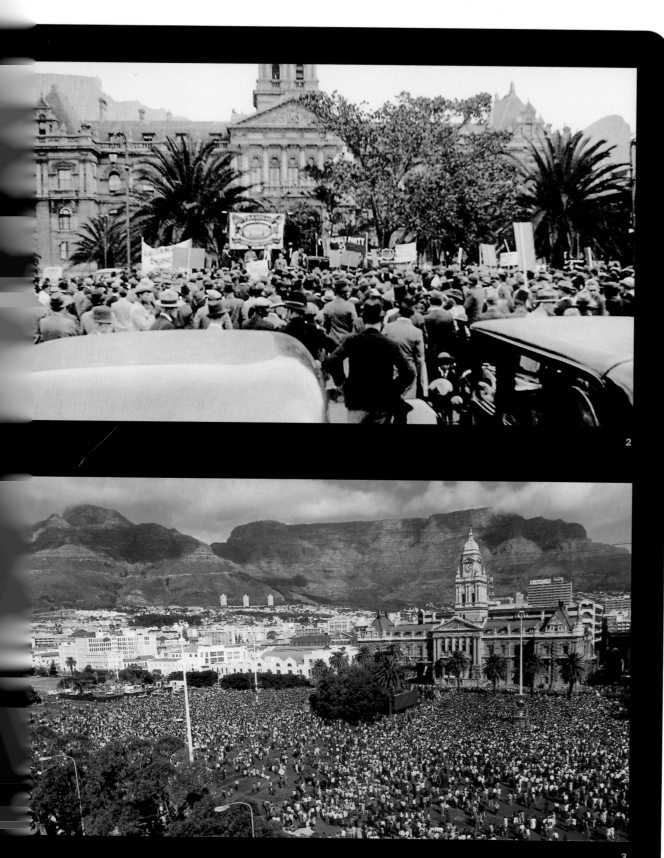

On 11 February 1990, people gathered on the Grand Parade for an event few had expected to experience: an address by Nelson Mandela. As the eyes of the world focused on Cape Town, Mandela made his first public appearance in 27 years.

Immediately after his release from Victor Verster, Mandela's car left for the Grand Parade. He was amazed by the huge assembly of people along the route. The traffic was so overwhelming that it unnerved the driver, who turned the car around and drove straight out of the city centre. 'Not since the celebrations marking the end of the Second World War have such numbers gathered in Cape Town's streets,' a German writer observed. Millions of international television viewers witnessed the event too. When Mandela eventually arrived at the Grand Parade, it was dusk, and he had to borrow his wife's spectacles to read his speech.

2

Labour leader Bill Andrews addresses a war-time gathering on the Grand Parade, 1940s.

Mandela was aware that some would be doubting his revolutionary intentions and speculating that he had been 'bought off' by the authorities. He said: 'Today I wish to report to you that my talks with the government have been aimed at normalising the political situation in the country. I wish to stress that I myself have at no time entered into negotiations about the future of our country except to insist on a meeting between the ANC and the government.'

3

The expectant crowd waits for Mandela to arrive.

On the third day of his freedom, a crowd of more than 100 000 people welcomed Mandela at the FNB Stadium in Soweto. In his speech he invited all South Africans to join forces against

the 'dark hell of apartheid' and work together towards a non-racial democracy. 'Although the ANC is as opposed to black domination as it is to white domination, many whites fear majority rule. We must clearly demonstrate our goodwill to our white compatriots, that a South Africa without apartheid will be a better home for all. We call on those who, out of ignorance, have collaborated with apartheid, to join our liberation struggle.'

4

The welcoming rally in Johannesburg

5

Ahmed Kathrada, Winnie Mandela, Nelson Mandela, Walter Sisulu and Andrew Mlangeni join the crowd in the singing of 'Nkosi Sikelel' iAfrika'.

Despite this conciliatory gesture, Mandela insisted that the ANC would 'pursue the armed struggle against the Government as long as the violence of apartheid continues'. The crowd roared in approval. But he also strongly condemned 'mindless violence'. He urged students to return to school, and called for 'discipline during the irreversible march to freedom'. In the difficult months that lay ahead, as conflict and disagreement threatened to derail the negotiations, the question of whether the process was 'irreversible' or not would occupy the minds of many South Africans almost daily.

'Homecoming' also meant extensive travel for Mandela, to meet with his comrades in exile and thank the millions who had worked for his release and the liberation of South Africa. His first priority was to report to ANC headquarters in Lusaka, to strategise on the negotiations. He then toured the continent, after which he flew to Stockholm, the highlight of his tour, to see Oliver Tambo. Tragically, Tambo had recently suffered a major stroke, brought on by a punishing

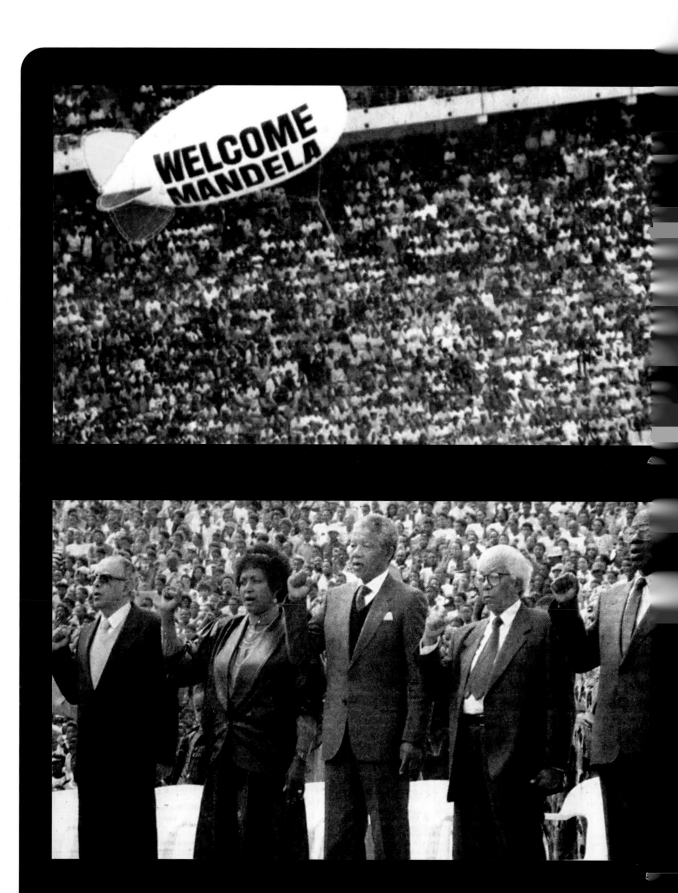

Grand Parade, Cape Town

6

7

schedule while preparing the ANC's Harare Declaration, which mapped out the terms for liberation, and from then onwards was unable to contribute fully his finely honed strategic skills, in the next historic phase of the ANC's struggle for a negotiated revolution.

In June, Mandela visited many countries in Europe to thank the anti-apartheid groups for their work. A highlight of the North American leg of his tour was a visit to Harlem, 'the Soweto of America', as Winnie Mandela termed it at the time. The trip was peppered with celebrations, crushes and crowds, a New York ticker-tape parade, awards, television interviews, welcome dinners, speeches and gifts.

6
Mandela with the Queen of Great Britain and Northern Ireland. In 2000, Mandela was awarded the highest legal honour, the Queen's Counsel.

7
A joyful reunion in Stockholm, Sweden, after 28 years apart. Tambo and Mandela had last seen each other in 1962 during the latter's secret journey abroad to raise support for the armed struggle. 'When we met we were like two young boys in the veld who took strength from our love for each other.'

8, 9
East or west, Mandela is welcomed around the world.

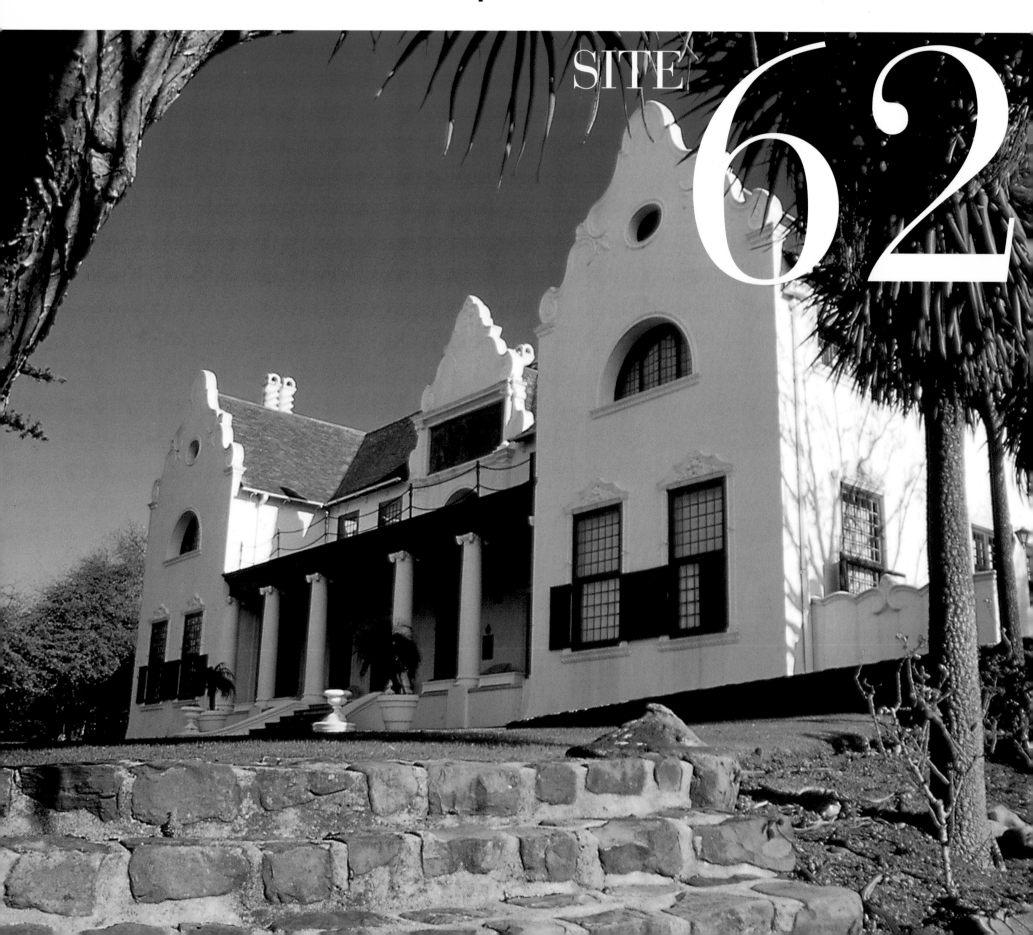

Groote Schuur, Cape Town

SITE 62

Bringing the two sides to the table

The gabled mansion called Groote Schuur, echoing the traditional Cape Dutch style of an earlier colonial period, was built at the foot of Table Mountain by mining magnate Cecil John Rhodes a century ago. It has always served as the splendid residence of colonial governors and white prime ministers and presidents. Today, Groote Schuur is open to the public, and guided tours can be arranged.

When he looked back at the first meeting between the ANC and the government at Groote Schuur, the official Cape Town residence of President de Klerk at the time, Mandela recalled: 'Some of our delegation joked that we were being led into an ambush on the enemy's ground.' It was to be the first of many faltering steps taken by opposing groups to approach one another, and to begin the dialogue which Mandela and the ANC had called more for than thirty years earlier.

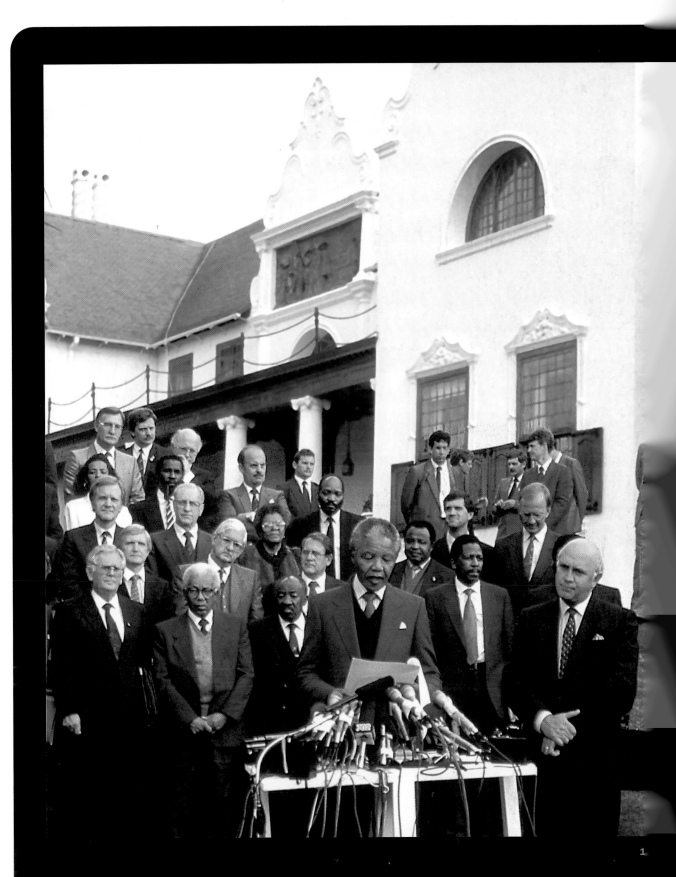

1

The Groote Schuur meeting. MK Commander Joe Slovo (front left) was granted amnesty so that he could attend.

1

Groote Schuur, Cape Town

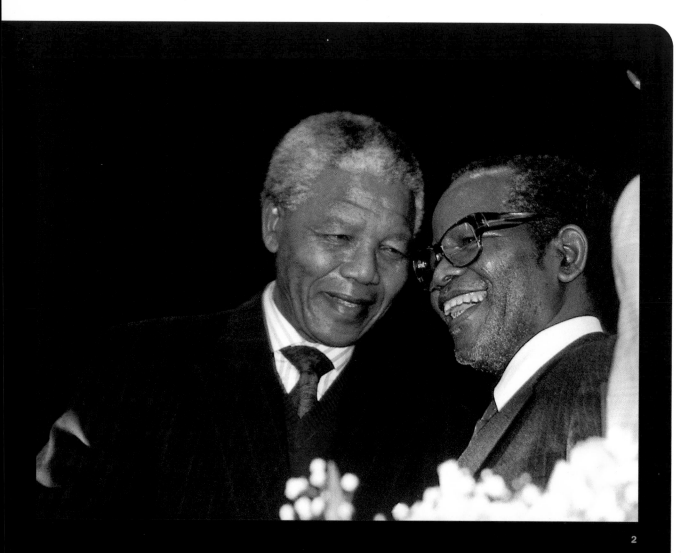

2

In July 1991, the ANC held its first conference inside South Africa in thirty years. In the presence of Oliver Tambo, who had been debilitated by a severe stroke, Mandela was unanimously elected president. Tambo was honoured with the title National Chairman. In his acceptance speech, Mandela paid tribute to his predecessor, whose astute leadership had sustained the movement through the arduous years of exile and brought it back home intact. 'You have entrusted me with the presidency of the ANC. It is a daunting task ... It will not be very easy for me to follow in the giant footsteps of Comrade O.R.'

In May 1990, a delegation from the ANC met the government at Groote Schuur in Cape Town. Unexpectedly, the atmosphere was cordial. 'Many wondered out loud why such discussions had not taken place long before'. As Thabo Mbeki later said to reporters, 'Each side had discovered that the other did not have horns.'

The outcome of the deliberations was the Groote Schuur Minute. Its key statement read: 'The government and the ANC agree on a common commitment towards the resolution of the existing climate of violence and intimidation from whatever quarter, as well as a commitment to stability and to a peaceful process of negotiations.'

Mandela invited other groups to participate in the search for peace. The PAC rejected the offer: they would not enter talks, they said, until the government had abolished apartheid laws. The Conservative Party objected to several clauses in the Groote Schuur Minute, including agreements to lift the state of emergency, release political prisoners, suspend political trials and withdraw troops from the townships.

In June 1990, the state of emergency was indeed lifted. But before the final steps to abolish apartheid could be taken, the government demanded the suspension of armed struggle. The ANC baulked. Violence in the townships was increasing, and it was clear — to the ANC and PAC at least — that it was being fanned if not instigated by government agents. How could the ANC lay down arms in these circumstances? An impasse had been reached.

It was Joe Slovo who proposed that in order to move forward with negotiations, it was necessary to suspend the armed struggle unilaterally. Mandela later recalled: 'My first reaction was negative; I did not think the time was ripe. But the more I thought about it, the more I realised that we had to take the initiative and this was the best way to do it. I also recognised that Joe,

whose credentials as a radical were above dispute, was precisely the right person to make the proposal.'

In reply to strong objections from some members of the National Executive Council, Mandela said that it had always been the purpose of the armed struggle to bring the government to the negotiating table. On 6 August, the ANC and the government signed the Pretoria Minute, suspending the armed struggle (though not terminating it, as Mandela assured his supporters). 'The point which must be clearly understood is that the struggle is not over, and negotiations themselves are a theatre of struggle, subject to advances and reverses as any other form of struggle.'

In October, the Separate Amenities Act was repealed. The following February, the Group Areas Act, the Land Acts of 1913 and 1936, and the Population Registration Act were wiped off the statute books. Legally, senior National Party government ministers declared, apartheid no longer existed. But this was a premature statement. A difficult and sometimes treacherous process lay ahead before political democracy, let alone economic redress, could be achieved.

3

Nelson Mandela and Jeff Radebe in full Zulu regalia, at a rally in KwaZulu Natal. Radebe is now Minister of Public Enterprises.

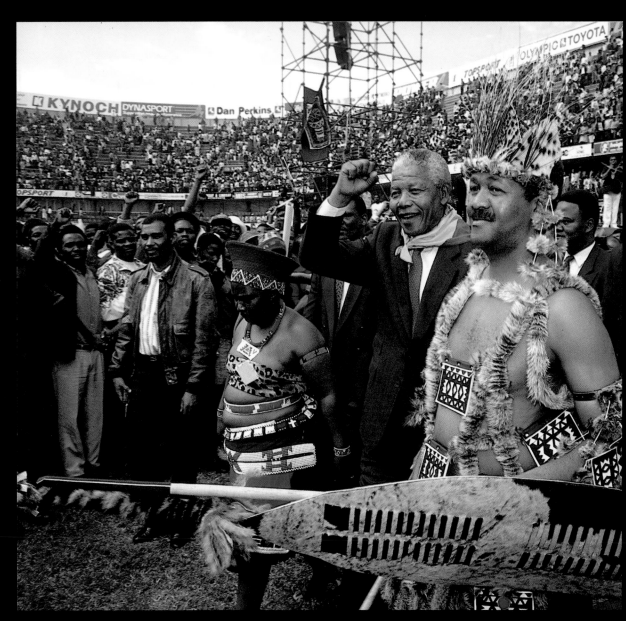

3

Just weeks after his release, Mandela told a crowd in Durban: 'Take your guns, your knives and your pangas, and throw them into the sea! Close down the death factories. End this war now!' But the youth in the audience — 'the shock troops of the struggle', as Mandela defined them — were disappointed with what they perceived as his failure to understand the imperative of political dominance in KwaZulu-Natal. It would take years before the general population would grasp the import of Mandela's more far-sighted message: that political differences needed to be transcended in order to unite against the common foe of violent and manipulative resistance to freedom and democracy.

World Trade Centre, Kempton Park

SITE **63**

Convention for a Democratic South Africa

The World Trade Centre, in Kempton Park near Johannesburg Airport, was the venue for South Africa's 'negotiated revolution'. Mandela afterwards wrote that the Convention for a Democratic South Africa (CODESA) was the most important constitutional convention since 1909, which was itself a betrayal of democracy, 'for none of the representatives there that day was black. In 1991, the majority of them were.'

It would be nearly two roller-coaster years, demanding the creative skills of all the team, before the negotiating parties finally approved an interim constitution. Today, the transformed site is a casino, hotel, and shopping and convention centre. Ironically, there is some continuity, for the World Trade Centre was the site of an historic gamble for the ultimate prize of a peaceful transition to democracy.

1
Mandela discusses a tricky point with ANC representatives Jacob Zuma and Mac Maharaj.
2
Leading negotiators: (Front) Mangosuthu Buthelezi, F.W. de Klerk, Nelson Mandela. (Standing) government ministers Pik Botha and Roelf Meyer, and ANC delegates Cyril Ramaphosa and Joe Slovo.

World Trade Centre, Kempton Park

The 'real talks', as Mandela called them, began on 20 December 1991. In the following days, seventeen of the nineteen participating organisations signed a declaration of intent, setting out guidelines for a future constitution. The Inkatha Freedom Party (IFP) and the homeland of Bophuthatswana refused to sign the document, while the PAC did not join the talks at all.

3
Migrant workers on the march in Tokoza, 1992

Mandela had commented that negotiations themselves would be a 'theatre of struggle', and so it proved. Alliances were formed, both openly and in the back rooms, and every tactic in the handbook was brought into play. By the middle of 1992, the talks were deadlocked over the extent of veto rights of minority groups in the Legislative Assembly.

4
People displaced from their homes by violence in an East Rand township

One of the biggest problems during the negotiations was that the political tensions at the World Trade Centre were played out against a background of escalating violence in the townships and villages. Sectarian conflict, both in KwaZulu-Natal and on the East Rand, had been worsening steadily since 1990. Much of this conflict was played out between supporters of the IFP and the ANC. But sinister forces were at work. Even as former enemies sat down to negotiate, violence escalated in the wider society. There were killings almost every day. Passengers were thrown off trains or murdered in the compartments; bystanders were shot dead at taxi ranks; whole families were violently expelled from their homes.

On 17 June 1992 a group of heavily armed men went on the rampage in the township of Boipatong, near Sharpeville, slaughtering 46 people. Witnesses reported that the killers came from a hostel inhabited by Zulu IFP supporters, who had expelled tenants from other ethnic groups. Boipatong was the fourth mass killing in Gauteng in a week.

After every massacre, Mandela had argued that negotiations were the only route to peace. At a rally after the bloodbath in Boipatong, he was faced with banners that read 'CODESA a white elephant — let us fight' and 'Mandela, we want arms now'. With a heavy heart, he acknowledged that the talks had failed to stem the carnage. 'I have heard you,' he said to the crowd. 'The negotiation process is in tatters. We are back in Sharpeville days.' In the 18 months of negotiations, nearly 8 000 people had lost their lives in political violence. Mandela broke off the talks.

In response to Boipatong, the ANC and its partners — the Congress of South African Trade Unions, the South African Communist Party and the civic organisations — took to the streets. It was the largest political strike in South African history — a national stay-away to protest against the 'Third Force' which seemed to be operating with impunity throughout the country.

This mass action inspired a march on Bisho, the capital of the Ciskei homeland, about a month later. The homelands had proved to be a challenge to the ANC's vision of a 'democratic and united South Africa'. In 1990, Mandela had made a pragmatic appeal to his followers to welcome former homeland leaders back into the liberation movement, and this conciliatory approach had enabled many to join the peace process. But a few homelands held out in bitter

5

An ANC Self-Defence Unit comrade guarding a house

World Trade Centre, Kempton Park

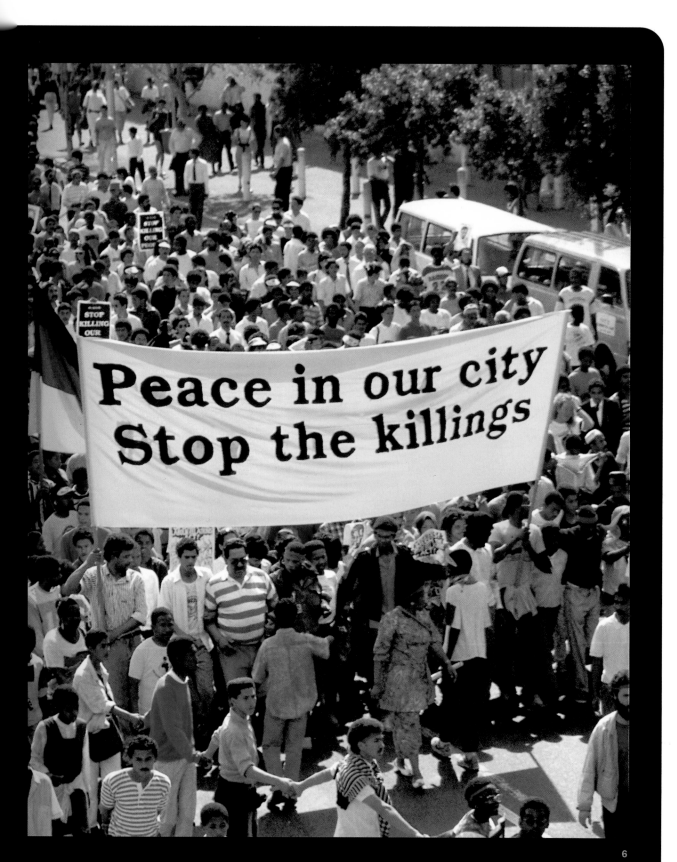

opposition. Confrontations in Bophuthatswana and Ciskei dramatically signified the collapse of the homeland system.

On 7 September 1992 the 'insurrectionists' in the ANC alliance embarked on a march to challenge the Ciskei leader. Thousands of ANC members converged on the sports stadium in Bisho for a mass rally. But they met with a ruthless response. In full view of television cameras, Ciskei troops opened fire with machine-guns, killing 29 people and wounding more than 200.

6
'Rolling mass action': workers take to the streets after the collapse of the talks.

Mandela was horrified. He was also disturbed by the irresponsibility of the leaders involved. He publicly reprimanded them and called on the ANC to halt mass action. 'Like the old proverb that says the darkest hour is before the dawn, the tragedy of Bisho led to a new opening in the negotiations. I met De Klerk in order to find common ground and avoid a repetition of another tragedy like Bisho.' A few weeks later, the Record of Understanding was signed, and the constitutional deadlock was broken.

This did not mean the turmoil was over. Violence had spilled over into the ANC's 'Self-Defence Units', formed originally to defend communities against attack. But now many of these units were fuelling the conflict. In a speech in the East Rand township of Katlehong in mid-1993, Mandela made a plea for political tolerance: 'The task of the ANC is to unite black people as well... Responsibility for ending violence is not just the government's, the police's, the army's — it is also our responsibility... If you have no discipline, you are not freedom fighters. If you are going to kill innocent people, you don't belong to the ANC. Your task is

reconciliation. You must go to your area and ask a member of Inkatha: why are we fighting?'

Right-wing extremists also threatened CODESA. In April 1993, on Easter Saturday, Chris Hani, South Africa's most popular leader after Mandela, was assassinated outside his house. A woman driving past witnessed what happened and alerted the police. Within minutes the killer was under arrest. It transpired that Janus Walus was a Polish immigrant with a hatred for communism. He was working with right-wingers in the Afrikaner Weerstandsbeweging — the Afrikaner Resistance Movement.

The assassination brought South Africa to the edge of the abyss. The possibility that the country would erupt into a racial civil war had never seemed so real. That evening, Mandela appeared on television to address the nation: 'Tonight I am reaching out to every single South African, black and white, from the very depths of my being. A white man, full of prejudice and hate, came to our country and committed a deed so foul that our whole nation now teeters on the brink of disaster. A white woman, of Afrikaner origin, risked her life so that we may know, and bring to justice, this assassin ... Now is the time for all South Africans to stand together against those who, from any quarter, wish to destroy what Chris Hani gave his life for — the freedom of all of us.'

But the disruption continued. In June, members of the Afrikaner Weerstandsbeweging smashed through the glass entrance of the World Trade Centre in an armoured vehicle. The men stormed into the conference chamber, brandishing weapons, swearing and assaulting people. They had time to scrawl abusive slogans on the walls and urinate on the floor before they were apprehended.

In that same month, the negotiating parties fixed on a date for the elections. Mandela

Looking back from the end of the decade at the killing of Chris Hani, the journalist Kaizer Nyatsumba wrote: 'It is thanks to the ANC leadership, but particularly to President Mandela, that the situation did not deteriorate to the level of a civil war with racial overtones. Mandela, both at a press conference at ANC headquarters as well as in a powerful national address on television, called on black people to be calm and not to take the law into their own hands. This was a very defining moment in South Africa's history, because that act of statesmanship on Mandela's part effectively saw a premature passing of the baton of national leadership from then state president F.W. de Klerk to him.'[33]

7

World Trade Centre, Kempton Park

appointed Cyril Ramaphosa, the ANC's Secretary-General, to work with the government's chief negotiator, Roelf Meyer, on drafting a new constitution. Ramaphosa was a former general secretary of the National Union of Mineworkers and, in Mandela's view, 'probably the most accomplished negotiator in the ranks of the ANC'. Meyer had recently been appointed Minister of Constitutional Development. The two men had developed an understanding and a good working relationship. 'Their joint efforts in the political arena... contributed significantly to South Africa's gradual emergence from the darkness'.[34]

8

Mandela and De Klerk in Stockholm to receive the Nobel Peace Prize in December 1993. But the consensus that was reached after the betrayals, and fears for the future, wore down the leaders of both parties. Although they both tried to put up a graceful front, the tension between them was palpable.

After much bargaining, the outcome was reasonably reassuring to whites. Parties were guaranteed cabinet posts, the jobs of civil servants, white soldiers and policemen were protected, and an Independent Electoral Commission was appointed to monitor the election. A powerful constitutional court was entrenched to safeguard a Bill of Fundamental Rights. On 18 November 1993, the session at the World Trade Centre approved the interim constitution. It happened to be Ramaphosa's birthday, and so the negotiators raised a glass to him and to the new country he had helped to imagine.

9

The IFP and ANC celebrate Tokoza's 'closure' on violence. The Tokoza Memorial, which records the names of 688 people of all political affiliations who lost their lives in the years of violence, is not far from the World Trade Centre. President Mbeki, who attended the unveiling in October 1999, called the Memorial a symbol of healing and closure. The Memorial was a community initiative, led by the Tokoza Displacees' Committee, representing those driven from their homes during the violence.

Ohlange School, Inanda

SITE 64

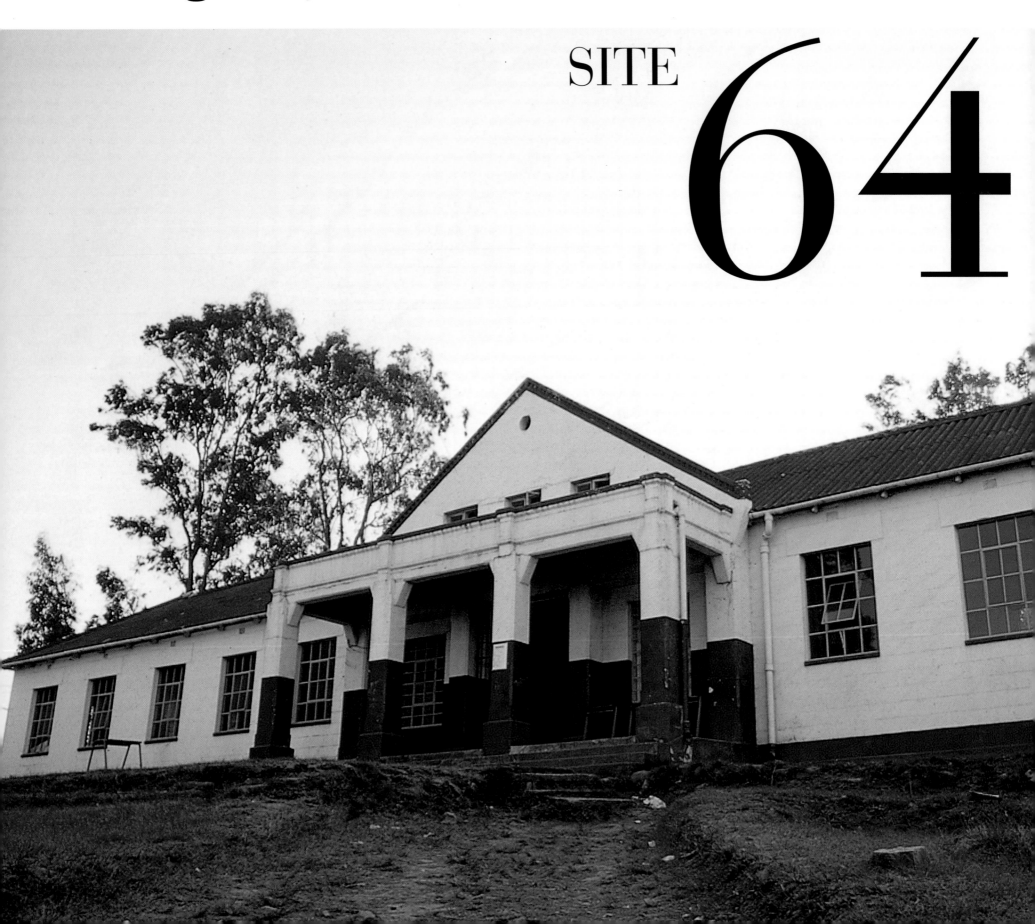

The first democratic elections

On 27 April 1994 South Africans went to the polls for the first time in a democratic election. Mandela cast his vote at Ohlange School in Inanda, not far from Durban. The area has a rich background: both Mahatma Gandhi and trade unionist A.W.G. Champion lived and worked here. The school was founded by the great educator and choral musician, John Dube, who is buried in the grounds. For Mandela, casting his vote near Dube's grave was a way of bringing history full circle. Dube was the first president of the ANC in 1912, and now the mission he had begun all those years ago was about to be achieved.

Although the high school is still operating, it has been badly neglected and has fallen into disrepair. In 1999, Mandela raised funds from business to give this historic institution a facelift.

1
Mandela casts his vote at Ohlange School, 27 April 1994.

2
'The images of South Africans going to the polls that day are burned in my memory. Great lines of patient people snaking through the dirt roads and streets of towns and cities ... [T]he violence and bombings ceased, and it was as though we were a nation reborn.'

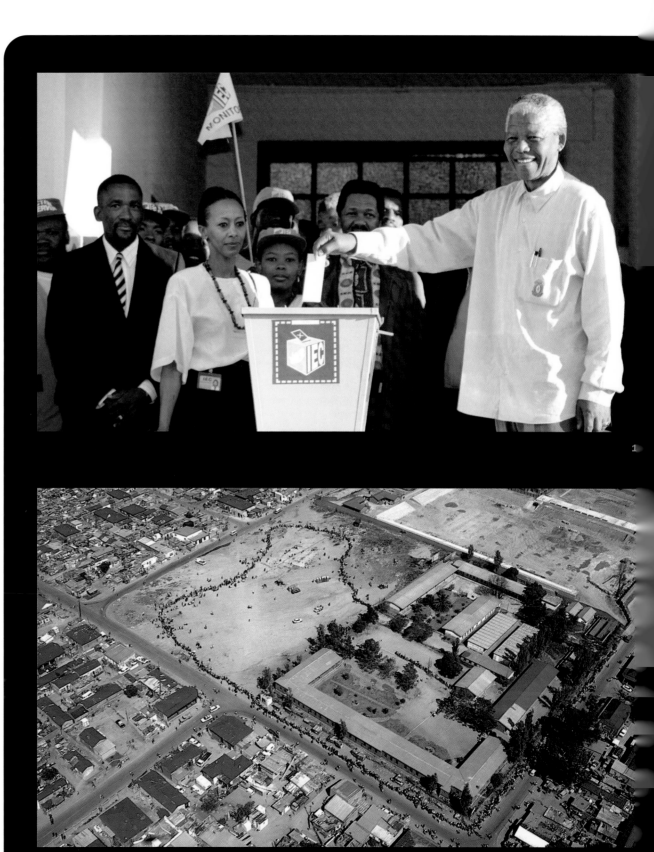

Ohlange School, Inanda

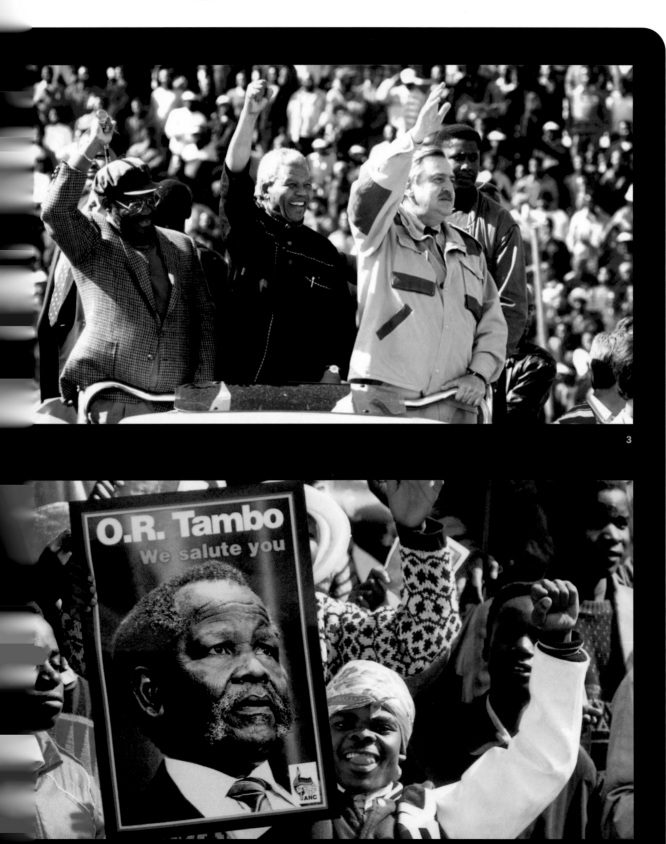

The Record of Understanding, which brought the National Party and the ANC closer together, finally produced an historic decision. In June 1993, the parties at CODESA set the date for South Africa's first non-racial, democratic elections: 27 April 1994.

3

Leaders of three parties at a rally in 1994 — Mangosuthu Buthelezi of the IFP, Mandela of the ANC and Pik Botha of the National Party — in a show of the Government of National Unity — GNU

The new rapport between the major parties had created tensions with the Inkatha Freedom Party. Feeling that they had lost their former associates, the IFP formed the Freedom Alliance with right-wing groups and homeland leaders, and withdrew from the constitutional talks. The Freedom Alliance refused to join the elections, and were still holding out on 12 February, the deadline for political parties to register. Mandela then announced a series of concessions. Although more violence followed in the coming months, nearly all those who had withdrawn eventually found ways to save face and enter the election contest. After four turbulent but riveting years, the country stood on the threshold of democracy for the first time in its history. In a gesture of political freedom and reconciliation, Mandela cast his vote in the IFP stronghold of KwaZulu-Natal.

4

Tambo remembered in the run-up to the 1994 elections

'When I walked to the voting station, my mind dwelt on the heroes who had fallen so that I might be where I was that day, the men and women who had made the ultimate sacrifice for a cause that was now finally succeeding. I thought of Oliver Tambo, Chris Hani, Chief

Luthuli and Bram Fischer. I thought of our great African heroes, who had made great sacrifices so that millions of South Africans could be voting on that very day; I thought of Josiah Gumede, G.M. Naicker, Dr Abdullah Abdurahman, Lilian Ngoyi, Helen Joseph, Yusuf Dadoo, Moses Kotane. I did not go into that voting station alone on 27 April; I was casting my vote with all of them.'

Of all of these, Tambo must have been most poignantly in Mandela's thoughts. Barely two weeks after Hani's assassination, Tambo had died. For thirty years, he had managed the difficult task of holding together a movement in exile, and its survival was a tribute to his highly focused and ceaseless work. Tambo was one of Mandela's few intimate friends. When Mandela formally announced his separation from Winnie, Tambo and Sisulu were at his side. Tambo's death was a massive blow to him. In his autobiography, Mandela describes how he constantly thought about his friend during his long years in prison.

'In Plato's allegory of the metals, the philosopher classifies men into groups of gold, silver and lead. Oliver was pure gold; there was gold in his intellectual brilliance, gold in his warmth and humanity, gold in his tolerance and generosity, gold in his unfailing loyalty and self-sacrifice. As much as I respected him as a leader, that is how much I loved him as a man.

Though we had been apart for all the years that I was in prison, Oliver was never far from my thoughts. In many ways, even though we were separated, I kept up a life-long conversation with him in my head. Perhaps that is why I felt so bereft when he died. I felt, as I told one colleague, like the loneliest man in the world. It was as though he had been snatched away from me just as we had finally been reunited.' The 1994 election would not have been possible without the 30-year preparation led by Oliver Tambo.

Mandela was inaugurated as president on 10 May 1994 at the Union Buildings, Pretoria (see Site 42). In his speech he declared: 'We have, at last, achieved our political emancipation. We pledge ourselves to liberate all our people from the continuing bondage of poverty, deprivation, suffering, gender and other discrimination. Never, never, and never again shall it be that this beautiful land will again experience the oppression of one by another.'

Genadendal, Cape Town

SITE

65

Family reunion

Genadendal, President Mandela's Cape Town residence, is on land that was once part of the Groote Schuur estate. A portion of the estate was sold to form Westbrooke farm, and the manor house was built in 1832. In 1912, the farm was sold to the Union of South Africa. President Mandela chose this house in preference to the traditional residence of the head of state, Groote Schuur, because that is filled with so many priceless antiques that he felt he would not be able to relax there with his family.

Westbrooke was renamed 'Genadendal' in tribute to the first mission station in the Western Cape. The Genadendal mission near Caledon was established by a German missionary among the Khoikhoi people. It was known for its progressive educational policies, and was the first institution to print educational books in Afrikaans. A number of contemporary politicians are descendants of the Genadendal community.

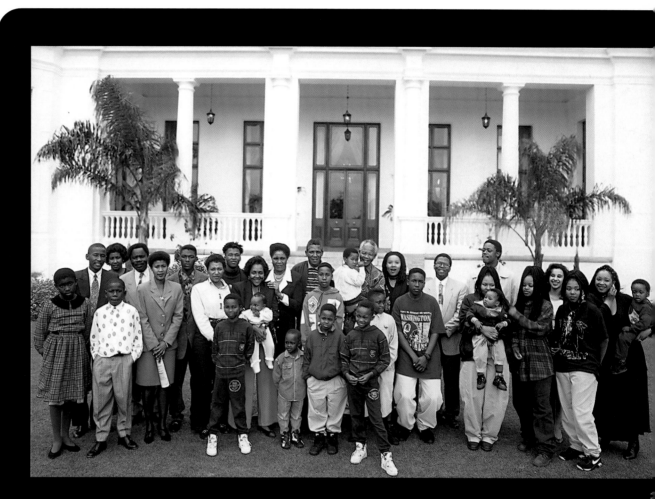

Mandela with his children and grandchildren outside Genadendal, the President's Cape Town residence, 1994 to 1999. Seen in the photograph are his four surviving children. Makaziwe, in the suit, is fourth from the left. Makgatho and Zenani are on either side of their father, while Zindzi is on the extreme right. The struggle came at a high cost to his family life. 'That was always the conundrum: had I made the right choice in putting the people's welfare even before that of my own family?'

Genadendal, Cape Town

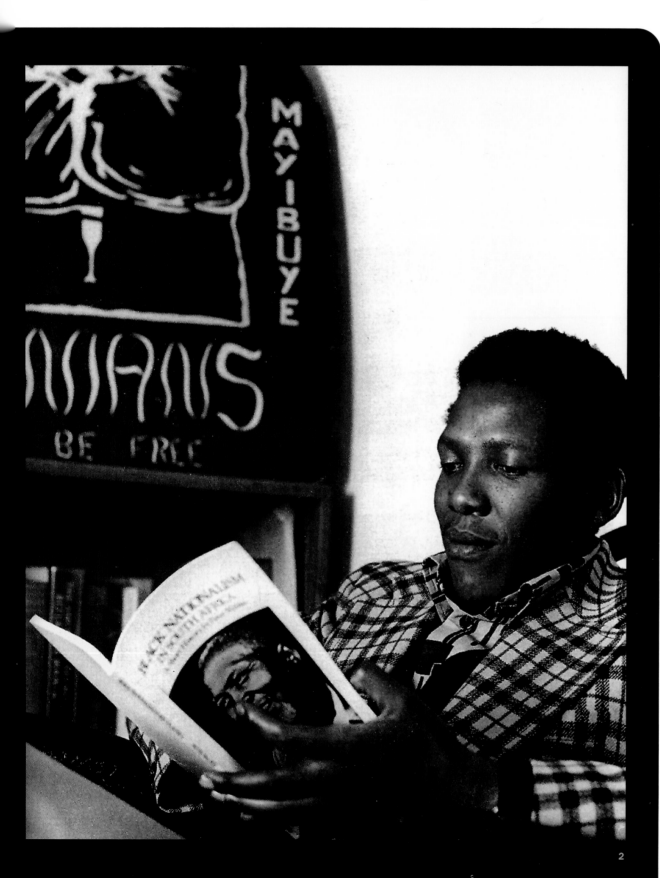

MAYIBUYE

BE FREE

2

Mandela had three children from his first marriage to Evelyn Mase. After he was sent to Robben Island, he never again saw his first-born, Thembekile. Makgatho, his second son, kept in touch with his father, but clearly missed his guidance. Eventually he qualified as a lawyer. Makaziwe, the third child, was a very determined young woman. She studied anthropology in the United States and obtained a Ph.D. For many years she too was alienated from her father, and felt the loss even more keenly after his imprisonment. She recalls how he once tried to explain his position to her in a letter from prison: 'What I need to do is worthwhile, not for you and the rest of the family, but for all black people.' But this was an abstract notion and no consolation. The reality for the children was that Mandela was an 'absentee father of the struggle'.

Throughout the years in prison, Mandela sustained an image of his second wife Winnie as the ideal woman, loving her and admiring her, longing for the moment when they would be reunited and share the happy family life so long denied them. But when he finally returned to Orlando West things were rather different.

2
Makgatho as a teenager. Like his father, he qualified as an attorney.

'That night, happy as I was to be home, I had a sense that what I most wanted and longed for was going to be denied me. I yearned to resume a normal and ordinary life, to pick up some of the old threads from my life as a young man, to be able to go to my office in the morning and return to my family in the evening, to be able to pop out and buy some toothpaste at the pharmacy, to visit old friends in the evening. These ordinary things are what one misses most in prison, and dreams about doing when one is free. But I quickly realised that such things were

not going to be possible. That night, and every
night for the next weeks and months, the house
was surrounded by hundreds of well-wishers.
People sang and danced and called out, and their
joy was infectious. These were my people, and I
had no right and no desire to deny myself to
them. But in giving myself to my people, I could
see that I was once again taking myself away
from my family.'

3

Strains in the marriage

While Mandela was still a prisoner, dreaming
of the things he would do when he was free,
Winnie had been banished to Brandfort. In 1985,
the house was petrol bombed and she came back
to Orlando. Over the following years her
behaviour became increasingly controversial.
She formed the 'Mandela United Football Club',
in reality a group of young bodyguards and
political street fighters. When their increasingly
thuggish activities became intolerable, some
United Democratic Front leaders publicly
distanced themselves from her. It was rumoured
that children and youths accused of being
collaborators had been beaten and tortured by
the football club. Others disappeared. Eventually
the body of the 14-year-old activist Stompie
Sepei was found and his killing linked to the
club's 'coach' and to Winnie herself.

4

Mandela with his great-granddaughter

The rumours reached Mandela. He
acknowledged, with anguish, the trauma, the
humiliation, the malice and deprivation that
Winnie had suffered, not least because she was
the wife of Nelson Mandela. These cruel times
had disturbed her deeply, even while she was
increasingly being admired for her courage to
confront the system head-on. Privately he

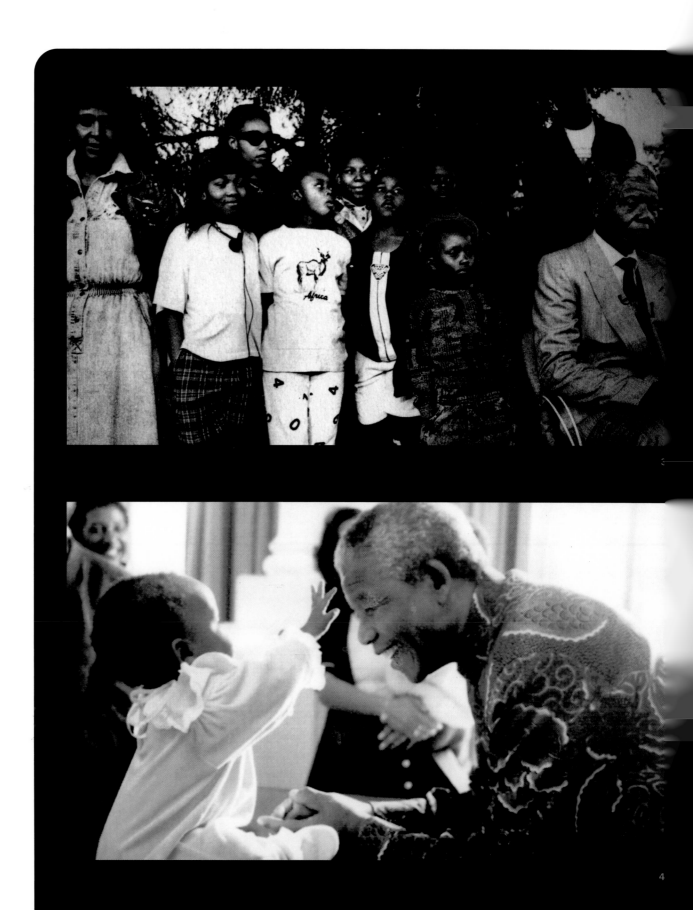

3

4

Genadendal, Cape Town

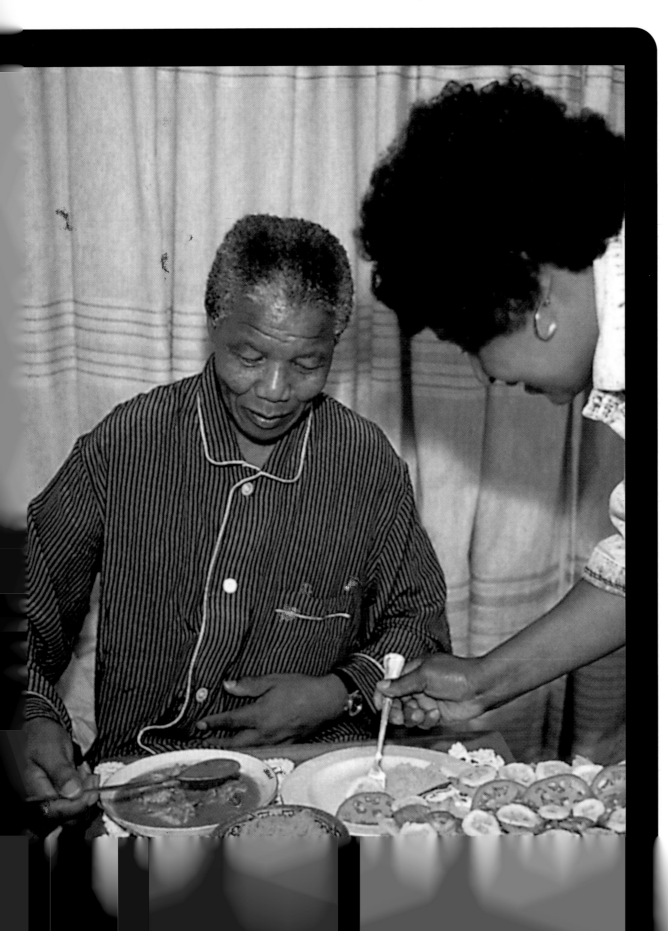

reprimanded Winnie and advised her to adopt a strategically lower profile. Publicly he remained loyal to her, even when she was tried and convicted on charges of kidnapping and being accessory to assault, for which she received a suspended sentence and a hefty fine. Indeed, after their formal separation, which occurred several years after his release, he continued to assert his belief in her innocence.

In April 1992 he announced his separation from 'Comrade Nomzamo Winnie Mandela' at a press conference, flanked by his oldest friends Sisulu and Tambo. 'I shall personally never regret the life Comrade Nomzamo and I tried to share together... I part from my wife with no recriminations. I embrace her with all the love and affection I have nursed for her inside and outside prison from the moment I first met her.' They were divorced two years later.

Winnie's rejection of a physical relationship with her husband and her poorly disguised infidelity were an aching public humiliation. Mandela's intensely private, proud nature had been reinforced in prison, where he had steeled himself to conceal his feelings from his jailers and even from his fellow prisoners who looked to him for leadership. His careful, delicately phrased account of the breakdown of the marriage during the divorce proceedings must have cost him dearly.

5
Winnie serves her husband breakfast.

'Ever since I came back from jail, not once has the defendant ever entered the bedroom whilst I was awake. I kept on saying to her: "Look, men and wives usually discuss the most intimate problems in the bedroom. I have been in jail a long time. There are so many issues, almost all of them very sensitive, I would like to have the opportunity to discuss with you." Not once has

she ever responded... I was the loneliest man during the period I stayed with her.'

One of his biographers, Mary Benson, also a personal friend, commented: 'He had survived political martyrdom only to face personal betrayal and unimaginable humiliation. He could well have been destroyed by the perversity of his wife's behaviour; instead he fought and won a very private battle. It was one of the most heroic episodes in his life.'[35]

In prison, Mandela had felt keenly the absence of the innocence and laughter of children. As a free man, and as President, he consciously sought out their company. He delighted in dropping in unexpectedly on his grandchildren's schools, listening to their stories and telling them some of his own. He made a point of visiting traumatised children, whether terminally ill, or victims of crime or violent conflict. His most energetic efforts to raise funds in the corporate sector were always with a view to alleviate and develop the lives of the children. Mandela also loved to plan slap-up parties for children at the slightest excuse. Mandela's Children's Fund is the wealthiest welfare organisation in South Africa, although its funds are always bespoken.

6
'The father of the nation'
Excited children catch a glimpse of President Mandela as he arrives to discuss land claims with the local community in Schmidtsdrift, Northern Cape, 1999.

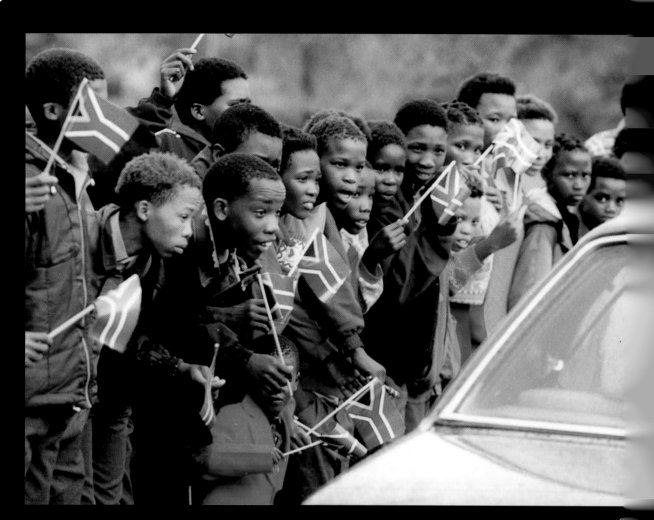

6

During the apartheid years, the Bushmen (*or Khoisan*) were used and abused by the Defence Force. Many were enlisted in the army. Their unique skills were utilized to track guerilla fighters active in the northern provinces and across the borders. After 1994, thousands of homeless Khoisan families were seeking land restitution. The process of negotiating land redistribution is under way.
The land issue continues to remain a thorny issue in some parts of southern Africa.

Parliament, Cape Town

SITE 66

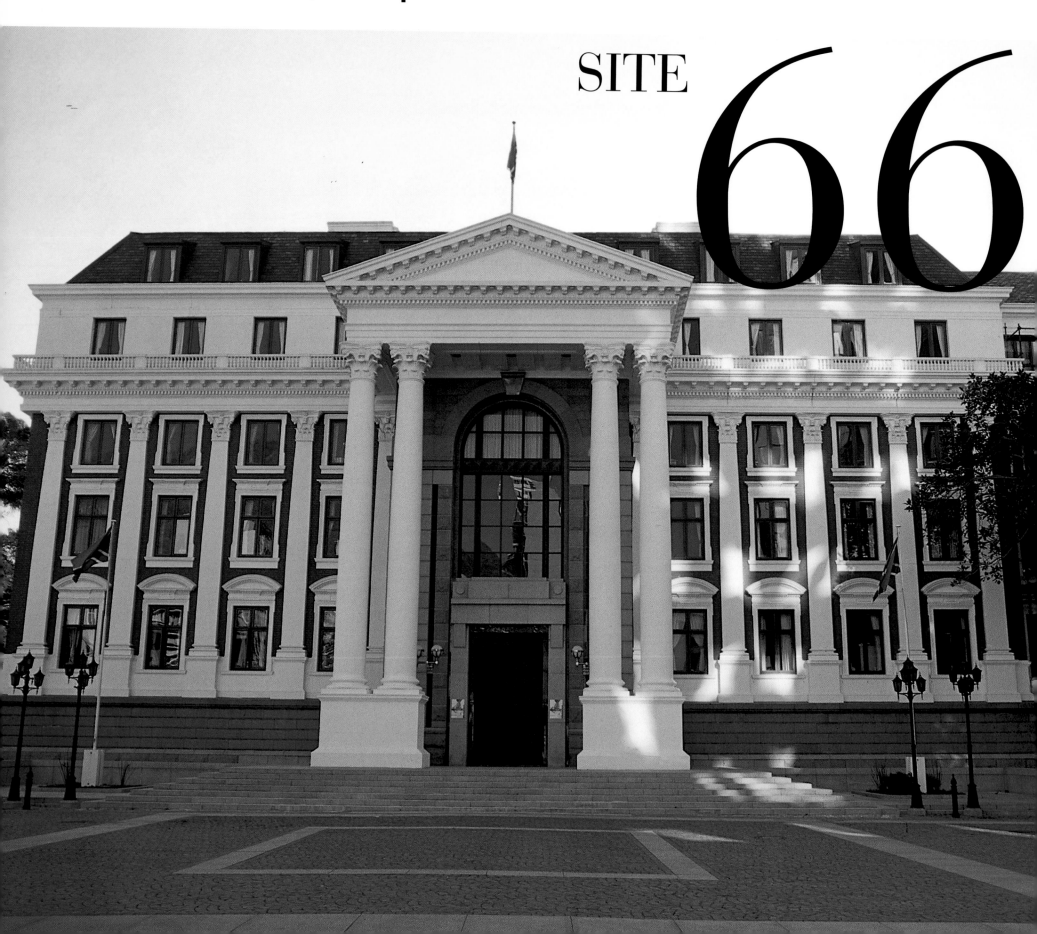

Women take their places

The Houses of Parliament were completed in 1884. The elegant building, with its statue of Queen Victoria in the gardens, served for 25 years as the seat of government for the Cape Colony. In 1905, after the Anglo-Boer South African War, the national convention held here provided a draft constitution for the Union of South Africa. The South Africa Act of 1910 excluded blacks, except black men with education or property in the Cape, from voting. Over the years even this was eroded. By 1948, when the National Party came to power, parliament was all white. In 1984, the constitution incorporated Coloureds and Indians in a tricameral parliament alongside whites — but Africans were still excluded. Only in 1994 was the universal franchise upheld. For the first time parliament became representative of all the people of South Africa.

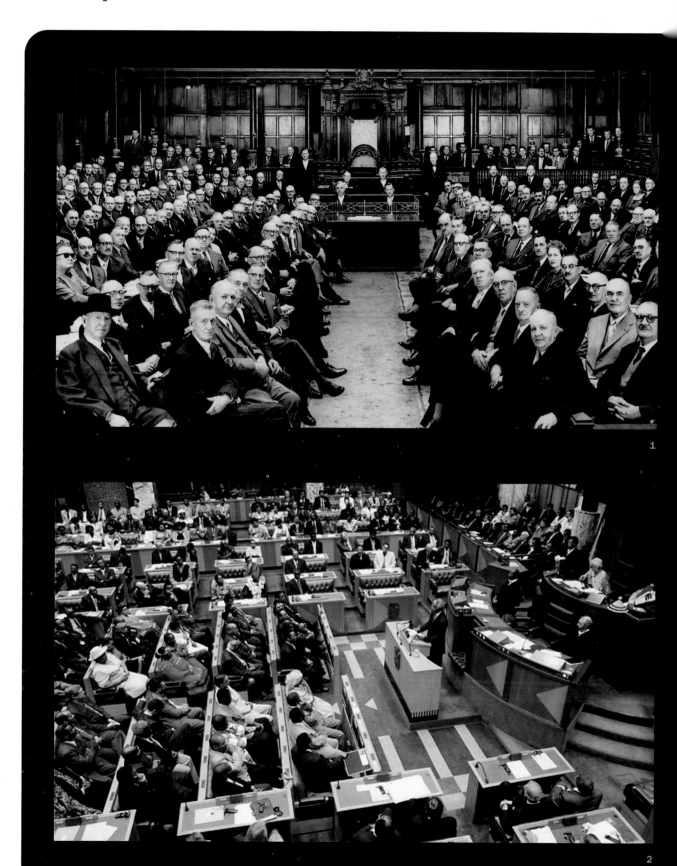

1
The first parliament of the new National Party government in 1948; a gathering of white men

2
Excitement in the air: the first session of the first democratically elected parliament is about to begin.

Parliament, Cape Town

3

The vote was extended to white women in South Africa in 1930. Although there was a qualified franchise for black men in the Cape at this time, black women were excluded from the new dispensation. The first-ever woman Member of Parliament — it goes without saying that she was white — was elected in the 1930s. Her name was Margaret Ballinger and she was the forerunner of an impressive band of liberal women. In later years, a handful of female MPs represented the National Party, but until 1994 the proportion of women in government seldom reached 5 per cent.

One of the achievements of the new democratic government has been the more equitable representation of women at national and provincial level. This may be attributed to years of struggle around gender issues within the liberation movement. By 1999, 111 out of 400 MPs were women, one of the highest proportions of female representation in the world. At a senior political level, 31 per cent of ministers and deputy ministers were women. Women had also been appointed as Speaker and Deputy Speaker of the House.

3
Mandela with Helen Suzman, MP for the Progressive Party (now the Democratic Party), who for decades was the 'lone parliamentary voice of true opposition to the Nationalists... Mrs Suzman was one of the few, if not the only, member of Parliament who took an interest in the plight of political prisoners.'

Even so, women MPs with children found it difficult to cope with the long parliamentary hours. Some women whose families lived far from Cape Town did not see their husbands and children regularly. A number of marriages broke down, and a few women MPs resigned because of domestic pressures. Partly as a result of these difficulties, there have been positive changes to

parliament. A crèche has been set up, and institutions have been established to strengthen the work of female parliamentarians. Women have also lobbied for and achieved guarantees on gender equality. These include the ratification of the Convention on the Elimination of All Forms of Discrimination against Women; the establishment of the Commission for Gender Equality; and the recognition of 9 August as Women's Day, a national holiday. For the first time, legal provisions exist for all women to own land and housing — no small accomplishment given that most of South Africa's farmers are women! New legal protections for women include the Domestic Violence Act, the Maintenance Act, the Recognition of Customary Marriages Act, and the Termination of Pregnancy Act (although the latter was not supported by all women). Less inspiringly, but more importantly, dealing with the shockingly high incidence of rape and abuse of women and children has become a national priority. But MPs, men and women, also represented many more constituencies of the formerly marginalised — the rural poor, the unemployed, the racially oppressed, the rapidly growing urban populations, the youth, the neglected cultures and indigenous traditions. 'We must continue the struggle', said President Mandela, 'to give life to what we said in the Freedom Charter — that South Africa belongs to all who live in it, black and white, and that no government can claim just authority unless it is based on the will of the people as a whole'.

In its first five years parliament worked incredibly hard. It passed more than 500 laws of redress: modifying, scrapping or introducing new legislation to give legal backing to the South African constitution.

4

Mandela's first speech in parliament

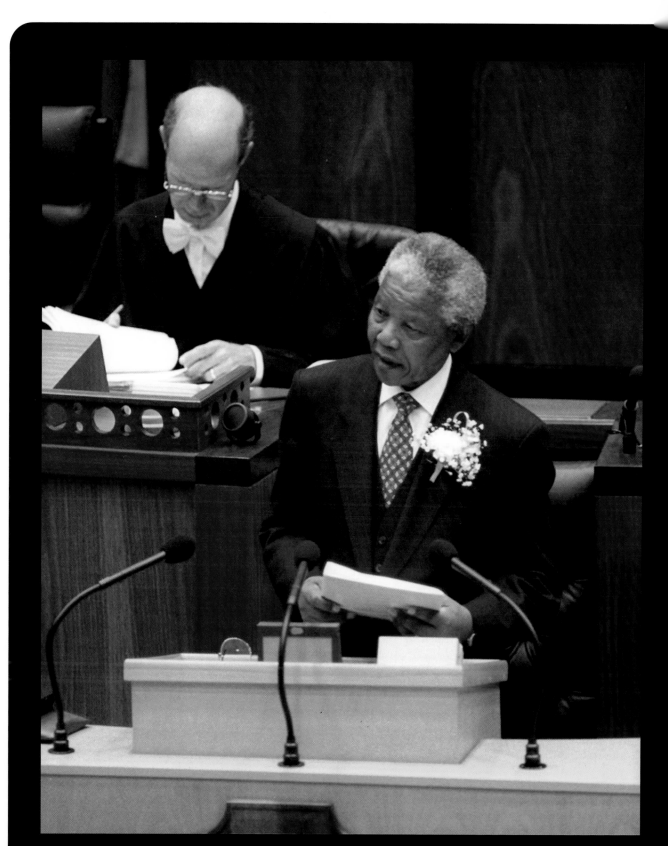

East London City Hall

SITE

67

The message of reconciliation

The first hearings of the Truth and Reconciliation Commission (TRC) took place in the East London City Hall. This Victorian building dating from 1897, with its marble staircase and splendid stained-glass windows, represents the handsome face of South Africa's colonial past. The TRC hearings were held in the main auditorium, which seats 450 downstairs and 240 in the gallery. Outside the City Hall are two guns, one of which was used in the Basutoland campaign of 1850. The Queen Victoria Clock Tower, which resembles London's Big Ben, was built to commemorate Victoria's six decades on the throne. Steve Biko's statue is the first attempt to challenge the colonial domination. The choice of East London for the TRC's first hearings was significant: the Eastern Cape, the original frontier of colonial conflict, had probably endured more repression over the years than any other region in the country.

1

Mandela speaks in a Cape Town mosque. Kader Asmal, (now Minister of Education), is seated just to the right.

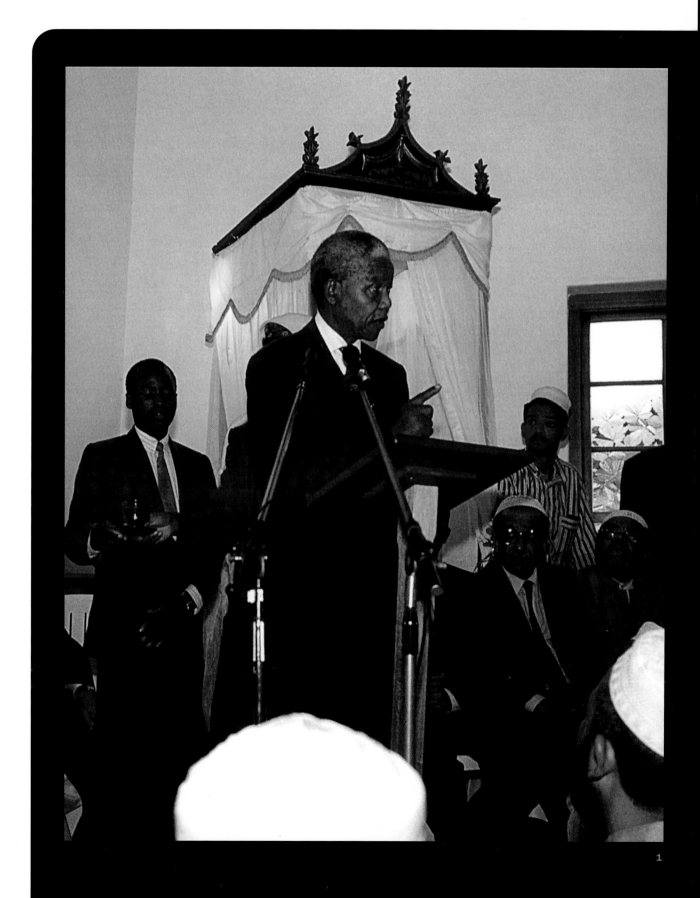

East London City Hall

In 1995, President Mandela commissioned the TRC to hear personal testimony about South Africa's recent history, and to heal and reconcile the nation. Archbishop Desmond Tutu, the Nobel Peace Prize winner who had done so much to provide moral leadership during the 1980s, was appointed as chairperson.

Both victims and perpetrators came forward 'to tell the truth'. No remorse was required from perpetrators, but amnesty would be granted only if the crimes were politically motivated and the perpetrators made a full disclosure. Ultimately, amnesty was granted to people across the political spectrum, from young comrades involved in violence in the townships, to liberation movement saboteurs, to security policemen and apartheid assassins.

2
Daniel Sebolai, 64, who lost his wife and son in the Boipatong Massacre in 1992, holds back the tears during a workshop on issues related to the TRC in Sebokeng Oct 28, 1998.

The Commission was not without its critics, from both the left and the right. Some of the former political and military leaders accused the process of being a 'witch hunt', while activists and intellectuals felt that by confining itself to gross human rights abuses, the TRC was prevented from conveying the brutality and structural violence of everyday apartheid, and the grinding heartbreak that the system had wrought day-to-day on the mass of the black population. Nevertheless, its achievements were significant: thousands of victims of apartheid were able to tell their stories in public for the first time; and thousands of perpetrators seeking amnesty divulged the facts about atrocities and abuses in which they had been involved. The existence of death squads and 'dirty tricks' operatives, long alleged by the opposition, was finally confirmed. It was revealed that Winnie

Mandela, for instance, had been surrounded by spies and agents provocateurs. It was verified that the Cradock Four had been murdered by the police. The families of Biko, Timol and hundreds of others gave chilling evidence of loathsome acts perpetrated against activists who resisted apartheid — torture in detention, kidnapping, smear campaigns, poisonings, psychological terror tactics, shootings. Scores of testimonies also confirmed that a 'Third Force' — indeed 'Third Forces' — had been operating to destabilise opposition organisations and derail the country's first democratic elections.

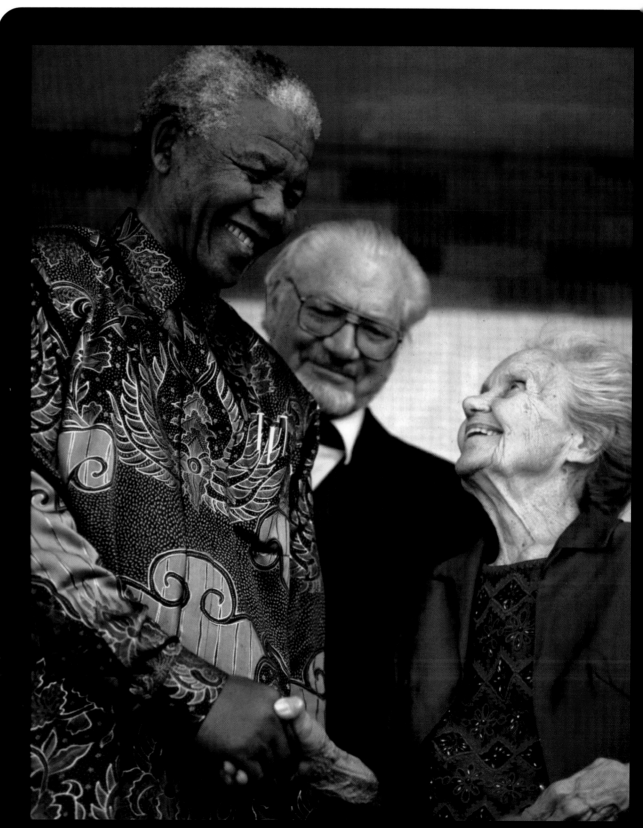

3

Mandela with Mrs Betsie Verwoerd, widow of Dr Hendrik Verwoerd, the 'architect of apartheid'. Mandela had invited former first ladies (including the widows of leaders of the liberation movements) to tea in Pretoria, but Mrs Verwoerd, by then in her nineties, was too frail to travel. So the President visited her instead at the Afrikaner stronghold of Orania, established by her daughter and son-in-law.

Amazingly, many witnesses found it in themselves to forgive their tormentors. In her testimony, Cynthia Ngewu made this moving statement: 'This thing called reconciliation... if I am understanding it correctly... if it means this perpetrator, this man who has killed Christopher Piet [her son], if it means he becomes human again, this man, so that I, so that all of us, get our humanity back... then I agree, I support it all.'

Hundreds of witnesses made modest requests, asking for no more than the return of the remains of their loved ones. They asked for reburial, for symbolic reparation, or for the education or training of the dependents of the victims.

In 1999, the TRC presented its report. It had heard the testimony of thousands of witnesses —

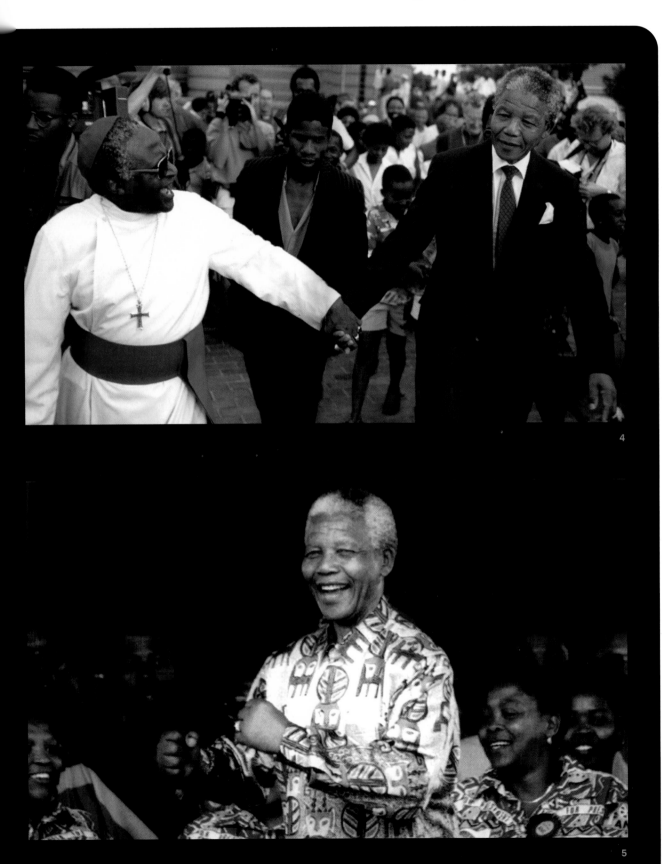

only a tiny proportion of the millions who had suffered directly from the racist policies of the past four decades. Although the Commission had been obliged to consider only gross abuses, it tried to place the testimonies in their wider context, exposing the systematic, day-to-day violence of apartheid. The report did not omit the abuses committed against suspected collaborators by the ANC in its correction camps. Although the ANC criticised what it perceived as an inadequate distinction between oppressors and freedom fighters, Mandela accepted the report and thanked the Commission. The TRC recommended that R3 billion be set aside over five years for compensation, restitution and symbolic reparation.

4

Tutu and Mandela join hands. This was the day on which the report of the Truth and Reconciliation Commission was handed over to the President. 'History does not wipe away the memories of the past,' concluded the TRC. 'It understands the vital importance of learning from and redressing past violations for the sake of our shared present and our children's future... Reconciliation requires a commitment, especially by those who have benefited and continue to benefit from past discrimination, to the transformation of unjust inequalities and dehumanising poverty'.

5

Celebrating democracy — the Madiba jive

While the TRC was the most powerful arena of reconciliation, Mandela shrewdly used other national symbols for their unifying effect. He enthusiastically embraced the new South African flag and celebrated the national emblems in sports. He insisted that the new national anthem — a hybrid of the old official anthem 'Die Stem' and the liberation movement's 'Nkosi Sikelel'

iAfrika' — be sung at public gatherings. Through his example these symbols have become more inclusive.

Mandela's strategy of promoting reconciliation beyond South Africa's borders was not always successful. Some African leaders, wary of South African domination, did not appreciate the application of 'Madiba magic' to their countries' ills. Laurent Kabila, for instance, who ousted Mobutu Seseseko in 1998, would not concede recognition to his enemies, despite Mandela's blandishments. The Democratic Republic of the Congo, unable to negotiate the way forward through painstaking consensus, subsequently drew its neighbours into yet another war of attrition.

Internally, some South Africans began to criticise Mandela's policy of reconciliation, arguing that he had bent over backwards to accommodate white fears, allowing many whites to remain insensitive to black poverty and unemployment.

But to the end of his presidency, Mandela retained his aura. In March 1999 he persuaded Muammar Gaddafi of Libya to surrender to fair trial in a neutral country the men accused of sabotaging the PanAm plane that crashed over Lockerbie in 1988. The American government had been critical of South Africa's links with Libya, an ally of the ANC in the exile years; now they had to acknowledge the fruits of Mandela's stubborn support for an unpopular friend, who had 'backed the ANC when we were alone'.

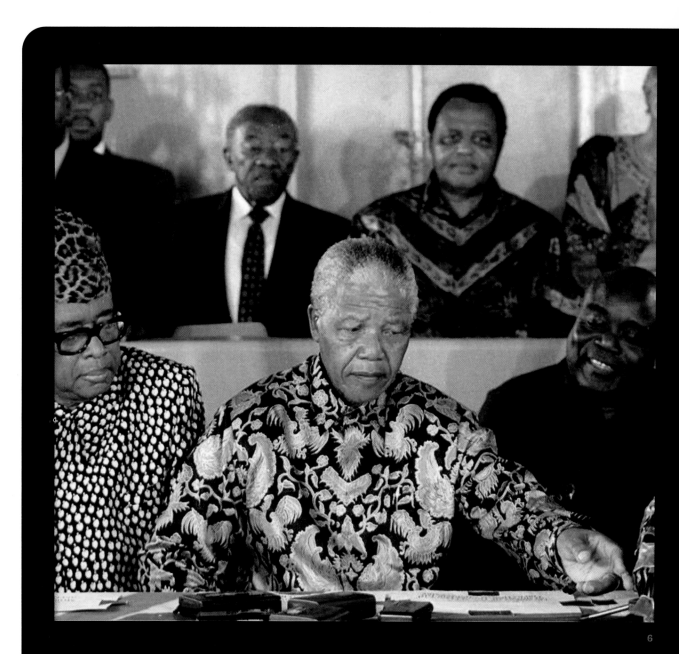

6

President Mandela, together with ANC cabinet ministers Alfred Nzo and Joe Modise (back centre and right), meet with Mobutu Seseseko, former dictator of Zaire (now the DRC) and guerrilla leader Laurent Kabila in an attempt to reach a negotiated settlement in that war-torn country.

4 Thirteenth Avenue, Houghton

SITE
68

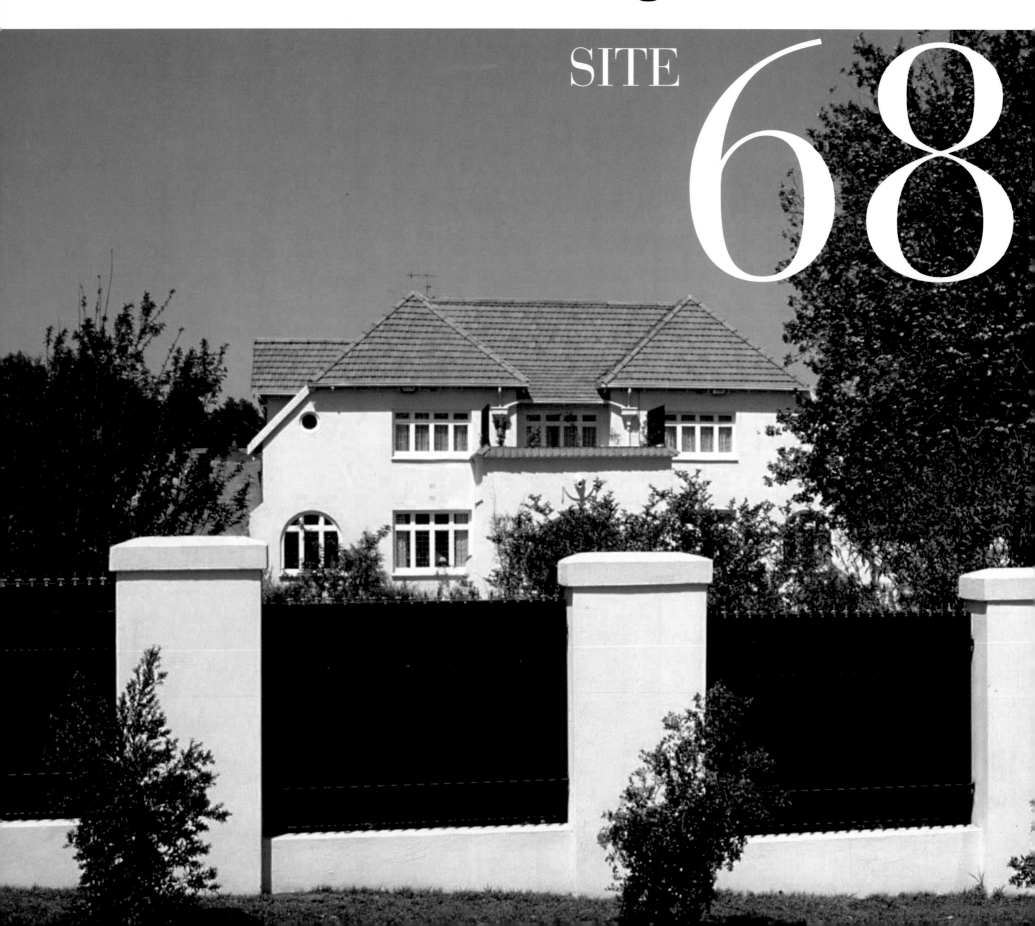

Birthday cakes and wedding bells

After his release, Mandela had resisted moving from 8115 Ngakane Street in Orlando West to the more palatial house Winnie had built on the ridge. 'I wanted to live not only among my people, but like them.' With the breakdown of his marriage, however, he moved to the old and affluent Johannesburg suburb of Houghton, where he could accommodate his bodyguards, secretaries and staff. The ANC bought him the house. This was also a practical decision, as by then he was receiving visits from many high-level deputations, including heads of state, and it was easier to see them at a more accessible, central location. Mandela grew to love this house, and later bought it from the ANC. It is now his Johannesburg headquarters. It was from this house that Mandela married Graça Simbine Machel, on 18 July 1998, on his 80th birthday.

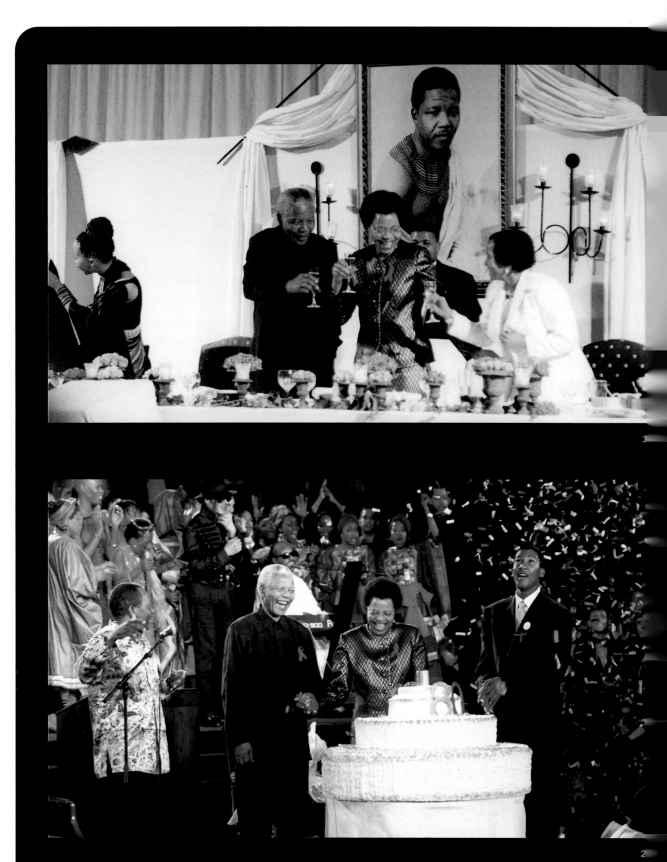

1
The wedding day

2
Blowing out the candles. On the right, Mandela's grandson, Mandla, son of Makgatho.

4 Thirteenth Avenue, Houghton

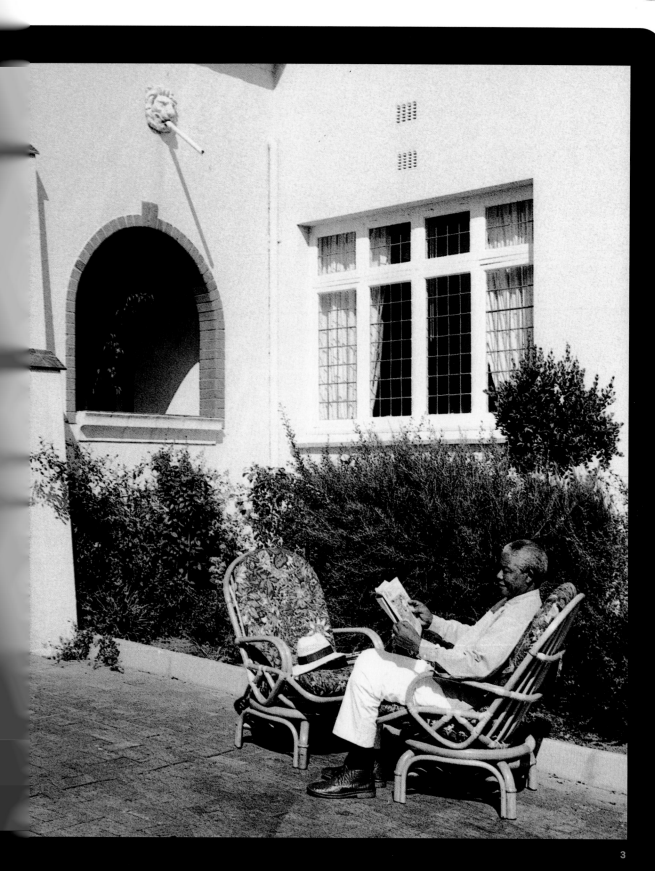

3

'If I ever grow up, I want to be like Nelson Mandela. He is the world's oldest teenager, he is in love, he dances, he does not wear a tie and is president of a great country. But more than anything else, I would like to treat my enemies like he does.'
— Hugh Masekela, jazz musician

In 1998, Mandela and Graça Machel were married. Graça, the widow of Samora Machel, is renowned for her community work, particularly amongst children. She had fought for Frelimo in the war of liberation in Mozambique. Mandela approached the prospective marriage in a respectfully traditional way. Early in 1998, he sent a group of Thembu clansmen to Maputo to negotiate discreetly for her hand. The secret negotiations took two months and several journeys. Finally, lobola was fixed at sixty prime cattle.

3
At home in Houghton. When Mandela first moved into his Houghton home he confessed to being 'the loneliest man' — until his romance with Graça Machel, whom he married on his eightieth birthday.

Mandela cut a fine figure at the wedding. He always had a penchant for fine clothes. On the Island he had fought against the prison uniform of short pants, and when a pair of long pants was given to him, they pleased him more, he recalled in his autobiography, than a 'pin-striped three-piece suit'. Some 25 years later, when he was about to meet Prime Minister P.W. Botha for the first time, he was indeed fitted out with a three-piece suit. When Mandela walked out of Victor Verster Prison a few years later, he was elegantly dressed in the conventional suit again — but it was a Western image he soon shed. Unexpectedly, he became a trendsetter in fashion, popularising the African-

style 'Madiba' shirt — loose-fitting, comfortable and light-hearted.

'To the vast majority of his countrymen, Nelson Rolihlahla Mandela remains their favourite South African.'

4

Children suffered terribly under apartheid. The migrant labour system and the pass laws broke up families, while poverty and the absence of parents placed the burden of childcare on aged grandparents and older children, especially daughters. After 1976, thousands of children were killed in political conflict, and countless others traumatised by their exposure to violence. Mandela has done much to sensitise society to children. He initiated a Children's Fund, to which he donated a third of his salary during his term as president. He has also persuaded many wealthy admirers, both locally and internationally, to contribute towards specific projects such as schools, clinics and feeding schemes. With the encouragement of Graça Machel, who has worked tirelessly for UNICEF, these initiatives have expanded beyond South Africa's borders.

5

Although Mandela has a quick temper and a sharp tongue, this is often softened by his warmth and humour. On one occasion, when Tony Leon, leader of the Democratic Party (the official opposition after the 1999 elections) had criticised the government, Mandela dismissed his constituency as a small, privileged elite, declaring: 'His is just a Mickey Mouse party.' Leon furiously retorted, 'If he thinks we are Mickey Mouse, President Mandela is Goofy!' A few weeks later, Mandela was visiting a Johannesburg hospital when he learnt that Tony Leon was a patient there, undergoing a minor operation. Mandela decided to pay him a surprise visit. As he neared Leon's ward, Mandela called out: 'Mickey, Goofy is coming to visit you.'

4

5

Mafikeng's Montsioa Stad

SITE 69

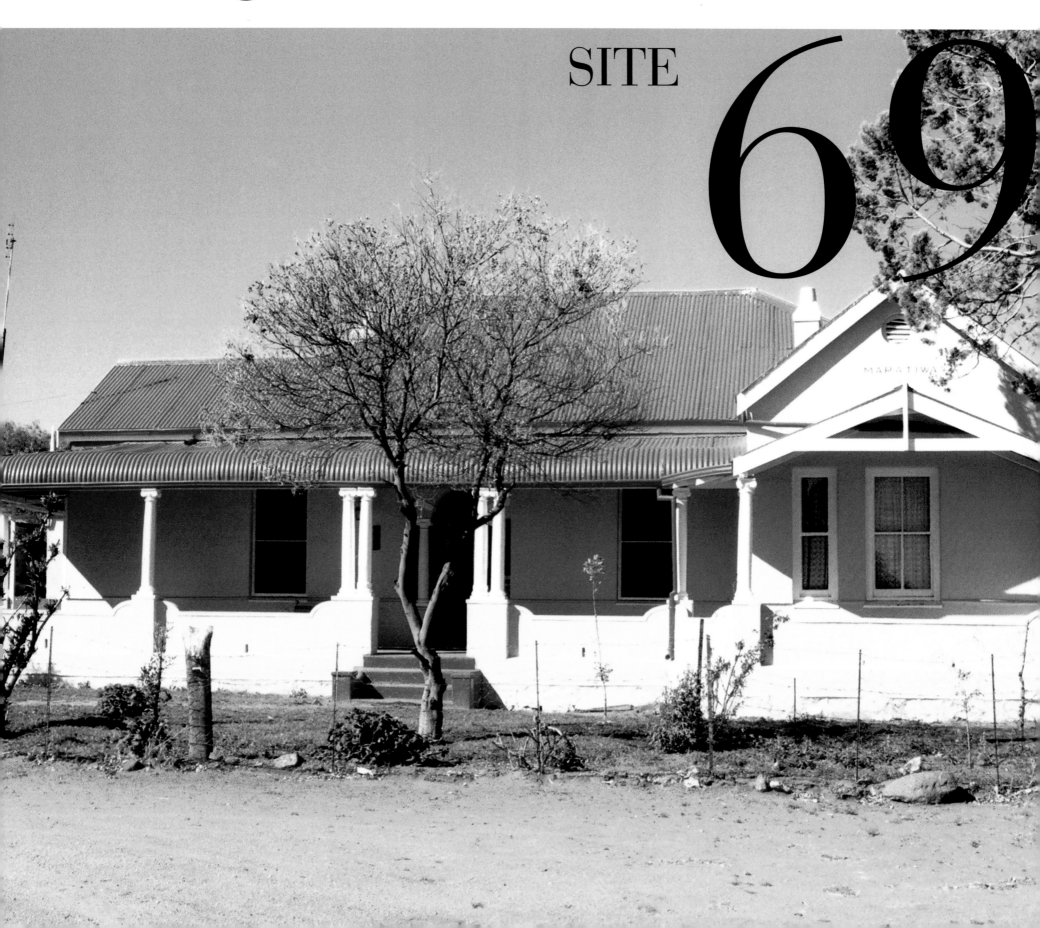

ANC Congress, December 1997

At the ANC's 1997 Congress in Mafikeng, Mandela bade farewell to his presidency of the party. The choice of city was in a sense a homage to one of the ANC's most illustrious founders, Sol Plaatje, whose Boer War Diaries recorded the seige of Mafikeng in 1899 — 1900. Mafikeng was built around Montsioa Stad, the ancient kgotla (meeting place) of the tribal elders of the Barolong tribe. The Stad is rich in history and sites of significance. It includes the Maratiwa House of Dr Modiri Molema, whose tenant was Sol Plaatje — reporter, novelist, scholar, and translator of Shakespeare into the Tswana language. There is also a museum, established in 1903, in the old City Hall which houses a 'Siege Room', and exhibits stone and iron age artifacts. During the apartheid years the North West was named 'Bophuthatswana'. Site 63 describes the drama of this homeland's last gasp in 1993. Today's premier is the popular UDF and ANC leader, Popo Molefe.

1

Mandela with Mbeki, newly elected ANC president, at the 1997 national congress in Mafikeng, where Mandela resigned as president of the ANC.

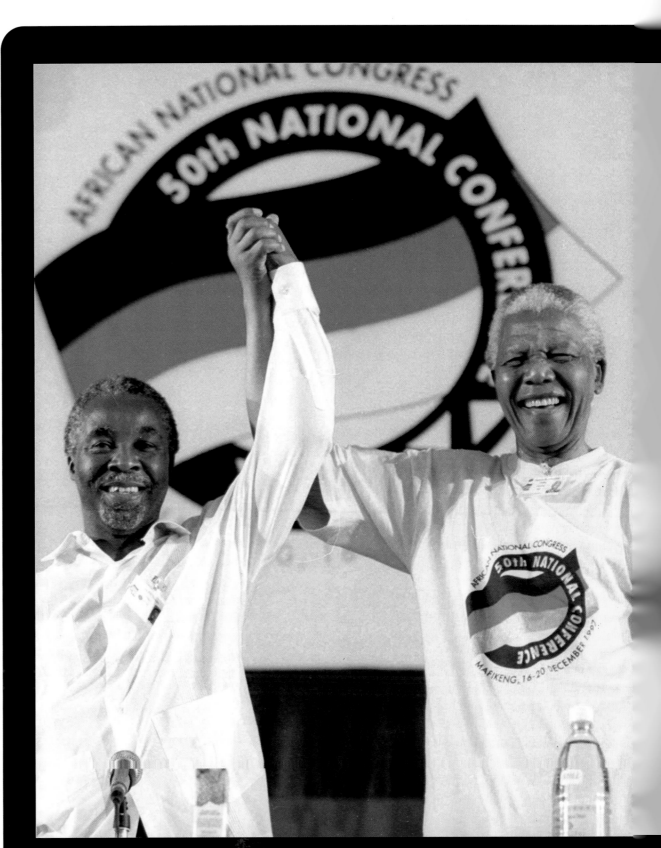

Mafikeng's Montsioa Stad

At the Mafikeng Congress, Mandela gave an exhaustive assessment of his years in office, examining the achievements of the ANC in government, and looking soberly at the enormous challenges that still lay ahead. The two thousand delegates broke up into commissions, and for the next two days talked earnestly about the way forward. In the evenings singers, musicians and dancers performed their warm appreciation of Mandela, who joined in on the stage. On the last day, Thabo Mbeki was unanimously elected the new ANC President. Mbeki had been born into the struggle. His father, Govan Mbeki, had been an activist intellectual since the 1930s, and was sentenced, along with Mandela, to life imprisonment. Thabo had been in exile since his school days. During that 30-year period, his education and training in the UK and in the USSR, and his political and diplomatic work, with Oliver Tambo as his mentor, were all to prove invaluable for the demanding work that lay ahead to revive a developing country burdened by gross inequalities.

By the end of Mandela's term of office, millions of citizens were still poor and unemployed. Transformation was not moving fast enough. The 'sunset clause,' many felt, had hampered the progress of educated young people moving into positions of responsibility in government departments. Huge challenges remained — the schools had to be integrated, medical care democratised, services provided for forty million people and no longer for the few. Many thousands remained homeless, and crime persisted. Above all, unemployment continued to haunt families.

2

Northern Province children taking great delight in operating the new waterpump in the village.

Surveys amongst workers, however, showed a remarkable political maturity, despite high levels of unemployment and the workers' burden of supporting the jobless. Most recognised that there had been improvements, although a major task of reconstruction and delivery still awaited the government. Five years was a short time to redress the gross inequities of more than three centuries of colonialism and white supremacy. They would, they said, give the ANC another term to deliver on their policies.

By the 1999 elections, Mandela's government was able to claim a progressive constitution, more than 700 000 houses, clean water, electricity, telephones, better rural roads, new classrooms and sports and recreation facilities, and the beginning of the redistribution of land. It had sensitised the public and the law to the rights of children, the aged, the disabled and women.

On 2 June 1999 South Africa was due to go to the polls again. Despite the huge challenges facing the new government, Mandela's term had made great strides. In conflict management, diplomacy and deal-making, no other party could touch the ANC. True to his convictions over the past four decades, Mandela had delivered a free and democratic country. Miraculously, he had inculcated a national acceptance of multi-culturalism and reconciliation. He had overseen 'the world's politest revolution'. But: 'The truth is that we are not yet free... We have not taken the final step of our journey, but the first step on a longer and even more difficult road. For to be free is not merely to cast off one's chains, but to live in a way that respects and enhances the freedom of others. The true test of our devotion to freedom is just beginning.'

3

Traditional leaders in the Union Buildings

Qunu

SITE 70

Bringing the world home

Soon after Mandela was released, he chose a site in Qunu to rebuild his family home. Although Mandela continues to travel the world, and shares other homes with Graça, this childhood place continues to be Mandela's primary abode: it was the home of his mother, his father's brother Solomoni, and his aunts who married into the Qunu families of Krexe and Ngcebetselene.

To the surprise of many, the house he built in Qunu was an exact replica of the one he had lived in at Victor Verster Prison. Mandela explained that after more than two decades of bleak imprisonment, that relatively simple warder's house was to him the acme of comfort, the most luxurious environment he had ever enjoyed in his long life. But since his marriage to Graça, Madiba has made alterations to the Qunu house, extending it to accommodate his growing family. In the era of globalisation, it is even more important to him that his grandchildren and great-grandchildren feel rooted in the village and remain close to their heritage.

In April 2000, a team of British gardening experts secretly transformed a bare patch of ground overlooked by Mandela's study in Qunu into a delightful garden complete with trees and a pond. The gardeners, whose BBC television programme *Groundforce*, is devoted to such surprise make-overs, usually work on gardens that belong to ordinary people, but an exception was made for Madiba. Graça Machel and Ahmed Kathrada were both party to the surprise, and the whole exercise was watched by 18 million viewers in Britain.

'Nelson Mandela is one of the world's most inspirational figures,' gardener Alan Titchmarsh explained. 'His struggle has been a lesson to us all and I was particularly struck reading in his memoirs how important gardening became to him during his imprisonment.'[36] In his book, Mandela described the vegetable garden he cultivated at Pollsmoor as one of his happiest diversions. 'It was my way of escaping from the monolithic concrete world that surrounded us.'

Qunu

Although rooted firmly at home, since his retirement Mandela has continued to play a significant role in world affairs.

The Mandela 'miracle' had led to world approval for the new South Africa. But this did not come without contradictions. When he was released, Mandela found a very different world from the one he left behind to serve his life sentence. During his lonely decades in prison, changes were taking place in the world that were to culminate in the collapse of the Soviet Union. These changes also led to a revolutionary economic thinking, away from the Keynesian belief in state intervention, back to the 19th-Century idea that the market rules. When Mandela was released in 1990, his first speech at the Grand Parade reaffirmed the idea of nationalisation. But within two years, pressures in the new global order had led to a shift in ANC thinking, to support for privatisation and the reduction of state responsibilities.

2
Demonstrations in Seattle, USA, outside the World Trade Organisation Conference 1998. Many South Africans joined in this protest against free market policies and unemployment in an unequal global world.

Mandela's growing involvement in world affairs brought with it an exposure to the ferment of the end of the millennium. Mandela's global prestige, and his calm, authoritative style, were very persuasive, and he used them to encourage foreign investment. Although the response of the world business community was disappointing, Mandela continued on a personal level to coax individual financiers and industrialists to contribute to South African development.

Since retiring as president, Mandela has continued to play a highly significant role as a conciliator in Africa and the rest of the world. After the death of Julius Nyerere, esteemed first

president of Tanzania, the delicate task of facilitating peace talks in Burundi was bestowed on Mandela. In the year 2000, he met a range of rebel groups, painstakingly crafting consensus in the face of opposition, trying to reach a democratic solution in a society where trust had been shattered.

As an African nationalist leader who went on to become head of an independent state, Mandela came to represent an alternative role model. Rather than clinging to power, as if his role in the liberation struggle entitled him to perpetual rulership, he voluntarily passed on the baton through democratic elections. In 1999, perhaps inspired by Mandela, Kenneth Kaunda abandoned his bid for the presidency of Zambia, and announced his intention of becoming a senior statesman and mediator in the continent at large.

Relinquishing the presidency freed Mandela to speak his mind. In a private visit to Britain and Ireland, he expressed his irritation with the self-appointed role of the United States and Britain in world affairs. He cited the examples of US-led military action in Iraq and Kosovo despite the objections of China and Russia, and without the approval of the UN Security Council. 'They want to be the policemen of the world ... It's a totally wrong attitude. They must persuade those countries ... They must sit down and talk to them. They can't just ignore them and start their own actions.'[37]

Mandela continued to work against the personality cult created around him, insisting that he be regarded as part of a collective team in the tradition of the ANC. Some found this difficult to grasp. 'But what happens to your ego?' Larry King asked in a CNN interview. 'I am the creation of the ANC', Mandela replied. 'My ego is shared by all the men and women in the ANC. It does not belong to any one individual...'[38]

Nelson Mandela facilitates peace talks with Burundi President, Pierre Buyoya, at Houghton headquarters.

Qunu

Mandela, seen here with Juan Antonio Samaranch, President of the International Olympic Committee (IOC), pays a visit of support and encouragement to delighted South African Olympic athletes and team officials at the Homebush Athletes Village in Sydney, Australia prior to the start of the games, September 2000.

In South Africa, the nature of Mandela's role has been perhaps better understood. On 22 February 2000, examining Mandela's mediation in Burundi, *The Star* editorialised: 'Mandela has no magic. The solution to South Africa's problems was found because men and women in this country were prepared to trust erstwhile enemies and sacrifice ground to realise a common objective. Mandela is trying to achieve something similar ... in Arusha.'

For South Africans, Mandela continues to represent moral regeneration. He has encouraged whites to shoulder the obligations that come with their privileged position, and contribute towards social redress. He has given 'a generous reading of the racial situation in this country', journalist Xolela Mangcu observed dryly.[39]

At a conference on racism in June 2000, Mandela said: 'We have, in the international politics of the 20th Century, grown used to the concept of politics as the art of the possible ... it has become almost unfashionable to speak of politics and morality.'

It was a timely reminder of the cultural and political landscape that shaped Mandela: a world represented by leaders such as Sol Plaatje, Chief Luthuli, Oliver Tambo and other African humanists, whose moral obligation extends to humanity as a whole. In the context of the new global order, it has been Mandela's historic role to foreground a South African tradition of inclusiveness and humanism. In that same tradition, it is the mission of his successor, Thabo Mbeki, to sensitise people worldwide, especially those in positions of power, to the eradication of poverty, and the quest for a democratic world order.

4

5

An early morning walk back home in Qunu. Mandela described imagining days like these in his retirement: 'Waking up with the sun, to walk the hills and valleys of my country village, Qunu, in peace and tranquillity.'

'I have walked that long road to freedom. I have tried not to falter; I have made missteps along the way. But I have discovered the secret that after climbing a great hill, one only finds that there are many more hills to climb. I have taken a moment here to rest, to steal a view of the glorious vista that surrounds me, to look back on the distance I have come. But I can rest only for a moment, for with freedom come responsibilities, and I dare not linger, for my long walk is not yet ended.'

Photo Credits

Introduction, pg 5

Courtesy Luli Callinicos

Map

Illustrated by Sally MacLarty

Part 1

Intro
1. Eli Weinberg
2. South African Library
3. A.M. Duggan-Cronin
4. Courtesy Luli Callinicos

Site 1 – Mvezo
Peter McKenzie
1. A.M. Duggan-Cronin
2. A.M. Duggan-Cronin
3. A.M. Duggan-Cronin
4. Luli Callinicos
5. A.M. Duggan-Cronin
6. UCT Library

Site 2 – Qunu
Peter McKenzie
1. Peter McKenzie
2. Peter McKenzie
3. A.M. Duggan-Cronin
4. Luli Callinicos
5. A.M. Duggan-Cronin
6. A.M. Duggan-Cronin
7. Peter McKenzie

Site 3 – Mqhekezweni
Peter McKenzie
1. Peter McKenzie
2. H. Kuckertz
3. Luli Callinicos
4. A.M. Duggan-Cronin
5. Peter McKenzie
6. A.M. Duggan-Cronin
7. Peter McKenzie

Site 4 – Bumbane
Lesley Townsend, SA Heritage Resources
1. A.M. Duggan-Cronin
2. Mayibuye Centre
3. *African Contrasts*, Shepherd & Paver
4. Wits Historical Papers
5. Wits Historical Papers

Site 5 – Clarkebury
Peter McKenzie
1. *The Deathless Years*, Clarkebury Centenary Publication, Cory Library
2. *The Deathless Years*, Clarkebury Centenary Publication, Cory Library
3. *The Deathless Years*, Clarkebury Centenary Publication, Cory Library
4. Albany Museum
5. *The Deathless Years*, Clarkebury Centenary Publication, Cory Library
6. *The Deathless Years*, Clarkebury Centenary Publication, Cory Library

Site 6 – Tyhalarha
Lesley Townsend, SA Heritage Resources Agency
1. A.M. Duggan-Cronin
2. A.M. Duggan-Cronin
3. Luli Callinicos

Site 7 – Healdtown
Peter McKenzie
1. Courtesy Mrs Enid Webster
2. Courtesy Mrs Enid Webster
3. Peter McKenzie
4. Peter McKenzie

Site 8 – Fort Hare
Peter McKenzie
1. Fort Hare Calendar 1940
2. Fort Hare Calendar 1940
3. *African Contrasts*, Shepherd & Paver
4. Courtesy Dr Lancelot Gama
5. Fort Hare Calendar 1940

Site 9 – The Bhunga, Umtata
Peter McKenzie
1. *African Contrasts*, Shepherd & Paver
2. Times Media Limited
3. *African Contrasts*, Shepherd & Paver
4. Mayibuye Centre

Part 2

Intro
1. Courtesy Neil Fraser – GJMC
2. MuseuMAfrica
3. Mayibuye Centre

Site 10 – Newtown Compound
Joanne Bloch
1. Mayibuye Centre
2. MuseuMAfrica
3. Eli Weinberg

Site 11 – The Pass Office, Albert Street
Peter McKenzie
1. Eli Weinberg
2. *Stage and Cinema* magazine 1919, African Studies Library, Johannesburg
3. Eli Weinberg
4. Eli Weinberg

Site 12 – Alexandra Township
Peter McKenzie
1. *Libertas* 1942
2. Bonile Bam
3. Bailey's African History Archives
4. Eli Weinberg
5. *Libertas* 1942
6. Bonile Bam
7. Times Media Limited

Site 13 – Walter Sisulu's Office
Peter McKenzie
1. Luli Callinicos
2. Mayibuye Centre
3. Peter McKenzie
4. Times Media Limited

Site 14 – The Sisulu Home, Orlando West
Peter McKenzie
1. Courtesy Walter and Albertina Sisulu
2. Courtesy Walter and Albertina Sisulu
3. Courtesy Walter and Albertina Sisulu
4. MuseuMAfrica
5. Mayibuye Centre
6. Alf Kumalo

Site 15 – Park Station
Peter McKenzie
1. *JHB Style* Clive Chipkin
2. Times Media Limited
3. *African Contrasts* Shepherd & Paver
4. Joao Silva/PictureNET Africa

Site 16 – Dr Xuma's House
Peter McKenzie
1. Community of the Resurrection
2. Eli Weinberg
3. *The Star*, 12/10/1991
4. *The Deathless Years*, Clarkebury Centenary Publication, Cory Library
5. *African Contrasts*, Shepherd & Paver

Site 17 – City Hall steps
Peter McKenzie
1. Times Media Limited
2. Mayibuye Centre
3. Mayibuye Centre
4. Mayibuye Centre
5. Mayibuye Centre

Site 18 – The Supreme Court
Peter McKenzie
1. Times Media Limited
2. Times Media Limited
3. Jurgen Schadeberg
4. Bailey's African History Archives

Site 19 – Bantu Men's Social Centre
Peter McKenzie
1. Mayibuye Centre
2. Bailey's African History Archives
3. *African Contrasts*, Shepherd & Paver
4. Bailey's African History Archives
ANC Youth League document, Wits Historical Papers
5, 6 from *Freedom in our Lifetime*, Edgar, ka Msumza
7. Mayibuye Centre
8. Bailey's African History Archives
9. Bailey's African History Archives

Site 20 – The Planet Hotel
Peter McKenzie
1. Bailey's African History Archives
2. Bailey's African History Archives
3. Mayibuye Centre
4. Jurgen Schadeberg

Site 21 – The DOCC
Peter McKenzie
1. Bailey's African History Archives
2. Times Media Limited
3. Bailey's African History Archives
4. Bailey's African History Archives
5. Touchline Allsport

Site 22 – Wits University
Peter McKenzie
1. *Libertas* 1941
2. Wits Archives
3. Wits Archives
4. Wits Archives
5. Courtesy George and Arethe Daflos
6. Bailey's African History Archives
7. Courtesy Sheila Weinberg

Site 23 – Kapitan's
Cedric Nunn
1. GJMC archives Metropolitan Centre Johannesburg
2. Bailey's African History Archives
3. Courtesy Lazar Sidelsky
4. Bailey's African History Archives
5. *The Passive Resister* 1947
6. Eli Weinberg

Site 24 – Kholvad House
Peter McKenzie
1. Courtesy Ahmed Kathrada
2. Wits Archives
3. Courtesy Ahmed Kathrada
4. *African Contrasts*, Shepherd & Paver
5. Courtesy Pahad Family

Site 25 – Mary Fitzgerald Square, Newtown
Peter McKenzie
1. Times Media Limited
2. MuseuMAfrica
3. Courtesy Lou Haysom
4. *African Contrasts*, Shepherd & Paver
5. NUM

Part 3

Intro
1. Bailey's African History Archives
2. Times Media Limited
3. Mayibuye Centre

Site 26 – Makgasa Hall, Bochabela
Peter McKenzie
1. Bailey's African History Archives
2. Courtesy SA Heritage Resources Agency
3. Mayibuye Centre
4. Mayibuye Centre

Site 27 – Luthuli House
Peter McKenzie
1. Eli Weinberg
2. Bailey's African History Archives
3. Courtesy Luli Callinicos

Site 28 – Chancellor House, Fox Street
Peter McKenzie
1. Jurgen Schadeberg
2. Peter McKenzie
3. Bailey's African History Archives
4. *The Star*
5. Courtesy Luli Callinicos

Site 29 – National Acceptances House, Rissik St
Peter McKenzie
1. Mayibuye Centre
2. Mayibuye Centre
3. Bailey's African History Archives
4, 5, 6 Mayibuye Centre
7. Times Media Limited
8. Louise Gubb/Trace Images

Site 30 – Gandhi Square, Rissik St
Peter McKenzie
1. MuseuMAfrica
2. Mayibuye Centre
3. Bailey's African History Archives
4. Mayibuye Centre

Site 31 – Red Square, Fordsburg
Joanne Bloch
1. Bailey's African History Archives
2. Mayibuye Centre
3. Eli Weinberg

Site 32 – Curries Fountain, Durban
Peter McKenzie
1. *New Age Newspaper* 1960, Wits Historical Papers
2. *New Age Newspaper* 1960, Wits Historical Papers
3. Clint Zassman
4. *Images of Defiance*, Ravan Press

Site 33 – New Brighton, Port Elizabeth
Peter McKenzie
1. Mayibuye Centre
2. Bailey's African History Archives
3. Bailey's African History Archives

Site 34 – The Magistrate's Court, Johannesburg
Peter McKenzie
1. Bailey's African History Archives
2. Bailey's African History Archives
3. Bailey's African History Archives

Site 35 – Chief Albert Luthuli's House, Groutville
Peter McKenzie
1. Bailey's African History Archives
2. Times Media Limited
3. Bailey's African History Archives

Site 36 – Sophiatown
Peter McKenzie
1. Mayibuye Centre
2. Bailey's African History Archives
3. Bailey's African History Archives
4. Mayibuye Centre
5. Mayibuye Centre
6. Bailey's African History Archives

Site 37 – Meadowlands, Soweto
Peter McKenzie
1. Bailey's African History Archives
2. Wits Historical Papers
3. Times Media Limited

Site 38 – St Mary's Cathedral, Johannesburg
Peter McKenzie
1. Mayibuye Centre
2. Bailey's African History Archives
3. Eli Weinberg
4. PictureNET Africa

Site 39 – District Six, Cape Town
Lesley Townsend, SA Heritage Resources Agency
1. Cloete Breytenbach
2. Cloete Breytenbach
3. Cloete Breytenbach
4. Bailey's African History Archives
5. Bailey's African History Archives
6. Mayibuye Centre
7. Mayibuye Centre
8. Courtesy Ciraj Rassool
9. George Hallett

Site 40 – COSATU House, Johannesburg
Bonile Bam
1. Paul Weinberg/South Photographs
2. Jurgen Schadeberg
3. Mayibuye Centre
4. Times Media Limited

Site 41 – Freedom Square, Kliptown
Bonile Bam
1. Mayibuye Centre
2. Wits Historical Papers
3. Mayibuye Centre
4. Mayibuye Centre
5. Bailey's African History Archives
6. Mayibuye Centre

Site 42 – Union Buildings, Pretoria
Graeme Williams/South Photographs
1. Bailey's African History Archives
2. Bailey's African History Archives
3. Bailey's African History Archives
4. Eli Weinberg
5. Bailey's African History Archives
6. Bailey's African History Archives

Site 43 – The Old Fort, Johannesburg
Courtesy Urban Solutions Architects, Johannesburg
1. MuseuMAfrica
2. Jurgen Schadeberg
3. Mayibuye Centre

Site 44 – The Old Synagogue, Pretoria
Peter McKenzie
1. Bailey's African History Archives
2. Bailey's African History Archives
3. Bailey's African History Archives
4. Peter Magubane
5. Bailey's African History Archives

Site 45 – Orlando Hall, Soweto
Peter McKenzie
All other photographs in this site are from
Bailey's African History Archives.

Part 4

Intro
1. New Age Newspaper 1962, Wits Historical Papers
2. Bailey's African History Archives

Site 46 – Sharpeville
Bonile Bam
1. MuseuMAfrica
2. Bailey's African History Archives
3. MuseuMAfrica
4. Bailey's African History Archives
5. Mayibuye Centre
6. Times Media Limited

Site 47 – Pleissislaer Hall
Peter McKenzie
1. Bailey's African History Archives
2. Bailey's African History Archives
3. Mayibuye Centre

Site 48 – Ngquza Hill, Pondoland
Courtesy S. Grootboom, Directorate of Museums and
Heritage Resources, Eastern Cape
1. Eli Weinberg
2. Mayibuye Centre
3. Mayibuye Centre
4. The Star
5. Mayibuye Centre
6. Mayibuye Centre
7. Times Media Limited
8. Times Media Limited

Site 49 – Howick
Gallo Images
1. Clint Zassman
2. Mayibuye Centre
3. Eli Weinberg
4. Alf Kumalo

Site 50 – Rivonia
Raymond Eckstein Photography
1. SA Police Collection, Wits Historical Papers
2. Courtesy Helmut Schneider
3. Wits Historical Papers
4. Bram Fischer — Afrikaner Revolutionary, Stephen Clingman
5. Eric Miller/iAfrika Photos

Part 5

Intro
1. Peter McKenzie
2. Mayibuye Centre
3. Peter McKenzie

Site 51 – Robben Island
Mark Skinner
1. Peter McKenzie
2. Top: New Age Newspaper 1959, Wits Historical Papers
 Bottom: South African Library
3. Alf Kumalo
4. Mayibuye Centre
5. South African Library
6. Mayibuye Centre

Site 52 – 8115 Ngakane Street, Orlando West
Peter McKenzie
1. Times Media Limited
2. Graeme Williams/South Photographs
3. Mayibuye Centre
4. Alf Kumalo
5. Alf Kumalo
6. Alf Kumalo
7. Times Media Limited
8. Times Media Limited

Site 53 – Phefeni School, Orlando West
Peter McKenzie
1. Times Media
2. Eli Weinberg
3. Bailey's African History Archives

Site 54 – Rocklands, Mitchells Plain, Cape Town
Peter McKenzie
1. Paul Weinberg/South Photographs
2. Guy Tillim/South Photographs
3. Themba Nkosi
4. Mayibuye Centre
5. Gideon Mendel/Mayibuye Centre

Site 55 – Machel Monument, Mbuzini,
Mpumalanga
Steve Hilton-Barber
1. Les Bush/PictureNET Africa
2. Mayibuye Centre
3. Mayibuye Centre

Site 56 – The Steve Biko Garden of
Remembrance
Luli Callinicos
1. Adil Bradlow/PictureNET Africa
2, 3, 4, 5 and 6 from Mayibuye Centre

Site 57 – South Africa House, Trafalagar
Square, London
INPRA
1. Times Media Limited
2. Mayibuye Centre
3. Graeme Williams/South Photographs

Site 58 – Pollsmoor Prison, Cape Town
Peter McKenzie
1. Peter McKenzie
2. Adil Bradlow/PictureNet Africa
3. Guy Tillim/South Photographs

Site 59 – Jabulani Stadium, Orlando
Eddie Mtswedi
1. Mayibuye Centre
2. Courtesy Luli Callinicos
3. Mayibuye Centre
4. Images of Defiance, Ravan Press

Site 60 – Victor Verster, Prison
Peter McKenzie
1. Courtesy Ters Ehlers
2. Times Media Limited
3. Peter McKenzie
4. Courtesy The Argus

Part 6

Intro
1. Louise Gubb/Trace Images
2. Graeme Williams/South Photographs
3. The Star
4. Times Media Limited

Site 61 – Grand Parade, Cape Town
Peter McKenzie
1. Chris Ledochowski
2. Mayibuye Centre
3. Times Media Limited
4. The Star
5. The Star
6. Adil Bradlow/PictureNET/Africa
7. CDC Photo Unit
8. Courtesy ANC Archives
9. Detroit Free Press/Courtesy ANC Archives

Site 62 – Groote Schuur, Cape Town
Peter McKenzie
1. CDC Photo Unit
2. Times Media Limited
3. Paul Weinberg/South Photographs

Site 63 – The World Trade Centre, Kempton
Park
Courtesy Global Resorts
1. Ken Oosterbroek/PictureNET Africa
2. Paul Velasco/PictureNET Africa
3. Ken Oosterbroek/PictureNET Africa
4. Ken Oosterbroek/PictureNET Africa
5. Cedric Nunn
6. Peter Magubane
7. Peter Magubane
8. INPRA
9. Sunday Independent

Site 64 – Ohlange School, Inanda
Peter McKenzie
1. Henner Frankenfeld/PictureNET Africa
2. Times Media Limited
3. Henner Frankenfeld/PictureNET Africa
4. Peter Magubane
5. South African Library, Cape Town

Site 65 – Genadendal, Cape Town
Peter McKenzie
1. Times Media Limited
2. Alf Kumalo
3. Alf Kumalo
4. Peter Magubane
5. Peter Magubane
6. TJ Lemon

Site 66 – Parliament, Cape Town
Peter McKenzie
1. MuseuMAfrica
2. Eric Miller/iAfrika Photos
3. Peter Magubane
4. Adil Bradlow/PictureNET Africa

Site 67 – East London City Hall
Peter McKenzie
1. Rodger Bosch/iAfrika Photos
2. Greg Marinovich/PictureNET Africa
3. Henner Frankenfeld/PictureNET Africa
4. Times Media Limited
5. Mandela Birthday Souvenir
6. AP Photo/Walter Dhladhla/Pool

Site 68 – 4 Thirteenth Ave, Houghton
Paul Velasco/PictureNET Africa
1. Times Media Limited
2. Times Media Limited
3. George Hallett
4. Henner Frankenfeld/PictureNET Africa
5. Courtesy Ken Andrew

Site 69 – Mafikeng's Montsioa Stad
Courtesy M.M. Kotze
1. Adil Bradlow/PictureNET Africa
2. Motlhalefi Mahlabe
3. Times Media Limited

Site 70 – Qunu
Times Media Limited
1. BBC Worldwide 2000
2. INPRA
3. Times Media Limited
4. AP Photo/Nathan Richter/Pool
5. Anton Hammerl

Site Addresses

This Address List is incomplete. Some of the places identified below do no have addresses as such, but rather vague directions, as they were never accorded a place on the South African map.

The apartheid map of South Africa tended to identify roads and railways which serviced white farmers, white traders and white urban areas. This practice was not new. Its origins lay in colonial policies and attitudes. The concept of Cecil John Rhode's Cape to Cairo route for the British Empire is a typical example of how land, space and sites of significance were seized and appropriated by colonisers. Through most of the 20th Century, white South Africans, in their travels around the country, never had to see a township or reserve, much less an informal settlement, unless they were trained to look.

Some of the addresses in this book are being identified formally for the first time. Many of the more remote or rural places and even some sites in the towns themselves do not have official directions, but can be identified by the local people pointing a finger and saying, 'It's over there!'

Site 1: Mvezo
Elliotdale Road, off N3 highway from Umtata to East London

Site 2: Qunu
Off N3 highway from Umtata to East London

Site 3: Mqhekezweni
Follow signboard off N3 highway from Umtata to East London

Site 4: Bumbane
Follow signboard off N3 highway from Umtata to East London

Site 5: Tyalarha
Follow signboard off highway from Umtata to East London

Site 6: Clarkebury
Take highway from Umtata to East London, take Engcobo turning, take Munyu offramp

Site 7: Healdtown
Follow sign boards on the road to Fort Beaufort and King William's Town

Site 8: Fort Hare
On the outskirts of Alice on the road to King William's Town

Site 9: The Bhunga renamed Nelson Mandela Museum (Bhunga Building)
Corner Owen Street and Nelson Mandela Drive, Umtata

Site 10: The Newtown Compound
The Workers Library and Museum, corner Jeppe and Bezuidenhout Streets, Newtown

Site 11: The Pass Office
80 Albert Street, Johannesburg City Centre

Site 12: Mr Xhoma's house
7th Avenue, Alexandra

Site 13: Walter Sisulu's Office
Corner West and Commissioner, off Diagonal Street, Johannesburg City Centre

Site 14: The Sisulu home
7372 Magang Street, Orlando West, Soweto

Site 15: Park Station renamed The Johannesburg (Park) Station
Corner Wolmarans and Rissik Streets, Joubert Park, Johannesburg (Between Harrison, Wolmarans, Leyds and de Villiers Streets) or entrance off Leyds Street via Harrison Street, next to Rotunda Building

Site 16: Dr Xuma's house
73 Toby Street, Sophiatown

Site 17: Johannesburg City Hall
Corner Rissik and President Streets, Johannesburg City Centre

Site 18: The High Court
Corner Pritchard and Von Brandis Streets, Johannesburg City Centre

Site 19: Bantu Men's Social Centre renamed Traffic Department
Between Eloff Street Extention and Loveday Street Extention on the corner of Village Road

Site 20: The Planet Hotel
83 Mint Road, corner Gilles Street, Fordsburg

Site 21: The Donaldson Community Centre (DOCC) renamed YMCA
4565 Rathebe Street, corner Mooki Street, Orlando East, Soweto

Site 22: University of the Witwatersrand
Senate House, corner Jorissen and Station Streets, Braamfontein

Site 23: Kapitan's Café
11a Kort Street, between Market & President Streets, Johannesburg City Centre

Site 24: Kholvad House
27 Market Street, between West and Becker Streets, Johannesburg City Centre

Site 25: Mary Fitzgerald Square
The Market Theatre Precinct, between Jeppe and Bree Streets, corner Bezuidenhout Street, opposite Museum Africa, Newtown

Site 26: Makgasa Hall
King Street, Bochabela, Mangaung, Bloemfontein, pass Paradise Hall in Mkuhlane Main Road (travelling from Dewetsdorp Road)

Site 27: The ANC Head Office renamed Luthuli House
51 Plein Street, Johannesburg City Centre

Site 28: Chancellor House
25 Fox Street corner Becker, Johannesburg City Centre

Site 29: National Acceptances House renamed National Union of Mineworkers
7 Rissik Street, Johannesburg City Centre

Site 30: Gandhi Square
corner Rissik and Fox Streets, Johannesburg City Centre

Site 31: Red Square renamed Oriental Plaza
Corner Bree and Main Streets, Fordsburg, Johannesburg

Site 32: Curries Fountain Stadium
24 Winterton Walk, off Botanic Gardens Road, Durban

Site 33: New Brighton Station
Ferguson Road, Port Elizabeth City Centre, follow signs to Qeqe Petrol Station, the old site of New Brighton Station is opposite the PPC Factory and F & Q Building

Site 34: The Magistrates' Courts
Corner West and Fox Streets, Johannesburg City Centre

Site 35: Chief Albert Luthuli's house
Groutville, Stanger, nearby graves of Chief Albert Luthuli and his wife, KwaZulu Natal

Site 36: Church of Christ the King
49 Ray Street, Sophiatown

Site 37: Meadowlands
A suburb in Soweto

Site 38: St Mary's Cathedral and Darragh House
Corner de Villiers and Wanderers Streets, Johannesburg City Centre

Site 39: District Six Museum
25a Buitenkant Street, Cape Town

Site 40: COSATU House
1 Leyds Street, Braamfontein, Corner Biccard, Johannesburg

Site 41: Freedom Square
Centrally located between Union Road, K53 Highway and Klipspruit Valley Road, Kliptown, Soweto, close to Kliptown Station

Site 42: Union Buildings
Government Avenue, off Hill Street, Pretoria

Site 43: The Old Fort
Corner Joubert and Pretoria Street, Braamfontein, Johannesburg

Site 44: The Old Synagogue
Paul Kruger Street, Pretoria

Site 45: Orlando and Kimberley
Orlando Communal Hall
448 Mooki Street, Orlando, Soweto
Robert Sobukwe's house
6 Naledi Street, Galeshewe, Kimberley

Site 46: Sharpeville Memorial
Corner Eiso and Zwane Streets, Sharpeville, Vereeniging, Gauteng

Site 47: Plessieslaer Hall
Zibukezulu High School Grounds, F.J Sithole Road, off Edendale Road, Imbali, Pietermaritzburg

Site 48: Ngquza Hill Memorial
Outside Flagstaff, Pondoland, Eastern Cape

Site 49: Howick
Howick Falls
Off N3 Highway, take Howick North off-ramp, off Falls View Road, Howick City Centre
Howick Mandela Monument
N3 Highway to Tweedie, on the R103, Natal Midlands

Site 50: Lilliesleaf Farm
8 Winston Ave, Rivonia, Johannesburg

Site 51: Robben Island
Embark the ferry from the Waterfront dock, Cape Town

Site 52: The home of Nelson and Winnie Mandela
8115 Ngakane Street, Orlando West

Site 53: Phefeni Junior Secondary School
7374 Vilakazi Street, Orlando West, Soweto

Site 54: Steve Biko's home
698 Ginsberg, King William's Town, Eastern Cape

Site 55: Rocklands Civic Centre
Off Park Ave, corner Park Ave & Lancaster Roads, Mitchells Plain, Cape Town

Site 56: The Samora Machel Monument
Signboard off Komatipoort Road, on the highway from Nelspruit to Mozambique, Mbuzini, Mpumalanga

Site 57: Trafalgar Square
London Central

Site 58: Pollsmoor Prison
Near M3 entrance to Ou Kaapse Weg, Steenberg Road, Tokai, Cape Town

Site 59: Jabulani Stadium (Official name Johannesburg Amphitheatre)
Koma Road, near Jabulani Police Station, Jabulani, Soweto

Site 60: Victor Verster prison renamed Klein Drakenstein prison
Off R300 Highway between Paarl and Franschoek, Wemmershoek, Eastern Cape

Site 61: Grand Parade
Darling Street, opposite the Cape Town City Hall, between Darling, Plein, Buitenkant and Strand Streets, Cape Town City Centre

Site 62: Groote Schuur Estate currently Public Works Department
The Rondebosch Estate, corner Rondebosch Main Road and Klipper Road, Rondebosch, Cape Town

Site 63: World Trade Centre renamed Caesar's Palace Hotel and Conference Centre
64 Jones Road, off R24 highway to Johannesburg Airport, Kempton Park, Johannesburg 10118

Site 64: Ohlange High School
Off Inanda Main Road, in the Mshayazase area, Inanda, Durban

Site 65: Genadendal (The presidential residence)
The Rondebosch Estate, corner of Rondebosch Main Road and Klipper Road, Rondebosch, Cape Town

Site 66: Parliament
Main entrance in Plein Street, Cape Town, can also enter between Lile and Parliament streets

Site 67: East London City Hall
Corner Oxford and Argyle Streets, East London

Site 68: The headquarters of Nelson Mandela
No.4 13th Avenue, Lower Houghton, Johannesburg

Site 69: The Sol Plaatjie residence
Maratiwa House, Seweding, identifiable by tall trees, Montsioa Stad, Mafikeng (or go to the Mafeking Museum in Martin Street next to the Post Office, identifiable by the steam engine and ox wagon outside, they will take you to the residence)

Site 70: Mandela's Qunu home
On the main road from Umtata to East London, Qunu Administrative area, Qunu

Bibliography

Benson, Mary *Nelson Mandela: The Man and the Movement* (Penguin, 1994)

Benson, Mary *Robben Island*, a play based on historical records and testimonies of prisoners (Monday Night Playhouse, November 1992)

Bernstein, Hilda *For their Triumphs and their Tears* (IDAF, 1985)

Bizos, George *No one to blame* (David Philip, 1998)

Callinicos, Luli *Gold and Workers* (Ravan Press, 1981)

Callinicos, Luli *Interview with Walter Sisulu*, Johannesburg, 31 October 1994

Callinicos, Luli *Working life: Factories, Townships and Popular Culture* (Ravan Press, 1987)

Carrim, Nazir *Fietas: A Social History of Pageview, 1948-1988* (Save Pageview Association, 1990)

Drum magazine various issues

Hagemann, Albrecht *Nelson Mandela* (Fontein Books, 1995)

Hlatshwayo, Mi *The tears of a creator*, a praise poem performed at the launch of COSATU, 1985

Huddleston, Trevor *Naught for your Comfort* (Collins, 1956)

Joseph, Helen *If This be Treason* (Contra, 1998)

Joseph, Helen *Side by Side* (Ad Donker, 1986)

Karis, T. and Carter, G. (eds) *From Protest to Challenge: Documents of African Politics in South Africa 1882-1964, Volume 2: Hope and Challenge 1935-1952* (Hoover Institution Press, 1987)

Karis, T. and Gerhart, G *From Protest to Challenge: Documents of African Politics in South Africa 1882-1964, Volume 3: Challenge and Violence: 1953-1964* (Hoover Institution Press, 1987)

Karis, Tom Interview with Oliver Tambo *Witwatersrand Historical Papers*,1963, New York

Kathrada, Ahmed *Robben Island Poster*, 1993 (page 230)

Krog, Antjie *Country of my Skull* (Random House, 1998)

La Guma, Alex *A Walk in the Night* (David Philip 1991) *Libertas* magazine, 1942

Lodge, T. and Nasson, B. *All, Here, and Now: Black Politics in South Africa in the 1980s* (Ford Foundation and David Philip, 1991)

Luthuli, Albert *Let My People Go* (Fontana, 1962)

Mandela, Nelson *Long Walk to Freedom* (Macdonald Purnell, 1994)

Mandela, Nelson *No Easy Walk to Freedom* (Heinemann, 1965)

Mandela, Nelson Speech to the *MK National Conference*, September 1993

Mandela, Nelson Statement from underground, 26 June 1961

Mandela, Nelson Statement while on trial, 1962

Mandela, Winnie *Part of My Soul Went With Him* (Penguin, 1985)

Mangcu, Xolela in the *Sunday Independent*, 4 June 2000

Mattera, Don *Memory is the Weapon* (Ravan Press, 1987)

Meredith, Martin *Nelson Mandela: A Biography* (Penguin, 1997)

Modisane, Bloke *Blame Me on History* (Thames and Hudson, 1963)

Mqhayi, Krune Praise poem on the occasion of the visit by the Prince of Wales to Healdtown, 1925

Ndlovu, Sifiso *The Soweto Uprisings: Counter-memories of June 1996* (Ravan Press, 1998)

NECC *What is History?* (Skotaville, 1987)

New Age newspaper, various issues

Plaatje, Sol *Native Life in South Africa* (Ravan Press, 1982)

Preamble to the Constitution of South Africa, 1996

Sampson, Anthony *Mandela: The Authorised Biography* (Harper Collins, 1999)

Sampson, Anthony *The Treason Cage: The Opposition on Trial in South Africa* (Heinemann, 1958)

Saturday Star, 22 April 2000

Schadeberg, Jurgen *Voices from Robben Island* (Ravan Press, 1994)

Sparks, Allister *Tomorrow's Another Country: The Story of South Africa's Negotiated Revolution* (Struik, 1994)

The Star, 27 January 1999

The Star, 6 April 2000

Themba, Can *The Will to Die* (David Philip, 1982) includes article *Requiem for Sophiatown*

Umkhonto we Sizwe Leaflet, announcing the formation of

Van Wyk, Chris *'Face to Face'* Taxi Project, July 2000

Xuma, Dr A.B. *African Claims* (a document), 1944

End Notes

[1] page 31: Krog, Antjie *Country of my Skull* (Random House, 1998), pp. 136-7

[2] page 62: Callinicos, Luli *Gold and Workers* (Ravan Press, 1981), page 40

[3] page 81: Themba, Can *Requiem for Sophiatown* (David Philip, 1982), p. 107

[4] page 83: Modisane, Bloke *Blame Me on History* (Thames and Hudson, 1963), pp. 34-5

[5] page 91: Callinicos, Luli *Gold and Workers* (Ravan Press, 1981), p. 209

[6] page 98: Carrim, Nazir. Fietas: *A Social History of Pageview, 1948-1988* (Save Pageview Association, 1990), p. 74

[7] page 135: Interview by Luli Callinicos, Johannesburg, 31.3.93

[8] page 151: Meredith, Martin *Nelson Mandela: A Biography* (Penguin, 1997), p. 94

[9] page 166: Mattera, Don *Memory is the Weapon* (Ravan Press, 1987), p. 151

[10] page 166: Huddleston, Trevor *Naught for your Comfort* (Collins, 1956), pp. 123, 126

[11] page 167: Themba, Can *The Will to Die* (David Philip, 1982), p. 108

[12] page 171: Huddleston, Trevor *Naught for your Comfort* (Collins, 1956), pp. 125-6

[13] page 174: Sampson, Anthony *The Treason Cage: The Opposition on Trial in South Africa* (Heinemann, 1958), p. 101

[14] page 177: La Guma, Alex *A Walk in the Night* (David Philip, 1991), p. 21

[15] page 185: Leon, Levy, Interview by Luli Callinicos, telephonic, 13.10.98

[16] page 193: Bernstein, Hilda *For their triumphs and their tears* (IDAF, 1985) p. 89

[17] page 215: Benson, Mary *Mandela*, (Penguin, 1986) p. 88

[18] page 222: Sampson, Anthony *Mandela: The Authorised Biography* (Harper Collins, 1999), p. 567

[19] page 223: Mandela, Winnie *Part of my soul went with him* (Penguin, 1985), p. 60

[20] page 227: Sampson, Anthony, *Mandela: The Authorised Biography* (Harper Collins, 1999), p. 186

[21] page 227: Oliver Tambo in Mandela, Nelson *No Easy Walk to Freedom* (Heinemann, 1965), p. xvii

[22] page 233: Benson, Mary *Robben Island* (Monday Night Playhouse, November 1992)

[23] page 237: Schadeberg, Jurgen *Voices from Robben Island* (Ravan Press, 1994), p. 57

[24] page 237: Schadeberg, Jurgen *Voices from Robben Island* (Ravan Press, 1994), p. 17

[25] page 242: Winnie Mandela in Benson, Mary *Nelson Mandela: The Man and the Movement* (Penguin, 1994), p. 147

[26] page 243: Benson, Mary *Nelson Mandela: The Man and the Movement* (Penguin, 1994), p. 168

[27] page 245: Ndlovu, Sifiso *The Soweto Uprisings: Counter-memories of June 1996* (Ravan Press, 1998)

[28] page 246: NECC *What is History?* (Skotaville, 1987), p. 45

[29] page 259: Bizos, George *No One to Blame* (David Philip, 1998)

[30] page 262: NECC *What is History?* (Skotaville, 1987) p. 87

[31] page 267: Sampson, Anthony *Mandela: The Authorised Biography* (Harper Collins, 1999), p. 268

[32] page 278: Nelson Mandela's Speech to the MK National Conference, September 1993

[33] page 295: Nyatsumba, Kaizer in *The Star*, 27 January 1999

[34] page 296: Hagemann, A. *Nelson Mandela* (Fontein Books, 1995), p. 7

[35] page 307: Benson, Mary *Nelson Mandela: The Man and the Movement* (Penguin, 1994), p. 235

[36] page 327: Titchmarsh, Alan in the *Saturday Star*, 22 April 2000

[37] page 329: Mandela, Nelson in *The Star*, 6 April 2000

[38] page 329: 17 May 2000

[39] page 330: Mangcu, Xolela in the *Sunday Independent*, 4 June 2000

Index

References to photographs are printed in Italic